How to use this book

The main text provides a survey of the city's cultural history from the Roman period to the present time. It is illustrated with paintings, sculpture, architecture and general views.

The map (pp. 238-239) shows the principal monuments, museums and historic buildings, using symbols and colours for quick reference.

To find a museum or gallery turn to Appendix I, which lists them alphabetically, with their address, opening times and a note on their scope and contents. The larger collections are sub-divided into departments. Page numbers indicate where these are mentioned or illustrated in the text.

To find a historic building or church turn to Appendix II, which gives a similar alphabetical list of important buildings, landmarks, monuments, fountains, squares, etc.

For information on artists—painters, sculptors, architects, goldsmiths, engravers, etc.—turn to Appendix III. Here are listed those who contributed to the cultural greatness of Paris and whose works are now to be seen there. Each entry consist of a biographical note, details of where the artist's works are located, and references to the main text where they are mentioned or illustrated.

World Cultural Guides

PARIS

André Chastel

150 illustrations
in colour and black and white

special photography
by Mario Carrieri

Thames and Hudson · London

De tous les biens de cette mortel vie
A plus qu'autres cités n'ont;
Tous étrangers l'aiment et aimeront,
Car, pour déduit et pour etre jolis,
Jamais cité telle ne trouveront:
Rien ne se peut comparer à Paris.

Of all the treasures of this mortal life
She has more than other cities have;
All foreigners love her and always will,
Because, for pastime and for making merry,
They will never find her like among cities:
Paris is without compare.

Eustache Deschamps (1346-1416)

Translated from the French
by Emily Lane, Barbara Thompson and David Britt

The World Cultural Guides
have been devised and produced by
Park and Roche Establishment, Schaan

ISBN 0 500 64003 3

Printed in Italy by Amilcare Pizzi S.p.A.

Contents

Aerial photographs pp. 22, 27, 83,
110, 116, 118, 177 by R. Henrard,
pilot and operator, Paris

End-paper illustration: Paris in 1530,
plan by Sébastien Munster, the
oldest engraved plan of the city

Jacket illustration: Notre-Dame de
Paris, at night by Jouanne,
Atlas Photo, Paris.

Significant dates
in the history of Paris

52 BC	Lutetia on the Ile de la Cité, inhabited by the Parisii, burned during the Gallic Wars. Roman town on Left Bank.
c. AD 250	St Dionysius (Denis), first bishop of Paris, martyred on Montmartre
451	Prayers of St Geneviève, patron saint of Paris, said to have saved the city from the Huns.
508	Clovis I, first Christian king of France, makes Paris his capital.
885-87	Successful defence against the Normans.
987	Hugh Capet, Count of Paris, becomes king of France. Paris established as French capital.
990	Present Saint-Germain des Prés begun.
1163	Notre-Dame begun.
c. 1200	Louvre begun. Philip Augustus's city wall.
c. 1219-1319	Mendicant orders established on the left bank.
1226-70	Louis IX (St Louis).
1245	Sainte-Chapelle begun.
1257	Robert de Sorbon founds the Sorbonne.
1337	Hundred Years War begins.
1358	Paris commune under Etienne Marcel rebels against the Dauphin (later Charles V).
1364-80	Charles V. Extends area enclosed by city wall on right bank.
1370	Forteresse Saint-Antoine (Bastille) begun.
1383	Revolt of the Maillotins.
1420	Henry V of England enters Paris.
1436	Charles VII regains control of Paris.
1527-28	Francis I decrees return of court and government to Paris.
1564	Tuileries begun by Catherine de Médicis.
1572	Massacre of St Bartholomew's Day.
1577	Pont Neuf begun.
1588	Henry III forced to leave Paris on the Day of the Barricades.

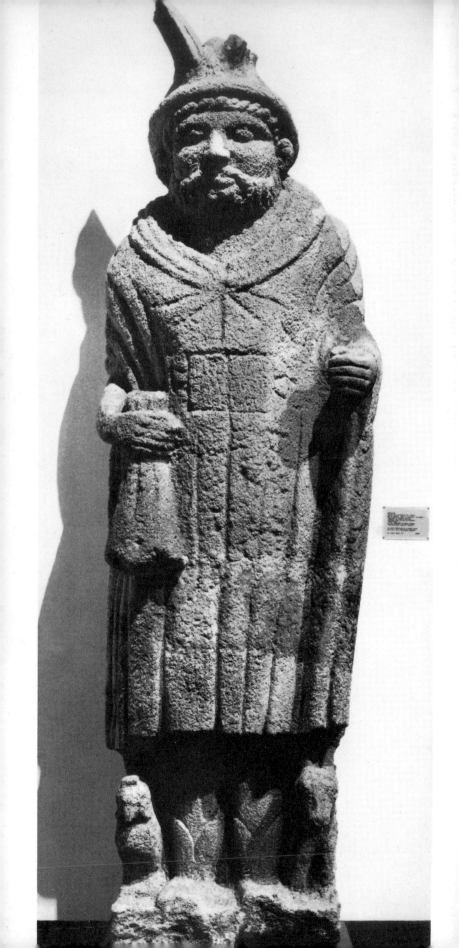

The City on the Seine

'You must learn to look at the city and see the variety and the intricacy of its forms. Anyone who actually lives in an urban centre – great or small – carries "the image of the city" within him' (Kervin Lynch, *The Image of the City*, Cambridge, Mass., 1960). Whether the mental representation is complete or partial, dull or vivid, is directly related to the personal and cultural potential of the beholder. When it is an impoverished picture, it is because the person's experience fails to supply light and shade, reference and stimulus. Similarly with the visitor and the tourist, except that in their case the 'image' is an acquired one, corresponding simply to the need to find their way about and satisfy their curiosity, and is accompanied by a sort of intellectual reverie, which plays an important part particularly in the case of certain historic cities. It is not easy to account for the attraction exerted by these places, and one is tempted to treat them like mysterious, complex individuals, with a magnetism and an aura of their own: individuals whom one loves and even desires.

Paris is more than two thousand years old, and for at least seven hundred years has enjoyed enormous prestige. By the thirteenth century, it had all the attributes of a great city, boasting a cathedral, churches, bridges, the tower of the Louvre, and a very fine circular wall, thirty feet high and nine feet thick, studded with sixty-seven towers. Remains of this wall are visible in the rue Guénégaud and the rue Clovis on the left bank of the river, and one of the towers stands at 55, rue des Francs-Bourgeois, on the right bank.

Towards 1250, Paris became definitely established as a great university city, and in 1257, Robert de Sorbon, chaplain to Louis IX, founded the Sorbonne, destined to survive even in name to the present day. Evidence of the prestige of the university, which had many privileges, is the famous quatrefoil medallion, depicting the students of Paris, on the north portal of Notre-Dame. At the time of the scholastics, it became the most important university in the west, and both St Albert the Great (some think Place Maubert is named after him) and St Thomas Aquinas taught there. Students, like Roger Bacon from England and Dante Alighieri from Italy, flocked from all over Europe for improvement, and a cosmopolitan 'Latin Quarter' soon began to thrive in the area between the Montagne Sainte-Geneviève and the Seine. Already the qualities most appreciated in both men and women

◁
Gallic Mercury. Celtic, c.1st century A.D. *Musée des Antiquités Nationales, Saint-Germain en Laye.*

were a certain polish and freedom of manners, coupled with a ready wit. *'Il n'est bon bec que de Paris'* (There's no tongue like a Paris tongue), wrote François Villon, and a fourteenth-century poet, Eustache Deschamps, was sad when he left the city of pretty girls and fine clothes.

> *Adieu m'amours, adieu douces fillettes.*
> *Adieu Gran Pont, hales, estuves, bains.*
> *Adieu pourpoins, chauces, vestures nettes...*

> 'Farewell my loves and gentle maids,
> Farewell great Bridge, markets, stews and baths,
> Farewell doublets, hose and vesture neat . . .'

Paris had the good fortune to be celebrated by writers and artists at an early date, and the tradition went from strength to strength from Villon to Baudelaire, and from the miniaturists to Claude Monet. It is not far-fetched to see all this both as a natural impulse towards advertisement and at the same time a reflection of the pleasurable and poetic atmosphere Paris has had for so many people throughout the ages. One must be for or against Paris. It may be that one has to be sensitive to its charms in order to put up with its equally notorious inconveniences and discomforts. But the long-lived if not constant role the city has played as capital of the arts, at least since the end of the twelfth century, sways one almost inevitably in its favour. The construction of Notre-Dame and the Sainte-Chapelle made it the undisputed centre of Gothic art. It led the way in architecture, sculpture, and what might be regarded as the two most characteristic achievements of medieval painting, stained glass and miniatures; the Parisian miniature grew internationally famous in the reign of St Louis and in the school of Jean Pucelle. At the same time, many lasting craft traditions developed, such as leatherwork, joinery and the goldsmith's art. And, though sometimes activity slowed down or there was a period of stagnation, the crafts never entirely disappeared and the artistic sense was never lost.

When a visitor arrives in a place, he normally derives a certain satisfaction from observing the general lie of the land and a few distinctive features. In Paris, the scars rather unevenly marking the urban tissue help to gain a rough idea of the concentric rings corresponding to the successive walls that enclosed the city. The 'megalopolis' of twelve million inhabitants, that some desperately hope to make manageable for 1980, will perhaps bring to life a few satellite towns, descendants of those which once gravitated round the city amid the forests and the fields. Scatterings of inhabitants, public establishments, and industrial plants from Nanterre to Saint-Maur and from Saint-Denis to the valley of Chevreuse reach Paris by a series of major roads, which cross, at regular intervals, the Boulevard Périphérique, now assuming the character of threshold to the historic city. It approximates to the line of the nineteenth-century fortifications (1839 onwards), and its construction at the dawn of the industrial era witnessed the illusion that the burgeoning capital might yet be contained. The relation between the outer network of fast highways shortly to appear and this familiar contour is the same as that between it and the ring of boulevards built on the line of an eighteenth-century city wall. Between the two lie the former villages, which were first enclosed in the nineteenth century and have never been totally assimilated. The names of several neighbourhoods evoke these old communities, where groups of craftsmen, colonies of people from the provinces, the success of local architecture,

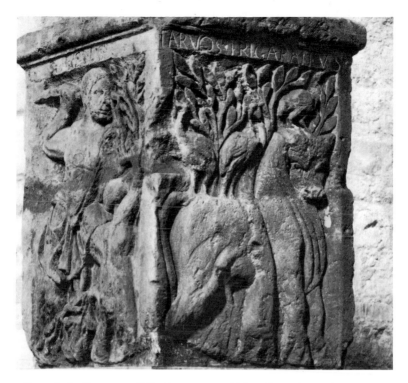

*Altar of the Boatmen. Gallo-Roman, A.D. 14-37. Base of a votive
monument set up by the corporation of nautae of Paris. Musée de Cluny.*

and a host of customs and social peculiarities, luckily noted down
just in time by observant historians, preserve something of the original
individuality. Auteuil, Passy and Neuilly lie in the west, then Bati-
gnolles, the district of the lesser bourgeoisie, Montmartre, flanked by
the working-class quarters of Saint-Ouen and La Chapelle, the fascin-
ating townships of Belleville and Charonne, bustling with craftsmen,
and finally, in the south, Ivry, Gentilly, Montrouge, Vaugirard and
Grenelle, which still have a village air about them.

The outer boulevards run from Etoile to La Villette and the Barrière
du Trône on the right bank, and from the Salpêtrière to Montparnasse,
and thence to Grenelle on the left, marking the fifteen-mile length of
the wall known as the Enceinte des Fermiers Généraux, which was
erected between 1784 and 1789. This amazing structure was punc-
tuated with forty-five massive toll-gates designed by Ledoux. (Three
of these virile propylaea are still intact.) This was the Ancien Régime's
last attempt to restrain the overflowing city by including the quarters
growing up mainly in the west and north as a result of the wave of
speculation of property, the new development, and public works.
The Enceinte mounted two hills, Chaillot in the west and Montmartre
in the north, but excluded Belleville, Ménilmontant, and the Butte
aux Cailles, the three hummocks later incorporated by the 1839
fortifications. Paris was now the city of the six hills, but only the
Montagne Sainte-Geneviève, directly dominating the Seine on the left
bank, had been part of the original nucleus.

Consequently it is not hard to read the passage of history on the
map, nor in the field either, on the whole, except that towards the

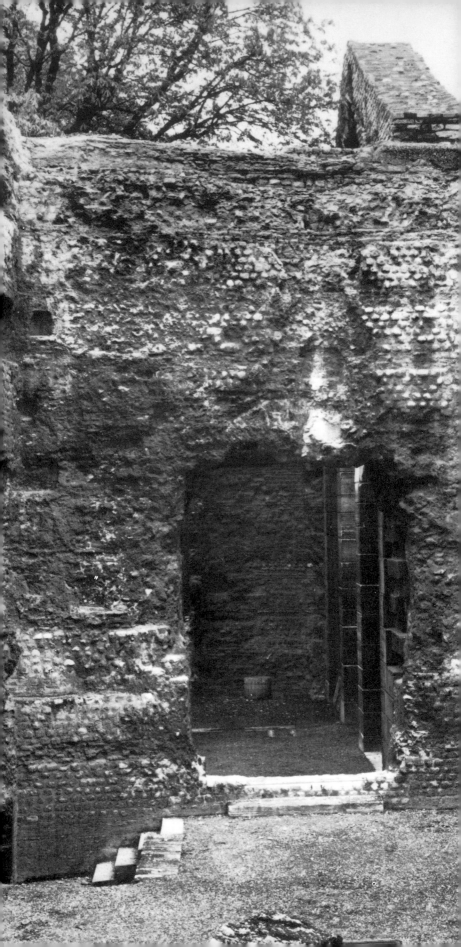

*Hall at south end of Roman bath,
Musée de Cluny. Roman, end of
2nd century* A.D. *Remarkable brick
and stone composite construction.*

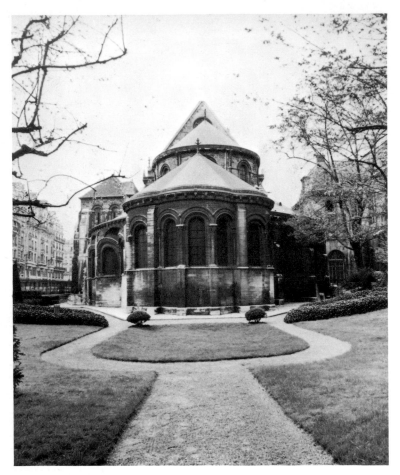

Apse of the abbey church of Saint-Martin des Champs, 1130-40.

centre the different periods become more and more entwined. Even stepping back in imagination a few centuries does not really help us to picture the medieval rampart built by Charles V in the fourteenth century, although there are one or two useful landmarks on the right bank. The wall ran in a semicircle from the Louvre to the Bastille, and its line is still marked by the Grands Boulevards, where the monumental gates of the classical era have replaced the old fortified entrances. But across the river, no fresh defences were constructed by Charles V, and the city remained bounded by the earlier wall, built in the late twelfth century by Philip Augustus. This rampart enclosed a similar stretch of land on the right bank and, although the basic structure has been largely disguised by later developments, part of its outline can still be glimpsed in the design of the streets themselves. Naturally the whole area as been reconstructed, but the slanting thoroughfares radiating round the Halles on either side of the

▷

Tower of Saint-Germain des Prés, beginning of 11th century, upper portion altered in 19th century. The first part of this celebrated abbey church to be built; the last, the choir, was finished in the 12th century.

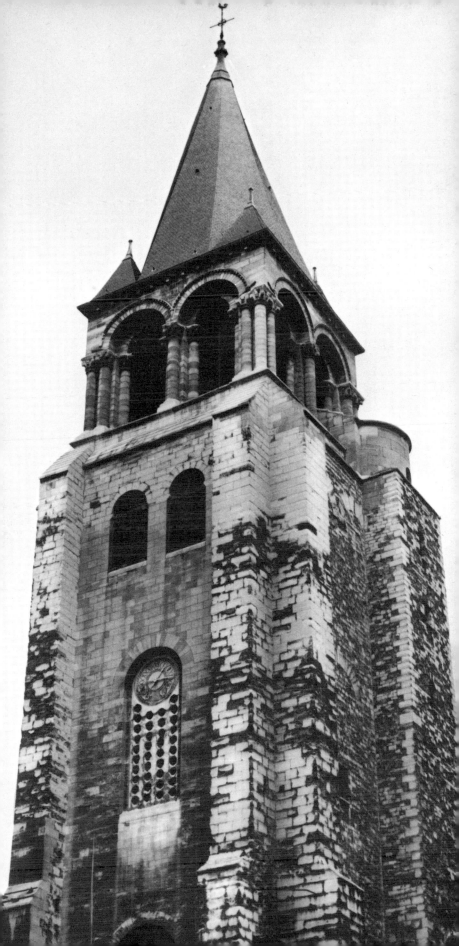

rue Saint-Honoré, and the rue des Lombards and the rue de la Verrerie sloping significantly southwards to the rue Saint-Antoine, and the artery that slips through the rue de Buci, the rue Saint-André des Arts, and the rue Saint-Séverin, all point to where it passed. Then there is the itinerary leading up from the quai de la Tournelle along the rue de Bièvre and the rue Maître-Albert, climbing the rue de la Montagne Sainte-Geneviève to Saint-Etienne du Mont. Patterns like these are a common feature of many ancient cities, but in Paris they are astonishingly coherent, showing how slowly and surely it has evolved. The continuity is all the more surprising as the city has known upheavals of almost every order in the course of its history. It is like a palimpsest, heavily charged in the middle, but nevertheless allowing the various texts to show through here and there. The fascination of Paris surely has something to do with this historical density.

A glance at the early shape of the city immediately suggests another more basic permanence in the topography, geology and ecology of the site. The oval overlapping rings encircling Paris actually lie at the heart of a vast geographical arrangement, which has only gradually revealed its true worth. This is what is called the *bassin Parisien,* a typical example of a sedimentary basin. Within a radius of about forty miles of the Cité lies a ring of Tertiary deposits suitable for the cultivation of cereals and vegetables. Anti-clockwise from south to east, north and west, the areas are Beauce, Brie, Valois and Vexin, each divided into smaller sub-regions, like Hurepoix in the south, and north of Saint-Denis, the little plot called France. Paris soil is related to all of these zones, with the significant consequence that its peculiar geological structure has helped to supply abundant building materials. Soft stone comes from Gisors, ashlar from Mantes, and millstone from Longjumeau. Gypsum (plaster of Paris) was extracted in Paris itself, where the Cretaceous subsoil produced subterranean passages in several places. On the south side of the city, the network of galleries called the Catacombs is a curious vestige of these old quarries, covering an area of about 12,000 square yards. The entrance is by the gate-lodge of the Barrière d'Enfer, Place Denfert-Rochereau. They served mainly as an ossuary later on, first when the Innocents charnel-house was destroyed in 1735, and again, in 1792, after the bloodiest days of the Revolution. The chalky nature of the soil, however, created many problems for builders, especially at Montmartre.

A radius of eighty miles encloses more Cretaceous terrain in every direction except the south, though this type is less moist and favours different kinds of crops. Vast forests, essential to balance the land-scape, covered the area in between the two zones, and the abundance of wild boar and deer made the Ile de France into a huntsman's paradise. The remains of these forests are fringed with numerous towns and châteaux that have always had a close relationship with the history of the capital.

The surroundings of the city thus reflect the circular arrangement governing the inside; Paris forms a round target lying at the centre of a much greater geological target, the Ile de France. And yet the image of the double disk is not altogether adequate, because it omits the sinuous slanting arabesque of the Seine and the great cross marked by the north-south and east-west routes that intersected in the neighbourhood of the Ile de la Cité.

North-south meant the road from Flanders through Saint-Denis, and on to Orléans through Etampes, and more broadly still, a link between

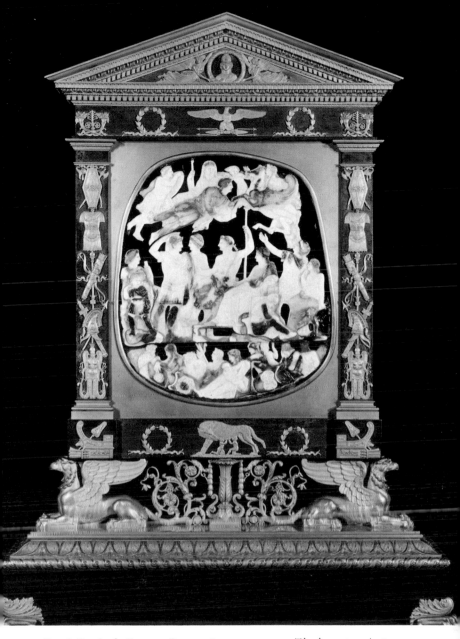

Grand Camée de France. Roman, 1st century A.D. The largest ancient cameo known. It represents the glorification of Germanicus.
Formerly in the Saint-Chapelle, it has a mount of the Napoleonic era.
Cabinet des Médailles, Bibliothèque Nationale.

P. 18
Façade and south tower of the abbey church of Saint-Denis, 12th-13th centuries. This basilica was begun just before 1140 by Abbot Suger.

P. 19
Rose window, north transept of Notre-Dame, 1258. Subjects from the Old Testament; in the centre, Virgin and Child. The glass is remarkable for its tones of blue.

(below) East end of Notre-Dame, showing the flying buttresses built by Jean Ravy, 1318-44. The façade was badly damagee in the Revolution, and restored in the 19th century. The parapet was added in the 14th century.

P. 20/21
West front of Notre-Dame de Paris, 1190-c.1250.

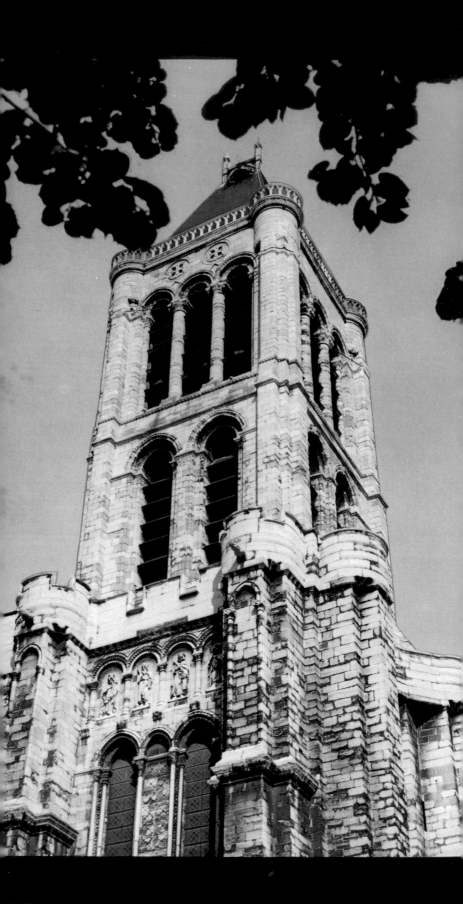

the North Sea and the Mediterranean lowlands. It is unlikely that
the way to the north was the most important in Celtic times. But a
few significant points along its path have considerably affected the
history of Paris, the growth of the royal domain, and in fact the
entire country.

In the south, Montlhéry, with a tower that served as a look-out,
guarded the approaches to the capital city. Once the basilica of
Saint-Denis, more than a league to the north, had become the necro-
polis of the Capetian monarchs, the northern road, with its continuation
within the walls, the rue Saint-Denis, became the recognized triumphal
way for royal 'entries' and funerals. It was also one of the principal

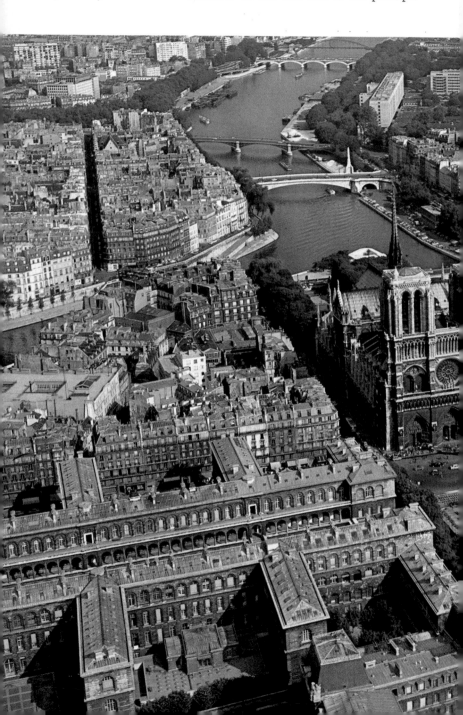

*The flèche or spirelet of
Notre-Dame de Paris, as restored
by Viollet-le-Duc, 1859-60.*

Notre-Dame and the Ile de la Cité.

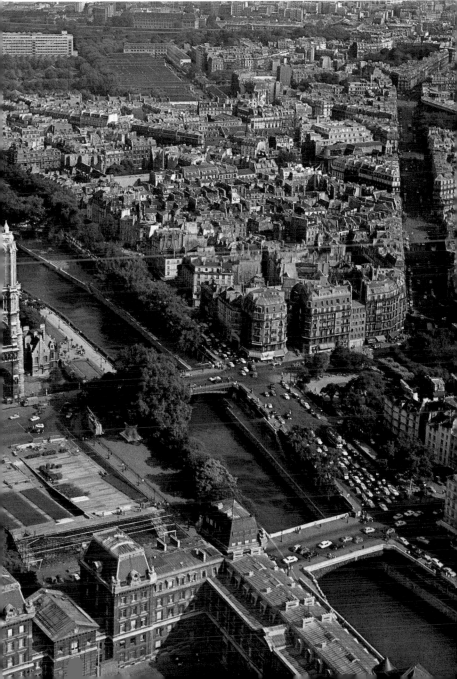

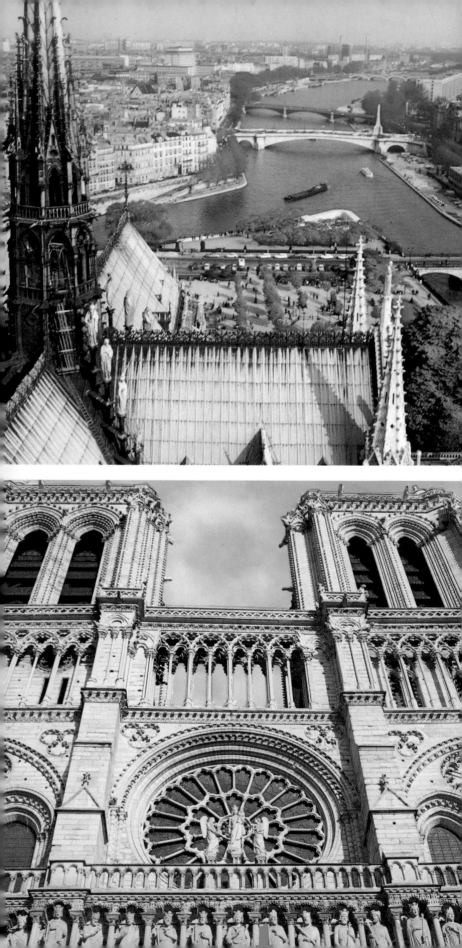

trading routes. The south-western branch commenced on the Ile de la Cité and departed by the long rue Saint-Jacques, sloping upward from the river bank.

The east-west axis linked the eastern provinces, where the tributaries of the Seine open out like a fan, with Normandy. One way eastwards, beyond the confluence of the Marne and the Seine, led to Melun, and thence to Burgundy via Sens on the Yonne, or to Champagne via Meaux. All these localities were intimately connected with the capital. It was not until Paris was given an archbishop of its own in 1622 that it ceased to depend on the archiepiscopal see of Sens, the Gallic capital of the Senones. The Paris mansion of the archbishops of Sens, the Hôtel de Sens, is one of the most important examples of late fifteenth-century domestic architecture.

The way to the west lay along the right bank through Pontoise or Mantes, and here the roads keep closer to the course of the river. For two hundred years, this direction had brought the dreaded Viking *drakkars*, and even in the twelfth and the thirteenth centuries, Normandy was still a dangerous frontier, constantly harried by the English, who were the masters of south-west Aquitaine and the Channel coasts. Château-Gaillard (1197), the fortress of Richard Coeur de Lion, marked the bounds of the French domain in the time of Philip Augustus, and the sturdy Louvre (1204 onwards), erected conspicuously before the western gates of Paris, was, in a sense, the answer of the king of France.

All this invites reflection on another factor, which quickly appeals to the imagination of the attentive visitor, although its importance has dwindled considerably since the transformations of the nineteenth century: the close association between the city and the river. The great familiar tributaries converging near Paris make it a naturally advantageous centre of communications. Timber from the north and the east, wines from Burgundy, and cereals from Brie, could all be conveyed by the river. The organization of water transport was a thriving occupation in the time of the ancient Parisii, and they kept it up long after the Romans came. One remarkable Roman monument is the altar to Jupiter Optimus Maximus raised by the corporation of Parisian *nautae* (boatmen) under Tiberius.

During the Middle Ages, the 'water-merchants' grouped into a powerful company, which eventually created the office of mercantile provost (*prévôt des marchands*), who was the chief magistrate of the city. Their seal bears a ship, surviving in red and blue in the coat of arms of the city of Paris. Maps plotted in the late thirteenth century show to what extent Paris still depended on these waterways for the supply of provisions and trade. Old plans place a congestion of barges and boats round each of the various gates to the city, and one by Jacques Gomboust dating from 1652 clearly indicates boats congregating at the eastern end of the Ile Saint-Louis, at the spot where the channel between the islands opens into the river, and at the point of the Ile de la Cité.

The chief shelters and landing-stages lay on the north side, because the south bank flooded easily and consisted almost entirely of marsh-

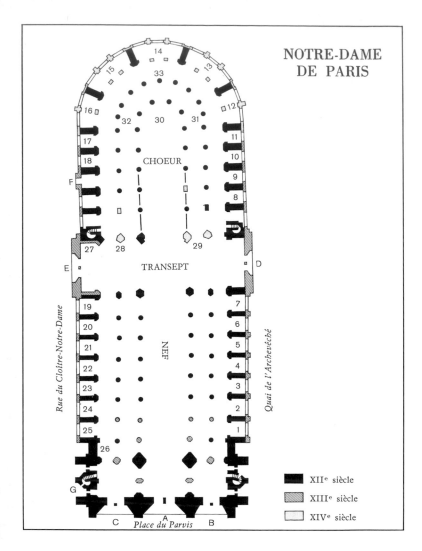

NOTRE-DAME DE PARIS

CHOEUR

TRANSEPT

NEF

Rue du Cloître-Notre-Dame

Quai de l'Archevêché

■ XIIe siècle

▨ XIIIe siècle

□ XIVe siècle

G

C *Place du Parvis* A B

EXTERIOR - *A - Portail du jugement dernier / B - Portail Ste Anne / C - Portail de la Vierge / D - Porte St Etienne / E - Porte du cloître / F - Porte Rouge / G - Entrance to Towers.*

CHAPELS - 1: *Chapelle Saint Eloi;* 2: *Chapelle Saint François Xavier;* 3: *Chapelle Sainte Geneviève;* 4: *Chapelle Saint Joseph;* 5: *Chapelle Saint Pierre;* 6: *Chapelle Sainte Anne;* 7: *Chapelle Sacré Cœur;* 8: *Sacristie des Messes;* 9: *Chapelle St Denis;* 10: *Entrée du Trésor et de la Sacristie;* 11: *Chapelle Ste Madeleine;* 12: *Chapelle St Guillaume;* 13: *Chapelle St Georges;* 14: *Chapelle de la Vierge;* 15: *Chapelle St Marcel;* 16: *Chapelle St Louis;* 17: *Chapelle St Germain;* 18: *Chapelle St Ferdinand;* 19: *Chapelle Sainte Clotilde;* 20: *Chapelle Saint Landry;* 21: *Chapelle Notre-Dame de Guadalupe;* 22: *Chapelle Saint Laurent;* 23: *Chapelle Sainte Enfance;* 24: *Chapelle de Saint Charles;* 25: *Chapelle des Fonts Baptismaux;* 26: *Sculpture:* Notre Dame de Bonnegarde (1722) Vassè.

TRANSEPT - *27 - Prédication de St Paul à Ephèse (May 1649) Eustache le Sueur. / 28 - Sculpture : St Denis (XVIIIe c.) N. Coustou. / 29 - Sculpture : Notre Dame de Paris (14th century).*

CHOIR - *30 - Pietà (1732) Nicolas Coustou. / 31 - Sculpture : Louis XIII (1715) Guillaume Coustou. / 32 - Sculpture: Louis XIV (1715) Coysevox. / 33 - Sculpture: Matiffas de Bucy (1304).*

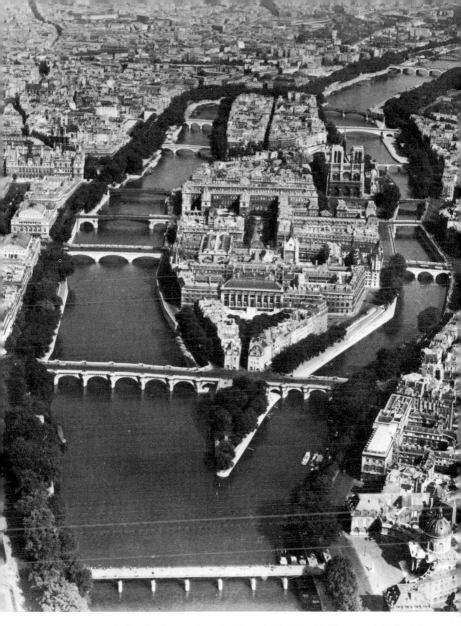

Aerial view of the Ile de la Cité, showing the bridges linking it with the left and right banks: the Pont Neuf (across the point of the island), the Pont Saint-Michel and the Pont au Change; the Pont au Double and the Pont d'Arcole.

land, apart from one embankment built up near the Cité at quite an early date. It took some time to reclaim the left bank from the mud and the water-meadows, which accounts for its slower rate of development. The right bank, on the contrary, was regarded, from at least the beginning of the historical period, as firm ground, capable of withstanding the swell of the river, like one of the various cliffs that hem it in from north or south on its turbulent way to the sea.

The fact that the banks on either side of the central island had such different properties is an adequate commentary on the origins of the town. North of the river, human settlements were sporadic in the Palaeolithic age, and almost non-existent in Neolithic times. There was little trace of the Parisii, the Celtic inhabitants of the Ile de la Cité,

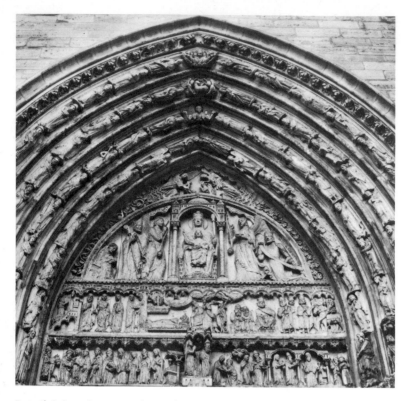

Portail Sainte-Anne, west front of Notre-Dame, c. 1160-70. Double lintel with scenes of the life of the Virgin, surmounted by the Virgin between two angels, flanked in turn by Bishop Maurice de Sully and King Louis VII; it was built up from of an earlier, narrower doorway when the present façade was built (c. 1190-c. 1250).

before 300 BC, and by 51 BC it was occupied by the Romans. A temple stood in the east and possibly a palace in the west, but the active town of Lutetia was the one the Romans built on the slopes of the hill to the south of the river, with a forum, now rue Soufflot, and two baths. Remains of the larger bath, which measured 300 by 195 feet, can be seen in the Musée de Cluny gardens. Outside the town, there was a fairly large amphitheatre (the Arènes de Lutèce), which can be seen close to the rue Monge.

The barbarian invasions around AD 280 forced the inhabitants of the Roman town to withdraw into the Cité and hurriedly construct a wall. Archaeological excavations have now established its outline and structure. It failed to prevent the sack of Lutetia; but the site had proved its worth and a new town was built by the Merovingians. Clovis made the island his capital in 508. Later, it again lost its political significance, and finally succumbed to the terrifying Viking raids. At last, after much devastation and burning, a more stalwart rampart was erected, enabling the inhabitants to put up a successful resistance to attack in 885. By then the Dukes of Paris had begun to exert

▷

Extrados of the Portail de la Vierge, west front of Notre-Dame, 1210-20. Angels, prophets and king of Judah.

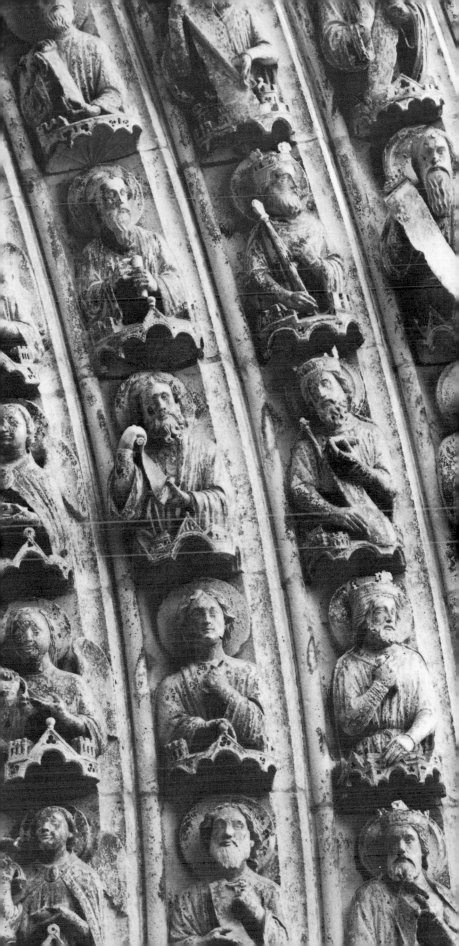

their authority, and a third town, accompanying the rise of the Capetian dynasty, involved considerable urban expansion in the area to the north called the Faubourg d'Outre-Pont (the suburb beyond the bridge). The first definite boundary was the link established between the mounds of Saint-Germain l'Auxerrois in the west and Saint-Gervais in the east, both of which were probably included within the city wall constructed at the end of the eleventh century. On the left bank, there were many enclosures and vineyards, and Merovingian monastic foundations still flourished in two small towns that had their own walls and their individual activities, Saint-Germain des Prés, destined to a great future, and Saint-Marcel, on the road to Melun.

A number of legendary figures were associated with Paris, and soon became the objects of popular cults. Innumerable sanctuaries were built to commemorate the first Bishop, St Dionysius of Paris, who, after he had been decapitated at Montmartre, carried his own head to his sepulchre in the abbey of Saint-Denis. The episode has been frequently recorded on church portals, and appears on the reredos of the Parlement of Paris, dating from about 1455 and now in the Louvre. Other churches were dedicated to the shepherdess from Nanterre, St Geneviève, the patron saint of the city, whose body was transported to the Montaigne Sainte-Geneviève, a hill south of the river, after her death in the sixth century. Many foundations, including Saint-Germain des Prés, honour St Germanus of Paris, bishop in the third quarter of the sixth century. These traditions formed part of everyday life, as there were always festivals and all kinds of religious practices and rites. In 632, King Dagobert chose the site of Saint-Denis for his own tomb and founded an abbey. This illustrious establishment, afterwards the necropolis of the Capetian kings, was authorized to run a market, called the Foire du Lendit, which brought in substantial revenue. Later, Suger, Abbot of Saint-Denis and minister to Louis VII, was able to turn these funds to good account when he embarked on his bold plans to rebuild the church in 1144.

Like all great medieval centres, Paris abounded in relics, and many shrines were created or revived around these hallowed remains. In connection with the cult of the dead, numerous Merovingian churches were constructed close to the graveyards bordering the walls, and in other parts of the outskirts. A number of the sarcophagi discovered near the rue Saint-Jacques and in the precincts of the neighbouring Saint-Séverin are exhibited in the Musée Carnavalet.

Much of the information about these primitive churches is found in the account of the martyrs and confessors of Gaul by the sixth-century prelate, St Gregory of Tours. However, almost all the twenty-five examples that scholars have listed for the period from the fourth to the end of the tenth century have been perpetuated in a form very different from the original unassuming pre-Romanesque structures. These were rebuilt, some of them reappearing as early as the ninth and tenth centuries. We thus know that Saint-Julien le Pauvre must have occupied the site of the existing church at the crossroads of two important Roman highways, the road to Orléans, now rue Saint-Jacques, and the road to Lyons, then corresponding to the rue Galande. On the right bank a small mound behind the present Hôtel de Ville, levelled in the nineteenth century, bore the chapel of Saint-Gervais-

▷

Virgin and Child, in St-Germain des Prés. Marble, 14th century. This sculpture in the 'Paris Style' was probably originally in Notre-Dame.

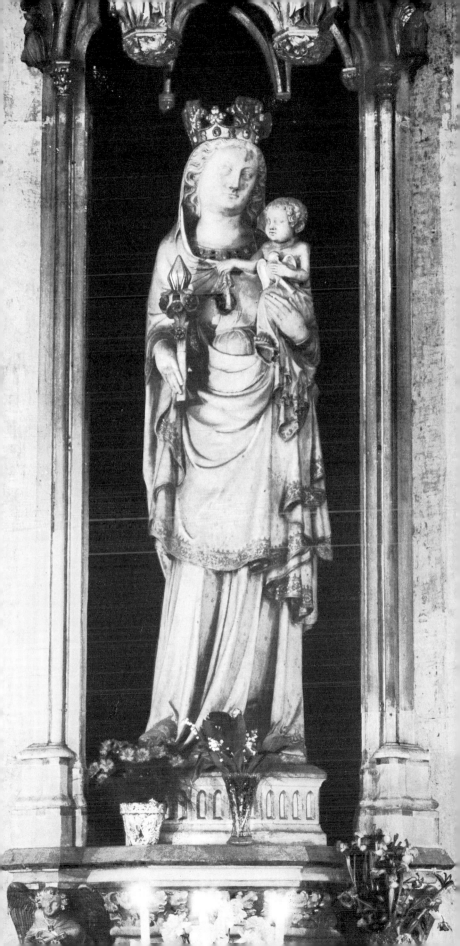

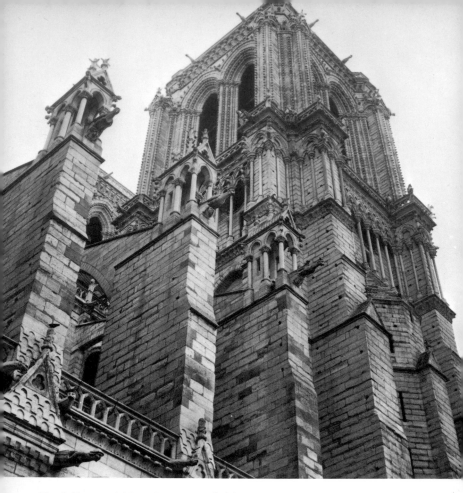

North Tower of Notre-Dame, completed 1235-50.

Saint-Protais, which was reconstructed in the sixteenth century. And outside the walls stood the first church of Saint-Laurent, at the prolongation of the rue Saint-Martin above the passage du Bras-Mort, marking the former bed of the Seine.

Soon after 500, Clovis chose the hill where the great Roman establishments had been on the south bank as the site for his basilica and abbey of the Saints-Apôtres, 'the first church ever to be founded by a king of France', according to early authors, who have transmitted the inscription on his tomb. The foundation was later rededicated to St Geneviève; and the crypt containing the remains of the saint and of Clovis himself was left untouched when the church and the cloisters were reconstructed towards the end of the twelfth century, the period when the cultus of the saint was at its height, by Abbot Morard, afterwards Bishop of Tournai. The church was destroyed in 1807, but the tower, called the Tour de Clovis, with a Romanesque base, and the refectory, now serving as a chapel, form part of the buildings of the Lycée Henri-IV. Even as late as the middle of the eighteenth century, an immense new church was started nearby in honour of St Geneviève, and, about 1880, different artists were commissioned to paint murals relating the story of her life. The most famous paintings are the ones by Puvis de Chavannes.

Another venerated Parisian figure was St Martin of Tours, who gave his name to the second road running perpendicular to the Seine.

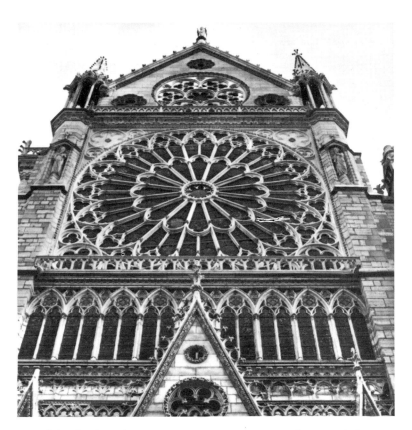

Lateral façade of north transept, Notre-Dame, c. 1250. The rose window, above an open gallery, is surmounted by a pediment.

Quite a distance from the town in the north, a pilgrim's hospice adjoined a monastery, also called after St Martin, which became a Cluniac priory in 1071. Part of the walls that enclosed the hospice are still visible, including the towers at 51 rue de Vertbois, and 7 rue de Bailly, and also the eleventh-century belfry. The church was rebuilt after 1135, with an interesting arrangement of outer supports to the apse, foreshadowing the Gothic system. The superb refectory was a later addition. The priory took over the church of Montmartre at the end of the eleventh century; it was used by a convent. Vestiges of the early building and parts of a Roman pillar were incorporated in the present Romanesque church of Saint-Pierre de Montmartre, where three naves and three apses are separated by pillars. There are pointed arches in the main apse, but no use of Gothic structural patterns.

The third-century Christian chapel and burial place which lay on the left bank, on the slopes of the hill beside the river Bièvre, formed the nucleus of the small town of Saint-Marcel, called after a sixth-century bishop. In the tenth century, it became fully established within its own walls, and in the eleventh it was endowed with its own church.

Another increasingly influential domain prospered outside Paris beside the huge water-meadows in the west, slowly being reclaimed from the marshes; here, in the sixth century, Childebert I built a shrine for the relics of his dearly beloved St Vincent. This church was eventually

dedicated to St Germanus, and rebuilt at the end of the eleventh century, with a stout square belfry, by Abbot Morard. It was modified further in the twelfth century. In a sense, Saint-Germain des Prés can be regarded as a guide to Parisian art, just as its estate, only slowly integrated into the capital and suffering countless vicissitudes, can be said to reflect the history of the city itself. The old church was one of the rare examples of the architecture of the year 1000 in Paris, and the new building, consecrated by Pope Alexander III in 1163, marked an important stage in the evolution of Parisian liturgy, worship and architectural orders. The influence of the abbey of Saint-Germain des Prés was always great. In 1721, since tradition insisted upon its antiquity, the Benedictine monk Montfaucon 'did not doubt but that the eight large statues in the portal... represented seven princes or princesses of Merovingian days': the so-called kings of the first race. Accordingly, 'in 1793, it was thought fit to destroy them' (Emile Mâle).

The garland of abbeys and enclosures round Paris is good evidence of that link between town and country, which is indispensable to the mechanism of any city, and provides the economic key to urban development. The names of streets like the rue du Four (the Oven) and the rue du Vieux-Colombier (the Old Dovecote) show that Saint-Germain des Prés was a rich farming region. In addition to the market-gardening along both sides of the city wall, some other very productive zones lay along the different approaches to the city. They were connected with the centre by good roads, and soon grew into vast estates, under the aegis of the châteaux and grounds that have perpetuated their fame.

Another very ancient feature that has persisted through the ages is the quality and the abundance of the plants and trees mingling with the architecture in the city itself. At the start of the Christian era, when there was only Lutetia, the low-lying native town on the island, and the great Roman city on the slopes to the south, vineyards and gardens grew in profusion. The Emperor Julian the Apostate, whom the Praetorian guard crowned in Lutetia in AD 360, has left a testimony of his admiration for this city, where everything was pleasing, the curve of the river, the limpid water, the mildness of the climate, and the vine. During the Middle Ages, even the most densely populated areas in the centre had their enclosures with kitchen gardens and orchards, and the new wall of Charles V enclosed many more market-gardening areas, called *coutures*. The important role of the monasteries in this respect has already been mentioned. When Charles V decided to live in the eastern part of town, in the Hôtel Saint-Paul, he organized a dazzling concatenation of little flowered courtyards and orchards with vine-arbours, menageries and aviaries. The names of some of the streets recall them, like Cerisaie (cherry-orchard) and Beautreillis (splendid vine), though the entire estate was parcelled out as building land under Francis I in the 16th century. Some of the sculptures on the portals of Notre-Dame also have details showing the more typical aspects of agricultural life within the city.

The rise of the great princely mansions, like the Luxembourg, the Tuileries, and many that were less spectacular, in the surrounding

▷

Interior of Notre-Dame, completed c. 1220.
The rhythmic effect of the sexpartite vault is remarkable.

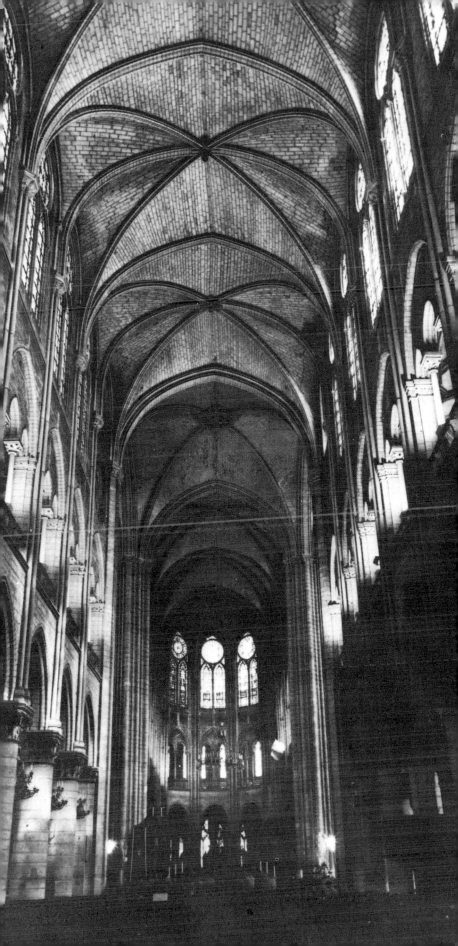

districts, laid more emphasis on the importance of placing houses in relation to their grounds. But it also underlined the contrast between the overcrowded quarters in the city, choked with houses, where movement was difficult, and the spacious areas belonging to bankers and noblemen. Foreign visitors were struck by this element of rurality in Paris, so easily transformed into places of pleasurable resort.

Each fresh extension of the walls entailed additional planning of parks and gardens, and provided a constant source of speculation. Thus the eighteenth-century Enceinte des Fermiers Généraux catered for a broad tree-lined outer Boulevard and new pleasure grounds, like the Parc Monceau, named after the village of Monceau lying beyond the village of Roule. On the orders of Philippe d'Orléans, Carmontelle refashioned this huge space in the English manner, introducing a romantic setting of artificial ruins round a small ornamental lake. A few of the small villas, known as *folies*, that were popular about the same time, still survive in one or two areas.

Finally, in the nineteenth century, the Bois de Boulogne in the west and Vincennes in the east were absorbed within the boundaries, and the brilliantly artificial experiment of the Buttes-Chaumont, an irregular picturesque modern park, was created, along with a few public gardens, called *squares* after their English counterpart, the garden squares of London. Intersections were planted with trees, and more gardens were introduced to set off public buildings, but there were never any privately owned squares like those in London - though they would not be out of place in some parts of Paris such as the Place Dauphine or the Place des Vosges. The public ones that do exist are tended by the municipality, which also sees to the upkeep of the trees, especially the plane-trees along the boulevards, and the ornamental vegetation in large gardens like the Trocadéro. Each successive concentric enclosure has confirmed the description of Paris as the city of the river and the trees.

The Gothic City

By about 1200, Paris had become one of the great cities of the West, and for many, *the* great city. On the right bank, it was enclosed by a semicircular rampart with a radius stretching from the new tower of the Louvre (1190) to the church of Saint-Jacques de la Boucherie, which stood on a hillock near the intersection of the road to Saint Denis and the road to Meaux. The church more or less represented the old centre of the city, close to the end of the Pont du Châtelet, where the police were housed. (The fourteenth-century bell-tower was lowered to ground level when the hillock was levelled in the nineteenth century, and still dominates the Place du Châtelet.) A little further east, the town reached up to the walls behind the Hôtel du Roi de Sicile, named after Charles of Anjou, brother of St Louis IX. Beyond the grounds of the Benedictine abbey of Saint-Martin des Champs to the north-west, there lay the impressive Commanderie du Temple, with a keep dating from 1265. After the suppression of the Templars by Philip the Fair in 1312, it was used as a centre for trade and exchange

▷
The second south window of the Sainte-Chapelle, 1246-48.
The four-lobed medallions carry scenes from the Book of Ezekiel.

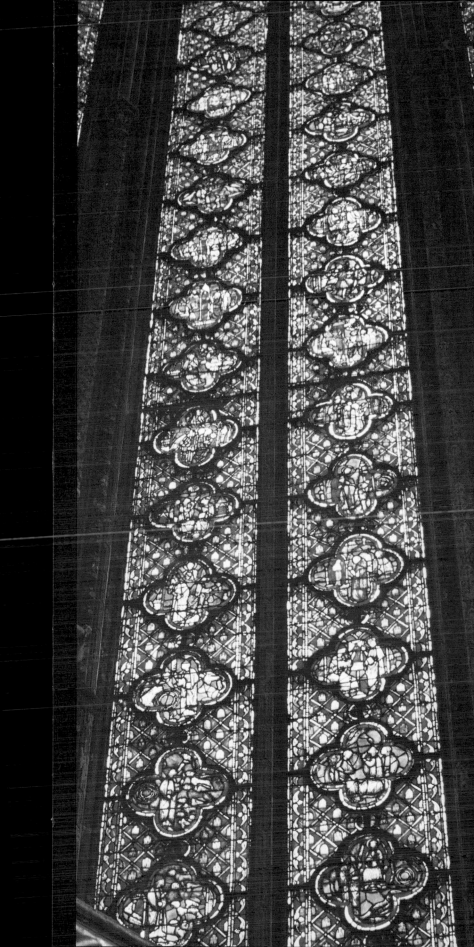

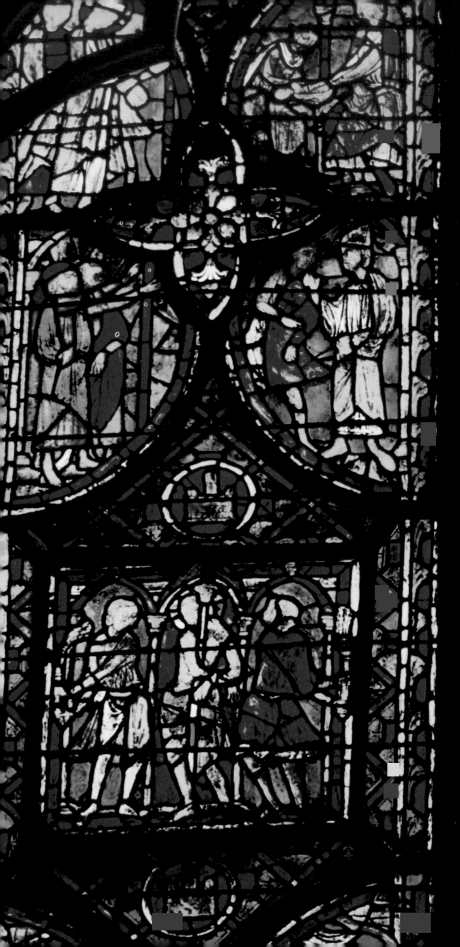

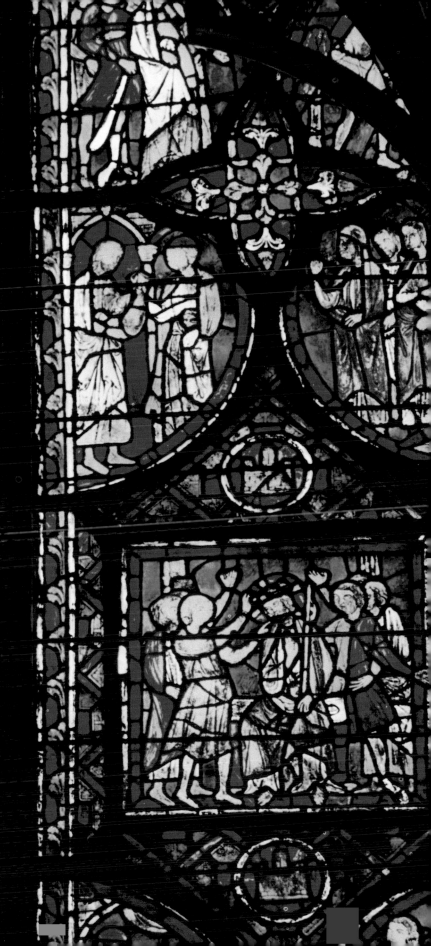

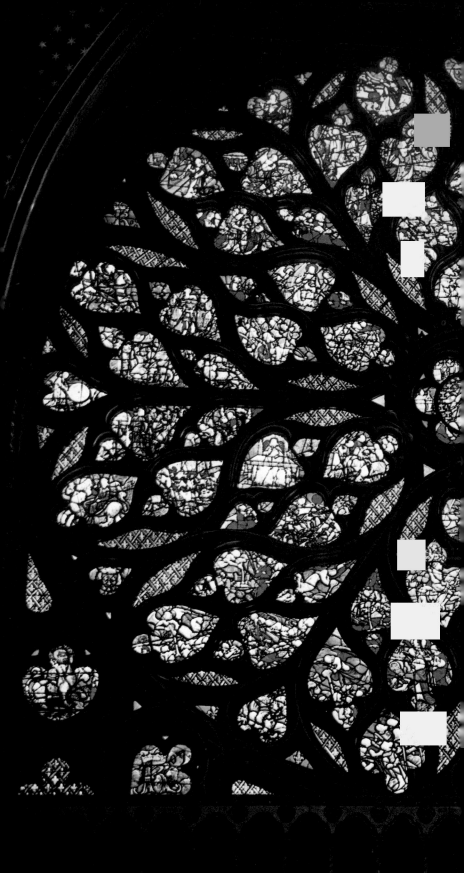

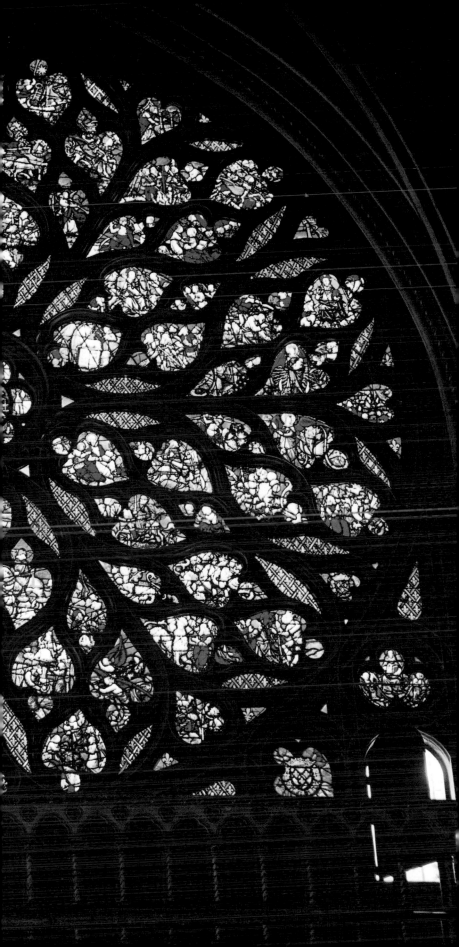

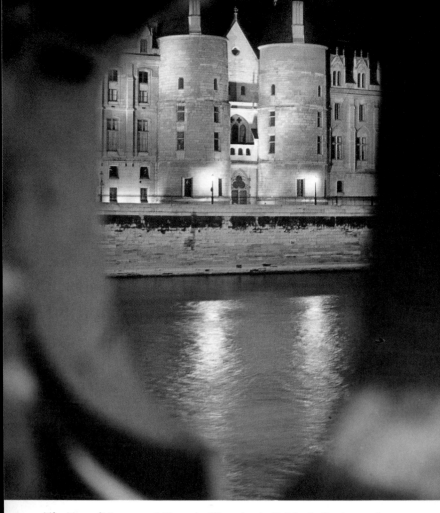

The Tour d'Argent and Tour de César, in the Palais de Justice, 13th century.
Built by St Louis; until the time of Henry IV they stood at the water's edge.

P. 38/39
Window of the Passion of the Sainte-Chapelle,
end 13th century. Flagellation (left) and Crown of Thorns (right).

P. 40/41
West rose window of the Sainte-Chapelle, c. 1490. The theme is the
Apocalypse; the diameter is 9 m. (29 feet).

P. 42/43
The Conciergerie, in the Palais de Justice, 14th century. This is a relic
of the medieval Palais de la Cité;
the clock tower was altered in the 16th and 19th centuries.

before disappearing altogether in 1796. Its name survives in that of the Faubourg du Temple.

Almost the whole of the left bank area was occupied by the university, girded with high walls and gates and accommodating a great number of religious foundations within its precincts. Towards 1220, the Dominican friars, the Jacobins, built a college on the Montagne Sainte-Geneviève, with a front looking on to the rue Saint-Jacques; the entire establishment was destroyed in 1800. The Franciscan Collège des Cordeliers, founded in 1230 on the site now occupied by the rue de l'Ecole de Médecine, was demolished in 1702; the refectory was spared, and later became incorporated in the Faculty of Medicine. It has since been made into the Musée Dupuytrin. In 1244, the reformed Cistercians also founded a college, the Collège des Bernardins, on the Clos du Chardonnet. Parts of the buildings are still intact, including the superbly vaulted refectory at 24 rue de Poissy, which is shortly to become a museum to house the remains of former Parisian monuments. To the east, the abbey of Saint-Victor developed its own great monastic enclosure. It was destroyed during the Revolution, and replaced first by the Halle aux Vins, and more recently by the Faculty of Science. Outside the city, safe within their own walls, there were the Benedictines of Saint-Germain des Prés and the craftsmen of the thriving township of Saint-Marcel. The new covered market, the Halles, were set up at Les Champeaux at the corner of the rue Saint-Denis and the rue Saint-Honoré, despite the all too evident proximity of the Innocents charnel-house, creating an increasingly unpleasant situation as time went on.

In all, there were about 200,000 inhabitants, an exceptionally high number for such a small area; Paris, Milan and Venice were the most densely populated cities in the West. Nevertheless, Gothic Paris should be pictured as semi-rural and in constant touch with the surrounding country districts, where royal and princely estates were growing up. St Louis IX was born in Poissy, but he signed many decrees at Fontainebleau, where even in those days the crown possessed a kind of manor-house on the edge of the forest, close to a famous spring. He also liked to stay at his Château de Vincennes to the east, a favourite with all the Capetian kings.

Paris was inseparable from its rich environment both culturally and economically. The reciprocal exchanges on every level stimulated an inventive and enterprising frame of mind that seemed to permeate the entire Ile de France, turning it into the laboratory that produced the Gothic spirit. Villard de Honnecourt's precious album, now in the Bibliothèque Nationale, MS. 19,093, dates from the second half of the thirteenth century and shows how advanced technical knowledge had become by that time. This treatise contains observations on building-site procedure, diagrams of new projects, and geometrical formulae for sculpture as well as for building, which, according to Henri Focillon, are proof of the persistence of Romanesque abstraction throughout the Middle Ages. Nor was the organization of labour so simple as is commonly believed. Suger had to resort to all the enormous wealth of Saint-Denis in order to complete his crypt and choir by 1144, that is to say, in just over three years. Episcopal works, conducted by the cathedral chapters, proceeded far less speedily and smoothly as a rule; a notable exception is Notre-Dame, which was begun in 1163 and consecrated in 1182.

It is generally accepted that architects already knew how to organize large internal spaces harmoniously by means of a ribbed vault. Ogives

had been used in one or two places, such as Durham Cathedral, Sant'
Ambrosio, Milan, and also in the Ile de France, in the ambulatory of
the small rustic church of Morienval and in the side-aisles of Saint-
Etienne at Beauvais, built from 1110-40. The recipe was then adopted
for two new churches outside the walls. One was Saint-Pierre de
Montmartre, the small conventual church still standing beside the
Sacré-Coeur on the hill where St Dionysius and his followers are said to
have been martyred, and the other, the priory of Saint-Martin des
Champs, with a choir erected about 1135, bearing eight radiating ribs,

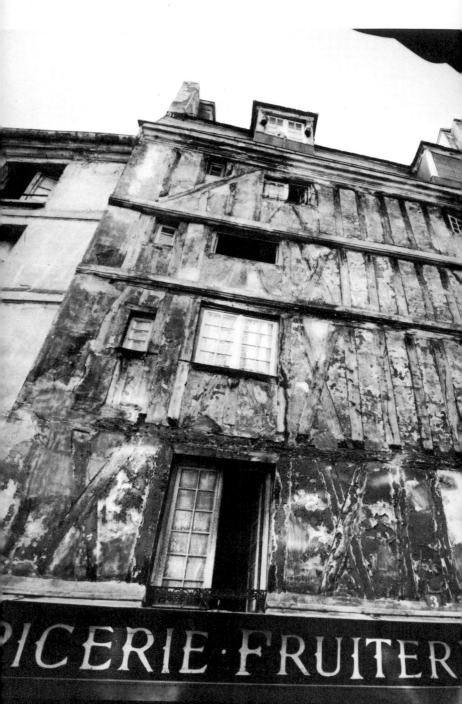

and a broad ambulatory. This church marked the first real success in the new Gothic manner, but it was not until Suger embarked upon Saint-Denis itself that the complete formula was definitely established. 'Saint-Denis is not only a masterpiece,' wrote Henri Focillon, 'it is also a considerable event in the history of medieval civilization; and it is the achievement of one man.' . The next step was to use the new style in a great and spectacular building. This was Notre-Dame de Paris, only a little later than Senlis, Noyon, and the south transepts of Soissons and Laon. Notre-Dame closes the period of transition from

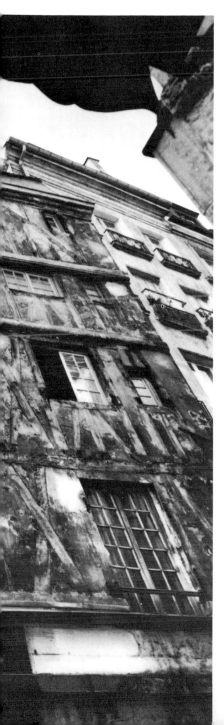

Half-timbered town house, 3 rue Volta, III, perhaps 14th century. This is said to be the oldest house in Paris.

Romanesque structure, still apparent in the four-storey construction, to the Gothic system where the lateral volumes lean upon each other thanks to the combination of the supports, the important feature being the adoption of the thin wall. Later, the developments in the new way of building caused a few modifications in the initial arrangements. The rectangular plan without projecting transepts, the tapering bays, the suppression of the storey with the *oculi* (round windows) from 1225-30, the tall windows and the flying buttresses were all typically Parisian elements. The justly famous flying buttresses round the apse were built at the same time as the chapels, 1290-1320. The same features reappear in a number of places, like the graceful Saint-Leu at Esserent, about twenty-five miles north of Paris, not far from Beaumont-sur-Oise. This church is admirably situated on a spur of land overlooking the river, and has been very carefully restored after being severely damaged in 1944. There is also Saint-Sulpice at Favières, on the road to Etampes, with smaller dimensions, but still quite a large church for a country town. The rectangular plan of Notre-Dame was generally held as representative, and the only other great Gothic structure in Paris, Saint-Eustache, close to the Halles, reproduced the pattern fairly closely The provost of Paris laid the foundation stone in 1532, but building continued well into the seventeenth century.

The use of the sexpartite vault, and the height and massive character of the façade, mark Notre-Dame as belonging to the end of the 'early Gothic' period, although some transformations later on allowed the cathedral to benefit from the simpler, more luminous solutions adopted in Chartres, Amiens and Reims. The extreme grace of the south transept (1258), organized around a gigantic rose window, was ultimately a response to the important innovations made about 1230 in the new treatment of the structures in the nave of Saint-Denis, by Peter of Montreuil, and later in the Lady Chapels of Saint-Germain des Prés in Paris and Saint-Germer de Fly, a delightful church on the borders of Norman Vexin and the Ile de France, begun in the twelfth century and completed later. The new width allotted to the glass bays made it possible to introduce more lancets, so that the windows could meet and the walls virtually disappear. This was the manner adopted in Champagne and Normandy in the fourteenth century and soon taken up all over Western Europe. In Paris itself, there is one more fine example of luminous, airy space in the refectory of Saint-Martin des Champs, but it was not really followed up except for the simple two-storeyed Saint-Leu-Saint-Gilles, dating from 1320, and the 'Flamboyant' touches like those added to Saint-Séverin in the 1500s and 1600s.

This extension, and, as it were, intensification of the role of the stained-glass window was one of the dominant traits of the new architecture, and Paris happens to provide ample opportunity to observe and understand this aspect of medieval art. By the middle of the thirteenth century the trend had become general, and had found full expression in Saint-Denis, where the bays are adapted to the new design of the windows with their many medallions. The next great sequence was Chartres, but before it was quite completed, the first of the important Parisian sets was begun in the Lady Chapel of Saint-Germain des Prés. After the chapel was demolished, some of the panels

▷
La Belle Madone. Ile de France,
beginning of 14th century. Musée du Louvre.

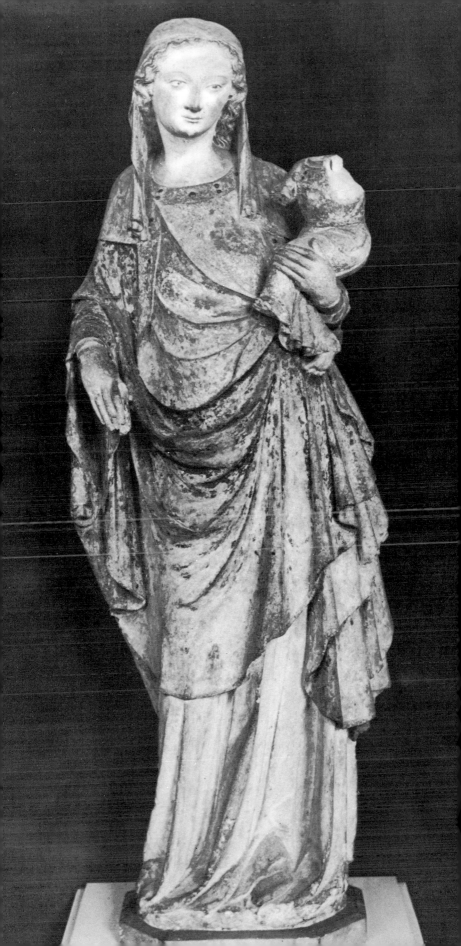

were re-used for another chapel in the ambulatory, and eight went to Saint-Denis; more than thirty others are in New York, Baltimore, London (Victoria and Albert Museum), Montreal and elsewhere. But the most extraordinary event of all was the creation of the Sainte-Chapelle, Louis IX's 'stone reliquary' for his relics of the Passion (1248). Here the upper storey has fifteen windows forty-five feet high, entirely replacing the walls. The whole of the Old and New Testaments are condensed in a series of small medallions, in an alert nervous manner that has often been likened to the fine outlines of contemporary miniatures, soon to gain fame as the 'Parisian' style. Less than ten years later, the influence of the new style had spread to the north and south windows of the transepts of Notre-Dame, and soon the interiors of all the northern French cathedrals were bathed in mauve and purple light from airy compositions of blue and red glass.

Contrary to what is frequently believed, the sequel to these brilliant beginnings was not an anti-climax. About 1380, yet another trend began to emerge in stained glass, with the extensive use of grisaille and silver-stain and the disposition of large figures beneath architectural canopies. One of the earliest examples was the *St James* in Saint-Germain des Prés, robed in blue damask. When Hippolyte Flandrin was asked to decorate the church in 1858 the window was transported to Saint-Séverin, and it can still be seen in the first bays of the nave. The upper windows in Saint-Séverin, including a large *Trinity* dating from the middle of the fifteenth century, show that Paris also played a part in the great artistic flowering in the late Middle Ages. The

Remains of the doorway from the Chapelle de la Vierge, Saint-Germain des Prés, by Peter of Montreuil, 1425-55. Garden of the Musée de Cluny.

sixteenth century is represented in Saint-Gervais and Saint-Etienne du Mont, and Saint-Nicolas du Chardonneret has a few of the geometrical designs which came into fashion in the seventeenth century. One can say that Paris recapitulates five centuries of the art of the stained-glass window, but the most beautiful of the seventeenth-century achievements is still the chapel at Versailles, where all ornament is limited to the frame. Saint-Séverin, with the coloured compositions by Jean Bazaine (1966) in the apse, is the place to obtain an idea of the modern evolution of stained glass. This specific form of art, so intimately linked with architecture, has a function rather akin to that performed by the fresco in the Mediterranean countries.

Sculpture of course is the other indispensable complement to a sacred building. Plastic forms bring out the ornamental resources of a church and illustrate the discursive, representative function of the whole. In Claudel's words, it is as if the entire structure were inhabited by a 'clergy of stone'. The Ile de France was decisive in the development of the art of sculpture, but Parisian churches also contributed to the new experiments that were soon to spread all over Europe. Among the churches near the capital, Saint-Denis shows the new type of 'royal portal'; Senlis has a tympanum with the Coronation of the Virgin; and Mantes has a few instances of the transition from the figure represented as part of the pillar to the free-standing statue fully occupying its space, as in the lateral portals at Chartres; the same trend appears, less regally perhaps, but not without authority, in the portals of Notre-Dame. The old twelfth-century tympanum

re-used in the south portal (Portail de Sainte-Anne) does not detract from the balance and the gravity of its composition, parallel to the serene group on the central portal showing Christ at the Last Judgment and slightly later than the installation of the Portail de la Vierge to the north with two superposed registers (1210-20). The mastery of execution and the imagination in the immense variety of figures decorating the archivolt and the piers, despite the excessive restoration, transform the decoration into a brilliant parade of vices and virtues, the labours of the earthly cycle, and the trials of the other world. And everywhere, outside and in, on mouldings, capitals, corbels and responds, there is the captivating local flora. 'Viollet-le-Duc was the first to notice that about 1280, at the dawn of the Gothic era, there seemed to be a predilection for the tight buds and flowers of early spring . . . During the thirteenth century, the buds burst into flower, the leaves opened out, and from 1400 onwards whole branches, stems of rose-trees, and shoots of vine would intertwine around the portals' (Emile Mâle, *Religious Art in France, XIII Century,* 1913 and 1961). The church thus also had a share of the spontaneity and the pleasing images that occurred in contemporary verse in Latin and French.

The change of architectural tone and rhythm that is so obvious when the monumental cathedral is compared with the ethereal Sainte-Chapelle also appears in sculpture over a similar lapse of years. The feeling of subtlety and the exquisite minor key in the apostles of the Sainte-Chapelle (1245-48) is continued in the south portal of Saint-Denis (*c.* 1260) and in the disposition of the medallions sculpted in delicate low-relief on the portals of the transepts of Notre-Dame (1240-56), including scenes of everyday life in the Latin Quarter. This emphasis on the familiar is as much a part of the new trend as the attempts to portray suppler figures and to perfect the contour of the arabesque. The style has often been linked to the stylized secular ivory figurines, which were very popular about that time. The motif of the smile, which went with the elegant leaning stance, had already appeared, though it was not in fact a Parisian creation. The composition in the tympanum on the portal of the north transept of the cathedral, known as the Porte Rouge (before 1370) is another fine example of the dainty manner, showing the Virgin as a queen receiving the tributes of St Louis and his consort Margaret of Provence. The figure has the same contained majesty as the fourteenth-century Virgin from Saint-Aignan, known as *Notre Dame de Paris,* placed against the south-east pillar of the crossing. Their elegance also heralds the 'courtly' style which produced countless statuettes of comely Madonnas, and became a speciality of the workshops of the Ile de France.

The great tradition of the monumental tomb began with the recumbent figures of the Plantagenets at Fontrevault in Touraine and was continued at Saint-Denis, in the tombs of former kings ordered by St Louis. Now that the abbey had become the royal necropolis, it soon turned into a museum of French sculpture. In the monument of Philip the Bold (*c.* 1300) the very pronounced combination of a faithful rendering of the princely habit with the ritual dignity of attitude inaugurated a genre which was to prevail for a long time in Western art. But the notion of the lifelike statue was gradually developing. The first convincing examples of the sculptural portrait appear under Charles V, in the decoration of the great newel stair in the Louvre, and in the statues in the Célestins, from 1365-70, showing Charles V as St Louis and Jeanne of Bourbon as Margaret of Provence. By then the sculptors' names were known. Almost all of them came

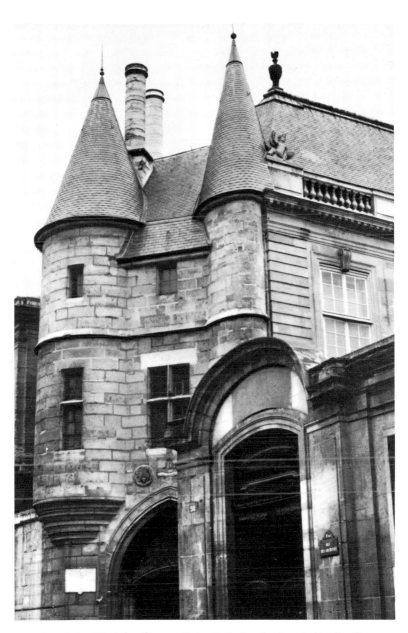

*Remains of the Hôtel de Clisson, 1371. Built for the Connétable de Clisson;
a fine example of 14th-century domestic architecture. It became the Hôtel de
Guise in the 16th century, and was absorbed together with the Hôtel
de Soubise into the Archives Nationales.*

from the north, like André Beauneveu of Valenciennes, who served
first Charles V and then the Duc de Berry, although the full extent
of his activities is still uncertain.

The miniature holds a very special place in Parisian art. The Ile de
France played practically no part at all in the extraordinary blossom-
ing of manuscript illumination in the eleventh and twelfth centuries.
With the advent of the Gothic, however, and parallel to the new
'unbending' in sculpture and the appearance of more graceful

architectural forms, there grew up in Paris a new style that was elegant, brightly coloured, and in perfect harmony with the other instances of Parisian taste that are identified with the 'courtly' manner. One of its finest manifestations was the *Psalter of St Louis* (1253-70). Master Honoré perpetuated the same airy lucidity in the *Psalter of Philip the Fair* in 1296. The place where the illuminators lived and worked was around the rue de la Parcheminerie (*parchemin* = parchment) not far from the rue Saint-Jacques, and in particular in what is now the rue de Boutebrie.

This artistic breakthrough had enormous repercussions on all branches of Western art, and can be regarded as the first affirmation of a true Parisian style, linked with a need for elegance and distinction and expression through fine, graceful forms. It tended to reappear at regular intervals, and was finally perfected by Jean Pucelle, the remarkable miniaturist who produced the *Breviary of Belleville* (1323-26). Here the mannered loveliness and facility of line create an art based on the ornamental arabesque, and a whole new repertoire of *drôleries,* ingenious and witty minor ornaments. By the fourteenth century, the new style was firmly established, and Paris participated in the elaboration of what is known as International Gothic, and popularized some of its discoveries. Under Charles V, when illumination began to widen its range, there is considerable evidence that painters were acquainted with Flemish and Italian works. In fact, the geographical position of Paris stimulated the art, and some of the best miniatures were produced around 1400.

There was also a certain tendency to adopt subdued tones and occasionally monochrome, as in the Cluny mitre and the sober, delicate, exquisitely patterned silk altar frontal, known as the *Parement de Narbonne* (1374), now in the Louvre. But with the *Book of Hours of Marshal de Boucicaut*, a definite step was taken towards the exploration of pictorial space within the limits of a single illustrated page. The group of artists working for the Duc de Berry soon showed that the miniature possessed all the properties of painting. The Duke, who resided as frequently in his Parisian mansions, the Hôtel du Grand Nesle and the Hôtel du Petit Nesle, as in his great châteaux, was known for his taste for luxury and refinement, and this is transmitted remarkably well in the paintings that were done for him. *Les Très Riches Heures* is the unforgettable summit. However, although Paris preserves most of the essential documents today, it was on the banks of the Loire, under the auspices of Fouquet, that the French portrait first appeared.

Literature, too, found its inspiration away from the capital, although in Rutebeuf, the protégé of the brother of St Louis, for example, there is something of the lively, bantering tone, with a hint of melancholy and restlessness, usually associated with Paris. It is also found in the amazing François Villon, the poet of low life, imprisoned in the Châtelet about 1465 and never heard of again, whose work is so typical of a certain current of Latin Quarter life. Later, about 1500, Gringoire too strikes a note that is recognizably Parisian even today.

As the Middle Ages progressed, commercial activities in the capital expanded, and there was much concern for proper organization. Etienne Boileau's *Livre des Métiers* in the fourteenth century gives an excellent picture of this prospering side of life in the city. In the thirteenth century, sacred architecture had developed at a rate unparalleled since Merovingian times, and in many cases modern

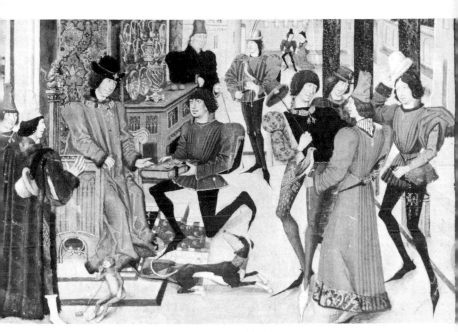

Miniature: Presentation to Charles the Bold, from Les Faits et Gestes d'Alexandre, *1468-70.* Bibliothèque Nationale, MS. FR. *22.527, f. 1.*

structures had replaced the old sixth- and seventh-century churches, taking up and enriching the traditional devotion to the legendary patron saints. Paris became a permanent showplace of the resources of the *opus francigenum*, the name which was coming into general use to refer to Gothic art. By comparison, domestic architecture was less advanced, but it caught up gradually from the reign of Philip the Fair (1285-1314) onwards. The Louvre of Philip Augustus was essentially a fortified keep surveying the undulating wall to the west; on the periphery, linked with some now well-protected green zones, noble houses were appearing, including those of the Dukes of Brittany, the Counts of Flanders and the Counts of Savoy, which have unfortunately all been destroyed. The Hôtel de Clisson (52 rue des Archives), built in 1371, is perhaps the earliest example of a building in the Marais; all that remains is the fortified gateway. A late fourteenth-century tower, known as the Tour de Jean sans Peur, still stands on the site of the residence of the Dukes of Burgundy, near Saint-Eustache.

It was important for royal authority to be made manifest, and so the administrative buildings of the State, which composed the Palais de la Cité (now the Palais de Justice), were also transformed. The technical skill of the royal engineers produced the two-storeyed construction of the Salle des Gens d'Armes, and above it the great hall (1301-15). Sixty-five pillars divided the great hall into four aisles. The square kitchens with four aisles were added by Jean le Bar in 1350. It has all been restored recently (1967) and is open to visitors. Twin towers emphasize the monumental entrance on the north side, and on the south there is the transparent fairy-tale Sainte-Chapelle. An idea of the appearance of the old buildings is given in the view from the left bank in the *Très Riches Heures du Duc de Berry.*

Under Charles V (1364-80) the old Louvre was somewhat refashioned,

and the great newel stair added by Raymond du Temple; this structure was to become a symbol of grandeur in French tradition. The city wall was moved out to the line of the present Grands Boulevards. As times became safer, interest shifted towards the eastern outskirts of Paris; there was building at Vincennes, at Bicêtre and at Beauté-sur-Marne, which Charles VII was to give to Agnès Sorel.

All these undertakings, greatly augmented what might be termed the artistic assets of the crown and the church. Gothic art fostered a demand for reliquaries, precious vases, chests and hangings, to give added lustre to public buildings. The 'furnishing' in the Sainte-Chapelle was as renowned as was the luxurious drapery in the royal great hall in the Palais. It was the point of departure of a tradition which was kept alive during the Renaissance, and which triumphed again publicly in the reign of Louis XIV. The first visible sign of the new trend came under Charles V, when rooms were set aside in the Louvre to show statues, enamel work, and pieces wrought in gold, and when the famous library, comprising more than a thousand volumes, was installed in the tower. It would certainly not be fanciful to see this as the origin of the Bibliothèque Nationale; it bore witness to the princely love of books that all the king's brothers shared, and especially the Duc de Berry. When this royal collection was exhibited at the Bibliothèque Nationale in 1968, it showed scientific treatises rubbing shoulders with books of devotion and thirteenth-century manuscripts beside more recent works.

The Reliquary of the Arm of Charlemagne, now in the Louvre, is an excellent example of how the cult of relics became connected with the affirmation of political supremacy. This small wooden object, plated with silver and set with enamels, was kept in Aix-la-Chapelle (Aachen) until 1794. It constitutes the first figurative document of the religious cultus of Charlemagne initiated by Frederick Barbarossa in 1165. Twelve arches show the six members of the imperial family in the company of Christ, the Virgin, angels and saints. Significantly, in a work by the Master of Moulins from the fifteenth century, in the National Gallery in London, the legendary Emperor appears among the patron saints of the house of France.

The ambition to acquire political hegemony was deep-rooted in the Capetian dynasty, and in the reign of St Louis (1226-70) the king of France enjoyed a general pre-eminence in the west. He had more effective influence even with the Papacy than had the Emperor, whose importance had been only nominal in Italy since the fall of the Hohenstaufens. During the following century, the alliances of the house of France brought Paris into contact with foreign courts and occasioned such events as the visit of the Emperor Charles IV, King of Bohemia, in the reign of Charles V. Many Italians lived in the city too, producing at least one excellent writer in Christine de Pisan. And after Valentina Visconti married Louis of Orléans, France seized the first opportunity it could to lay claim to Milan. But many projects remained unexecuted in this frustrating, disordered period, full of civil disturbances and over-accommodating reconciliations, an age when Paris really only lived on its former prestige.

Due to the unstable political situation in the capital, the fifteenth

▷

Tour Saint-Jacques, 1508-22. The sole remaining portion of the church of Saint-Jacques de la Boucherie, destroyed in the Revolution.

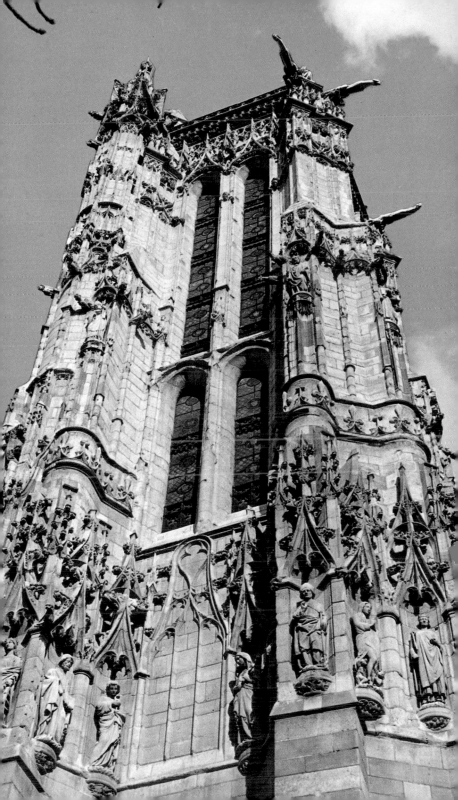

century was a period of stagnation and even impoverishment. The revolt of the Cabochiens (so called after their leader, the butcher Caboche) in 1413, followed the rising of the Maillotins (so called because armed with mallets) in 1382. These movements merely showed the burghers' utter exasperation with crushing taxes and the royal administration; more upheavals followed when the English occupied the city. English supremacy was supported by the Burgundians in 1418 and officially admitted in the Treaty of Troyes in 1420, when Charles VI recognized Henry V of England as his heir. At Henry's death in 1422, his baby son Henry VI was proclaimed king of the

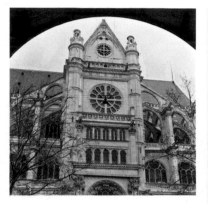

South lateral façade of Saint-Eustache, 1532-40. A transitional work; Gothic structure and proportions, overlaid by Renaissance decorative forms.

▷
Square du Vert-Galant, at the western tip of the Ile de la Cité, behind the equestrian statue of Henry IV.

two kingdoms, and the Duke of Bedford became Regent in France. This situation lasted until 1436, when the population, which had seemed reasonably satisfied with English rule, suddenly roused itself to acclaim Charles VI's son, Charles VII.

His solemn entry into Paris the following year was the prelude to the last stage of the Hundred Years' War, but it did not lead to the rehabilitation of the capital. It took almost a century for Paris to recover its former pre-eminence; its return to favour was symbolized by the reconstruction of the Louvre and the foundation of the Hôtel de Ville under Francis I (1533). In the intervening period, the cultural

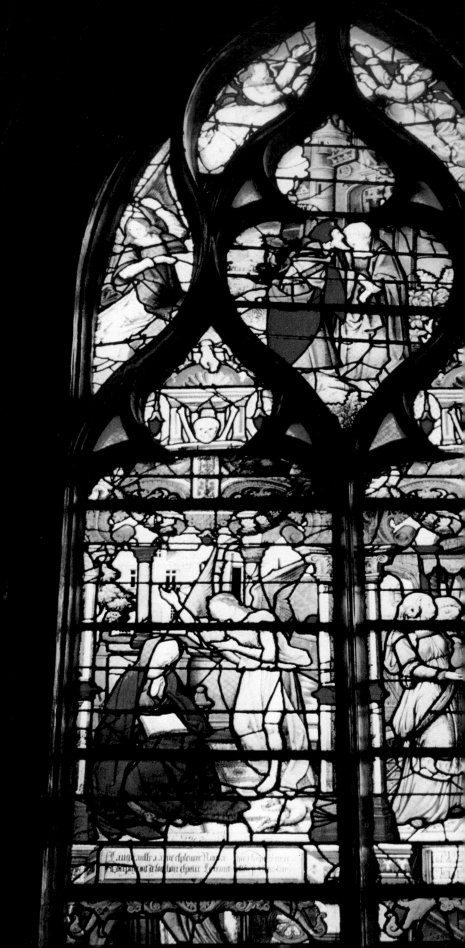

◁
Pinaigrier: Annunciation, *detail of window in the Chapelle de la Vierge, Saint-Gervais-Saint-Protais, c. 1520. Part of a group of three large windows representing* Scenes from the Life of the Virgin; *the colouring is exceptionally fine.*

P. 62/63
South façade, Château de Fontainebleau, with the pavilion built by J. A. Gabriel on the place of the former Pavillon des Poëles.

61

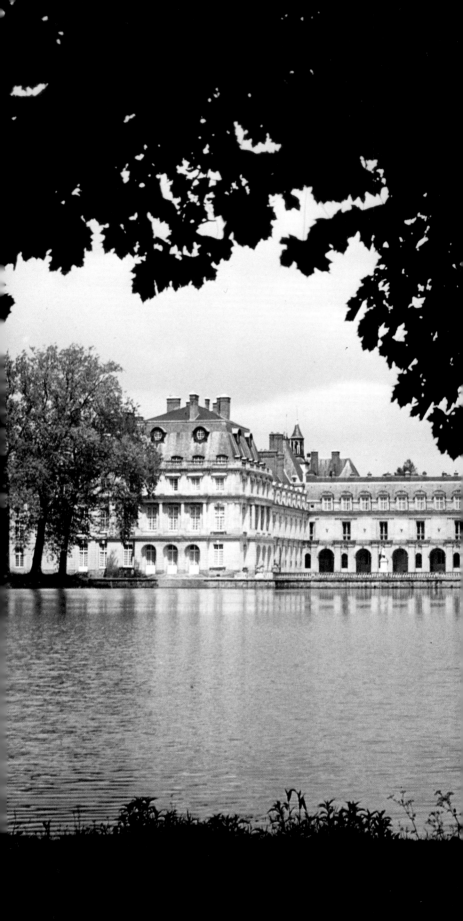

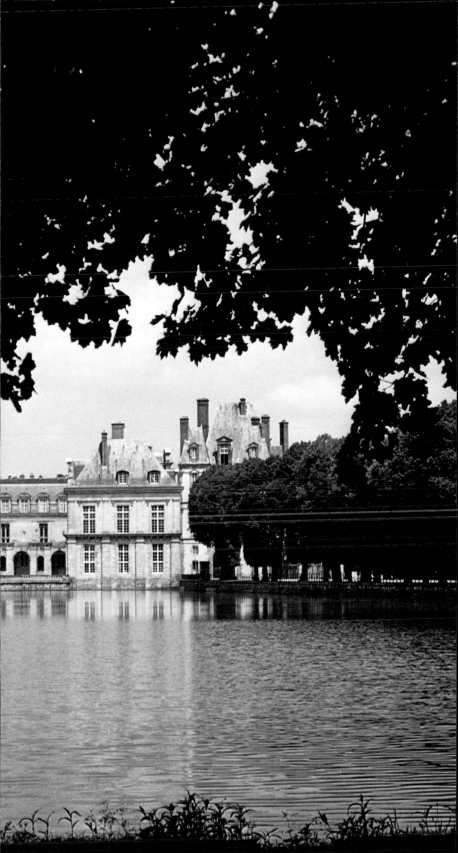

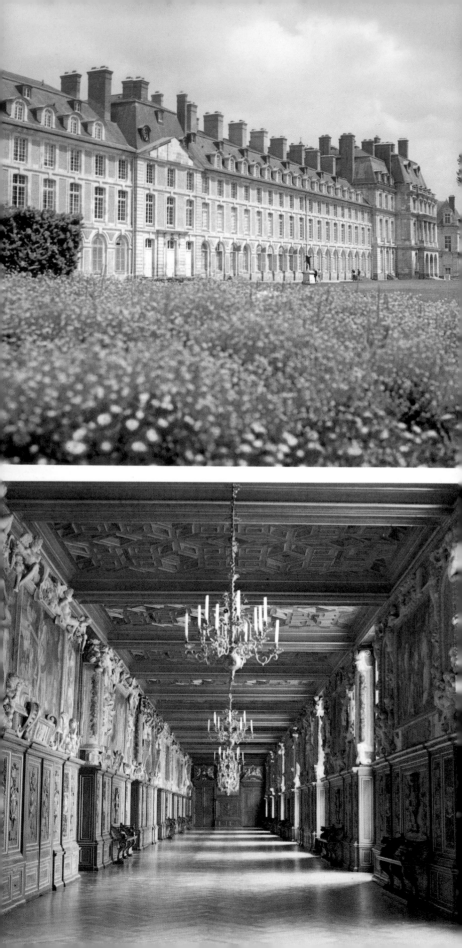

and artistic life, and the administration, of the country were carried on in the Loire valley, reaching Paris only intermittently. The great achievements of the French Renaissance owed virtually nothing to the intellectual climate of the capital, where the municipality and the Sorbonne seemed rather retrograde than progressive. For the first time, Paris had ceased to be a source of inspiration; but even so, as we shall see, it provided the framework that gave lasting shape to the post-Renaissance culture of France.

It is quite helpful to take the end of the fifteenth century as a vantage point and try to examine the general configuration and capacities of the city at the turning-point between the two great periods of Western history. Paris had expanded more on the right bank than on the left, and nowhere overlapped the wall of Charles V. Some gates had even been walled up because of political instability and the threat of rapine. The rampart ran from the Porte Saint-Honoré in the west to the Bastille in the east, roughly parallel to the earlier wall. South of the river nothing had changed. Districts and streets often retained their own special craft and trade connections. There is evidence of this in many local names, particularly round the Halles, the focal point of all commercial activity: the rue de la Cossonnerie was called after the middlemen between egg-producers and vendors; the rue des Lombards, after the moneylenders and bankers; and the Quai de la Mégisserie after the tannery beside the river where hides were dressed. Circumstances also encouraged the progress of cultivation within the walls and fishing in the river.

When the royal court came to Paris, after the end of Bedford's rule, it resided in the eastern quarters in the Hôtel Saint-Paul and the Hôtel des Tournelles, both of which were demolished to make room for eighteenth-century developments; the names survive in those of some streets. Their grounds occupied both sides of the rue Saint-Antoine, not far from the great Fortcresse Saint-Antoine, soon known as the Bastille, erected in 1370-82 by Provost Aubriot. As everyone knows, it was destroyed on 14 July 1789; a few traces of its walls can still be seen on the platform of the Métro station.

In the city itself, the buildings were often in bad repair, and there were few new constructions of note, apart from the Hôtel de Sens (begun in 1475), behind the church of Saint-Gervais close to the river, the residence of the archbishop whose see included Paris. Another fifteenth-century building on the left bank is the vast house of the Abbots of Cluny, grafted on to the remains of the old Roman baths. It was built under the direction of Jacques d'Amboise, a member of the powerful family that dominated French politics and cultural life under Louis XII. There were no particular innovations in its structure, apart from the tiered arrangement of the beautiful staircases in the courtyard, and the nobiliary turrets.

More than ever, Paris seemed to be a maze of narrow streets, full of pleasant surprises – an occasional statue, signs, quaintly overhanging storeys – but so narrow and congested they soon became the object of severe criticism. Various edicts were published to prohibit overhangs which hid the light of day from the thoroughfares, to impose

◁
South wing, Château de Fontainebleau, as rebuilt by J. A. Gabriel, 1738.

(below) Galerie François Ier, Château de Fontainebleau, 1534-39.
Woodwork by Seibec de Carpi; frescoes; plasterwork by Rosso and his group.

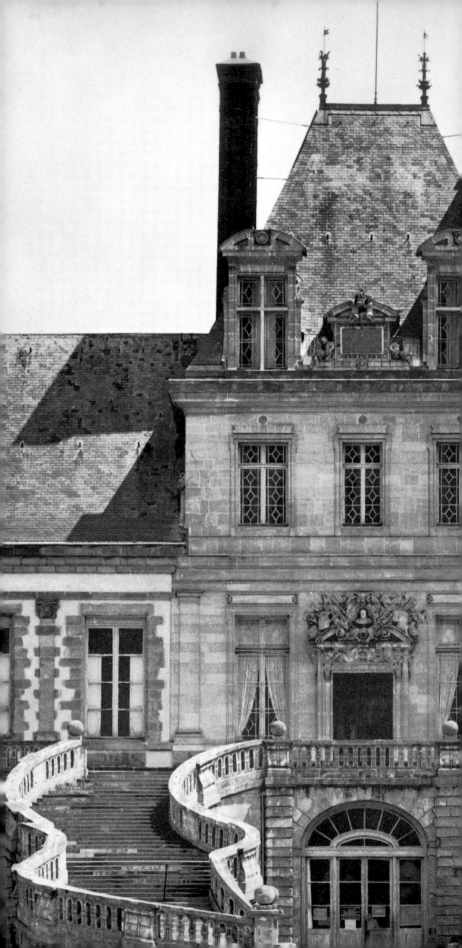

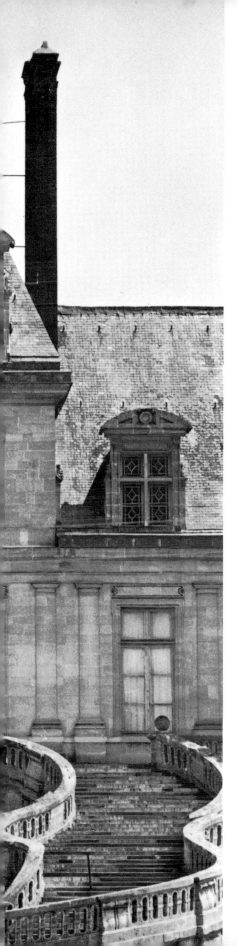

Entrance pavilion, Cour du Cheval Blanc, Château de Fontainebleau, with staircase by Jean A. du Cerceau, 1634.

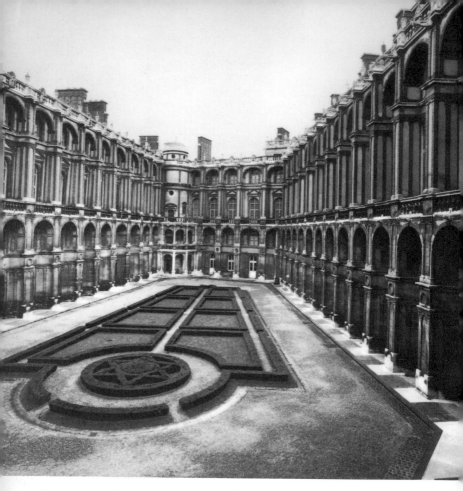

Inner courtyard with loggias. Château de Saint-Germain en Laye, by Chambiges, 1539.

a certain width, and to encourage construction in stone because of the danger of fire. The Italian town which Frenchmen such as the historian Commines prized most was Venice, with its display of palaces along the Grand Canal; in fact it is the warren of lanes round St Mark's that give the best idea of what Paris must have been like at the end of the Middle Ages. It also had an extraordinary combination of spires and belfries in the Ile de la Cité which lent a kind of gaiety to the urban landscape. The medieval island has been immortalized by Victor Hugo's unerring poetic intuition in some famous passages from his novel, *Notre-Dame de Paris*, written in 1831.

There were few new religious buildings in Paris in the 'Flamboyant' late Gothic period. The cloister of Les Billettes, at 24 rue des Archives, is one example, close to a fourteenth-century chapel built to atone for a Jewish sacrilege, which is inevitably recalled each time there is an upsurge of antisemitism in the capital. The nave of the old church belonging to the Louvre, Saint-Germain l'Auxerrois, was rebuilt from 1420-25. The portal with three bays and sculptures is the only one of its kind in Paris. In the grounds of Saint-Séverin, on the left bank, the galleries of the cloister ringing the charnel-house were also reconstructed, and some fine stained-glass windows were added to the church. In the neighbouring Hôtel de Cluny, Abbot Jacques d'Amboise ordered a fresco for the chapel of the Holy Angels, portraying him as benefactor. In the larger villages outside the town many small churches that had

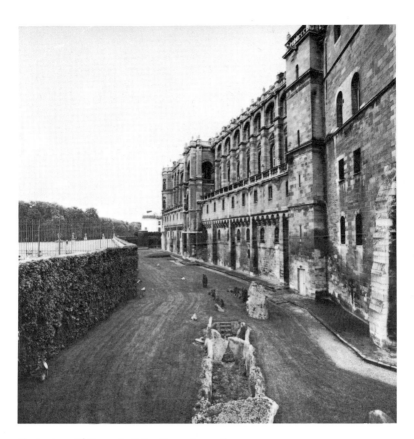

*East wing, Château de Saint-Germain en Laye,
by Chambiges, 1514-39.*

suffered during the wars were rebuilt, like the engaging little Saint-Germain, at Charonne in the east blessed in 1460 by Guillaume Chartier, then Bishop of Paris. This prelate also supervised the restoration of the Benedictine convent of Saint-Pierre de Montmartre, which got back its vaulted nave and its nuns.

The element of change also began to affect the bridges. The traditional arrangement had been totally inadequate to deal with the traffic passing between the islands and the banks of the Seine for a long time, and the intensification of trade and travel added to the urgency of the situation. In the thirteenth-century 'itinerary for pilgrims from London to Jerusalem', Paris was represented by its main bridge, the Grand Pont at the south arm near the Hôtel-Dieu. The Grand Pont was guarded by the Châtelet spanning the rue Saint-Denis, while the Petit-Pont on the other side of the Ile de la Cité was guarded by the heavy mass of the Petit Châtelet spanning the rue Saint-Jacques on the left bank. The Pont Notre-Dame, parallel to the Grand Pont, led only to the Orléans road. Thus the main north-south axis, well marked by two long streets, traversed the Île de la Cité in a zig-zag. Eventually, at the end of the fourteenth century, the Pont Saint-Michel was built to align with the Grand Pont, and the bridge of Notre-Dame was extended in 1421. These efforts were the start of a series of gradual developments which punctuated the expansion of the city. The Pont Notre-Dame, carried away when the river was in spate in 1492, was

reconstructed probably according to a plan by a Veronese monk, Fra Giocondo. This important achievement of a modern engineer was the first instance of the Italian impact. It had six arches and carried sixty-eight houses. (The present bridge dates from 1853.)

Medieval city bridges must not be pictured as openings on to the river, but rather as prolongations of the existing streets. They were lined with houses, and there was no general view for the crowds, who flocked there for various other purposes. In fact, it was only with the construction of the Pont Neuf, planned as early as 1577 to link both banks across the point of the Cité, but not finished until 1605, that the new type of open bridge was introduced. People at last became aware of the prospect afforded by the river and the spectacle of the banks of the Seine. Thereafter, each new bridge became an opportunity for interesting schemes, such as the Pont au Double, facilitating the access to Notre-Dame, and the Pont-Marie, called after its sponsor, which was erected in 1618-35 at the time when the Ile Saint-Louis was being developed. A ferry service was organized near the Tuileries, where a very fine bridge, the Pont Royal, was constructed in 1685, later matched by the Pont Louis-XVI (1790), now known as the Pont de la Concorde. In 1804 the Empire contributed the first iron footbridge, the Pont des Arts, and the Third Republic was responsible for the Pont Alexandre-III in 1900. Each of these achievements had the double effect of easing the traffic and completing the prospect, acording to a logic that has made the system of bridges in Paris one of the most eloquent and revealing in the world.

The Royal City

Paris was no more a focal point of Renaissance culture than it had been of the Romanesque. But the sixteenth century is none the less significant in the history of the city; it witnessed the introduction of certain new preoccupations which came to their fulfilment in the following century.

In Paris, the Renaissance is not completely identified with the vogue for things Italian. As a result of the succession of military expeditions begun by Charles VIII (1494) and finally brought to an end by Henry II (1559), France as a whole did indeed take on a southward orientation, both in politics and in culture, that it had never shown previously; but for Paris the consequences were indirect. The emphasis should in fact be laid not on this but on the political unification of the country; this was carried out by the monarchy, first under the dashing leadership of the last Valois, then, after the terrible civil wars fomented by the Protestant heresy, under the shrewd management of Henry IV and the forceful rule of his Bourbon successors and their ministers. In these successive crises, Paris several times had a key part to play. The first occasion was when Francis I, in 1527, decided to restore to the capital its political function and its pre-eminence; this meant, for the Crown, not so much a return to Paris as a return to the Ile de

▷

Fontaine des Innocents, by Jean Goujon, 1548-49. A monumental loggia set up on the corner of the rue Saint-Denis for the solemn entry of Henry II, it was moved in 1788 to the middle of the Place des Innocents, laid out on the site of a former cemetery. The fourth side of the structure was added by Pajou.

France. The second occasion came at the end of the century, when Henry of Navarre was compelled to lay siege to the city in order to gain acceptance as king, an acceptance which came with his abjuration of Protestantism and the famous words 'Paris is worth a Mass'.

The century of the Renaissance was a difficult one. It witnessed the magnificence of the solemn entries of successive kings, which were spectacular shows staged by the municipality in the interests, partly, of its own prestige. It witnessed also the assertion by the municipality (the Hôtel de Ville) of a greater degree of independence; it now ran its own fiscal affairs and had taken its place as a third force alongside the king, with his prerogative, and the clergy and nobility, with their countless privileges. Paris did have a few nuclei of Protestantism, but the common people, inflamed by their preachers, periodically rose against the heretics, and in 1557-58 pursued them into their retreats in Saint-Médard and the Faubourg Saint-Germain. Parisians were not

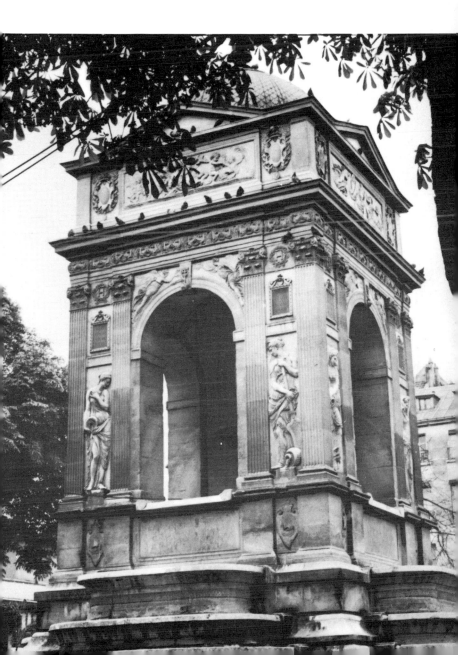

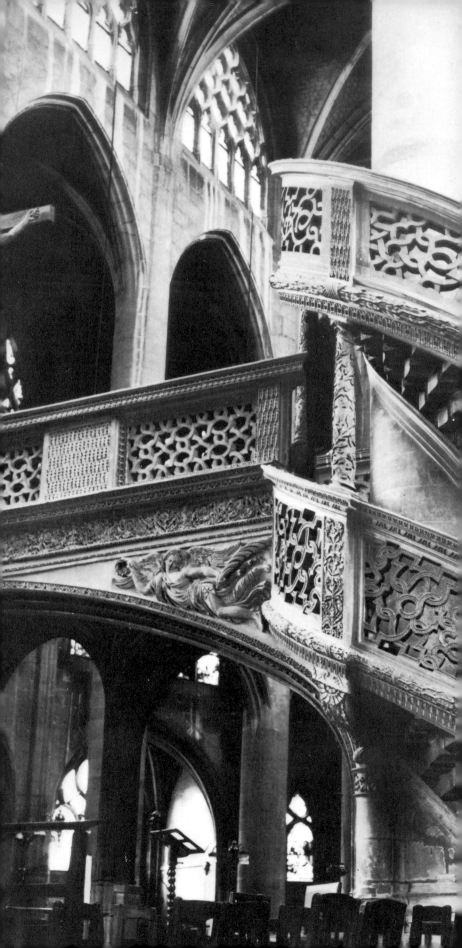

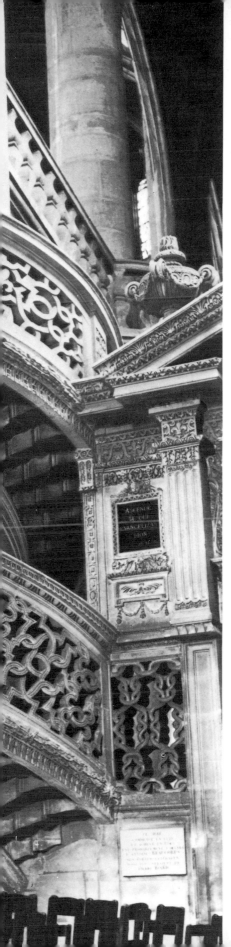

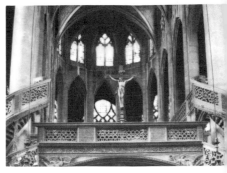

The interior of Saint-Etienne du Mont, 1492-1586.

Rood-screen (jubé) *of Saint-Etienne du Mont, 1525-35. This brilliant composition has been attributed to Philibert Delorme; the spiral steps were built round the piers of the choir in about 1545.*

averse to burnings at the stake; and the St Bartholomew atrocities in 1572 triggered off a wave of mob violence. Paris, in the hands of the Guises and the Ligue, repudiated Henry III's decision to recognize the right of Henry IV to the succession, and called in Spanish help to resist Henry IV, who finally had to lay siege to it (1589). Once peace came again, the Parisians recovered the court of Parlement, the national government, the favour of the king, their former good humour, and their former prosperity.

At length, after experiencing the ups and downs of revolt and popular unrest, Paris became, under Cardinal Richelieu (minister to Louis XIII from 1624 to 1642), the administrative base of a solidly based monarchy and the diplomatic centre of Europe. But the situation was to change again: the government of Richelieu's successor Mazarin, during the minority of Louis XIV, made itself unpopular through a fiscal policy which hurt the bourgeois, and there were riots and barricades in the streets of Paris once more. This so-called *Fronde des Parlementaires* in 1648-49, which had the support of the masses, was to be the last serious explosion before 1789. The ten-year-old king was never to forget the day when he had had to make a hurried escape to Saint-Germain en Laye. As far as the Parisians were concerned, the affair was soon forgotten; the young king long enjoyed much popularity among the people and the aldermen, and his ministers made plans for improvements. But Louis never got over his aversion to Paris; and in 1670, when he was sure of himself and firmly in power, Paris was abruptly stripped of all its political importance by the transfer of the court to Versailles.

In the course of these two centuries Paris gradually regained its role as an intellectual market-place, a city that welcomed foreigners, and a school of elegance and fashion, and acquired its lasting place on the European map. Scientific activity received institutional support, through the foundation by Francis I of the Collège de France. In the following century came the building of the observatory (Perrault, 1668-72).

In 1626 the royal physicians set up the Jardin des Plantes Médicinales, in the virgin terrain east of the abbey of Saint-Victor; this was the starting-point of the development of a great institution of biological study that was to attain its full maturity in the time of the great naturalist Buffon, its director from 1739 to 1788. In 1793, the Revolutionary statesman and educational reformer Joseph Lakanal reorganized it as the Muséum National d'Histoire Naturelle, the official title which it bears to this day. The institution was developed and extended throughout the nineteenth century, with the old Jardin des Plantes as its nucleus.

In the course of the seventeenth century the luxuriant and multifarious learning of the Renaissance gave way, under the influence of the confident rationalism of French society, to a phase of discipline and orderliness whose influence can be detected in all fields of activity. The genius of the French people revealed itself fully by going to logical extremes: making fully explicit certain contradictions such as that between the 'Stoic' rationalism of Descartes and the 'mystic' rationalism of Pascal. But there were a great number of intellectual forces at work. Great religious leaders like Cardinal de Bérulle were hard at work, as were the Jesuits, to reinvigorate the Church. There were numerous new foundations and new church and convent buildings. And also conflicts: Pascal took the Jesuits vigorously to task in his *Lettres Provinciales*, a savage polemic in favour of the 'Christianity of feeling' (*christianisme pathétique*) that was taught among the followers

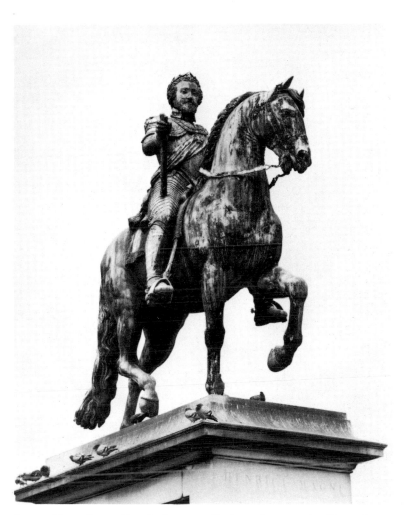

Lemot: **Henry IV** on Horseback, *1818. Replaces the statue by Giovanni Bologna set up between the two halves of the Pont Neuf after the king's assassination in 1610.*

of Jansenius in the monastic community of Port-Royal, tucked away in the wooded valley of Chevreuse. The demand for logic, dignity and strictness that inspired them encountered much sympathy among the members of the bourgeoisie and the titled lawyer class (the *noblesse de robe*) in Paris, who were hostile to the growth of irreligion among the intellectuals and members of high society.

This was also the age of preciosity, of romance and of sumptuous frivolity. A whole spectrum of attitudes to life coexisted. A moralistic tendency, drawing on Montaigne and the ancients, gradually came to dominate the literature favoured by educated Parisian readers, which, as exemplified by Molière, Racine, Boileau, La Bruyère, and later Voltaire, was incisive, socially critical, and destructive of illusions. These were the first classic figures in French literature who could be considered as representatives of a 'Parisian' mentality.

The aristocracy was caught in the golden toils of the court; this had already been an important phenomenon in the reign of Henry II as Madame de Lafayette's great historical novel *La Princesse de Clèves*

(1678) brilliantly shows – and, after the aristocratic risings of the Fronde in the mid-sixteenth century, inexorably became a closed and confined society under Louis XIV. It produced a number of distinguished writers: Madame de Lafayette, La Rochefoucauld, Saint-Simon. But its lasting contribution to French culture lay above all in its interest in beautiful surroundings, the setting in which life was lived, the art of display. No survey, however cursory, of art and architecture in Paris in the sixteenth and seventeenth centuries could fail to be, in addition, a record of the splendour of aristocratic life.

The combination of all these factors, and the growing self-awareness which sprang from them, lend an exceptionally intense and varied character to the Parisian life of the sixteenth and seventeenth centuries: especially, of course, the seventeenth. Reason and passion, love of order and instinctual spontaneity, seriousness and love of amusement, all clash, or alternate, in activities which belong to such different social milieux that they sometimes seem not to belong in the same city. The aspirations, the certainties, and even the contradictions of this culture are reflected in the character of the city itself; during this same period Paris underwent a number of decisive transformations, many of which have not been adequately understood, and all of which are of great interest.

The pace of change was not constant. In the sixteeenth century Paris was caught between the chivalric illusions of the Valois monarchy, which turned everything into a celebration, a parade or a triumphal procession, and the violence of civil war. Its growth was intermittent. Dwellings spread out over the green spaces in the east and north; a few costly royal undertakings, such as the building of the new Louvre and the Tuileries, introduced the modern style in architecture; and the west end of the town had to be protected by a line of fortifications known as les fossés jaunes ('the yellow dykes', 1566) against the threat of attack by the Imperial armies.

Having put an end, in his own idiosyncratic style, to the civil wars, Henry IV was at leisure to think about the future shape of his capital. Over a period of fifteen years he undertook the most remarkable effort at reorganization that was made in Paris between the time of Charles V (in the fourteenth century) and that of Napoleon III. It would be too much to call it a complete remodelling, such as was undertaken by Haussmann after 1852; but what happened, from the time of the appointment of Henry's associate Sully as grand voyer in 1596, was a series of coherent measures which displayed both a remarkable sense of the basic necessities of urban life and an exceptional power of decision. The opening of the Pont Neuf in 1606, the first Parisian bridge to be unencumbered by houses, inaugurated a new era in Parisian planning, that of the river view. The consequence was the growth of the embankments (quais) and the appearance, with the building in the 1660s of the Grande Galerie du Louvre and the Collège des Quatre Nations on the facing bank, of a true river front. The process continued under Louis XIII with the building on the Ile Saint-Louis of an array of magnificent houses linked to the rest of Paris by more new bridges.

Henry IV's initiative was carried further by the opening in 1604 of the Mail, a mall or tree-lined promenade alongside the Arsenal (south of

▷

Rue de Tournon, showing the gatehouse of the Palais du Luxembourg, by Salomon de Brosse, begun 1615.

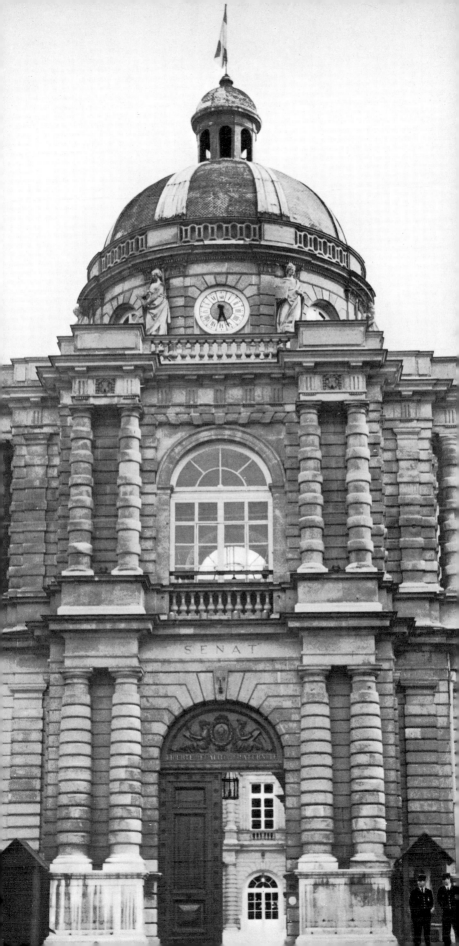

the Bastille); in 1616 the regent, Henry's widow (Marie de Médicis), built another promenade, the Cours la Reine (west of the Tuileries). Within the strict confines of the city walls, two processes took place which radically shifted the balance of the townscape. The first was the utilization of the last remaining vacant areas, including the Marais and the Temple precinct on the north-east, the west end of the Ile de la Cité, adjoining the Pont-Neuf, and the Ile Saint-Louis. The second was the creation of a new urban feature which was to find favour all over Europe: the symmetrical, carefully aligned and architecturally uniform city square. The emphasis at first went on the design and purpose of the squares themselves: triangular on the Ile de la Cité (Place Dauphine), square on the former site of Les Tournelles (Place

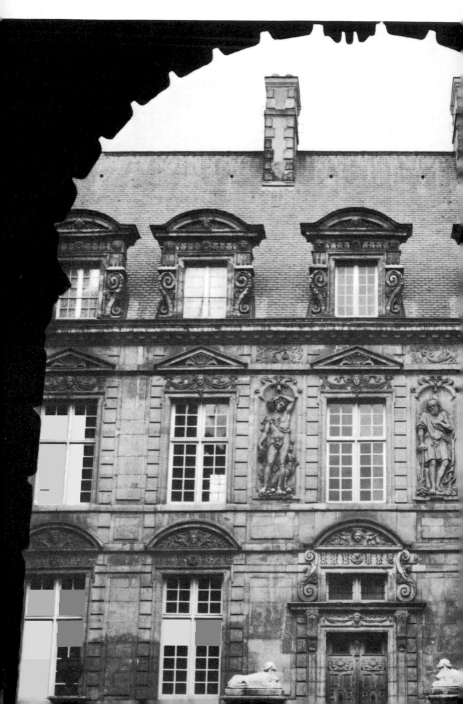

Royale, later Place des Vosges), or in the shape of the arc of a circle (Place de France, the ceremonial open space projected in 1609 for a site north of the Temple, but abandoned along with other projected public works in the period of uncertainty which followed Henry IV's assassination in 1610). Each of these squares had its purpose: dealings in commodities and securities on the Ile de la Cité; festivities and tournaments in the Place Royale; government precinct and market-place in the projected Place de France. If one adds to these undertakings the attention given by Henry IV and Sully to the development of the Louvre and to the problems of highway maintenance and building lines (edict of 1607), it is possible to claim that the principles of traditional town planning were laid down as early as 1600. If Henry

Façade of the Hôtel Sully, by Jean A. du Cerceau, 1624. The bas-reliefs are allegories of the Seasons.

IV had lived fifteen or twenty years longer, the Paris of the Ancien Régime would have looked very different; the problems of the city centre would not have been neglected as they were, and Haussmann's drastic surgery would not have been necessary two centuries later.

In the sixteenth century the new developments had been mostly in the centre. In the first part of the seventeenth they transferred themselves to the east, with the development of the Ile Saint-Louis and the transformation of the Marais; and after the 1650s the predominance passed to the west, along both banks of the Seine, while a large area outside Charles V's old wall finally merged with the city itself, which thus became an open rather than a fortified city. This additional ring of development featured massive foundations and modern plans; and a succession of notable public and private buildings mark the progress of the classical age of Paris. In the closing years of the seventeenth century, no city in Europe, not even Amsterdam with its master plan or Rome with its papal patronage, could boast a comparable galaxy of great buildings.

Before making a rapid survey of them, it is once more necessary to view Paris in its regional context. The ring of royal residences round Paris underwent a rapid expansion. In 1527, Francis I had declared that his court and government would thenceforward reside in his good city of Paris. This decision was accompanied by the destruction of the great feudal tower of the Louvre, prior to the building of the modern palace which replaced it, and by the rebuilding of the Hôtel de Ville, completed in the seventeenth century (this was burnt down during the Commune rising in 1871 and replaced by a modern building with a vaguely related design). On a site adjoining the Halles, work started on a large new church, Saint-Eustache, which had the original feature of combining a Gothic structure with an entirely new type of décor. This took an exceptionally long time to build (until 1640), as did Saint-Etienne du Mont, where the arches of the choir (1537) are Gothic and those of the nave semicircular. The magnificent choir screen (1525-35) is possibly by Philibert Delorme. Another design by this artist was the inspiration for the south porch of Saint-Nicolas des Champs, in the form of a pilastered triumphal arch; it was tacked on to the side of the church in 1575.

Most of these undertakings took a long time to come to fruition; in the meantime, Francis I built a giant Italianate villa, the Château de Madrid, in the Bois de Boulogne, and converted the old Château de Saint-Germain en Laye, which stood downstream, at the edge of a celebrated forest. At Compiègne, at the edge of another forest, he built another fine château.

The project to which he devoted the most attention was at Fontainebleau, where the old keep became the pivot for an extension to the east (the Cour Ovale) and to the west (the gallery and the Cour du Cheval Blanc). Here were kept the finest items in the royal art collections. In 1540 Francis's Italian court painter Primaticcio was sent to Rome to collect casts of the great ancient sculptures there; the bronzes made from these casts were displayed at Fontainebleau. (Moved to the Louvre in the seventeenth century, they have recently been replaced in the Galerie des Cerfs in Fontainebleau). Henry IV too took an interest in Fontainebleau, and enlarged it to its present size by adding the Cour des Offices and the Aile des Princes. The fondness of the French court for this great hunting-lodge, which was also a pleasant summer retreat, was to remain consistent. As long as the Ancien Régime lasted, and long after the creation of Versailles,

The Hôtel d'Angoulême, 1584-86. The composition, with a colossal order of pilasters, bays and pedimented dormers, is typical of a tendency to Mannerism in the architecture of the late 16th century.

Fontainebleau was the place where French kings came to seek coolness in the summer.

At Vincennes, the old keep still stands, between seventeenth-century wings by Le Vau; the royal chapel, begun under Charles V in the fourteenth century, was completed in the sixteenth by Philibert Delorme. It was here that Louis XIV moved, in his youth, when he left Saint-Germain en Laye.

Like Francis I, Louis at first turned his attention to rebuilding the Louvre; but, again like Francis, he finally settled elsewhere. It was as if every king felt the need to be represented by a building that was entirely his own. In this, no king ever succeeded better than Louis XIV at the Château de Versailles. Four leagues (i.e. three hours in a carriage) from Paris, on an awkward marshy plateau where Louis XIII had been content with a modest hunting-lodge, his son gradually and in successive stages built the most celebrated palace in the world. The first part to be built was a central brick and stone structure; then came the Cour de Marbre, and the west front, overlooking

P. 82/83

Fontaine Médicis, in the Luxembourg gardens, 1620. This nymphaeum, attributed to Salomon de Brosse, was moved to its present site on the eastern flank of the Palais du Luxembourg in 1861. The group of Acis and Galatea surprised by Polyphemus is by Ottin.

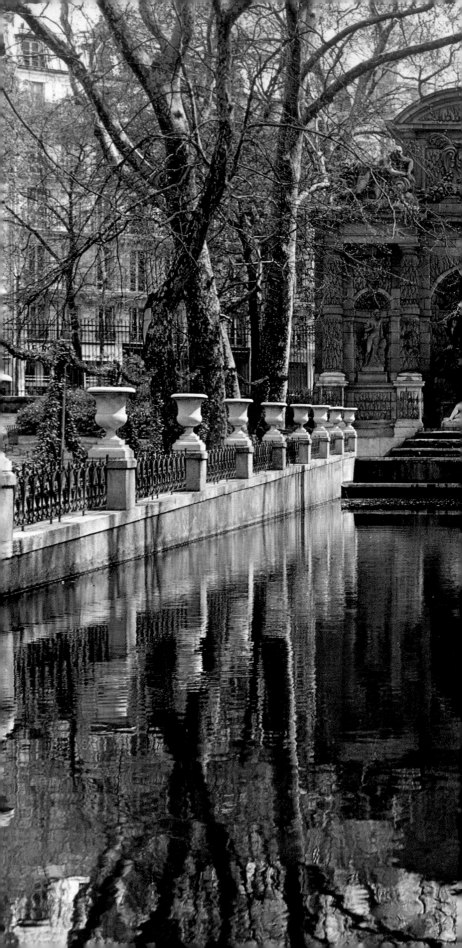

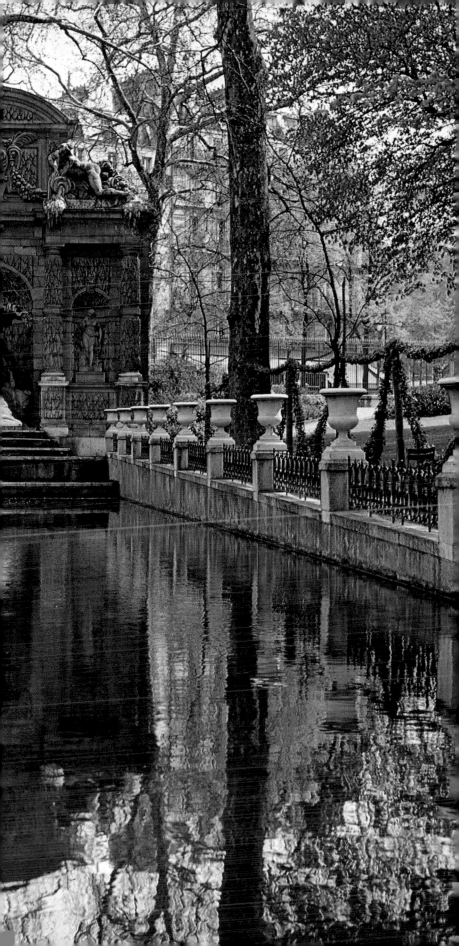

the expanse of terraces and watercourses which leads out to the park. Finally there came the gigantic main façade, built around the royal bedchamber and the superb gallery which leads to it. The chain of courtyards and outbuildings on the Paris side, the interplay of the terraces and shrubs along the axis of the grand canals, all contribute to a harmonious whole that makes one forget the business of government and think only of pageantry and excitement, the delights of court festivities, the pleasures of social gatherings at night, boating, theatrical performances – and the incessant demands of grandeur. This whole new formula in royal residences was elaborated architecturally by Jules Hardouin-Mansart and by Le Brun. If the king wanted a rest from formality and public exposure, there was the more secluded Trianon nearby, or his favourite retreat at Marly. He very seldom returned to Paris.

The Louvre and Versailles offer a quality which reappears in the building activities undertaken by countless members of the greater and lesser nobility. Private business and the court centred the life of the French aristocracy on Paris; and in its buildings in this area, it set out to adapt to its own requirements the twin Italian formulas of the urban palazzo and the rural villa. As early as 1532, Cardinal Du Bellay, just returned from Rome, had employed Philibert Delorme to build him an Italianate single-storey house at Saint-Maur; and Ronsard had praised the pastoral atmosphere of Cardinal de Lorraine's ingenious pavilion at Meudon, La Grotte. The country houses with gardens, and the elegant little houses of the Italian *casino* type, that sprang up around Paris are too numerous to mention individually. The modest

Aerial view of the Place des Vosges (formerly Place Royale), 1607-17.

pied-à-terre formula was adhered to more or less closely, according to the size of the estate concerned, the degree of accessibility, and the kind of pleasure the owner had in mind, which was often that of seclusion. All the nuances of élite social life are reflected in these structures, calculated in terms both of fitness for the site and of the exact social message that was to be expressed. Thus we have Sully, at Rosny, maintaining a certain military flavour; and, later, the Président de Maisons getting Mansart to build him a belvedere, admirably proportioned, high above the Seine.

The villages closest to Paris were also undergoing embellishment. At Reuilly, a rich financier built the so-called Folie Rambouillet, with a garden and groves of trees where he entertained a few chosen guests. Townspeople liked to take walks out to Auteuil and Passy, where, in the seventeenth century, there stood pretty villas, farmhouses frequented by famous writers, and religious foundations like the abbey of Longchamp. The country retreat of the Jesuits, with which Louis XIV's Jesuit confessor, Père de la Chaise, was concerned, stood on the hill of Ménilmontant (the site became the Père Lachaise cemetery in 1804). Almost all these villages, now of course long swallowed up by Paris, still contain vestiges of their ancient rural selves.

New religious buildings, of which there were very few in the sixteenth century and many more in the seventeenth, also tended to be located on the outskirts of the city. In Paris itself, there was the long-drawn-out enterprise of Saint-Etienne du Mont, brought to a conclusion in the early seventeenth century with an animated composite façade, and that of Saint-Eustache. The church of Saint-Gervais on the Ile de la Cité,

with its interesting stained glass windows, was furnished in 1616-21 with a regular façade, based on three superposed orders, which early sources attribute to Salomon de Brosse. This inspired the façade, wider and taller than the church itself, that was added to Saint-Paul-Saint-Louis, the Jesuit headquarters in the rue Saint-Antoine, by Père Derand. In addition, numerous parish churches were rebuilt with Roman-style vaults and with classical pilasters, and offer more variety than is commonly believed.

Above all, the religious communities built for themselves. The Temple de l'Oratoire in the rue Saint-Honoré, near the Louvre, was begun in 1621 on a large rectangular plan which reminds one of a Jesuit church; it was built to house Cardinal de Bérulle's Congregation of the

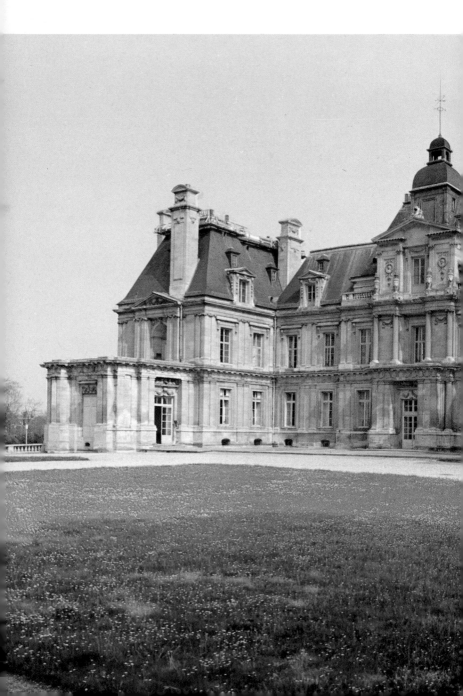

Façade facing park, Château de Maisons-Laffitte, by François Mansart, 1641-51.

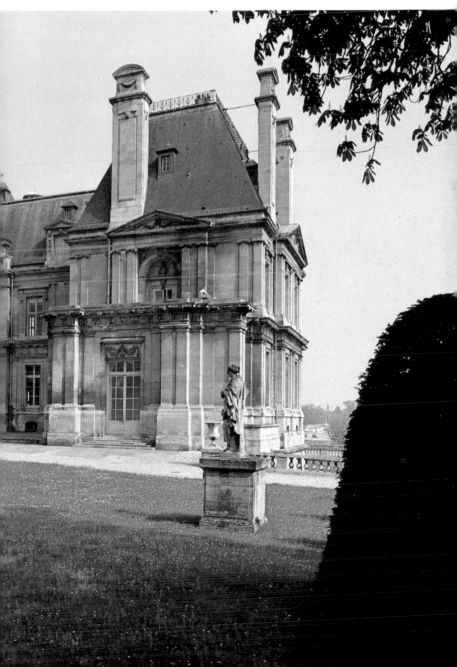

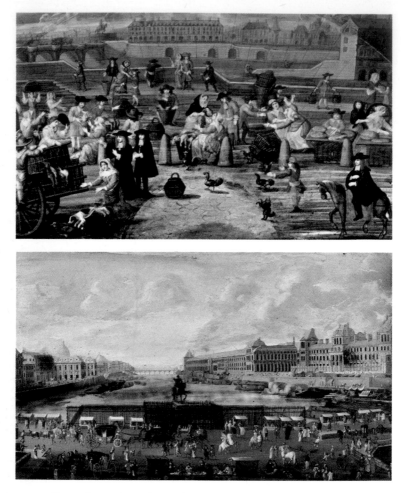

(top) The poultry and bread market on the quai des Grands-Augustins, looking towards the Pont Neuf, anonymous painting, c. 1660. Musée Carnavalet.

The Louvre from the Pont Neuf in Louis XIV's time, anonymous painting, c. 1665. On the left, the central pavilion of Le Vau's Collège des Quatre Nations (now the Institut), still without its dome. Musée Carnavalet.

Oratory. At the other end of Paris, in the rue Saint-Antoine, the young François Mansart built for the sisterhood of the Visitation a centrally planned church (now the Temple Sainte-Marie) that is one of the most original in Paris, with a colossal order supporting a circular inside cupola. On the Ile Saint-Louis, work began in 1664 on a new church to replace the old chapel of Saint-Louis en l'Ile; designed by Le Vau, it was not finished until 1725.

But the most spectacular of the new buildings were in the still undeveloped open spaces, where a dome took on a remarkable effect. Besides the buildings of the hospice of La Salpêtrière (1657) there was the abbey of Val-de-Grâce, beloved of Anne of Austria, with its cloisters and its elegant domed church towering above that of Sainte-Ursule de la Sorbonne; finally, dominating a vast empty expanse on the edge of the marshy plain of Grenelle, there was the vast and splendid Hôtel des Invalides; its great domed church of Saint-Louis, Roman in

its detail but Parisian in its *élan*, is a summation of the major themes of the architecture of the day. A worthy companion of Michelangelo's masterpiece in Rome and Wren's in London, it was to have no rival in Paris until Soufflot designed what is now the Panthéon.

Apart from a number of undertakings such as the new squares discussed later in this chapter, the nucleus of the city evolved in its own way, without any changes to the streets or to the overall layout — in short, without benefit of planning. Initiatives for change were intermittent, and were frequently not carried through.

Francis I's project for the Louvre did not take concrete shape until 1546, with the adoption of the remarkable plan of Pierre Lescot. Then the building of the west wing went ahead rapidly. Well integrated with a corner pavilion on the south-east, this structure, which was adorned with reliefs by Jean Goujon, was nevertheless incomplete, and remained awkwardly boxed in by the square shape of Charles V's fourteenth-century castle. One can only be amazed at the slowness with which decisions were taken and changes made. Catherine de Médicis, in the mid-sixteenth century, decided on the construction of a new palace, the Tuileries, outside the fortifications, and this raised the twin problems involved in carrying out what became known as the *grand dessein*: first to bring the courtyard of the Louvre to a reasonable size (this was done in the seventeenth century by Lemercier, who doubled its length), and second to link the rectangular Louvre complex with that of the Tuileries (this led to the building of the two galleries, the Petite Galerie and the Grande Galerie). In 1665-66, Louis XIV's minister Colbert organized an international competition for the east façade of the palace, facing the city — where, in spite of numerous projects, it was never possible to open up a square big enough to set the building off properly. The competition, to which Bernini contributed a baroque design, was won by Le Vau, Perrault and Le Brun, working as a team, with a design which marks the advent of three powerful forces in French architecture: a conception (monumentality), a doctrine (the imitation of antiquity) and a clan (the academics). When Louis XIV turned his back on Paris in 1670, work on the building was abandoned. The moats marked on Marot's contemporary engraving had not been dug; they were dug in 1967.

Around the Louvre the aristocracy built houses for themselves in an area which gradually spread to near the Halles. Some of the most opulent and elegant dwellings in Paris — the Hôtel Séguier, the Hôtel de Bullion and many others — were built in this neighbourhood. By the end of the seventeenth century all these buildings were in a state of disrepair, and they were converted into hotels (in the modern sense) or into offices: one became the Hôtel des Fermes, the tax-farmers' office, another the Hôtel des Postes.

At the same time the development of the Ile Saint-Louis and the popularity of the Marais district led to the building in these areas also of a number of interesting houses. Two examples, both in the rue Saint-Louis en l'Ile, were the Hôtel Lambert de Thorigny by Le Vau (1640), with its ingenious and spectacular gallery and staircase, and the Hôtel de Bretonvilliers (begun 1637), the house of the secretary of the Council of Finances, standing in extensive grounds, with ceiling paintings by Bourdon and Vouet (this was pulled down in the nineteenth century). On the quai d'Anjou, on the same island, a military commissary-in-chief, Gruyn des Bordes, said to be the son of a Paris innkeeper, commissioned Le Vau to build him a house (*c.* 1656) which has a particularly elaborate and coherent interior decorative scheme;

in 1682 it passed to the Marquis de Lauzun, the celebrated seducer, and it became known as the Hôtel Lauzun, the name it bears today.

In contrast with the Halles area, and in spite of tragic neglect, the Marais still possesses a string of excellent seventeenth-century houses. Few cities can boast such a well-preserved complex. In the rue Saint-Antoine stands the Hôtel Sully (Androuet du Cerceau, 1624), acquired by Sully from the financier Mesme Gallet in 1634. This house, with its rich sculptural decoration, has recently been restored. The nearby Hôtel Carnavalet (built as the Hôtel de Ligneris, 1544-60), which has sculptured ornaments by Jean Goujon, was refashioned in 1654 for a high official, the *intendant* Claude Boislève. Another wealthy individual, Amelot de Bisseuil, built himself a highly ornate residence, in the rue

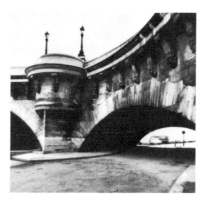

One pier of the Pont Neuf,
1578-1606. This was the first Paris
bridge to be free of houses; it
also had the first footpaths.

Pont Neuf, 1578-1606,
and quai de l'Horloge.

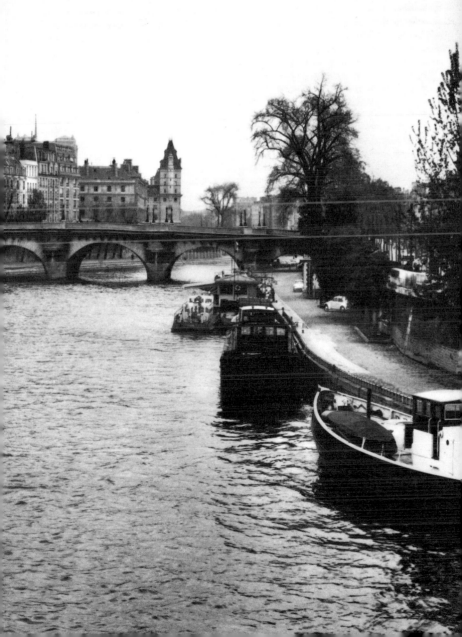

Vieille du Temple (Cottard, 1655-60), which later became known as the Hôtel des Ambassadeurs de Hollande; this too has recently been restored. The Hôtel Salé (J. Boullier, 1656 onwards), in the rue de Thorigny, was built for a tax-farmer concerned with the salt tax (hence the name), one Aubert de Fontenay. It has one of the finest of the many imposing staircases that are to be found in the town houses of the period. Finally, the delightful Hôtel de Beauvais, in the ancient rue François-Miron, is the finest work of Le Pautre (1665), who made

Inner courtyard of the Hôtel Carnavalet, showing a complex assembled after 1860 from a number of other buildings, including a pavilion from the Hôtel de Choiseul, which formerly stood in the rue Saint-Augustin, near the Bibliothèque Nationale.

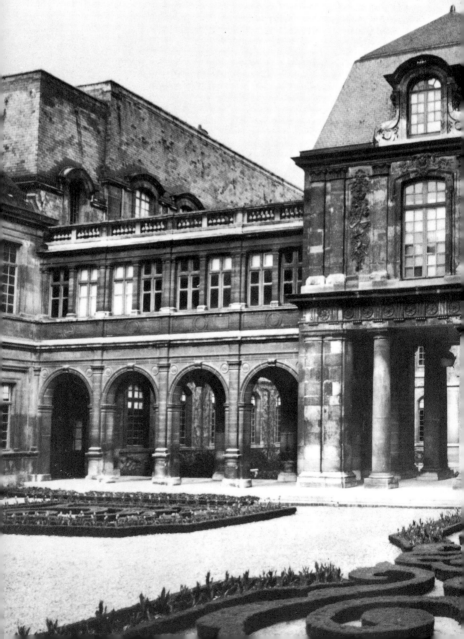

the most of a trapezoidal site by placing a sort of loggia at the far end
of the courtyard, over the domestic offices; the house owes its name
to Catherine Bellier (this word means 'ram', whence several allusions
in the sculptural decoration), a lady-in-waiting to Anne of Austria,
one-eyed but adroit, who was married to a certain Monsieur de Beauvais
whose capacity to turn a blind eye of his own is exhaustively docu-
mented by the gossips of the time.
The Marais went down in the world when it became fashionable to live

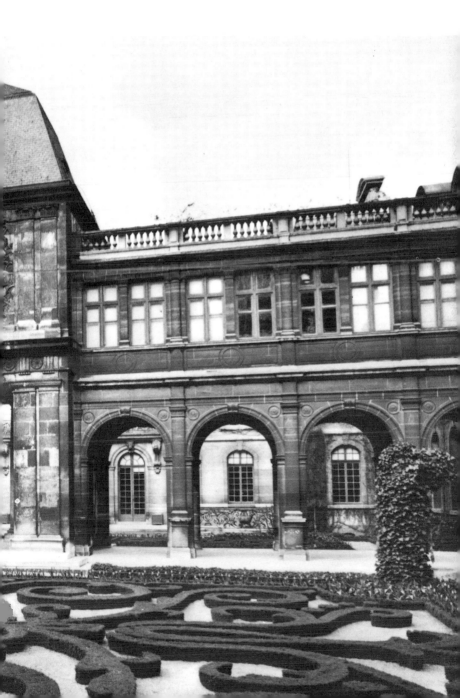

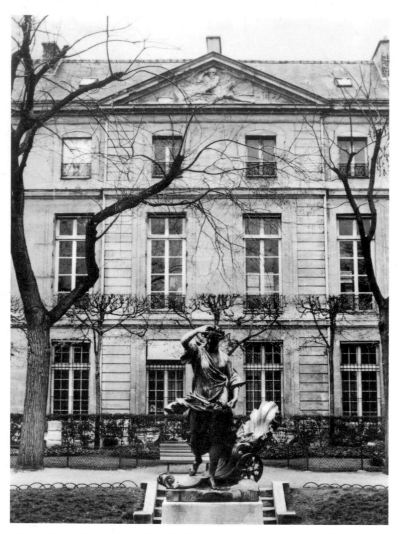

Garden front of the Hôtel Le Pelletier de Saint-Fargeau, by P. Bullet, 1687. Altered in the 18th century; now an annexe to the Musée Carnavalet.

in the Faubourg Saint-Germain, where there are still solid rows of aristocrats' houses in the rue de Varenne and the rue Saint-Dominique. Something rather similar took place in the Faubourg Saint-Honoré, outside the gates of the city.

For several generations the most popular building material was brick, embellished with vertical and horizontal courses of stone. This method of construction, common in the Loire region (as at Blois) and in Normandy, was adopted in Paris in the second half of the sixteenth century, in great houses like that of the abbots of Saint-Germain des Prés; its success was assured by its use in the Place Royale and the Place Dauphine. It was considered sufficiently noble in appearance to

▷

Inner courtyard of the Hôtel Carnavalet, with bas-reliefs of the Seasons *by Goujon (1544) and statue of Louis XIV by Coysevox.*

be used in royal country houses such as Verneuil (demolished), Monceaux (only a few remnants still standing) and Versailles (the original hunting-lodge of Louis XIII), as well as many other great châteaux round the capital. It was used in Paris for very elaborate houses like the Hôtel de Bellegarde, and there is no doubt that the men of the age were susceptible to the charm of the new effects that could be obtained through it. A historian of Paris, Sauval, wrote at the end of the seventeenth century: 'Red brick, white stone and black slate made such an agreeable combination of colours that they were used in all the great palaces'. This practice left its mark on Paris, and was to survive in the provinces, but died out in Paris town houses after the first third of the seventeenth century, when dressed stone came into general use. With this, effects of variety can be obtained only by introducing recessed bays and projections; and Parisian architecture offers these in every possible variation.

With so much building going on, architects and decorators began to form themselves into partnerships, of which that of Le Vau and Le Brun is the best known. The dominant position, which in the sixteenth century had been Philibert Delorme's, was long occupied by the Protestant Du Cerceau family. In 1572 Jacques du Cerceau I had published a remarkable account of *Les plus excellens bastimens de France* (new edition 1607), which mentions, in Paris, only the Louvre. He was the architect of the superb Pavillon de Flore, at the end of the Grande Galerie of the Tuileries. His brother, Jacques II, was placed in charge of work on the Louvre in 1592; he was also concerned with a number of town houses including the Hôtel de Bellegarde and the Hôtel de Mayenne. One of their nephews, Jean, built the Hôtel de Sully and the Hôtel de Bretonvilliers. The daughter of Jacques I married Salomon de Brosse, architect of the Protestant Temple de Charenton (1606), who built in 1615-20, on the Florentine model of the Palazzo Pitti, Marie de Médicis' great new Hôtel du Luxembourg (the old Luxembourg, which adjoints it on the west, became known as the Petit-Luxembourg). This vast palazzo was much criticized on grounds of size and expense, and a pamphleteer complained that it had cost 'more than all the expenditure of six of our kings'. To make it even more sumptuous, it was decided to furnish it with large-scale decorative paintings. Those in the west gallery, Rubens's amazing *Life of Marie de Médicis* (1625), have been in the Louvre since 1816. The nymphaeum which formerly stood close to the south-west pavilion was moved at the beginning of the nineteenth century and is now the Fontaine Médicis.

Another name that turns up repeatedly is that of Jacques Lemercier, a protégé of Richelieu's, and the designer of Sainte-Ursule de la Sorbonne. He was entrusted, in 1633, with the task of building, on a large irregular site along the rue Saint-Honoré, a mansion with two courtyards separated by a transverse building. This, which had to be put up in a great hurry, was the Palais Cardinal (now the Palais Royal). Its chapel, its theatre, its galleries decorated by Philippe de

▷

The Pavillon de l'Horloge (Pavillon de Sully) of the Palais du Louvre, built by Lemercier in 1624, at the time when Louis XIII planned to quadruple the size of his palace. The Tour de la Librairie, part of the Louvre of Charles V, was demolished to make way for it. The clock (horloge) was installed in place of a window at the Restoration. The caryatids are by Buyster, Guérin and Poissant.

Champaigne, and the ingenuity displayed in the design, made it a remarkable achievement.

The two most active architectural practices in the middle of the century were those of Le Vau and François Mansart, whose buildings, both public and private, are numerous and important. Le Vau, perennially interested in robust forms which express the architect's purpose with great energy, began in 1663 the Collège des Quatre Nations, paid for under a clause in Mazarin's will; the church, in the form of a Greek cross, its spacious interior full of light, is flanked by two curved wings linking it to two pavilions; the solemn portico is Roman in spirit. This building is now the home of the Institut de France, the body which

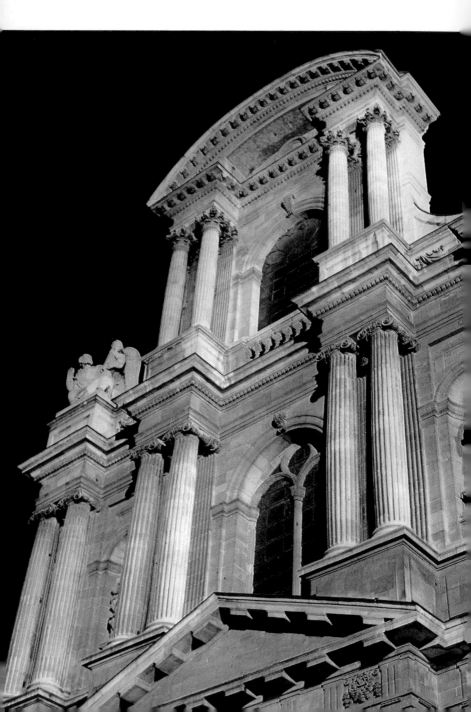

comprises the Académie Française and a number of specialized academies including the Académie des Beaux-Arts. Mazarin's tomb stands in it. Its most remarkable feature is the way in which it answers the south front of the Louvre, on the opposite bank, and gives shape to the riverside south of the Pont-Neuf. Le Vau was also involved in the building of the main façade of the Louvre, but his plan was modified and he had to submit to the compromise of the colonnade. It later fell to him to undertake the new Versailles.

François Mansart made his name with the splendid architectural conception of the Château de Maisons (now Maisons-Laffitte), on the Seine near Versailles. In 1643 he was commissioned by Mazarin to enlarge

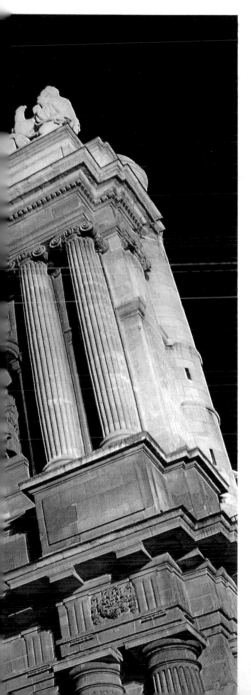

◁
Façade of Saint-Gervais-Saint-Protais, by Salomon de Brosse, 1616-21. The first façade in Paris to incorporate the classical pattern of three superposed orders.

P. 100/101
Façade of Saint-Paul-Saint-Louis, by Derand, 1627-42. Derand follows the example set by de Brosse at Saint-Gervais-Saint-Protais, but the ornamentation is more animated.

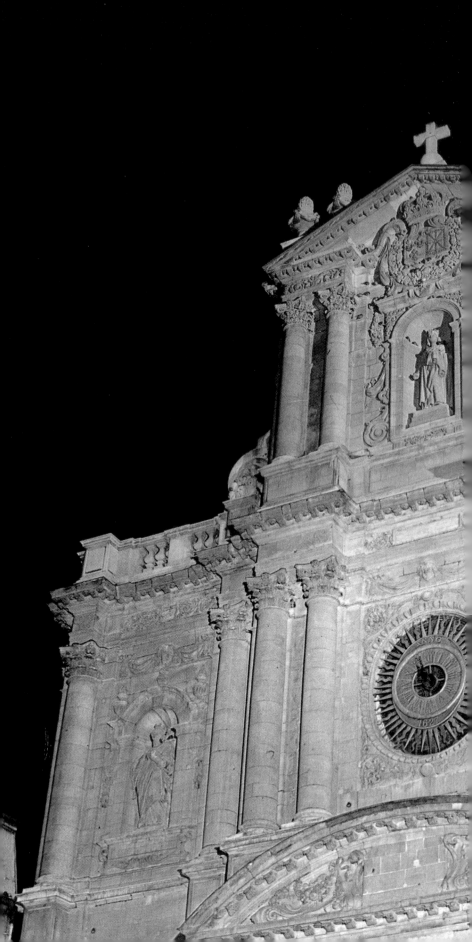

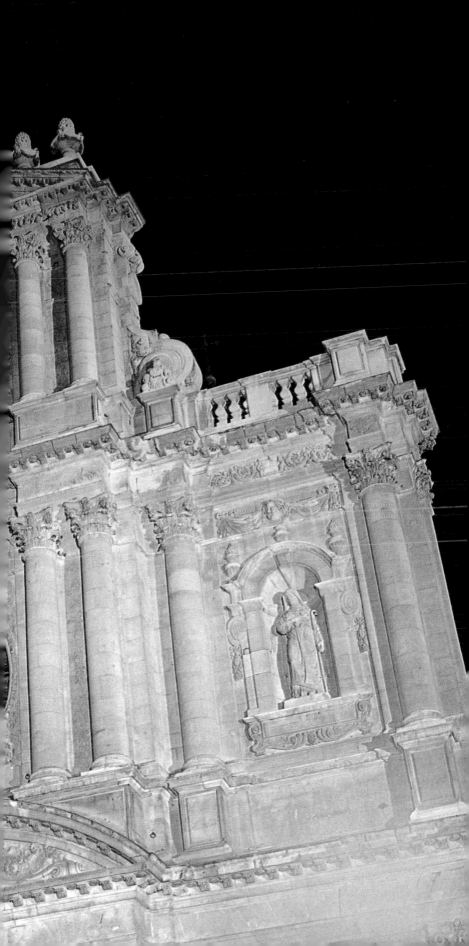

◁
*Upper part of the façade of the
church of Val-de-Grâce, by
Mansart, Lemercier, Le Muet and
Le Duc, 1645-67. Note the
splendour of the ornament.*

*P. 104
The Institut de France, by Le Vau,
1665-68. Built for Mazarin as
Collège des Quatre Nations.*

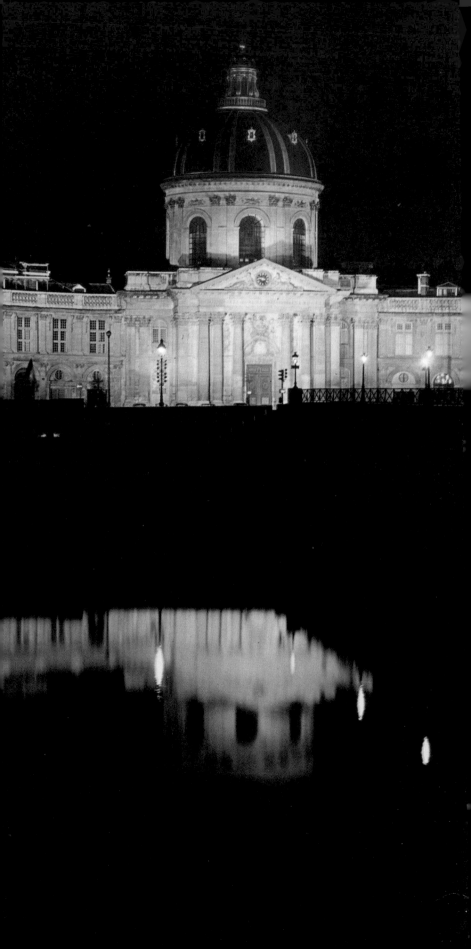

and beautify the great house which the Cardinal had leased from the finance official Tubeuf. He added two galleries designed to hold the minister's collections (these are now part of the Bibliothèque Nationale). He also completed the Hôtel Carnavalet and improved the garden front of the Hôtel d'Aumont (Le Vau, 1648). He also produced some remarkable projects for the Chapelle des Bourbons, a giant rotunda which was intended to be added to the royal basilica of Saint-Denis. Mansart's preference always went to the most imaginative solution; he bequeathed this sense of initiative to his nephew and pupil Jules Hardouin-Mansart, who brought to a successful conclusion, at Versailles, at the Invalides and elsewhere, colossal enterprises whose difficulties he resolved with flexibility and elegance as well as nobility. His art was in perfect accord with the aspirations of the reign of Louis XIV, in which the pomp of the baroque is displayed in a language of rigour and clarity.

Mansart's work was to be a decisive influence in the new interpretation that was given to the idea of the formal square or *place royale*. The Crown lands to the east of the city had been disposed of one after the other: the estate belonging to the Hôtel Saint-Paul was sold off as building lots in the reign of Francis I; that of Les Tournelles after the accidental death of Henry II in 1559. It was on some of this land that the Place Royale itself was laid out, forming an original and orderly urban ensemble, with a uniform decorative style, tall pavilions at the entrances, and pillared galleries along the ground floor. An equestrian statue was to round the whole thing off. A brilliant royal tournament in 1612 set the seal on the meaning and function of the square. (After acquiring a succession of different names during the Revolution, this square was given its present name of Place des Vosges in 1800, in honour of 'the *département* which was the first to pay its tax contributions in full'.)

Confusion and empty lots gave way to order, with open space serving both commercial convenience and the pleasure of the private citizen taking the air. The Place Royale provided a meeting-place and social centre for a whole neighbourhood which was growing and prospering. It became the scene of periodical public festivities. This particular square is important because it marks the starting-point of the classic art of urban design, of the popularity of the Marais among the aristocracy, and of the string of *places royales* which were to extend from east to west across Paris. From the Porte Saint-Antoine to the Place Louis-XV (Place de la Concorde), these squares constitute a kind of commentary on the history of successive reigns. The first of them gave added dignity to the route of the solemn royal entry into the city, or *entrée royale,* which in the seventeenth century started in the east, in the direction of Vincennes. This was the route followed by Louis XIV in 1660: along the rue Saint-Antoine to the Hôtel de Ville and the Palais de Justice, and finally back across the Pont-Neuf to the Louvre through the narrow streets which rose towards the Halles behind Saint-Germain-l'Auxerrois.

The Place Royale was placed astride this route; the Place Dauphine dignified the entrance to the Cité, providing a sort of triumphal corridor at the end of which the statue of Henry IV stood out against the sky. Two new squares completed this chain of moments of repose, while at the same time giving a more explicit turn to the 'cult' of kingship. At the instance of Marshal de la Feuillade, a great circus, articulated by an arcade surmounted by pilasters, was created as a setting for a statue of Louis XIV by Desjardins, the gift of the marshal

Façade of the Institut de France,
by Le Vau, 1665-68. This detail
shows the curve of the façade and
Le Vau's treatment of the orders.

himself. This was the Place des Victoires, which even had lamps all round it to enshrine this embodiment of royalty. (The present statue is a nineteenth-century replacement.) On the Vendôme estate, which had been thrown open to private development and speculation, another great square was laid out, the Place Vendôme (or, formerly, Place Louis-le-Grand). The plan is octagonal, with more of a unified façade than the Place des Victoires; placed just north of the rue Saint-Honoré, the square had as the termination of its southward vista the façade of the church of the Feuillants (later demolished) adjoining the Tuileries; at the other end one could see the façade of the Capucins. This kind of arrangement is typical of Renaissance town planning in Paris; a street or square was never opened up without also opening up a vista. In the centre of the square stood Girardon's equestrian statue of Louis XIV; it was destroyed at the Revolution and replaced in 1810 with a bronze imitation of Trajan's column.

Place des Victoires, by Hardouin-Mansart, 1685. This circus was designed as a grand setting for a statue of Louis XIV.

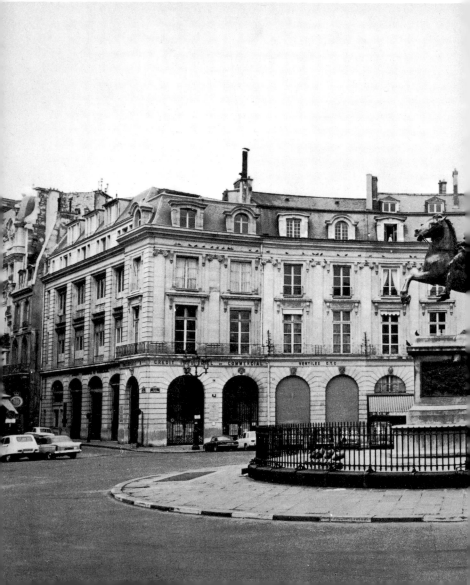

The tradition of the solemn royal entry into Paris survived as long as the Ancien Régime itself. Soo, too, did the plebeian merrymaking which transformed the appearance of the streets and crossroads. In the sixteenth century the processions passed along the rue Saint-Denis, which was also the route of royal funerals. On the occasion of one of the most memorable of these festivities, the solemn entry of Henry II, the municipality asked the painter Jean Cousin and the sculptor Jean Goujon to design the decorations. At the corner of the rue Saint-Denis and the rue des Fers, where the procession was due to halt to listen to musicians on a bandstand, Goujon erected a magnificent fountain, the Fontaine des Innocents. Much imitated during the eighteenth and nineteenth centuries, this structure originally stood against a wall. Moved in 1787, it was given a fourth side (that which faces the rue de la Ferronnerie) by Pajou. It ceased to be used as a water supply in 1860. Another monumental fountain, the Fontaine de la Croix du

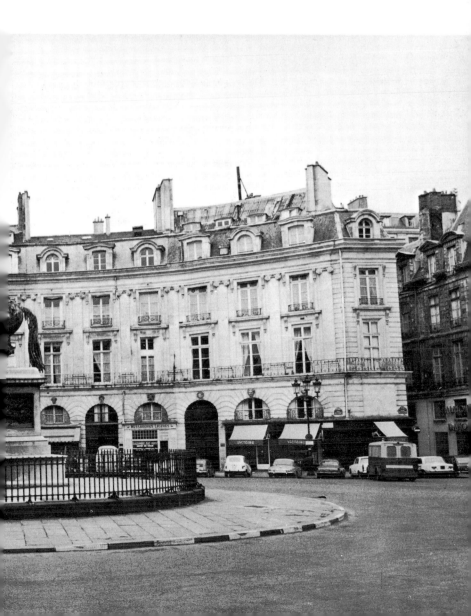

Trahoir at the Halles, goes back at least as far as the fifteenth century; it was rebuilt several times, the last time by Soufflot (1775).

Finally, on the northern arm of the Pont-Neuf, there was the structure of the Samaritaine, built on piles in 1608, to pump water along to the reservoir in the cloister of Saint-Germain l'Auxerrois which supplied the Louvre and the Tuileries. 'The pretty pavilion containing a pump which lifts water from the Seine for the right bank of the city, has a façade where the woman of Samaria is pictured helping Christ to drink, while up above there is a Flemish clock with a procession of figures and scenes and a quarterjack striking the bell to tell Paris the hours of the day (M. Poëte).

The gates of Paris came to reflect the elaborate figurative style of decoration, Italian in origin, which had been introduced in the arches constructed for the solemn entry of Charles IX in 1574 by Niccolò dell'Abbate and Germain Pilon. Although the military significance of the gates disappeared with the demolition of Charles V's wall in the 1670s, they still had undeniable prestige value. One after another, the medieval posterns gave way to compositions in the Roman style. The most famous ones were the Porte Saint-Denis, at the end of the rue Saint-Denis, built by Blondel in 1672, and Bullet's Porte Saint-Martin

Place Vendôme, by Hardouin-Mansart, 1687. Designed, like the Place des Victoires, to set off a statue of Louis XIV.

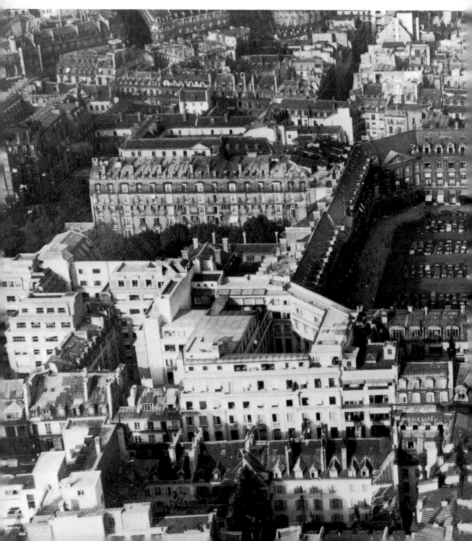

(1674). The rampart was replaced by a tree-lined esplanade, the Grands Boulevards.

Improvements were not limited to the periphery. Embankments were being constructed on either side of the river, and bridges were at last acquiring a view. There are some fine prints of the Pont-Neuf by Jacques Callot and Stefano della Bella. Parisians were conscious that the river front enhanced the appearance of the city, and set out to provide it with an even arrangement of façades, with great buildings to add variety. An example of this kind of development was the Quai des Grands-Augustins, then known as the Quai de Nesle, or de Nevers, on the left bank opposite the point of the Cité, before the creation of the Collège des Quatre Nations in 1665 lent it the dignity of a monumental counterpart to the Louvre. The eastern pavilion of the Institut occupies the site of the former Tour de Nesle, where the old moat surrounding the fortifications joined the Seine. This accounts for the houses in the street called Les Fossés, clamped against the old counterscarp like parasites, and clearly visible on the print. This was the precise spot where the medieval town linked up with the new quarters beyond the Porte de Buci.

Parallel to the rapid extension of the Faubourg Saint-Germain, all

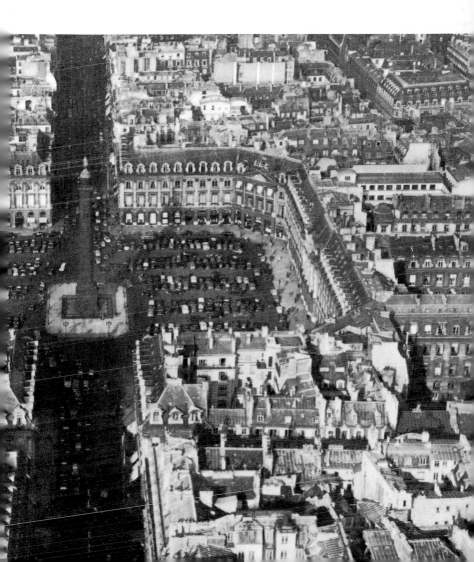

kinds of imposing houses also began to fill the Quai Malaquais and the Quai des Théatins (now Quai Voltaire). On the other bank, the new Quai du Louvre had a harmonious front, leading past the Tuileries until it reached the country beyond the pavilions of the Orangerie and the Jeu de Paume. The immense *place royale* which is now the Place de la Concorde was not conceived until the reign of Louis XV, but the Cours la Reine, along the old road to Chaillot, dated from 1616, and the Grand Cours, soon known as the Grande Allée du Roule or Champs-Elysées, was inaugurated in 1670. Both were intended for elegant excursions and were reserved for carriages.

As usual, similar development was continuing higher up the river, beyond the Ile Saint-Louis, where land had been sold for building since 1600. The Grand Arsenal, incorporating the house of the Grand Master of the Artillery, stood on the north bank opposite the Ile Louviers (now no longer an island). Philibert de Laguiche, Grand Master in 1584, added pillars in the shape of cannon; his successor, Sully, had the building refashioned a little later. The adjacent promenade, the Mail, owed much of its popularity to the croquet played there, as well as elsewhere along the disused ramparts (hence the name of the rue du Mail, built in 1630 to link the Porte Saint-Honoré with the Porte Montmartre). On the other side of the river, east of the Pont de la Tournelle and the Porte Saint-Bernard, there were more new creations under Louis XIII, including the Jardin des Plantes and the Petit Arsenal, known as the Salpêtrière (1634). This was converted in the following reign into a huge poorhouse which has a large, harmonious chapel, built on a Greek cross plan by Libéral Bruant in 1670.

The accumulation of artistic wealth matched the new wave in building. The collections began to be seriously constituted in the sixteenth century, when Francis I turned to foreign artists for work that Paris could not equal. Consequently much of Fontainebleau is by Rosso, Primaticcio and Niccolò dell'Abbate. Unfortunately Primaticcio's masterpiece, the Galerie d'Ulysse, was destroyed when the south wing of the Cour du Cheval Blanc was reconstructed by Gabriel.

The royal collections were replenished frequently with valuable Italian works, including Raphael's *St Michael*, the *Charity* by Andrea del Sarto, and above all, the principal paintings by Leonardo da Vinci, the original *Virgin of the Rocks* (the one in the National Gallery in London is a later copy), the *Mona Lisa*, the *St John the Baptist*, and, acquired at an uncertain date, the extraordinary group of the *Virgin and Child with St Anne*, with a blue landscape as a background to a most unusual arrangement of figures. Although Michelangelo never left Italy, in spite of constant invitations from Francis I, the two *Slaves* begun for the projected tomb of Julius II, and later given to Filippo Strozzi, happened to come into the possession of the Connétable de Montmorency, who placed them in honour in the courtyard at Ecouen. They too later entered the royal collections.

Under the last Valois, the interest in collecting developed from a fashionable accomplishment into a kind of passion for buying, and for demonstrating originality of taste. Francis I competed with Charles

▷

Porte Saint-Denis, by Blondel, 1672. A triumphal arch on the line of Charles V's wall (marked by the Grands Boulevards). Reliefs by the Anguiers celebrating Louis XIV's victories on the Rhine.

V of Spain, with varying success, amassing great quantities of statues, jewels and pictures. In the seventeenth century, with their Oriental screens, porcelain and furniture, Marie de Médicis, and above all Mazarin, introduced a new element; and more and more exotic works of art were brought to the west by the French and Dutch East India Companies. Louis XIV, who inherited part of this pile of riches, began a systematic buying policy for works of art. His agents sought information in foreign courts, and rifled collections of antique vases and coins. Then, in 1671, the king acquired the very large collection of drawings belonging to the Rhenish banker Eberhard Jabach, who had been living in Paris since 1638, and this meant that all the schools including Flemish and Dutch were represented in the royal collections. In this field the period produced two truly Parisian creations. First, in all the houses belonging to the nobility, there was a sudden crop of 'painted galleries' after the example set by royalty at Fontainebleau and in what is now the Galerie d'Apollon in the Louvre, with a painted interior at ground level and a decorated ceiling on the upper floor (where Delacroix completed the series). The crowning achievement of the genre was of course Versailles. The gallery in this sense had gradually turned into a kind of reception hall which was also a show-room for rare pieces and famous works of art. The gallery in the Luxembourg, decorated by Rubens, served both these purposes, and so did that in the Palais Cardinal. And an amazing number of private houses had their painted galleries. One of the few remaining examples is the one in the Hôtel Lambert, painted by Le Brun on the theme of Hercules. Simon Vouet's cycle in the Hôtel Bullion (rue J.-J. Rousseau) has been destroyed; those by Pérrier in the Hôtel de la Vrillère (headquarters of the Banque de France since 1855) and those in the Hôtel Séguier were all justly renowned. The practice was followed throughout France and abroad, but the profusion of decoration in Paris itself greatly contributed to the development of the French school of painting.

A new human type also appeared on the Parisian scene in the shape of the *curieux*, the art-lover, something of a dealer and invariably a collector, and passionately interested in pictures, prints and drawings. Not long afterwards Mariette and Crozat became experts of international repute. Dealers in prints flourished everywhere, supplying reproductions, which were more and more in demand, and also original works. The series by Callot and Israël Silvestre were soon famous.

Historians have recently somewhat rehabilitated the French painting of the first half of the seventeenth century, which we were accustomed to see a long way down the list after the great Italian and Flemish works of the period. Simon Vouet, Jacques Blanchard, La Hyre and Le Sueur were all Parisians; others, certainly no less in stature, such as Vignon, Valentin, Georges de la Tour and Poussin, were from the provinces. Almost all of them felt the lure of Rome, but their work was known and admired in Paris, they had friends there, and they often received official commissions. The French ambassador in Rome asked Simon Vouet to return in 1627; and in 1645, Poussin left for Paris at the request of Richelieu, although only for a year. Antoine le Nain opened a studio in Paris in 1660. It is quite easy to gain a knowledge of their work by visiting a few of the churches in Paris and then completing the itinerary with the pictures in the Louvre. Claude Vignon is represented in Saint-Gervais-Saint-Protais with a strange *Adoration of the Magi*. Georges de la Tour's 'nocturnes' acquired by Louis XIII left the royal collections a long time ago, but

Coysevox: Allegory of Mercury 1676. *Marble. Carved, with its companion, Allegory of Fame, for the horse-pond at Louis XIV's Château de Marly, a villa with a fine water garden, which was demolished in 1800. This work has stood at the entrance to the Tuileries since 1784.*

there is a glowing red *Nativity* in the Louvre and a *St Joseph the Carpenter,* as well as several other eloquent examples of the 'tenebrist' or post-Caravaggio movement in France. The dark paintings of this generation are represented by a *St Jerome* in the church of Saint-Leu-Saint-Gilles by T. Bigot, the famous *maître à la chandelle,* and the tumultuous *Death of St Louis* by J. de Lestin in Saint-Paul-Saint-Louis. Le Brun was also from Paris. His brilliant career can be followed from the Hôtel Lambert to Vaux-le-Vicomte and thence to Versailles.

The French artists who lived in Rome worked out a style of composition, which won lasting admiration and was adopted as a standard by all the schools of the Academy. Paris was the final springboard to glory for many of these painters, especially Claude and Poussin with some very impressive, austere canvases: the *Self Portrait,* the *Philistines Stricken with the Plague* (one of the first pictures ever to be sold privately for a large sum), the complex and sensitive series of the *Four Seasons,* and the expressive *Apollo in love with Daphne.*

As a contrasting trend, there were Coypel and the other 'colourists', somewhat influenced by the style of Versailles, who produced some powerful work. Another fine decorative artist was La Fosse, who decorated the cupola of the Invalides while Mignard was adorning Val-de-Grâce. The strength of Largillière, a Parisian who trained in the north, lies in elegance of portraiture and beautiful drapery.

Sculpture, which has always played an important role in French art, was the medium which best expressed the spirit of the Renaissance, both in Paris and in the Ile de France. The succession of sixteenth-century royal tombs in Saint-Denis alone provides a complete gallery.

The monument to Louis XII by the Justis, the tomb of Francis I by Bontemps, and the recumbent and kneeling figures for the tomb of Henry II and Catherine de Médicis by Germain Pilon, are all well-known examples. Jean Goujon's delicate, fluid art is admirably represented in the Fontaine des Innocents, the façade of the sixteenth-century Louvre, and the reliefs on the Hôtel Carnavalet. Pilon was also responsible for the amazing invention of the *Three Graces* on the monument holding the heart of Henry II. Some of the details of this work recall the *Diana* from the Château d'Anet, a naked princess seated beside a subjugated stag (now in the Louvre). The problem of the attribution of this masterpiece is still unsolved; it remains the most representative work of the French sixteenth century.

Sculpture is the great ceremonial art. On a chimney-breast at Fontainebleau there is a fine equestrian figure of Henry IV in high relief by Mathieu Jacquet; another in bronze stands at the end of the Ile de la Cité, by the centre of the Pont-Neuf. The tombs of Richelieu, Mazarin and Colbert, and the statues glorifying Louis XIV at Versailles, completed this intense concentration of all the resources of art. The groves at Versailles were peopled with innumerable allegories, including many of the finest compositions of the day, like Girardon's *Proserpine*, in the Bosquet de la Colonnade (a sort of round temple

Aerial view of the Invalides, by Libéral Bruant, 1671-76.

open to the sky), completed in 1685-86. The group of *Apollo Attended by Nymphs,* by Girardon and Regnaudin, is admirable, and then there are the *Horses of the Sun* by Marsy and Guérin, first of all intended for the Grotte de Téthys, which was destroyed in 1680, and later placed in another picturesque grotto by Hubert Robert. There is even the remains of a statue of Louis XIV by Bernini, relegated to the far end of the Pièce d'Eau des Suisses. Bernini had conceived a figure to overwhelm the beholder, but it failed to please and had to be transformed into a statue of Marcus Curtius.

Versailles provides another great attraction in its interior decoration. Under the supervision of Le Brun, the workshops had perfected a style which is seen in the wainscoting, framing, brackets and panels all over the palace. The five Salons succeeding one another on the north side, from the Salon de la Guerre to the Galerie des Glaces, were each dedicated to a mythological deity: Venus, Diana (the Salon containing Bernini's bust of Louis XIV), Mars, Mercury, and Apollo. Recent restoration has brought to life the gilded scrolls and luxuriant ornamentation.

This does not detract from the overall effect of the formal paintings, however, though in a sense they become subordinate, and the tapestries prove an excellent accompaniment to the furniture with its generous

curves and inlaid decoration. This recognition of the role of the tapestry as one of the most dynamic elements in the sumptuous setting completes the stylistic importance of Versailles. It also brings us back to Paris, at least as far as craftsmen and workshops are concerned. In 1667, the Manufacture Royale des Meubles de la Couronne, otherwise known as the Gobelins, an enormous organization employing cabinet-makers as well as tapestry weavers, was created. This factory, on the bank of the Bièvre, which Colbert placed under the direction of Le Brun, was to produce many masterpieces, including the great sequences of the life of the king, the months, and the life of Alexander the Great.

City of Reason

The pursuit of pleasure, as a reaction against the display of grandeur, can never have been better exemplified than in France after the death of Louis XIV in 1715. From 1700 onwards, Parisian society had shown a propensity towards a more agreeable way of life. All classes

Aerial view of the Château de Versailles, by Le Vau, Hardouin-Mansart and others, 1624-1740. The whole layout is symmetrical about an east-west axis.

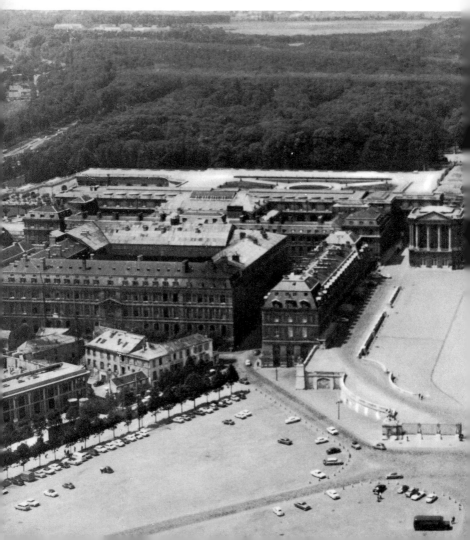

had shown an equal propensity, that is, but not all had had equal success. A lot of talk was going on, in drawing-rooms, in cafés, and in shops. There appeared on the scene a surprising number of thoughtful men, organizers and administrators of great ability, who set about improving the often poor conditions of environment and urban life. Paris was to become one of the centres where modern rationalism was to embark most boldly on its progress from dogmatism to criticism, from orthodoxy to free thought. Naturally, this change had been on the way for a long time, and it never became complete; the clash between traditional religious and political ideas and the spirit of criticism was going on long before the eighteenth century, and elsewhere than in Paris. But the Parisian intellectuals found themselves perfectly at home in the climate of debate, insinuation and irreverence characteristic of the age of the Enlightenment.

Ineluctable growth was the most conspicuous quality of the capital. Since the Middle Ages, a great number of decrees had been issued to restrict the size of new buildings and to prevent the houses from encroaching too much on the open spaces inside and outside the walls.

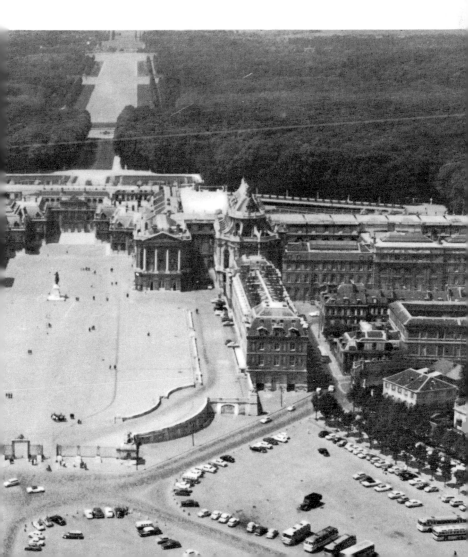

Louis XIV criticized the 'excessive display' of the town in 1672; and later on, the eighteenth-century rationalist *philosophes* insisted that 'the undue enlargement of the capital was draining the life-blood of the kingdom'. Building was proceeding at an unprecedented rate, the population constantly increasing, rents were mounting, speculation thriving, and seams were splitting on every side. The police were never idle, and all the urban functions in turn became problems to be aired and sifted at every level of the expanding social body, not without rapid transitions from good humour to impatience. Life in the city was subject to a host of different impulses which eventually culminated in the violence of the Revolution.

The amazing factor was the constancy of the conflicting views. In the fourteenth century, the Florentines had prided themselves on possessing a cleaner and better planned city than the Parisians, but the French capital was already universally recognized as an active centre of amusement. Whether or not they were sensible to the visual charm and animation of the streets, foreigners continued to find in Paris satisfactions of the most varied and even the most contrasting kinds. In his amusing *Lettres persanes*, the lawyer Montesquieu (he was from Bordeaux) makes fun of the bustle, the frivolity, the superficiality, of the sections of Paris society where no one could keep going without a lot of money. Other observers were only too happy to pass unnoticed in the chattering, tolerant crowd. 'I have less money than anybody, and I enjoy Paris, I enjoy myself and I am content' (Goldoni). Some people saw Paris as a sort of carnival in which every commodity and every pleasure was to be had at a price; Voltaire likened it to the noise and flurry of a barnyard. Others saw Paris life as simple and easy-going, as it certainly was for the strollers and lookers-on who lived in their little corners of Paris like villagers. Obviously both points of view were accurate.

Paris rapidly became one of the pleasure capitals of a European culture in which, from London to Venice, gambling, amorous intrigue and personal elegance were cultivated with equal enthusiasm. The streets, at least in the western part of town, were filled by a display of elegance; and the great preoccupation was with gardens and promenades. It was this that accounted for the immense success of the Palais Royal, where in 1781 Philippe d'Orléans (the Regent's grandson, and later a Revolutionary figure as Philippe-Egalité) opened up arcades in the Galerie de Valois and the Galerie de Chartres with a massive order of pilasters facing the gardens. The building that is now the Théâtre Français was built on the rue de Richelieu side, making skilful use of a confined space and using iron beams, then a new idea in building (1787-90); it has a fine porticoed façade and plenty of foyer space, for seeing and being seen.

Apart from the hospitable salons where the Abbé Prévost and Restif de la Bretonne placed their characters, the fashionable places of resort were the *guinguettes*, the little out-of-town taverns in the Percherons and Ménilmontant districts, and, in the centre, the cafés, which were popular meeting-places from the Regency onwards, with their regular customers, their readers and commentators of the *Gazette*. Some, like the Procope, in the rue des Fossés Saint-Germain, had literary traditions

▷

Terrace of the Château de Versailles, looking towards the Pièce d'Eau des Suisses.

which dated back as far as the 1680s; others attracted chess-players, or, like the Régence, lovers of philosophical debate like the character immortalized by Diderot as *Rameau's Nephew*. It is impossible to imagine the liveliness of thought, and the free-and-easy manners, of the age of the Enlightenment, without this background which embodies so much of the essence of Paris life.

The Grands Boulevards, with their shady trees, were tremendously popular; they were soon lined with places of amusement many of which developed, in the second half of the century, into buildings of some

Garden front of the Château de Versailles, by Hardouin-Mansart, 1678-86. Behind this façade, which replaces an earlier one by Le Vau, there runs the Galerie des Glaces.

size. An example was the Variétés Amusantes, built in the Boulevard de Temple in 1775; and in 1781 the burning of the opera auditorium of the Palais Royal led to the rapid construction of a replacement on the Boulevard Saint-Martin. But much thought was still given to the design of a great new opera house, for which a number of well-known architects produced projects. The Théâtre des Italiens, which gave its name to the boulevard of the same name, installed itself on the land of the Duc de Choiseul, who was forced to sell to pay his debts. It had a monumental colonnaded façade (by

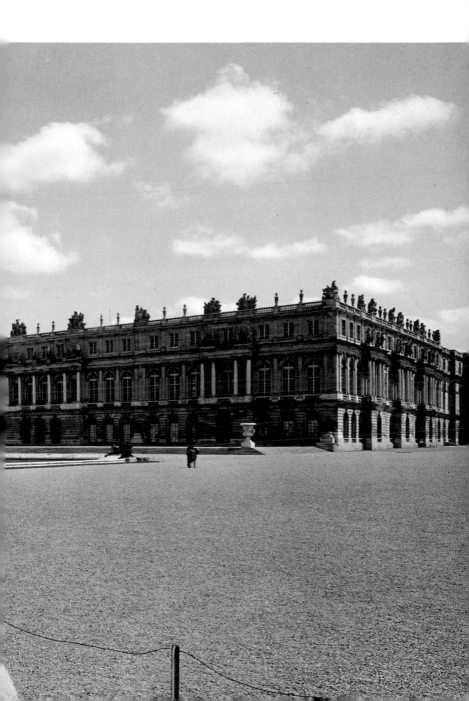

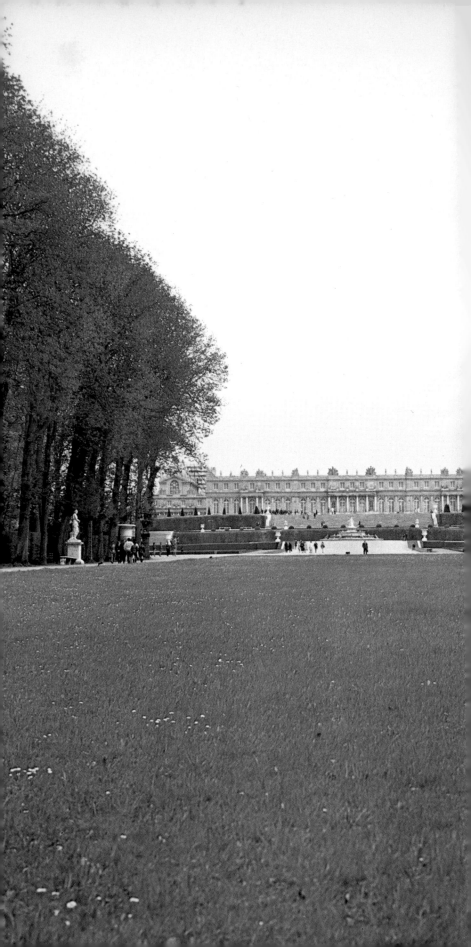

◁
Tapis Vert, the lawn above the steps known as the Grand Degré, Versailles.

P. 124/125
Pavillon Français, Versailles, by J. A. Gabriel, 1750. Built for Mme de Pompadour, and also known as the Salon de Compagnie et de Jeux.

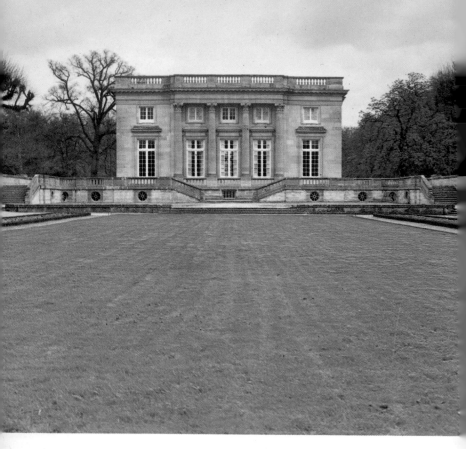

Petit Trianon, Versailles, by J. A. Gabriel, 1762-68. Built as a pleasance for Marie-Antoinette.

Heurtier), but this turned its back on the boulevard. (It was later to be burned down and rebuilt several times, and the Opéra-Comique now stands on the site.) The left bank had the fine building of the Odéon (Peyre and Wailly, 1779-82), whose clear-cut mass, flanked by arcades and fronted by a superb portico, dominates a square of its own.

What might be called the inner suburbs continued to participate closely in the life of the city, both as a source of food and as a place where people sought shade and seclusion in what were called *ermitages*. The fashion demanded buildings that were convenient, well arranged, and charming. Louis XV, advised by Madame de Pompadour, set the example by adding to his range of royal residences the Petit Trianon, elegantly set in a clearing in the Versailles park; even more unpretentious were Madame de Pompadour's own little house at Fontainebleau and that of Madame du Barry at Louveciennes. These villas, or *folies*, as they were known, built for intimate parties or for evenings of gambling, inspired brilliant architectural creations, such as Belanger's pavilion at Bagatelle in the Bois de Boulogne; this was designed in forty-eight hours and built in sixty-four days, in order to help the twenty-year-old Comte d'Artois (later Charles X) win a wager against his sister-in-law Marie-Antoinette. The 'Folie d'Artois', with its axial plan, its rotunda and its clear-cut volumes enlivened by vertical courses of stonework, remains, despite some unfortunate nineteenth-century alterations, one of the most agreeable relics of the eighteenth-century tradition of *la douceur de vivre*.

Often, as in the case of that of Carré de Beaudoine (1770), on the slopes of Ménilmontant, these villas derive directly from Palladio. All the famous architects built them. A significant map, that of the royal hunting preserves (*Les Chasses royales*, 1754-73), shows the near-continuity of the chain of châteaux, hunting-lodges, villas and pleasance which ran from the Marne to Staint-Germain en Laye; and beside the great houses which the Crown and the lesser grandees were beginning to find burdensome to run, there sprang up everywhere these minor buildings prettily decorated in an entirely new spirit.

The area west of the city seems to have been the only one affected by its spread. Paris overflowed in this direction with the Faubourg du Roule, which spread out from the new districts of Monceau and the Chaussée d'Antin, north of the Champs-Elysées. As a result of speculations, the sale of building lots, and a succession of private initiatives, a general social shift became apparent, and there appeared a tendency towards the segregation of different classes in different neighbourhoods. 'On the whole, the court nobility is in the Faubourg Saint-Germain, the financiers at the Chaussée d'Antin and the Palais Royal, and the law in the Marais.' It was in order to reorganize the link between the Tuileries and the new districts that J.A. Gabriel's immense Place Louis-XV (now Place de la Concorde) was built. This new *place royale* was laid out on a piece of land donated by the king in 1743 as a site for his equestrian statue. Gabriel carefully worked out an architectural plan, approved in 1757, with an arcaded ground floor surmounted by a colossal order like that used in the Louvre. A street that was intended to be subject to strict architectural regulation, the rue Royale, ran between the two symmetrical masses (the Hôtel Crillon on the west and the Garde-Meuble, now the Navy Ministry, on the east). For the first time a great square was opened out, with a river on one side, as was done by Pombal in Lisbon (the Praça do Comercio). A bridge was needed to serve as a prolongation of the axis defined by the rue Royale; this was the Pont Louis-XVI, by Perronet (now Pont de la Concorde). The necessary northern view-stopper was provided by the classical peristyle of the church of the Madeleine, projected in 1764 by Contant d'Ivry, and completed, after two changes of architect, in the next century on the model of the Maison Carrée at Nîmes. The Place de la Madeleine was laid out in 1824-27. On the left bank much the same function was served by the colonnade and pediment added by Poyet in 1808 to the river front of the Palais Bourbon.

The north-south axis of the Place de la Concorde intersects at right angles with the long east-west vista which runs from the Tuileries, along the Champs-Elysées, as far as the Colline de Chaillot (which will one day have to be rounded off with a suitable building; see below, p. 186). In the centre of the Place Louis-XV stood the equestrian statue of the monarch by Bouchardon, completed by Pigalle in 1763, and facing the Tuileries. It was destroyed at the Revolution, and the moats that were a feature of the square were filled in. The obelisk that stands there now, a gift from the Egyptian Khedive Mehemet Ali, was set up in 1836.

On the left bank, Gabriel designed the Ecole Militaire (1752-57), and the new Champ de Mars, to complement the existing Invalides complex, to which they stand at an angle corresponding to the curve of the river. For the new developments were by no means restricted to the new areas in the west; a host of problems that had been waiting for a solution for a generation or more were now at least tackled. The mint, for instance, which the authorities had made numerous attempts to move away from

its site at the north end of the Pont-Neuf, finally moved to a new Hôtel de la Monnaie on the left bank, designed in a style of great sobriety by Antoine (1768 onwards).

The dreadful situation which had been created for centuries by the close proximity of a food market, the Halles, and a charnel-house, the Charnier des Innocents, led to the elimination of the latter in 1786. The houses that still lined several bridges, the Pont Notre-Dame, the Pont au Change and the Pont-Marie, were demolished in 1785-88. Never had there been so much discussion of the problems of urban

Bernini and Girardon: Marcus Curtius. *Bernini's statue of Louis XIV, later altered by Girardon, re-named, and tucked away in the park at Versailles.*

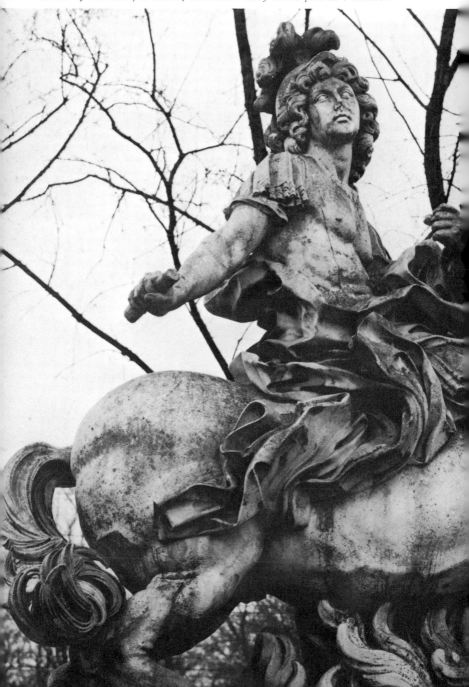

living. such as hygiene and traffic congestion. There developed an active awareness of social issues; but the new solutions which emerged were nullified by speculation, by financial crisis, and by the weakness of governmental authority. It is certain that if a number of problems, which were under discussion for a hundred years, such as the Halles and the opening-up of an east-west road, had been tackled properly by the Ancien Régime, the radical upheavals of the mid-nineteenth century would have been unnecessary.

The circumference of Paris had increased under Louis XIV. Under his

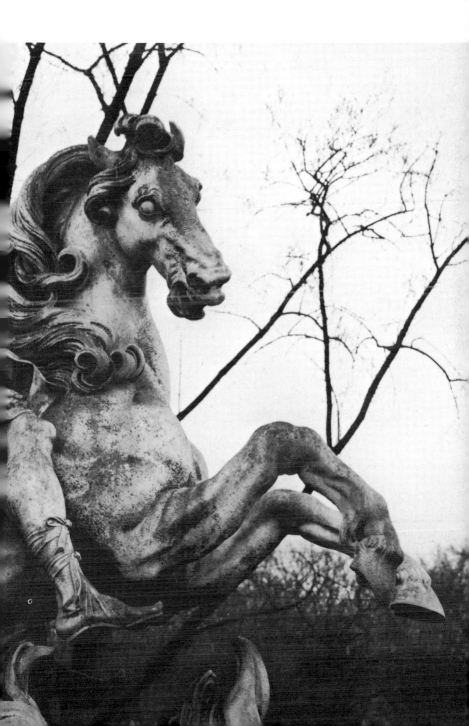

successors, the necessary conclusions had to be drawn from this. It was done, like most governmental acts in those days, in a way that called forth both confusion and criticism. This was the Enceinte des Fermiers Généraux, a ten-foot wall along a perimeter nearly fifteen miles long, built as an internal customs barrier to control and tax all commercial traffic; it was widely regarded as a vexatious imposition. Authorized in 1784, the Enceinte nearly doubled the area of the city (from 1300 hectares to more than 3000). For forty of the great tollgates or *barrières*, the great neoclassical architect Ledoux designed pavilions and propylaea of extraordinary grandeur and diversity. Three of his pavilions still stand: those at Parc Monceau, Villette and Denfert-Rochereau. They were a spectacular manifestation of a new architectural school which, since about 1760, had returned to the idea of a grand style, and which believed in the social vocation of art.

This change deserves some emphasis. It is just as characteristic of the eighteenth century as is the tendency towards lightness and grace that has already been mentioned. Neoclassicism, which was being popularized all over Europe at that time, in pamphlets, polemics and works of art, from Italy (Algarotti and Winckelmann) to England (the Adam brothers), was a vindication of strict, authoritarian form.

It is easy to follow, in Paris itself, the confrontation between the small-scale, ornate style, which might be called Parisian Rococo, and the severer, more geometrical neoclassical style. In 1704 François de Rohan, Prince de Soubise, Bishop of Strasbourg, commissioned a little-known architect, Delamair, to build him a luxurious house, which became known as the Hôtel de Soubise. Delamair built a stately colonnaded courtyard, but was then supplanted by Boffrand. This architect, whom

Bassin d'Apollon, *Versailles, by J. B. Tuby, 1668-70. The sun god's chariot emerges from the waters. Behind is the Grand Canal.*

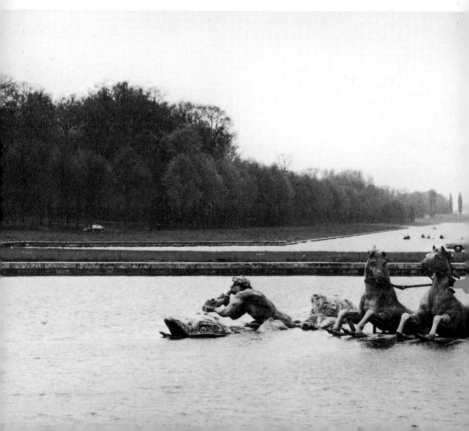

Rohan also used in Strasbourg, designed in 1732 the oval salon, with its decor of *chinoiseries* and *singeries* by Adam, Boucher and Natoire, which is one of the glories of the French Rococo. (This building, which became the headquarters of the Imprimerie Nationale in 1808, was taken over in 1925 by the Archives Nationales.) The exactly opposite tendency is represented by later interiors like that from the Hôtel de Chevreuse (1780, preserved in the Louvre), in which the straight lines are emphasized by the fluting of the pilasters, and where, in the rectilinear space thus defined, the furniture has taken on a structure, an outline and a pattern of ornament that express an entirely different spirit.

The church of Saint-Sulpice had been standing since 1675 without its lateral porches and its façade. Various schemes were put forward for its completion. One was an extraordinary Baroque project, designed by Oppenord at the request of the parish priest, Languet de Gergy, adapting a design of Borromini's to a Parisian context. The project that was actually carried out, in the mid-eighteenth century, is by Servandoni. It is a weighty, austere design, with two superimposed orders (Ionic above Doric), and a pair of towers, rising two storeys above the main body of the building, which were begun in 1749 and completed considerably later; the north tower was redesigned by Chalgrin in 1777-80.

A decisive event at this moment of transition was the construction of Soufflot's great church of Sainte-Geneviève. This was built to take advantage of a hilltop site (the Montagne Sainte-Geneviève), and in this sense at least was intended to rival Wren's St Paul's in London. But the concern with architectural rigour, the determination to keep close to the classical models of the Pantheon and the Baths in Rome,

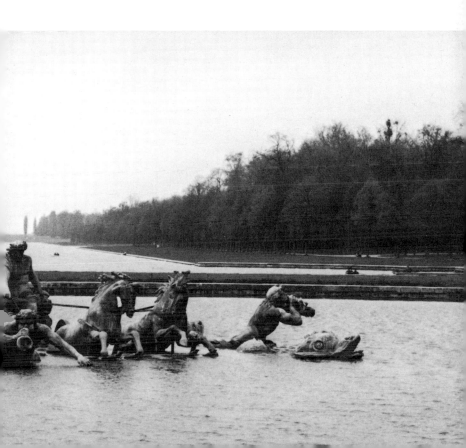

led, at least as far as the exterior is concerned, to a simplification of the detail, and a firm, massive articulation. The giant Corinthian portico, and the dome on its circular peristyle – like a circular *tempietto* mounted on a rectangular classical temple – asserted a new formal repertoire which was to inspire other architects for many years in Paris and elsewhere. But this is not all: in the interior, Soufflot set out to return to the basilical plan, but also to rival the sense of light, and the structural economy, of the Gothic. He succeeded only in part, as the weight of the dome caused movements in the walls and the tall windows had to be blocked in; this gives the outside the unfortunate appearance of a continuous wall. When the church was completed, in 1790, the revolutionary régime converted it into a shrine for the great men of France, the 'Panthéon des Grands Hommes'; used as a church for two periods during the nineteenth century, it finally became the Panthéon once more in 1885.

In the new district of Le Roule, the church of Saint-Philippe du Roule, begun by Chalgrin in 1774, is another step in the direction of the neoclassical basilical formula. It has a wooden barrel vault, resting on a continuous cornice supported by the columns; its Doric façade fronts a rectangular box.

The swing of the pendulum of taste from the side of enjoyment and frivolity to that of severity, and even sometimes dullness, can be traced in the face of the city as a whole. Thus, Bouchardon's Fontaine des Quatre Saisons (1739-46), in the rue de Grenelle, displays a rather toned-down Baroque, enlivened by the pleasant sculptured reliefs; it makes a vivid contrast with, for example, the hard lines of the Fontaine de Mars in the rue Saint-Dominique, by Beauvallet (1806-09).

Garden front of the Château de Versailles, by Hardouin-Mansart, 1678-86.

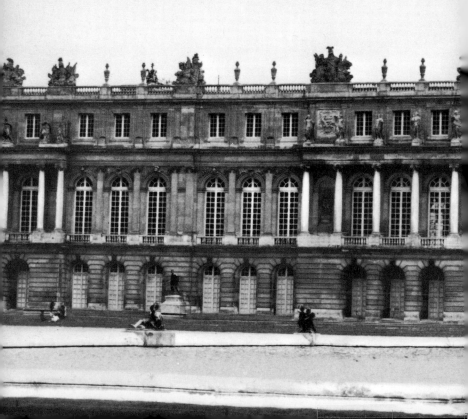

In the architecture of great private houses, the whole range of styles is present. In the Faubourg Saint-Germain, the façades, with tall, gently arched windows and light cartouches, have a graceful overall effect. An example is the Hôtel Matignon, built from 1721 onwards by Jean Courtonne, who showed extraordinary skill in planning the building with two façades which are not parallel, the courtyard front (rue de Varenne) and the garden front. This house passed to the Orléans family and was altered by Brongniart in the nineteenth century; from 1888 to 1914 it housed the Austro-Hungarian Embassy, and since 1935 it has been the official residence of French prime ministers. Just along the street, the Hôtel Biron, built for the former wigmaker Peyrenc de Moras by Aubert, and occupied by Marshal de Biron from 1753 onwards (it was the Russian Embassy in 1811-12, and it now houses the Musée Rodin), is another charming example of a style created with social life in view.

The domestic architecture built in the neoclassical style of Ledoux, in the second half of the century, has a completely different function. Unfortunately few examples of it remain; one of these is Ledoux's Hôtel d'Hallwyll, 28 rue Michel-Lecomte. One can imagine the full provocative impact of the style as it must have been in the house built for Madame Thélusson, in the brand-new rue de Provence, which was approached through a portico in the form of an imposing triumphal arch, leading by way of an austere flight of steps to a semi-rotunda set back between two wings almost entirely devoid of ornament. The neoclassical formula caught the imagination of the age. A minor, isolated, but nevertheless significant illustration of the form taken by this inspiration is the curious *trompe-l'oeil* simulation of a neoclassical

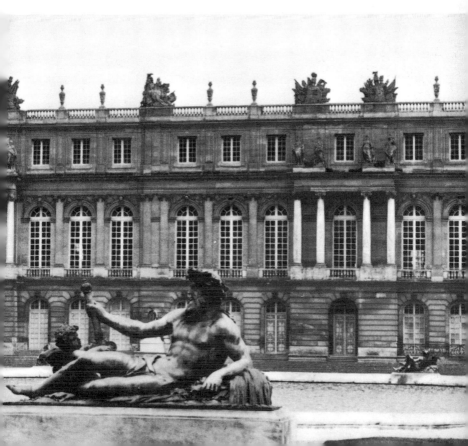

coffered vault that was created by an Italian decorator, Brunetti, for the tiny chapel built by Victor Louis in 1764 in the church of Sainte-Marguerite in the Faubourg Saint-Antoine (36 rue Saint-Bernard).

The two styles which coexist in the art of the period are neatly epitomized in the two façades of a single building, the Hôtel de Salm, now the Palais de la Légion d'Honneur (built for the Prince of Salm-Kirkburg by Pierre Rousseau in 1782, fired by the Communards in 1871, rebuilt after 1880). The river front is all simplicity and reserve; the courtyard of the rue de Lille side has a solemn colonnade. The first of these two styles, pioneered in Gabriel's Petit Trianon and carried to its conclusion in Béllanger's Folie d'Artois at Bagatelle (1777), tends towards grace through the use of a sparse, clear-cut simplicity, and may justifiably be described as a form of purism; its Parisian manifestations have a characteristic elegance of relationships and proportions. The other style, revolutionary and making no concession to the frivolities of the immediate past, or to traditional ideas of the attributes proper to any given class of building, took its cue from 'nature' in a rather specialized sense, and made conscious use of the psychological and even social power of great monumental structures. It was impelled by a complex ideology which has led to its being attributed to a contemporary tendency to 'megalomania'; it found its expression in Boullée's teaching and in Ledoux's treatises, and in countless projects for public buildings and places of assembly. The sometimes brutal radicalism of this movement inspired a number of vanished Paris houses by Ledoux, the same architect's great saltworks project (the Salines de Chaux, 1774), Boullée's extraordinary models for a national library, an opera house and a gigantic museum, Peyre's studies of hospitals and cenotaphs, and many other projects besides. The tide was running so strongly in this direction that in about 1780 the Comte d'Angivilliers asked Boullée to furnish a project for the transformation of the Château de Versailles with huge colonnades.

The massive Monnaie, by Antoine (*c.* 1770), the Hôpital Beaujon by Gérardin (1784), and the Ecole de Chirurgie by Gondouin (*c.* 1770, now part of the Ecole de Médecine), all show distinct signs of this 'revolutionary' tendency in architecture; but its prime manifestations were in the monster festivals and ceremonies of the revolutionary period itself, and in the great projects of Napoleon's time. The Empire period carried the tradition on; the new aristocracy added a style of decoration in which Pompeian and Egyptian inspiration were combined, and delighted in elegant outlines and pure swanlike curves. A fine example still in existence is the decor of the Salon des Saisons, on the first floor, and the Salon Vert (Hubert Robert) on the ground floor, of the Hôtel de Beauharnais, in the rue de Lille, built by Boffrand in 1713, but much altered during the occupancy of Eugène de Beauharnais after 1803 (it is now the German Embassy).

Paris had been divided into twenty *quartiers* or districts by a royal decree of 1702. The maps of the city, of which there were a large number, were standardized after 1728, with the publication of the *Geometral* of Abbé Jean Delagrive, who became city geographer in 1735. A spectacular undertaking of the 1730s was the plan in twenty sheets (32 by 20 ins) compiled by Louis Bretez in 1734-39 at the request

▷

Galerie des Glaces, Château de Versailles, by Hardouin-Mansart, Lebrun, and others. A host of decorators worked on this ceremonial gallery, which links the Salon de la Guerre, to the north, with the Salon de la Paix, to the south.

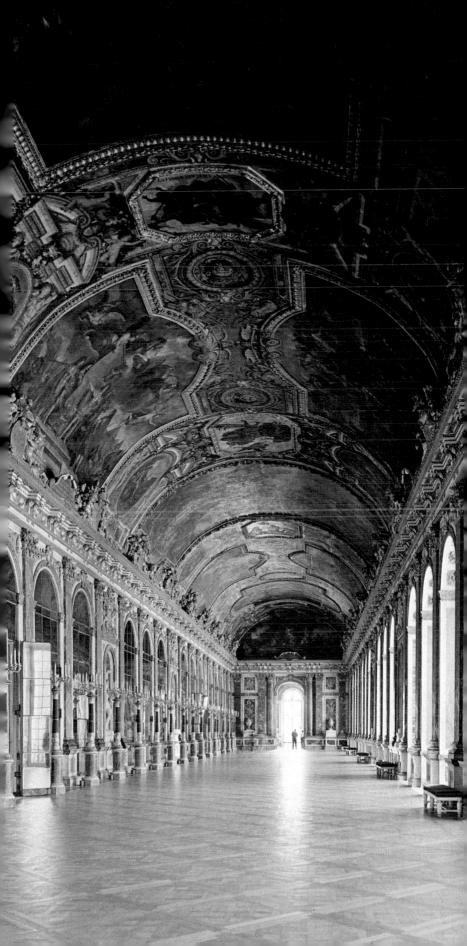

of Provost Turgot. This was undertaken, explicitly, 'for curiosity rather than utility', and was calculated to arouse the admiration of foreigners. This was the time when more and more historical and archaeological books about Paris, as well as guide books, began to be written. Never has Paris been the subject of so many handbooks, or so many enticing descriptions. It is symptomatic that Sebastien Mercier's *Tableau de Paris* appeared almost simultaneously with the systematic survey of the streets, with the key buildings 'drawn at half an inch to a fathom', begun by Edme Verniquet in 1774, finished in 1791, and published in 1796 (72 sheets).

Louis XIV had left Paris for Versailles in 1670. After his death the official residence of the king was the Tuileries, but the court moved about a lot, and Louis XV preferred his smaller houses. Nothing, of

Bassin de Flore, Versailles, by Tuby. Exemplifies the variety of the open-air décor at Versailles.

course, was ever the same after the populace went, in 1789, to fetch
Louis XVI back from Versailles to Paris. The French Revolution
brought with it the most powerful confirmation of the political primacy
of the capital that France has ever witnessed. The subsequent risings
in the provinces put this new-found authority to the test; but finally
the Consulate and the Empire (1802-15) consolidated Parisian dom-
inance, both within and beyond the borders of France itself.

The result of those twenty epic years, in which France stood at the
heart of the social and political changes that affected the whole of
Europe, was that the Parisian sense of vocation as a centre of power
reappeared in a new and positively obsessive form, in the first of the
nineteenth-century plans for the transformation of the city. This was
the astonishing set of plans drawn up for Napoleon, who had in mind

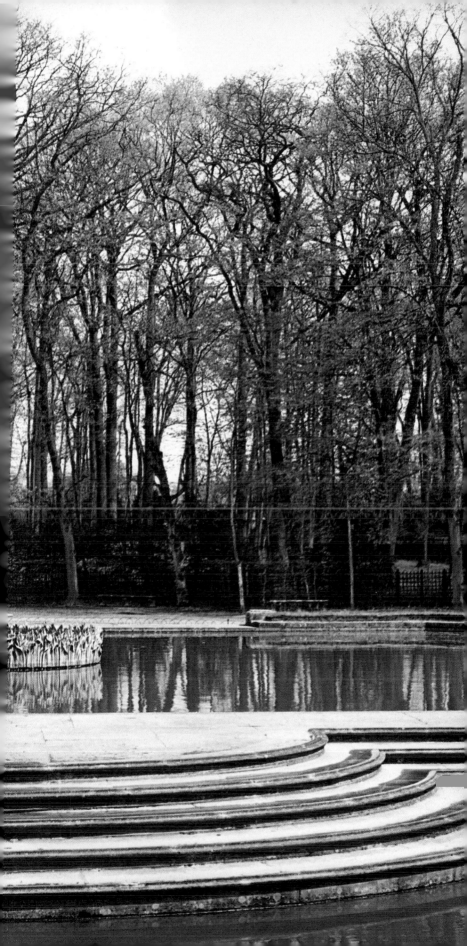

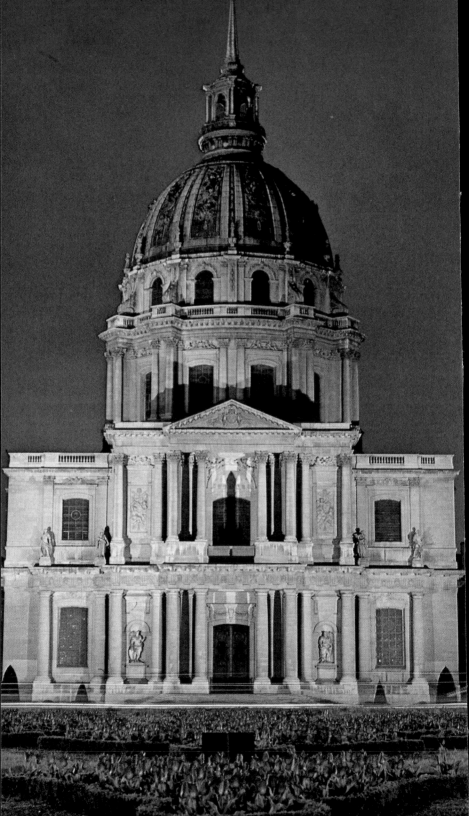

a complete redesigning of the centre of the city, with vast straight thoroughfares and with riverside embankments lined with statues and gigantic buildings: a plan on a colossal scale such as never been attempted until our own day. The destiny of Paris was caught up in the dream of a new world capital.

The time was ripe for change, after a hundred years of criticisms, complaints and projects. The revolutionary régime found itself in possession of the property that had been confiscated from the *émigrés*, and, even more importantly, the property of the clergy. This included the great enclaves formed by the abbeys of Saint-Germain des Prés and Saint-Martin des Champs, and the buildings of the Temple.

In the disused churches the Revolutionaries set up workshops, meeting-places and theatres; a considerable number of minor medieval places of worship, in varying states of disrepair, disappeared altogether. The new church of Sainte-Geneviève became the burying-place of great men, and took the name of the Panthéon. Mirabeau was the first to be buried there, in 1791, and Rousseau and Voltaire were to follow. The power of privilege had been broken; it was easier to acquire property compulsorily, and the church lands were available for redevelopment; the ideas that people had had about changing the face of the city now became feasible.

Naturally, all this was held up by financial crisis, war, and social upheaval. But the future was taking shape. This, at least, is the conclusion that can be drawn from the so-called *Plan des Artistes,* drawn up by a committee appointed in 1793, which was able to make full use of Verniquet's survey.

The Empire, with the decisiveness befitting a strong régime, set out to implement this programme of modernization. It was as if, having repudiated the Ancien Régime, the French nation, led by the Parisians, hoped to efface the traces of a defunct civilization. The fashion for the 'antique', the view that only Roman forms were in conformity with nature and reason, made the idiosyncratic confusion of the Gothic totally unacceptable. Paris was a modern city built round a medieval core; the city centre was a huddle of churches and public buildings. To the 'enlightened' spirits of the Revolution this seemed archaic, inconvenient, uncouth. It was therefore necessary to open up wide new streets, create open spaces, and introduce classical monuments and buildings wherever it was possible. One of the problems was that of the east-west cross route. The *Plan des Artistes* envisaged a single line from the Concorde to the Bastille, with a kink just by the Louvre in order to accommodate the line of its façade. In 1801 the line of a new street was decided on along the Tuilleries, across the Terrain des Feuillants; this was

◁
The Eglise du Dôme, by Hardouin-Mansart, 1679-1706. This was added to the east end of the military chapel of Saint-Louis des Invalides to serve as a chapel royal. The dome is 104 m. (341 ft) high overall.

P. 140/141
Bosquet de l'Obélisque, Versailles, by Hardouin-Mansart, 1706.

P. 142/143
The main façade of the Invalides, by Libéral Bruant, 1671-76. A monumental design incorporating a huge central gateway and using trophies (armour motifs) to frame the dormers above the attic storey.

to be the rue de Rivoli. The Louvre was altered by Percier and Fontaine, who built a north wing towards the Tuileries. At the entrance to the court of the Tuileries was set up the little Arc de Triomphe du Carrousel, on which, when it was built, stood the four bronze horses looted from St Mark's in Venice. The Madeleine was redesigned as a neoclassical Temple de la Gloire. The Pont d'Iéna was built to link the Champ de Mars with the Colline de Chaillot, where work started on levelling the site for the palace of the King of Rome, an immense colonnaded building which was to overlook a park stretching as far as the edge of the Bois de Boulogne.

These were only a few of the works undertaken by Napoleon in pursuit of a plan which would have swept away the entire centre of Paris, including the Ile de la Cité, to make way for a model city. Temples, statues and cenotaphs would symbolize the new age; the buildings of a modern administrative machine would be set up to govern

Temple de l'Amour, Versailles, by Mique, 1778. Rotunda with twelve Corinthian pillars enclosing a copy of Bouchardon's Cupid fashioning a Bow from Hercules's Club *(Musée du Louvre).*

the whole of Europe; there would be archives, barracks and schools. Paris lived for a while in the shadow of a super-plan, the product of the twin impulses of the Enlightenment, with its visionary rationalism, and the Empire, with its strong organizing impulse. The plan itself was hardly more than an outline; but the idea of it was to haunt the nineteenth century.

One completed structure gives the measure of the ambitions and the possibilities of the Empire period; the huge triumphal arch at Chaillot, commissioned from Chalgrin in 1806, which was to become the Arc de Triomphe de l'Etoile. The Minister of the Interior encouraged the construction of a monument which would 'inspire wonder in the traveller who enters Paris'. He wrote: 'This arch, superior to anything that has hitherto been done of this kind, would require, sited thus, to be of almost colossal dimensions ... Taking the palace (of the Tuileries) as the centre of Paris, just as Paris is the centre of the

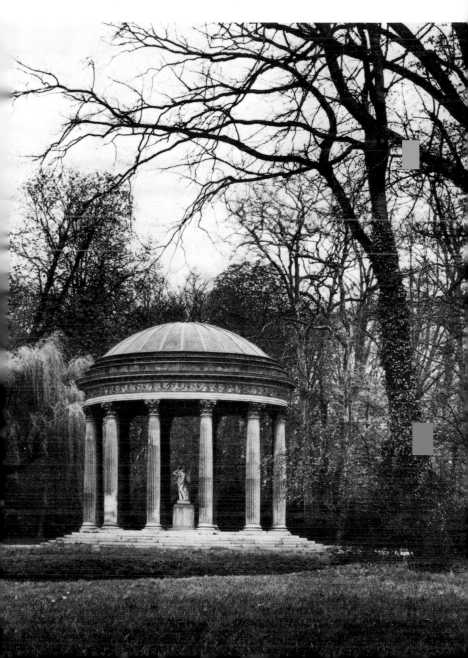

Empire, the monument would be seen from the centre of the capital.'
Completed in 1836 (a few years before the return, in 1840, of the
ashes of Napoleon), with its remarkable bas-reliefs by Rude, the Arc
de Triomphe is a massive and very skilfully balanced presence; by
virtue of the long streets which converge on it, it serves very success-
fully as a focal point within the Paris townscape. It was to be the
last monument of its kind to be built in Paris. But the Avenue des
Champs-Elysées goes round it, not through it, isolating it in the middle
of a gigantic intersection, the Place de l'Etoile; the symbolism of the
triumphal gateway, which had inspired the arches in the rue Saint-

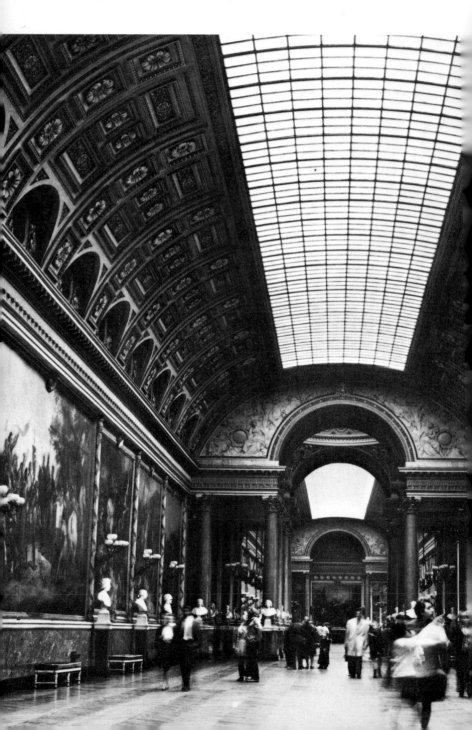

Denis and the rue Saint-Martin, has been abandoned in favour of the authority of the memorial.

The same tendency towards the monumental appears in all the arts. In painting, the eighteenth century opened with the great, colourful paintings of Coypel at Versailles and the Palais Royal (*The Aeneid*), and of Lemoyne at Versailles and in the churches of Saint-Thomas d'Aquin and Saint-Sulpice; a new dimension of sensibility was opened up by Watteau's Academy piece in 1717, *The Embarkation from Cythera*. It ended with David's austere *Sabine Women* of 1799.

◁
Galerie des Batailles, south wing, Château de Versailles, by Fontaine and Neupreu, 1837 onwards. Major decorative compositions by Delacroix, H. Vernet and others.

P. 148/149
Hameau de la Reine, Versailles. This rustic 'hamlet' is an elaborate exercise in the genre of the English garden, built for Marie-Antoinette by Mique from 1784 onwards.

For half a century the fashion was for a style of painting with strong relief, frothy and voluptuous both in manner and in subject, exemplified by Boucher and carried on in a more varied and emotive manner by Fragonard. The portraits of Nattier and Toque are sparkling bravura pieces; those of Quentin de la Tour employ the medium of pastel with an almost playful finesse; those of twenty others gaily pursue an easy formula. The genre scene, intimate and painterly in the hands of Greuze, quickly began to play a dominant role. A technique that is lively, quick, eminently well adapted to reportage, and to slightly salacious scenes, was taken up, after Fragonard, by Gabriel de Saint-Aubin, and his works are a foreshadowing of the 'Parisian sketch' which was to return to favour several times during the nineteenth century, particularly in the work of Constantin Guys.

The official painters worked rather in a vacuum, but their sweeping forms attest a knowledge of the work of Rubens, tempered by the French and academic predilection for decorum. History painting and large-scale religious painting were still indispensable requirements for the Prix de Rome, and this accounts for the existence of a number of conventional but finely-orchestrated paintings by Natoire, Fragonard and Vien; it was these painters who initiated the tendency to interpret the scene as a sort of coloured bas-relief, while Subleyras and Taraval pioneered the use of a cold colour-scale.

A friend of Fragonard, who had studied with him in Rome, Hubert Robert, came back from Italy with a new conception of landscape, based on the architectural view, and with strong archaeological undertones. This pre-Romanticism was extremely successful. But the love of land-scape painting, which had remained close to the French heart, was vigorously rejected as frivolous by the school of David. This Parisian pupil of Vien, a convert to Roman neoclassicism, rose to a position of dominance with *The Oath of the Horatii* in 1785. With his rigid rules of drawing, his imposition of a 'sculptural' style and his severity of effect, he proceeded to inaugurate a kind of personal Terror in matters of art. Henceforth everything was to be done at Paris. The privileges of the Académie des Beaux-Arts were abolished; but 'official art', that concomitant of nineteenth-century academicism, was to be largely the creation of David himself. As official painter to the Emperor, he intensified the colours of the skilfully composed commemorative paint-ing which he did of the *Crowning of the Empress* (1808). New forces were coming into play, not so much in the silvery light of Girodet as in the epic colour of Gros – and the immaculate linearity of Ingres, subtly refining the neoclassical heritage.

Monumental art has already been discussed. The strength of French sculptors still lay in large-scale compositions, like Pigalle's tomb of Marshal d'Harcourt in Notre-Dame. The sculptor most closely involved with Madame de Pompadour was Falconet, a man of lively tempera-ment, who made some charming models for reproduction in porcelain at Sèvres. In 1766 Diderot took him to St Petersburg, where he created a work of great sculptural power, the equestrian statue of Peter the Great; this is an echo of the French royal statues, none of which can match its fiery vigour. Houdon, who was the univeral favour-ite of Louis XVI's contemporaries, oscillates in rather an analogous way between agreeable figurines and serious portrait busts designed to reveal character rather than to fit the individual into a type; it was he who captured the image of illustrious men, Lavoisier, Rousseau, Franklin and Voltaire among them, and created a number of strikingly energetic female figures: Madame Elisabeth, the King's sister, and

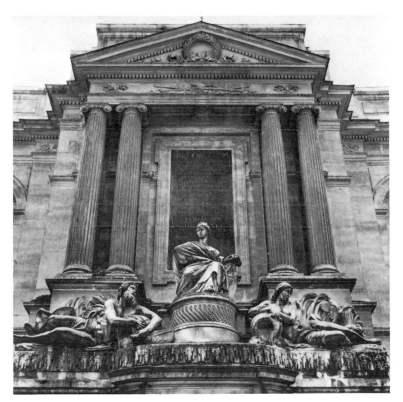

Fontaine de Grenelle, by Bouchardon, 1739-46. Allegory of Paris between Seine and Marne, in an Ionic temple.

Madame Brongniart, wife of the architect. Even with Canova, sculptor to Napoleon, the conventions of the heroic nude, which he used for all purposes, even to represent the Emperor, did not preclude an interest in gracefully entwined, slender, smooth outlines, and in contrived gestures.

Falconet was for a long time the director of the Manufacture de Sèvres (the royal porcelain works moved there from Vincennes in 1756, and the adjacent factory at Saint-Cloud closed down in 1766). This royal foundation owes its fame to its soft-paste porcelain, both *sujets* in monochrome biscuit and great set-pieces using the unique deep blue that made it famous. The demand became so general that other factories were established to make various related kinds of article, such as le Pont-aux-Choux for cheaper earthenware; Chantilly retained its importance for the delicate ware known as *Gorienne,* Sceaux for its plates with painted central medallions. In these fields French porcelain rivalled the subtlest creations of the Oriental art (there exist china vases enclosed in gilt bronze mounts).

Apart from their incomparable achievements in the field of porcelain, which were in universal demand, the greatest contribution to the reputation of Paris workmen and workmanship in the eighteenth century was made by the art of furniture-making. The workshops of the Faubourg Saint-Antoine never demonstrated their inventive capacity to better effect than in the production of new patterns of furniture, nor their resources of technical skill than in the quality and finish of the product itself. The stylistic shift within eighteenth-century art

appears in furniture in the transition from the rich and ornate style of Cressent and Saunier, in the 1730s, to the strict patterns and clearcut lines of Carlin and Riesener in the 1770s. Cabinetmakers and upholsterers are more or less inseparable; and there was no well-kept house in which new chair backs were not ordered, and changes made to the furnishings in general, every year. Hence the abundance of pieces still in existence in private and public collections. The Empire, with its clear articulations and its pure shapes, was to confirm, in this field as in others, the tendency already apparent in Louis XVI's time, to react against the brilliant 'frivolity' of earlier work.

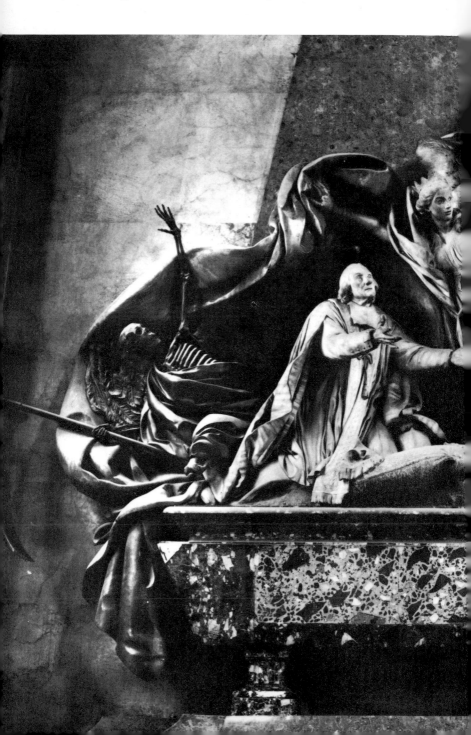

At the end of the seventeenth-century, the transactions of the Acadé-
mie des Beaux-Arts took a passionate turn with what has been called
the *querelle des Rubénistes et des Poussinistes,* the controversy be-
tween those who maintained the primacy of colour and those who main-
tained the primacy of drawing. The rivalry between the two principles
is endless; but this sort of debate on the merits of different styles was
to maintain in Paris an analytical agility of mind which went hand-in-
hand with the development of art criticism. It is impossible to describe
the life of eighteenth-century Paris without some mention of the regular
annual salons, the letters and reviews to which they gave rise, and

*Tomb of the parish priest Languet
de Gergy, in Saint-Sulpice, by
Slodtz, 1720. A remarkable
exercise in baroque movement.*

Façade of the Hôtel de Marcilly, 18 rue de Cherche Midi, by Claude Bonneau, 1738.

157

the activities of the writers of the regular newsletters which were sent to distinguished foreigners; they now added a section on art to their reports on literature and fashion. Grimm and Diderot thus endowed the happenings in cafés, salons, bookshops and studios with a dimension of European significance.

The policy of expanding the public collections of art was not pursued under Louis XV and Louis XVI as it had been in the preceding reign; but Paris did witness major sales such as those of the collections of Mariette and the Duc d'Orléans. The number of *curieux* was growing all the time, and collectors often came from abroad to acquire works of art and documents. The studio of Robert de Cotte, which contained a mass of plans, drawings and projects, came into the hands of Count Tessin, acting on behalf of the King of Sweden.

When the young Louis XV was brought to Paris – a city he was never to like much – by the Regent, his court was installed in the Tuileries. The palace begun in the sixteenth century by Philibert Delorme, on a site outside the old walls of the city, had remained unfinished. Now it was turned into a palace fit for a king, and was to be used by Louis XVI – who was besieged there by the mob on 10 August 1792 – and later by Louis-Philippe and by Napoleon III. The Tuileries thus supplanted the Louvre as the royal residence in Paris, and the latter changed its function. It was used as the head-quarters of official bodies such as academies, and for government offices, and studios were installed there for artists in receipt of State pensions. It is this surprising development that best exemplifies the cultural change that was taking place in Paris. In the basement beneath the Grande Galerie worked practically all the well-known artists of the day, from Coypel to Fragonard and David. This tradition did not cease until the Empire period. At the same time there developed the idea of gathering together the royal collections in a more coherent way, and housing them in an institution open to the public. The Marquis d'Angivillier had had the idea of a 'royal museum'. The Grande Galerie, which housed the annual official Salon – later to be held for many years in the Salon Carré – had therefore to be converted. Hubert Robert made a series of plans. Finally, after half a century, the *muséum national* was opened in 1793.

At the very moment in history when the Louvre assumed its new role, there occurred an extraordinary development that was to make it, for twenty years, a place where it seemed that all the masterpieces of European art were gathered together, a real-life anticipation of André Malraux's 'imaginary museum' of world art. From the outbreak of the revolutionary wars, French supply officers were requisitioning property, and works of art from the Low Countries and from Italy began to find their way to Paris, the city of free men. Somewhere behind this systematic pillage there lay the idea of the 'liberation' of art. It brought to the banks of the Seine the great Titians, Raphaels such as the *Foligno Madonna,* the most famous works of the Carracci, the *Altarpiece of the Lamb* and the *Descent from the Cross* by Rubens, just as if paintings had the same need to be freed from oppression as human beings. Naturally, the Empire continued the process, and regul-arly inserted into its treaties clauses providing for deliveries of paintings and other objects of value.

▷

Façade of the Panthéon, by Soufflot and Rondelet, 1757-90. This severely neoclassical building was formerly the church of Sainte-Geneviève.

The whole of Paris started to turn into one immense museum. The Lion of St Mark, taken from Venice, was set up on a fountain at the Invalides. There was talk at one point of setting a statue of Charlemagne, taken from Aix-la-Chapelle, on top of the column in the Place Vendôme. When the Temple de la Gloire (now the Madeleine) was mooted in 1806, it was proposed to adorn it with the statues of the Tiber and the Nile, from Rome, and with the quadriga from the Brandenburg Gate in Berlin. The Byzantine horses of St Mark were placed on top of the Arc de Triomphe du Carrousel. The love of spectacle that had marked the royal triumphal entries of earlier times now showed itself in the accumulation of treasures from all over Europe and their use as elements in an urban décor. The defeats of 1814 and 1815 led to the return of the pieces to their former owners (a number escaped the attention of the Allied commissioners thanks to the ingenuity of Vivant Denon). Nevertheless two lasting benefits resulted: firstly, the works themselves, many of them restored, were henceforth better and more widely known; and secondly, a whole generation of young artists, including Gros, Delacroix and Géricault, had had a chance to see the most remarkable collection of masterpieces the world has ever seen. The rapid and irresistible rise of French painting during the nineteenth century may well be partly explained by this.

Another related phenomenon appeared at the same time. In the former monastery of the Grands-Augustins (which now houses the Ecole des Beaux-Arts), a passionate lover of archaeology, Alexandre Lenoir, set out to gather the remnants of the monuments which the Revolution was busy destroying, to pile up everything that escaped the attentions of those who had pillaged the tombs of Saint-Denis, the church treasuries and the châteaux. Some members of the Convention, such as the Abbé Gregoire, were already denouncing this vandalism, pointing out that its result was to deprive the people of its own property. Lenoir received some support, and assembled, in the rooms and gardens of the old monastery, an incredible succession of historical exhibits. The *Diana* from Anet stood in a clump of trees not far from a collection of Gothic tombs. The riches and continuity of the art of the past were abruptly brought into focus, and the younger generation of historians, including Augustin Thierry and Michelet, were never to forget the stimulus provided by this weird and exciting place. To Lenoir's great sorrow, the collection was dispersed after 1815. But here again, the Romantic imagination took over; his collections had provided new insights, and other collections were formed. It was as part of the heritage of Lenoir that the collection of Alexandre Sommerard was acquired in 1843 to form the Musée de Cluny, adjoining the Roman baths. It was now the turn of Romanticism to provide the inspiration for the forming of collections.

City of Light

Paris in the post-Restoration period of the 1830s and 1840s was in the midst of a crisis; it was the object of a wave of migration which crammed the poorer areas to bursting, and worsened the conditions of life in the central and eastern parts of the city which were to be

▷

The dome of the Panthéon, seen against the night sky.

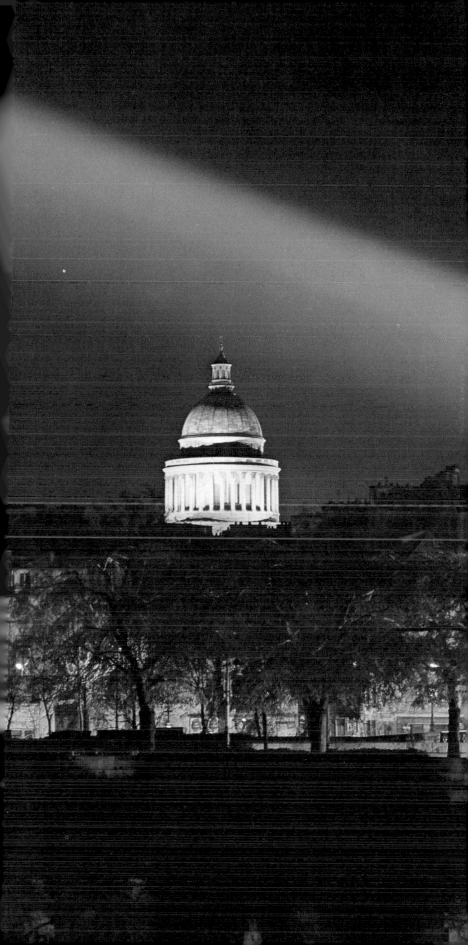

the source of future rebellions. The population of the city grew at great speed: just over a million in 1846, nearly two million in 1870. This movement was caused by the great upsurge in commercial activity and by the Industrial Revolution; the first railway in France, the line from Paris to Le Pecq, was opened in 1837, and a momentous law enacted in 1842 provided for the building of the first main lines, by private companies, with Paris as the starting-point. The primacy of Paris thus became an imperious geographical reality; in order to travel across France, it was now essential to pass through Paris. The design of railway stations was to become one of the characteristic features

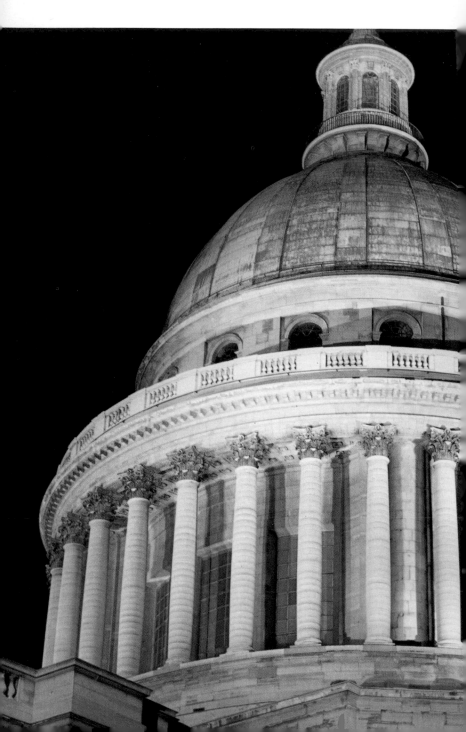

of the new big-city architecture, along with that of town halls, depart-
ment stores, banks, grand hotels and public utilities, as well as churches.
Building for private individuals, except in certain new districts and for
certain fortunate bourgeois, was now no longer in the forefront. These
great new buildings came into existence at intervals throughout the
century: from the Gare du Nord by Hittorf (first version 1847, second
1863) to Laloux's Gare d'Orsay (1898-1900) and the corpulent Gare
du Lyon by Toudoire (1902); from the shopping galleries of the Palais
Royal to the great Bon Marché store, an iron-framed structure built
for the drapers Boucicaut by the Boileaus, father and son, from 1872

◁
*The Corinthian peristyle round the
base of the dome of the Panthéon.*

P. 164/165
*Façade of the Hôtel de Soubise
(Archives Nationales), by Delamair,
1705-09. A notable feature of this
building is the horseshoe-shaped
forecourt.*

P. 166/167
*Grandes Ecuries, Château de
Chantilly, by Aubert, 1719-40.
Stable block built for the Duc
de Bourbon.*

onwards, the equally huge Grands Magasins du Printemps by Sedille (1882), and the Samaritaine, a rather more sinewy design (at least in its original form) by F. Jourdain. Other vast projects at the end of the century included the iron Bibliothèque Sainte-Geneviève by Labrouste (1885-1900), and the Métro, begun in 1898. Work was directed towards the addition of ever more complex new features to the urban pattern, now distended and distorted in all directions. The majority of these additions, and of the upheavals that attended them, took place under the Second Empire and during the first generation of the Third Republic; but whatever the prestige value of urban renewal for the régime which initiates it, it is in fact an inevitable consequence of the powerful pressures generated by a commercial and industrial society.

Under the Restoration there developed in Paris a curious urban feature, the arcade or *passage*. Less imposing, grand and ambitious than the giant arcades of Berlin and Milan half a century later, the Parisian

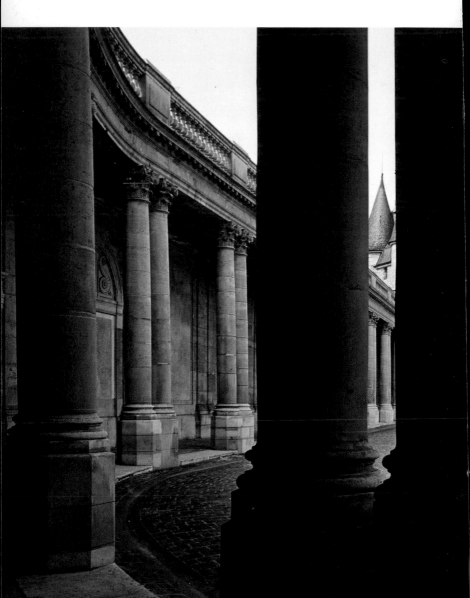

passage, glass-roofed and lined with unpretentious shops, was clearly derived from the arcades which were being built at the time in London; it has a measured, bourgeois quality, meant for idle strollers, often adorned with cafés and unusual shops. The Galerie Vérot-Dodat (entrance 19 rue J.-J. Rousseau), with its faded neoclassical charm, is one of the pleasantest early examples; better known are the thriving Passage des Panoramas (entrance 11 boulevard Montmartre), immortalized by Zola in *Nana* (1880), and the Passage de Choiseul (between 42 rue des Petits-Champs and 25 rue Saint-Augustin). At the end of the nineteenth century there were still more than twenty, and they played a prominent part in songs and novels as places suitable for the pursuit of amorous adventure.

The final unification of France centred on Paris, the focus of its economic and political life. After a short and enforced stay at Versailles (1871-75), the representative bodies of the Third Republic installed themselves in buildings in Paris which were already in existence; the

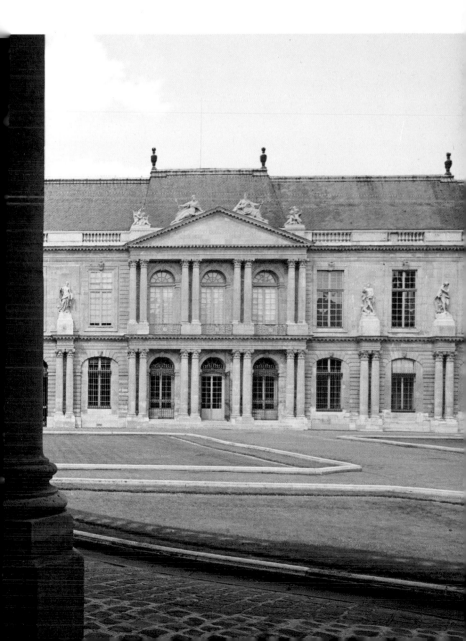

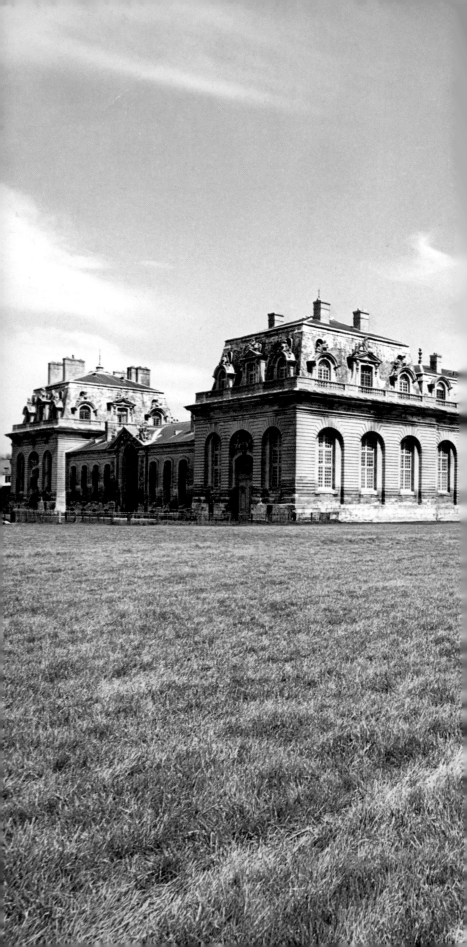

Pedimented porch of the Grandes Ecuries, Château de Chantilly.

Chamber of Deputies in the Palais Bourbon, the Senate in the Palais du Luxembourg, the President of the Republic in what became known as the Palais de l'Elysée. The history of the last-named is a typical one; originally the Hôtel d'Evreux (Mollet, 1718) it passed in 1748 to Madame de Pompadour, who put her brother the Marquis de Marigny into it, and in 1773 to the financier Beaujon. Confiscated at the Revolution, it was restored by Caroline Murat and later given to the Empress Josephine. The future Napoleon III lived there during his Presidency, from 1849 to 1851. The Salle des Fêtes and the winter garden were built on in 1886-88, and the building was restored in 1947. The mid-nineteenth century witnessed two major and far-reaching changes. The first was the growth of the city to the line of Thiers' fortifications, built shortly after 1840. This led to the absorption (in 1860) and the relentless urbanization of the peripheral villages of Batignolles, Vaugirard, Charonne and Belleville, and had the grave disadvantage of turning the city in upon itself and condemning the extramural areas, cut off from the advantages of belonging to a great urban complex, to neglect and atrophy. Paris as thus demarcated and fortified was the field in which the administrators and town planners of the Second Empire and Third Republic worked.

The walls themselves were of the traditional type; designed as a protection against military attack, they encircled Paris with a continuous rampart supplemented by seventeen detached forts; these last remained serious hindrances to the development of the Paris suburbs until the 1930s.

The second major transformation took place with the coming of the multi-storey office and apartment building. The result was that the

appearance of the streets, with their narrow frontages, was spoilt; over-high buildings produced a confused and restless skyline. Along newly-built thoroughfares and in newly developed areas the 'block' made its appearance, usually with a balcony running along the façade at top-floor level like a cornice; this arrangement became characteristic of the face of Paris. The variegated, active, powerfully contrasted world of Balzac lives on in the dwellings of the old Paris, both those of the upper classes, painfully and obstinately keeping up their standards, and those of the shopkeepers and workmen, restlessly alive in tumbledown squalor. In the next generation, with Zola, who built up his sequence of novels in the methodical manner proper to naturalism, everything takes place in modern shops, public places, well-to-do households, tenements built to rent. The metamorphosis is complete; another society has moved in, and in all the old buildings, in the central and eastern districts, live the poorest of the poor. Between Balzac and Zola came the 1848 revolution and the Second Empire, social rebellion and the imposition of order by means of an unprecedented programme of urban planning.

Alongside the novel, there appeared a new form of social document, typical of the nineteenth century and much used both in Paris and London, which kept social and political criticism very much alive, carried on the light-hearted chronicle of fashion and popular amusements, and even revealed something of the tensions created by such a brutally rapid evolutionary process: this new form was caricature, as developed through the use of lithography. Along with a host of other artists – including the delightful Gavarni – the savage and powerful Daumier holds open a window on the daily life of the middle and lower classes, with all their grimaces, their enthusiasms, their pettinesses and their courage. 'Leaf through his work,' wrote Baudelaire, 'and you will see unfolding before you, in all their fantastic and absorbing reality, all the living and monstrous beings that a great city can hold. All its fearsome, grotesque, sinister, laughable treasures: Daumier knows them all.' One of Daumier's most important paintings, an inspired and fervent document of republicanism, is *The Riot* (Phillips Gallery, Washington). These powerful but essentially prosaic images may be contrasted with the majestic vision of the old Paris, dark and dingy, doomed to destruction, afforded by the prints of Meryon.

Social ferment and the pressure of popular forces led to an explosion in 1848, and the phenomena of revolution were accompanied by so many philosophical, historical and 'scientific' arguments put forward by their partisans that the example of Paris attracted attention everywhere. In the Middle Ages Paris had been the world capital of eloquence, *le bien dire;* in the seventeenth century it became that of good taste, in the eighteenth century that of intelligence; in the nineteenth it became the model of revolutionary consciousness, or at least of social consciousness. The events of 1848 forced the intellectual to formulate new historical judgments, and for Karl Marx they were, as is well known, a decisive revelation. Engels considered Paris ('the city whose population combines, as does no other people, a passion for the pleasure of living and another for historic action') to be the meeting-place of the great currents of European history, the point from which spring, from time to time, electrical discharges which shake the world. Thus the nineteenth-century myth of Paris acquired, whether as a subject for admiration or for fear, a new dimension: the reputation of being the perennial source of modern democracy. The events of 1871

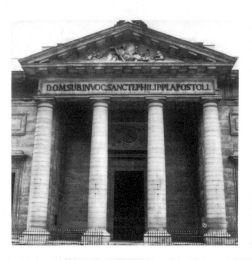

Doric pedimented façade of
Saint-Philippe du Roule, by
Chalgrin, 1774-84. The church
was enlarged by Baltard in
the 19th century.

Doric pedimented façade of
Saint-Philippe du Roule, by
Chalgrin, 1774-84. The church
was enlarged by Baltard in
the 19th century.

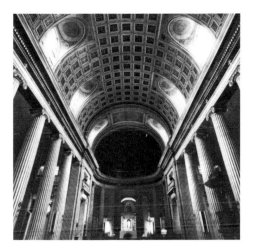

Interior of Saint-Philippe du Roule, by Chalgrin, showing fluted Ionic columns and coffered ceiling; the formula is inspired by the Early Christian basilicas.

and the social movements of the Third Republic contributed considerably to the maintenance of this idea in a Europe in which France was still surrounded on all sides by kingdoms and empires.

The Second Empire responded to the socialist challenge with an unprecedented effort at reorganization. Paris still bears the marks of this too clearly for anyone to be able to overlook its scope and its limitations, its efficacy and its weaknesses. Essentially, the course chosen by Napoleon III, and pursued with authority and enthusiasm by Baron Haussmann, was inherited from the First Empire; but the grand design was somewhat tempered both as a result of the new emperor's knowledge of, and affection for, London, and by the concern with alleviating the misery of the masses through facilities like collective housing and a better water supply.

The rue de Rivoli, work on which had started at the beginning of the century, was continued, with its arcades, as far as the Louvre, and then, without bending to follow the line of the colonnade, it was implacably extended as far as the Hôtel de Ville before changing direction slightly to link up with the old rue Saint-Antoine. This work necessitated the removal of two hillocks, one at rue du Louvre, the other, more difficult to deal with, at Saint-Jacques de la Boucherie. All that was left of this church was the tower. This was installed on new foundations, and, in its own *square,* has continued to mark the main crossroads of the capital. The isolation of the tower of Saint-Jacques is indicative of the method that was followed everywhere; the most important buildings were to be given emphasis. Thus, in order to give shape to the Place du Louvre, the rather nondescript square facing the east colonnade of the Louvre, Hittorf duplicated the church of Saint-Germain l'Auxerrois, building the town hall of the *arrondissement* on the other side of his pseudo-belfry. Again, in order to 'open up' the area round the Hôtel de Ville, more than half of the Ile de la Cité was razed to the ground, and it became an administrative centre.

Now that the main east-west axis was in existence, two boulevards were built at right angles to it, one north of the river, terminating at the Place du Châtelet, one south of the river terminating at the Pont Saint-Michel. The idea was that the domes and façades of large public buildings would punctuate and give meaning to the new vistas. Thus the lifeless rue de Rennes was built in 1853-66 in order to set off the Gare de Montparnasse, which stood at the end of it.

This systematic 'opening up' process went on all over the city, from the Place de la Bastille to the Gare du Nord, from the Gare du Nord to the Etoile, from the Trocadéro to Saint-Marcel, often paralleling or swallowing up the older streets. An enormous grid was thus laid over the city, and with some skill: the guiding principles were, firstly, pursuit of the straight line for its own sake, because it facilitates the flow of traffic (a perennial problem since the sixteenth century); secondly, the desire for embellishment, which led to the building of monuments and garden *squares,* and the tidying-up of intersections; and finally, the concern with strategic defence against popular risings. It would be absurd to regard this last as the sole preoccupation of Haussmann's planning, but the careful distribution of new barracks, and the words of the authorities themselves, make it impossible to discount it entirely. Thus the Place de la République (formerly Place du Château d'Eau) and the Place de la Nation (formerly Place du Trône), both of which have large barracks, are linked by an absolutely straight street about two miles long, the Boulevard Voltaire (formerly

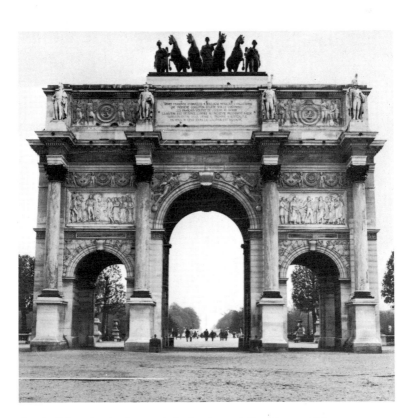

Arc de Triomphe du Carrousel, by Percier and Fontaine, 1806-8.
An imitation of the Arch of Septimius Severus in Rome, with
bas-reliefs celebrating Napoleon's victories.

Boulevard du Prince-Eugène), opened in 1862. Not all these new plans were carried out while Napoleon III and his *préfet*, Haussmann, were in power; but they have been closely followed by a municipal government doggedly faithful to the Haussmann model. The extension of the Avenue de Friedland (the Boulevard Haussmann) took its place among the outer boulevards in 1926. The principle of gradually imposing a theoretical building line is one of the most artificial and harmful aspects of this sort of town planning, by virtue of the arbitrary distruptions caused by the destruction of all the buildings which are out of alignment. Everyone now sees the evil consequences of cutting across existing patterns of building, as was done with the rue des Ecoles and the rue Etienne-Marcel (in 1883 the end of the latter unpardonably eviscerated Mansart's Place des Victoires). But this does not heal the great aching voids pointlessly created over the ruins of worthwhile buildings. There is hardly a district in Paris where, while appreciating the advantages offered to motor traffic, one fails to detect and to deplore the effects of 'Haussmannism'.

This process is also marked by the introduction of standardized architectural designs, the best example of which is probably the apartment blocks of the quai de la Mégisserie and the Boulevard Sébastopol; they are the logical outcome of the introduction in the eighteenth century of the collective dwelling-house. In these blocks a simple and typically Parisian formula was worked out under the Second Empire, with a conclusive demonstration of its advantages. At fifth- or sixth-floor

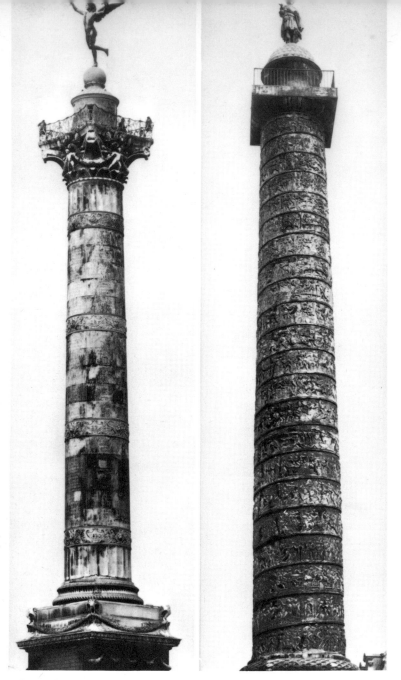

Colonne de Juillet, Place de la Bastille, by Duc and Alavoine, 1840-41.
Erected to commemorate Louis-Philippe's July Revolution of 1830;
47 m. (153 ft) high. At the top, The Genius of Liberty in gilt bronze.

(right) Colonne Vendôme, by Gondouin and Lepère, 1806-74.
Napoleonic imitation of Trajan's Column. First set up, with statue of
Napoleon by Chaudet on top, in 1806-10; destroyed in 1814;
rebuilt in 1834; destroyed in 1871; rebuilt in 1874.

level, cast-iron balconies provide a line of ornament which replaces
the cornice of earlier times. The first floor, the *étage noble,* has lost
some of its prominence. This type of building appeared everywhere, as
reconstruction proceeded. After 1880, it sometimes broke out in convex
balconies and Art Nouveau curlicues. A common feature at that time

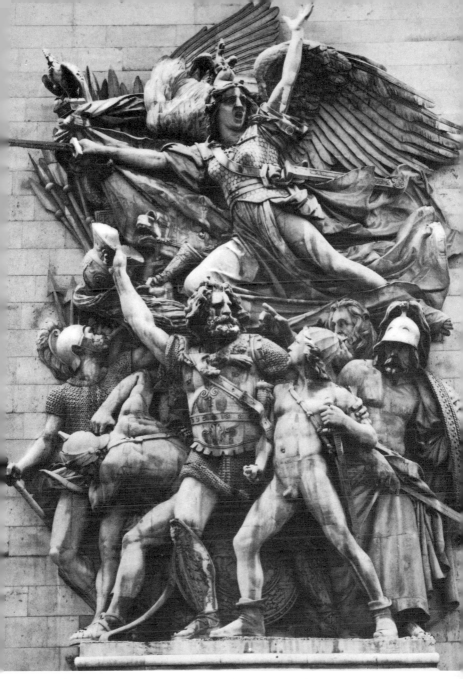

Rude: La Marseillaise, *1836, on the Arc de Triomphe de l'Etoile.*

was the corner rotunda, 'engaged', or partly embedded, in the main structure, and surmounted by a dome which adds a certain solemnity to the whole; examples are the Cercle de la Librairie, by Garnier, on the Boulevard Saint-Germain, and the buildings which flank the end of the Métro viaduct along the Boulevard de Grenelle. But the most remarkable *fin-de-siècle* variation on domestic architecture is that of Guimard at the Castel Béranger, in the rue la Fontaine, which has a profusion of invention which extends to all the detail of main doorways, wrought-iron work, fireplaces.

On the whole the Haussmann standardization was intelligently, if brutally, carried out; it would be pointless to deny that all these carefully coordinated operations possess the merit of being, for the first time in history, a unified overall plan. Their strength lay in their appeal to an ideal of modernity, comfort and bourgeois dignity which was entirely in keeping with the ideals of industrial civilization. This was apparent in the case of the Halles, which had witnessed no improvements since Francis I, apart from the setting up of the Halle au Blé, the wheat market (now demolished), on the site of the present Bourse du Commerce.

The use of iron in architecture had had a spectacular success at the Crystal Palace in London (1851), and had in fact been tried out in several places in Paris before that. It was adopted for the Palais de l'Industrie at the Universal Exhibition of 1855, and then, after a first unsuccessful attempt in stone, for Baltard's new Halles Centrales, begun in 1852. These were built on a wide flat site carved out alongside the church of Saint-Eustache, between the Halle au Blé and the Innocents, and set aside as early as 1842 by the *préfet* Rambuteau. A new diagonal street, the rue des Halles, connects the site with the Châtelet intersection, and the northern half of the rue Saint-Honoré was demolished. The plan provided for ten iron structures with pitched roofs supported by elegant cast-iron pillars. The complex was built in stages; the first six buildings, on the eastern side, were completed in 1857, the next four in 1890, and the new section adjoining the Bourse du Commerce in 1936. The effect of the glass roofs, and the lightness of the space inside, gave them great splendour. They were a success, and they were much imitated. It is clear that, as with the Eiffel Tower a generation later, the appearance of all this metal and glass was regarded as the triumph of a new age.

Zola gives the measure of the enthusiasm which accompanied this new architecture in the minds of certain people. 'Since the beginning of the century only one building has been built that is original, only one that is not copied from anywhere, only one that grew naturally from the soil of the age; and that one building is the Halles Centrales, do you understand, a bold piece of work, and one that is still only a faint revelation of what the twentieth century will be' (*Le Ventre de Paris*). The trade in foodstuffs, the spirit of the vendors, the lively plebeian air of the whole thing, endowed the place with a strong and attractive individual flavour. The Gare Saint-Lazare and the iron church of Saint-Augustin (by Baltard) are counterparts in the west.

One other enterprise which was supported by all the resources of the government, and which was the fulfilment of a long-standing preoccupation, was the Opéra, designed by Charles Garnier (1862), which is a masterpiece by virtue of the scale of the conception, and the magnificence of the entrance hall, lined with marble and porphyry and dominated by the last word in ceremonial staircases. A whole network of streets was laid out around this enormous edifice, and an avenue and a large square lead up to the entrance.

With all these great buildings, linked one to another by straight, mostly wide, and often tree-lined streets, Paris received, as it were, a geometric network of thoroughfares forcibly superimposed on an earlier, irregular texture. In the old Paris the clear-cut formal parks and open spaces had contrasted with the labyrinth of tortuous streets, with all its profusion of detail and of character. This situation was now reversed, and there was a curious tendency to compensate for the monotony of the straight streets by introducing into the parks and gardens a certain

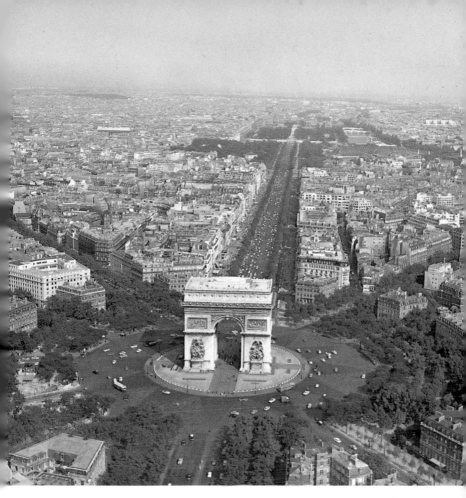

Aerial view of the Etoile (Place Charles-de-Gaulle) and the Champs-Elysées.

irregularity and disorder. The new open spaces were carefully contrived: the Bois de Boulogne was entirely redesigned by Alphand; and for the populous areas of eastern Paris there was its counterpart, the Bois de Vincennes. The hilly, various and charming complex of the Buttes-Chaumont was created, on a shapeless and neglected site riddled with gypsum quarries, after the incorporation of the outlying villages in 1860; and in the south there were the lawns and the shady trees of the Parc Montsouris (1868). The Folie de Chartres, or Parc Monceau, was redesigned. Twenty or so smaller gardens or *squares* were set up across the city. And a century later, none of all this has changed.

The age lived under the sign of historical knowledge, and the study of the art of the past, and particularly of French art, had made astonishing progress. A monument of erudition and technical accuracy like Viollet-le-Duc's *Dictionnaire d'architecture* (10 volumes, 1854-68) would have been unthinkable a century earlier. The worship of the Middle Ages supplanted that of Greek antiquity; it had its variants, in the interest in Byzantine and Moorish design. All this manifested itself, in a 'modern' form, in Paris, where all the aspects of what has been

P. 178/179
Fountain in the Place de la Concorde, by Hittorf, 1836-46.
The figures represent rivers.

◁
*Place de la Concorde, laid out by
J. A. Gabriel, 1757. The Obelisk
was set up in 1836.*

P. 182/183 and P. 184
*Two views of the Château de
Chantilly. Beside the Petit Château,
built by Bullant, 1560, for the
Connétable de Montmorency,
stands the Grand Château, built for
the Duc d'Aumale, 1876-82
(Montmorency's Grand Château,
1531, was destroyed at the
Revolution). It now houses the
Musée Condé, incorporating
Aumale's art collections, bequeathed
to the Institut in 1886.*

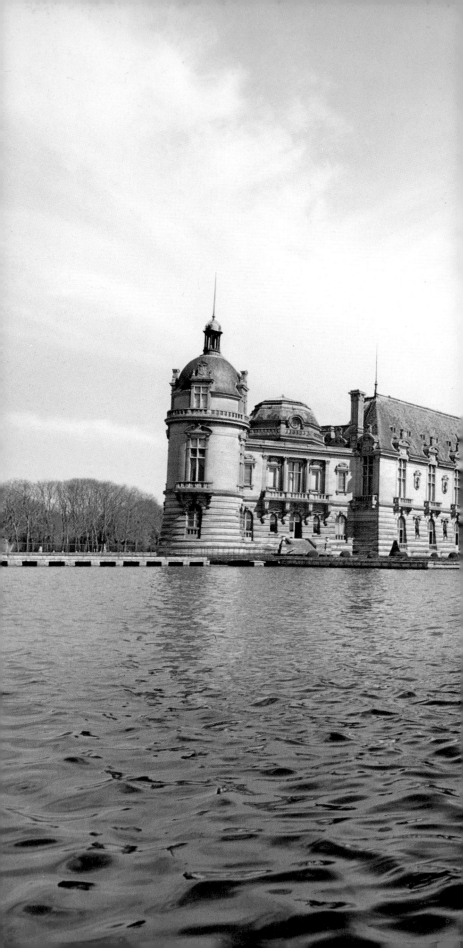

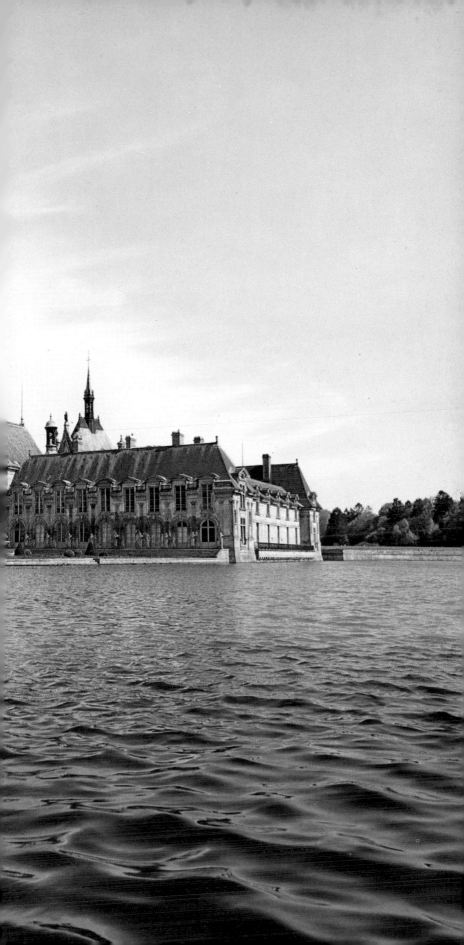

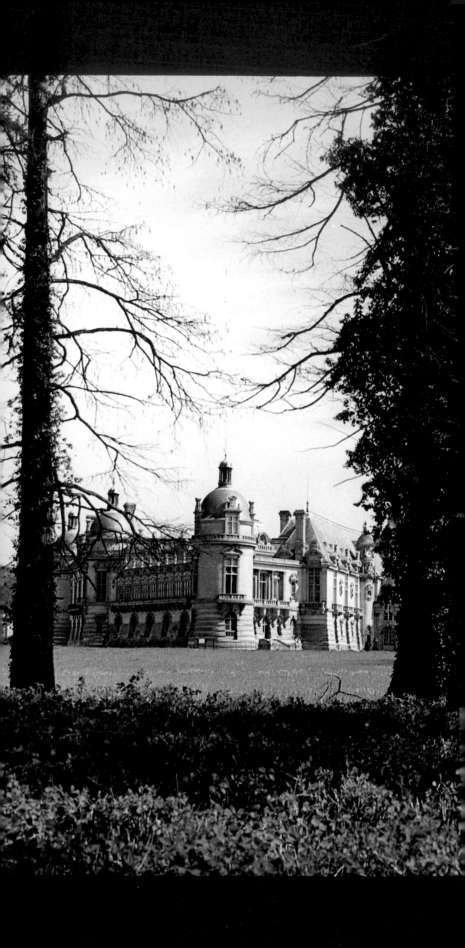

called historicism (or eclecticism) came together in one place. Hence the mixed pseudo-Renaissance style – considered to be well-suited to a commercial neighbourhood – which Ballu drew on for his church of the Trinité (1861 onwards) and the extraordinary 'Romanesque-Byzantine' adopted by Abadie, the restorer of medieval domed churches, for the vast white basilica of Sacré-Coeur, built on the heights of Montmartre by national subscription after the disasters of 1870-71. The soil was chalky, and shafts had to be sunk thirty feet down in order to make the building secure.

Meanwhile, Visconti and Lefuel had, by dint of (often inaccurate) pastiche and reconstruction, pulled together the great main body of the Palais du Louvre, which was now complete along the rue de Rivoli. The second Empire thus completed the work of the old monarchy. The burning down of the Tuileries palace in 1871, followed by the demolition of the remains (which were by no means beyond repair) in 1882, finally left the courtyard of the Louvre open on the garden side. The Hôtel de Ville, which was also set on fire by the Commune, was rebuilt, but without much in common with the sixteenth- and seventeenth-century architecture of the original building, in spite of an attempt at a Renaissance style.

In the year IX of the Revolution, under the Consulate, there was held in the courtyard of the Louvre an exhibition of the products of French industry which was repeated in 1803 and again in the autumn of 1806, this time at the Invalides. But it was not until the Second Empire, and until Great Britain had shown the way, that the *exposition universelle* appeared in its new form, designed both as an industrial trade fair and a prestige event, involving major art exhibitions. In 1855 the Palais de l'Industrie was set up in the Champs-Elysées, and a great retrospective of Ingres and Delacroix was mounted in a temporary building in the Avenue Montaigne. The western side of the city remained the chosen site of these great festivals of modern life and international rivalry. In them one can follow the stages in the development of mechanical engineering, as well as the various forms taken by industrial civilization's endless sanguine self-glorification.

The traces left by these exhibitions, and the examples they provided, constitute a considerable contribution to the changing face of Paris: after the 1867 exhibition on the Champ de Mars, there was the construction on the Colline de Chaillot, where Napoleon had planned to build the palace of the King of Rome, of the Hispano-Mauresque Palais du Trocadéro (demolished in 1937). In 1889, for the centenary of the revolution, there were erected two masterpieces of iron architecture, the Eiffel Tower and the Galerie des Machines. Much disliked at first by the intellectuals and the aesthetes, the tower (984 feet high, three levels with lifts, weight 7000 tons) eventually gained acceptance thanks to its striking outline and its siting, both of which have stood the test of time; but the immense hall of the Galerie des Machines, by Contamin and Dutert, was moved to the Champs-Elysées and finally destroyed in 1910.

Finally, the Exposition Centennielle in 1900, spread out along both banks of the Seine, witnessed the wild and immodest triumph of Art Nouveau, overflowing on to several of the surrounding avenues; it left behind it the two archetypal buildings of the new style, the Grand Palais for group exhibitions, the Petit Palais to serve as a museum; they frame a superb view of the Invalides, in which the eye is guided by the exquisite curve and the delightful ornaments of the Pont Alexandre-III. An entirely unexpected, profoundly satisfying harmony

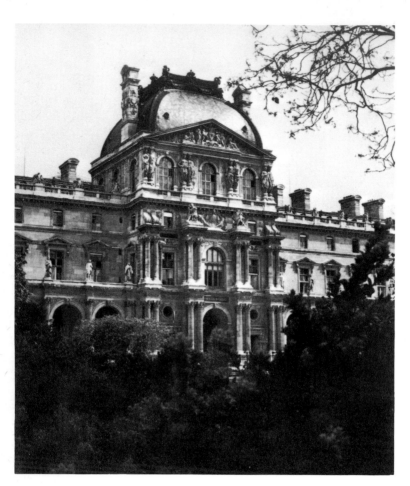

View from the courtyard of the Palais du Louvre, showing the wing added by Lefuel and Visconti, 1852-57, with the Pavillon Turgot and Pavillon Richelieu.

was thus set up at one of the most sensitive points of intersection of the river and the main axes of urban development.

The later exhibitions had little effect: the Exposition des Arts Déco-ratifs in 1925, apart from giving its name to the Art Déco style, might have marked the coming of a new spirit in industrial and ornamental design, but nothing came of it. The 1937 exhibition represents an opportunity lost; the 1878 Palais du Trocadéro was replaced not by Auguste Perret's design, which treated the hill as a series of terraces, as the Napoleonic project had done, but by the present building, by Carlu; this, with its central gap and its wall cutting brutally across the slope, has been much criticized.

Contrary to what is sometimes believed, both inside and outside France, Paris contains a considerable number of key buildings in which one can follow the development and the intelligent application of new techniques in architecture. After the hall of the Ecole des Beaux-Arts (Duban, 1834), iron-frame construction was brilliantly used in the Bibliothèque Sainte-Geneviève (1844-50) by Labrouste, who went on to create an airy masterpiece in the glass domes, supported on sixteen iron columns, of the Salle des Imprimés (reading-room) in the Bibliothè-que Impériale (1868, now Bibliothèque Nationale). This makes an

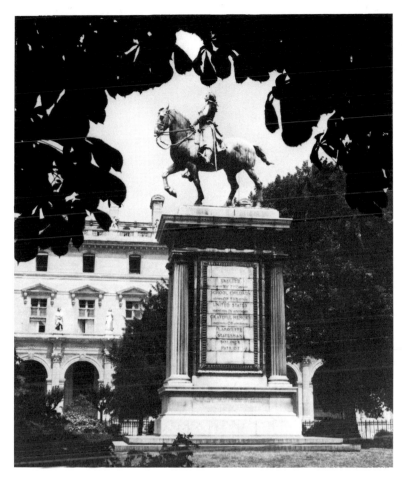

Cour du Carrousel, Palais du Louvre, showing the equestrian statue of Lafayette by P. W. Bartlett, given by the USA in 1900.

interesting comparison with the layout of the eighteenth-century refectory of Saint-Martin des Champs, incorporated in the Ecole des Arts et Métiers. Building Saint-Augustin (1860-71), after starting work on the buildings of the Halles, Baltard used an iron vault, supported by cast iron columns, and clad in a neo-Florentine stone decor.

Metal construction is used in the same way, to create a large interior space, treated according to a layout inspired by those of Roman baths, in Laloux's Gare d'Orsay (1898-1900); and it is vigorously employed in the well-lit hall which lies behind the colonnades of the Grand Palais by Deglane (1900). At 194 rue Réaumur, by Chédanne (1905), the iron skeleton appears on the façade. Two churches illustrate the problems involved in pursuing a striking effect in a religious structure by using modern materials: the metal-framed Notre-Dame du Travail (Astruc 1901) and the reinforced concrete Saint-Jean de Montmartre (Baudot, 1897).

In the realm of domestic architecture, Adolphe Loos's house in Montmartre, with the freedom of its plan and elevation (*c.* 1925), was followed by the geometric houses and apartment blocks of Mallet-Stevens (1927). Le Corbusier, showing for the first time the full measure of his genius at the Savoye house at Poissy (1929), furnishes an interesting

comparison with the unified masses, set off by a rhythmical succession of long parallel bays, used by the Neo-plasticist Dudok at the Cité Universitaire (1927). The unfortunately much-reworked hostel of the Fondation Suisse, on the same site, by Le Corbusier (1930), is significant because of its conspicuous use of piles; the Maison de Verre, the house of Dr d'Alsace by Chareau (1931), has an all-glass wall, a feature which reappears in the Restaurant Universitaire (1965). After 1945, in fact, all these features became common currency, but without always being accompanied by enough inventive resource.

Auguste Perret was invited to design the building of the state furniture repository, the Mobilier National (1935), treated with sobriety in his severe style of engaged supports and panels; the former Musée des Travaux Publics is also by him.

The 'pleasure of living' is the quality in Parisian life that has been the most consistently praised over the centuries; in the Second Empire it manifested itself in the love of amusements: the city, like the court, plunged into a round of dances, serenades, comedies and farces. Another feature of the attraction of Paris in the nineteenth century is that celebrated by Baudelaire: *le spleen de Paris,* the melancholy that lay at the

Pavillon Turgot, Palais du Louvre, by Lefuel and Visconti, 1852-57. Pediment and caryatids by Guillaume and Cavelier.

The Guichets du Carrousel, Palais du Louvre, between the Pavillon Latremoille and the Pavillon Lesdiguières; pediment with bronze haut-relief of The Genius of the Arts *by Mercier, c. 1880.*

heart of its poetic enchantment, the strangeness of the great city where everything is in a continual state of flux, and where passions quickly reach flashpoint, the realm of the anonymous crowd which surges through the great halls of the new department stores, the love-affairs flaunted in the streets, the comic bustle of passers-by, the noise of the traffic and the seething mass of strangers and foreigners; all this inspired in the poet a new feeling of remoteness and alienation, of curiosity and self-containment. The great city had become a power, an intoxication, from which there was no escape; it acted on the sensibilities at a profound and intimate level, and there were moments of deep emotion when it was possible to imagine, in Valéry's words, that the city was 'thinking itself' in the mind of the poet. Baudelaire, through the attention he paid to weird accidents, strange combinations of circumstances, to the eroticism which hung 'in suspension' in the streets of the capital, opened up a fruitful channel of poetic experience which was to be pursued by Mallarmé, Apollinaire, Breton and Aragon. During the period from the Restoration to the first decades of the twentieth century popular literature became full of references to the secret life of Paris, its function as the haven of eccentrics, adventuresses, nightbirds, who held the promise of all kinds of wonderful encounters. The indefatigable tellers of tales of Parisian adventure, scandal and surprise, such as Restif de la Bretonne in his *Les Nuits de Paris* (or *Le Spectateur nocturne,* 8 vol., 1788-94) and Sebastien Mercier in his famous *Tableaux de Paris* (12 vol., 1781-90), were followed by a succession of new epic novels, sharper and less erotic than the eighteenth-century works. Eugène Sue's *Les Mystères de Paris* (1843) and Victor Hugo's *Les Misérables* (1862) provided readers all over the world with a conducted tour of the lower depths of Paris life. From this sprang the extraordinary fantasy version of Paris, in which the city's streets,

its bridges and its crowds become a setting for stories of terror, which appears in the *Fantômas* novels by Pierre Souvard and Marcel Allain. These extraordinary tales very soon inspired the silent film director Louis Feuillade; there was also in 1921-22, a Chaplin film called *A Woman of Paris*, which belongs to the same tradition, and in 1923 René Clair made his charming and magical *Paris qui dort*.

Another element which rapidly became an important and interesting feature of Paris life is the poster. In the collection of street-cries, *Cris de Paris*, illustrated by Bouchardon (1742), the billposter already appears. The proclamations of successive governments, calls to arms, and invitations to prospective customers, took shape on the walls of the city in the form of posters. The curiosity value of these was supplemented under the Third Republic by a new quality; a number of artists, tired of the prevailing low standards, decided to take over the walls themselves, by courtesy of the commercial advertisers. The pioneering efforts of Chéret, continued by Toulouse-Lautrec, Bonnard and many others, enabled Paris to claim the honour of having inaugurated around 1890 a new artistic genre, with a comical, ironic, vulgar and at times unashamedly poetic flavour which is an essential ingredient of the whole *fin-de-siècle* atmosphere. The art of the Parisian poster very soon succumbed to the effects of over-exploitation, and it proved difficult to recapture its original freshness; it still produced a number of gems, in the work of Cappiello, who arrived in the city in 1897, and in that of Paul Colin and a few others.

In the last resort, it is and always has been the Parisian crowd itself, with its shifting moods and its insatiable appetite for amusement, that accounts for the endless life and excitement of the boulevards. The twentieth-century tone was set by the new cinemas and music-halls, not forgetting the indispensable Musée Grévin, the waxworks in the Boulevard Montmartre, where all the heroes of the day are to be found. The dominant, indeed overwhelming, role played by Paris in the economical and political life of the nation is reflected in intellectual life and the arts. But there is a compensating factor, which is the stimulus contributed to Paris itself by successive waves of influence from abroad. First of all there was the English trend, with the *dandysme* which drew its inspiration from Byron and Beau Brummell, and which was put to use by Baudelaire, and the artistic influence of Constable's landscapes and the picturesque art of Bonington. The fashion for Spain produced the picture reportages of Dauzats, the travels of Théophile Gautier, the influence of Goya, the massive scope of Louis Philippe's 'Musée espagnol', the Spanish links of the court of Napoleon III. German influence brought Liszt in music, Cousin and Renan in philosophy. Russian influence brought with it the spread of the Tolstoyan gospel, Turgenev in Paris, and, later, the triumph of the Ballets Russes. Italian influence, which had been a perennial constituent of Parisian theatrical and musical life since the Renaissance,

▷

Gallery linking Pavillon Denon and Pavillon Mollien, Palais du Louvre, by Lefuel and Visconti, 1852-57.

P. 192/193
Church of La Trinité, by Ballu, 1861-67. The style is an eclectic pseudo-Renaissance, with a portico preceded by a terrace.

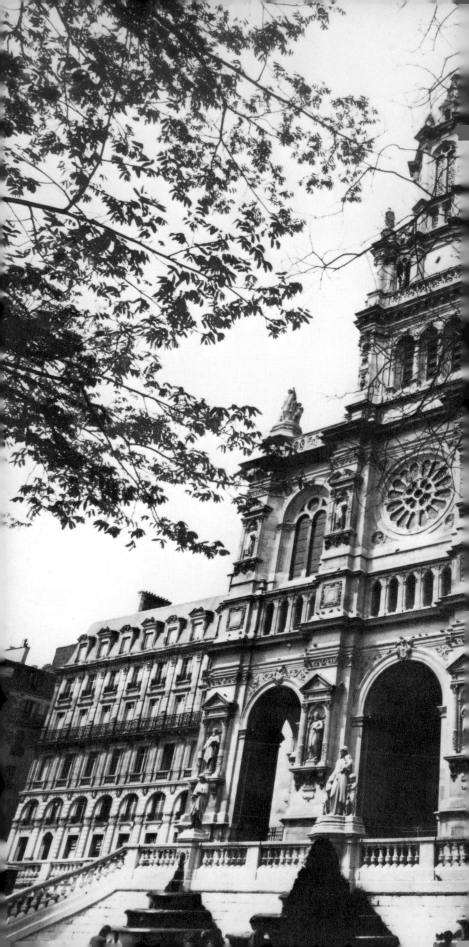

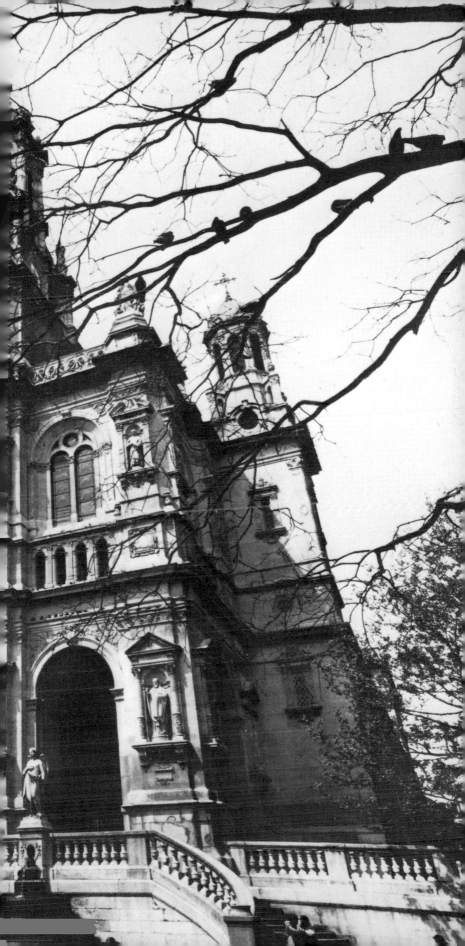

Statue of Mary Queen of Scots, in the Jardin du Luxembourg, 19th century. One of a group of figures of queens of France and other famous women which stand on the terraces of the park.

remained so for Stendhal, but was less important to Balzac. Rome and Venice still meant a lot to artists, but what came from Italy already belonged in the museums; it was part of the shared culture. In short, the welcome accorded at various times, out of curiosity or out of snobbery, to individuals, ideas and idiosyncrasies from foreign countries, the presence of visitors including writers and artists, and the friend-ships which they struck up, maintained a climate of cosmopolitanism which intensified during the second half of the nineteenth century and prevailed until the First World War.

Paris was perfect terrain not only for the profusion of 'novels of manners' which attracted the (rather undeserved) admiration of Nietz-sche, but also for the new currents of thought which captured the imagination of the intelligentsia of all the European capitals. It is striking that people as diverse as Sigmund Freud, Oscar Wilde, Henry James, Wassily Kandinsky and Rainer Maria Rilke should have come to Paris for certain elements indispensable to the development of their thought and their art. Publications such as the *Revue Blanche* regard-ed it as their mission to manifest the boldest and sharpest insights of contemporary international culture. There is wide agreement on the fact that the exhibition of 1900, for all its World's Fair vulgarities, marked the climax of a long process of cultural cross-fertilization. Long before then, the process had ceased to be a purely Western one; the discovery of Chinese art at the 1855 Exposition, the Khmer and Siamese pavilions at that of 1889, the fashion for Japanese prints, and the

innumerable books which came out of the process of colonization,
had all contributed, as had the Musée du Trocadéro, devoted to Indo-
china and founded in 1878 by L. Delaporte, and, a little later, the
Musée d'Ethnographie.

In parallel with this, new attitudes can be detected on the part of the
painters. The Romantics produced countless images of exotic passion,
on the theme of remoteness in space or time. It was above all the
painting that was done in Paris that benefited from the contributions
of other cultures: Dutch art (the Barbizon school), the German and
Davidian neo-primitives (Flandrin, Mottez), Raphael and his precursors
(Ingres and his school), Rubens and Titian (Delacroix), the school
of Caravaggio (Ribot and Bonnat), the Spanish and Flemish use of
paint (Courbet and the early Manet), the curious elegance of Japanese
prints (Tissot, Manet, Whistler), and, after the exhibitions of Eastern
and 'barbaric' art, the alien forms of Asia and the Pacific (Gauguin).
This state of receptivity turned Paris into an exceptionally sensitive
sounding-board, in which every artistic temperament found a stimulant.
Independent artists were provided with an accumulation of suggestions
and technical resources which equalled that with which the art of the
acknowledged masters furnished the practitioners of official eclecticism.
But in the midst of this rich culture, one direction clarified, that of
modernity. This linked the painters who were attached to the symbols
of passion (Delacroix) or to the powerful images which spring from
the transposition of everyday life (Manet) with those who kept in

mind only the shimmering of sunlight on familiar settings and subjects, the iridescence of the moment, the grace of the hours, the freshness of perception: the Impressionists. Grave and almost Baudelairian in Manet, this new freedom is applied in Monet and Renoir to garden scenes, walks, Sunday parties beside the water. The products of industry are freely incorporated, amid the shimmering of the air and its vapours, as are the movement of cabs and the reflections given off by bottles in a bar: Monet painted the *Gare Saint-Lazare*, Pissarro the *Avenue de l'Opéra*. Degas records dancers, horse races, passers-by in

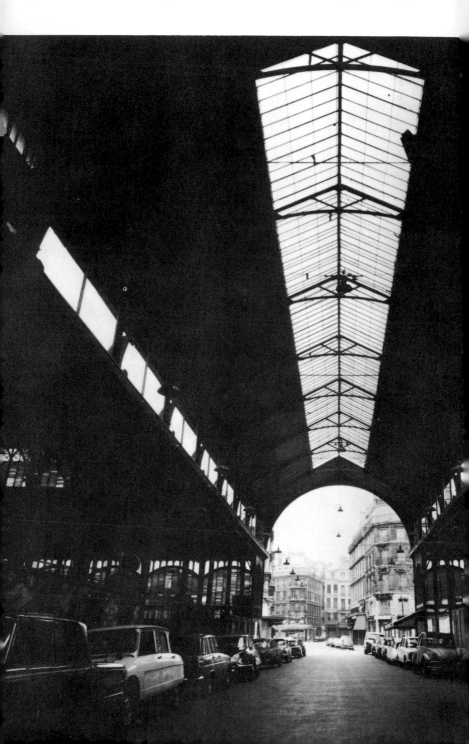

lively silhouette. And each contrives to capture all these effects through brushwork and colour combinations that are completely unprecedented. Impressionism has many local ties, in particular with Normandy and the Ile de France, but as a total phenomenon it could have come into existence only in Paris. In sculpture, similarly, Carpeaux and Rodin set out to do justice to a powerful and turbulent environment.

The abrupt expansion of industrial and commercial life within the Parisian conurbation initially followed certain predetermined lines: railways, roads and waterways. The satellite town of Saint-Denis, whose

Halles Centrales, by Baltard, 1851 onwards. A major achievement of the architectural use of iron; disused after the beginning of 1969, when the food markets moved out.

P. 198/199

Great staircase of the Opéra, by Garnier, 1862-75. The decorative paintings in this ornate setting are by Pils.

197

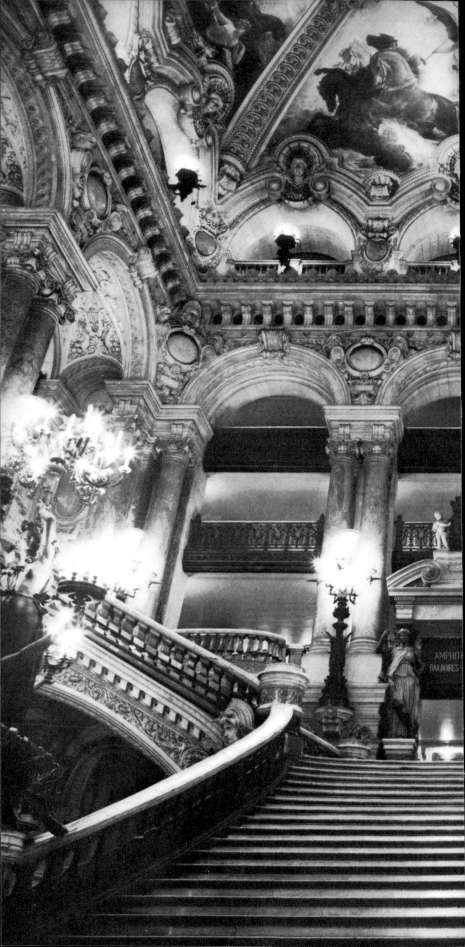

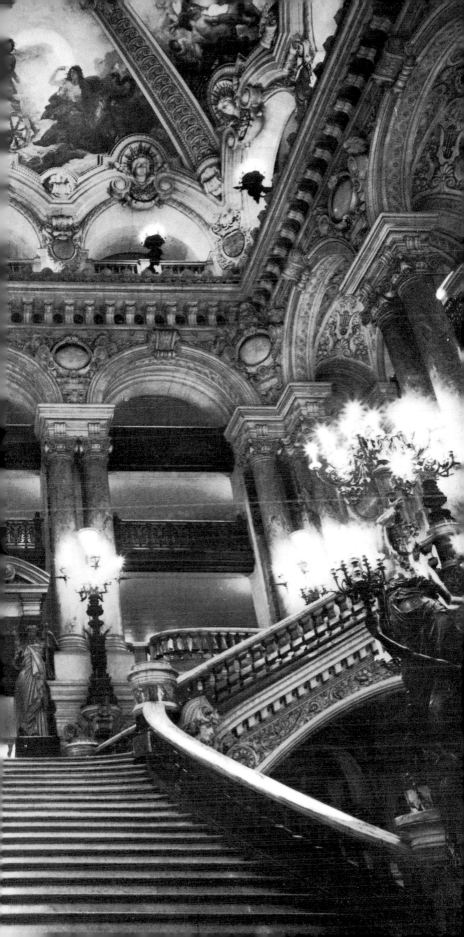

royal basilica had suffered severely at the Revolution, changed its character completely and was soon surrounded by the typical suburban sprawl of factories and sheds. Seurat captured the promenade of the Ile de la Grande Jatte just before the island in question, together with the whole zone north of Paris, was submerged in the amorphous flood of new industrial development. By a sort of intuition which is not as rare as it might seem, the painters rediscovered the royal rides of the Ile de France. Early on, in about 1860, in a corner of the Forest of Fontainebleau, at Barbizon, there gathered the group of *paysagistes,* landscape painters inspired by the example of the Dutch school, which was made up of Théodore Rousseau, Dupré and Millet. From that time onward the attraction of the site never failed. The Impressionists, too, loved the banks of the Seine and the Oise; they met at Argenteuil and at Auvers, where they were taken by Pissarro, and where Van Gogh was to come to die. Gauguin's personal corrective to the impact of industrial society lay further off, in a Brittany which seemed closer to prehistory than to the industrial revolution; but his admirers held their meetings in the Parisian countryside, at Maurice Denis's house at Saint-Germain en Laye; all the villages around had their own painters.

A perennial refuge for revolutionaries, voluptuaries and aesthetes, Paris periodically absorbs writers and artists who adopt it as their home: in the mid-nineteenth century it was the Polish painter Michalowski, later the Italian Zandomeneghi, the lively Boldini, painter of fashionable portraits, the subtle and tormented Modigliani, the Czech Mucha, prince of the Art Nouveau poster; and of course, after 1900, the youthful Pablo Ruiz Picasso and his Spanish friends. Then, at the time of the Russian pogroms, came the Jewish celebrators of anguish and jubilation, sensuality and torment: Soutine, Chagall, Pascin, Kisling, Zadkine. Often grouped in little exile colonies, these painters and sculptors found their spiritual home in Paris between the wars, forming what has for the sake of convenience been dubbed the Ecole de Paris. Artists of all the various detachments of the avant-garde joined in common events, as did those who stood on the margin of all the schools, preferring to keep at their disposal all the old technical instruments. The ultimate success of these men, who had formerly been generally vilified, was the triumph of that era when Paris was the great city of welcome, open to all in a climate of gentle anarchy.

All these convivial and often conspiratorial artistic gatherings and clubs, native and foreign, were in their heyday in a time when the gap was widening between serious, useful, profitable activities on one side and art on the other; art was starting to keep its distance from bourgeois ideology. A case in point, under the Second Empire, was the Café Guerbois, where one might meet Manet and Degas. Again in the years leading up to the First World War, the vitality of Marcel Duchamp and his brothers briefly attracted to Puteaux, in the midst of the faceless suburbs, the adherents of a 'cubist' movement dominated by deliberation and theory. But Montmartre and Montparnasse are more complex phenomena. The closeness of places of amusement such as bars, circuses, cabarets; the close contact with a population of poor people, often in trouble with the law, cynical and lively, and not yet romanticized in fiction; the taste for improvised domestic arrangements; the reluctance of youth to compromise; and the pleasure of beginning again from scratch, and in freedom, created on the slopes of the Butte, around certain streets in the 14th *arrondissement*, and in the rickety

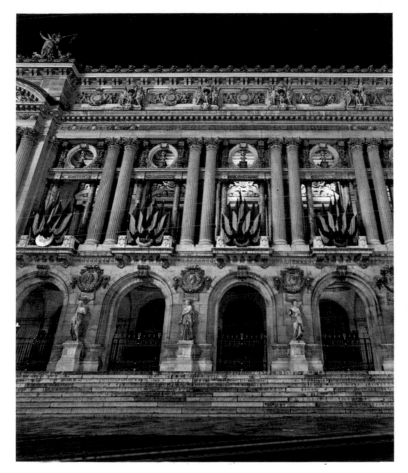

Opéra, by Garnier, 1862-75. The ornate façade is characteristic of the style of the Second Empire.

buildings of the so-called Beehive (Ruche) in the Passage de Dantzig, a unique atmosphere, compounded of gaiety, courage and resourcefulness, within a context of non-conformism. The Académic de la Grande Chaumière was founded in 1870; Gauguin returned from Tahiti to settle in the rue Vercingétorix in 1893; and Paul Fort, who has been called 'the true creator of modern Montmartre' (André Salmon), held court at the Closerie des Lilas. After 1945, another 'village' of intellectuals and artists came into being at Saint-Germain des Prés, with its own heroes, its own folklore, its own songs, and its cellars (*caves*), soon to be overrun with tourists.

Not all the history of modern art – architecture apart – can be interpreted in terms of the protracted conflict which, from Romanticism onwards, was carried on between the official masters of the Academy, dominating the annual Salon, and the unrecognized innovators. The annual Salon served to crystallize the opposing tendencies, until the moment when new organizations – the Société des Artistes Indépendants, the Salon d'Automne – gave everyone the opportunity to exhibit, and gave full rein to controversy. What was known as official art was not a homogencous entity. It is true that major decorative commissions for public buildings went to recognized painters;

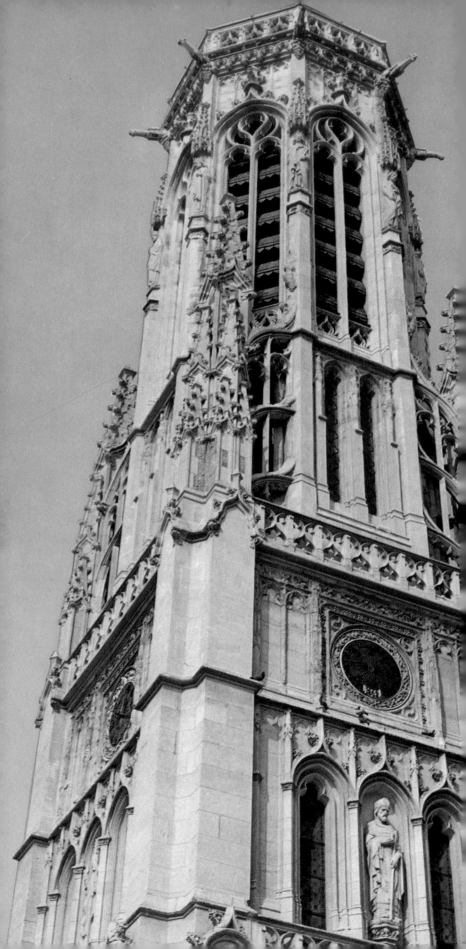

Saint-Germain l'Auxerrois. The
belfry by Ballu, 1860.
Frémiet: Seahorse, detail of the
Fontaine de l'Observatoire, built
by Davioud, 1875.

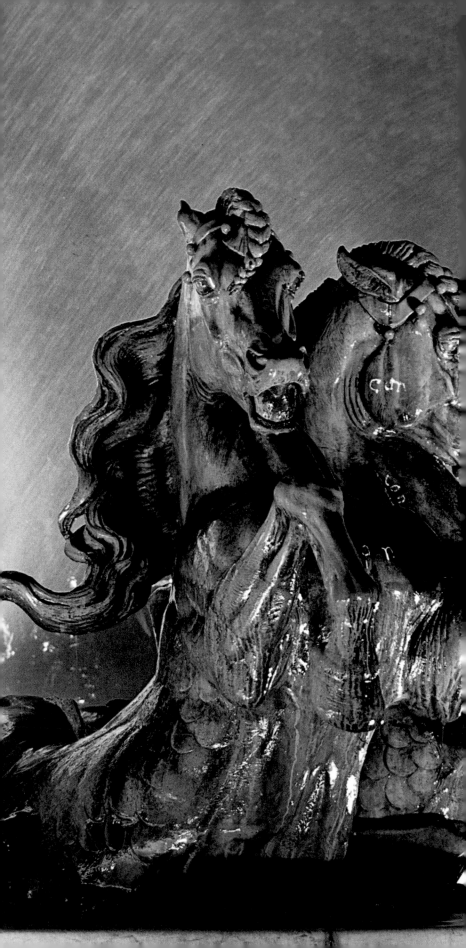

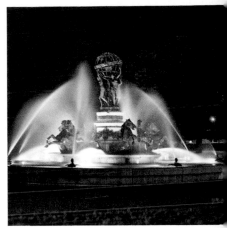

◁
Carpeaux: The Four Parts of the World, *detail of the Fontaine de l'Observatoire. A sumptuous and justly famous composition.*

P. 206/207
Petit Palais, by Girault, 1900. Built for the Exposition Centennielle, facing the Grand Palais on the approach to the Pont Alexandre-III. Its elegant façade has a monumental porch with, on the tympanum, an allegorical representation of the City of Paris.

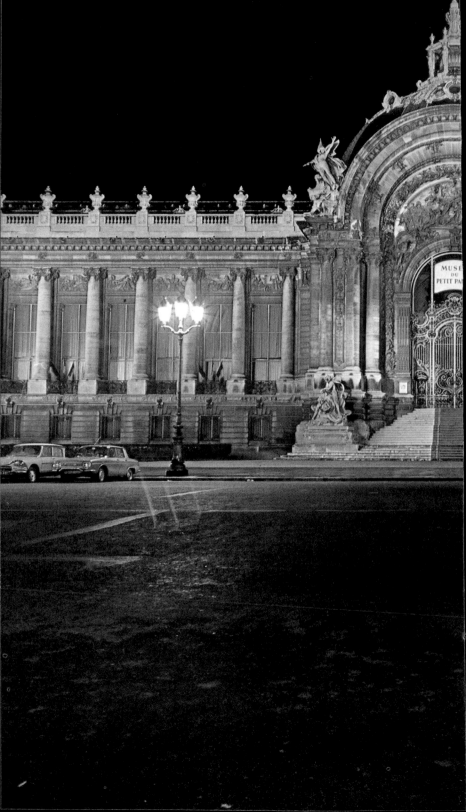

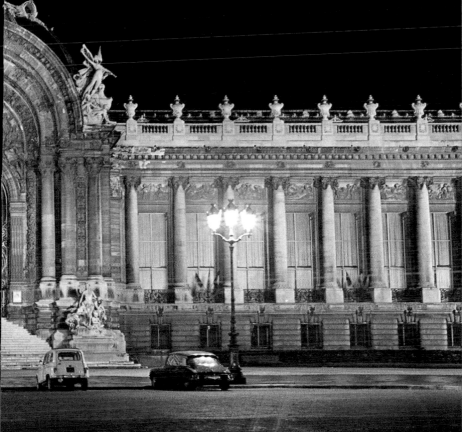

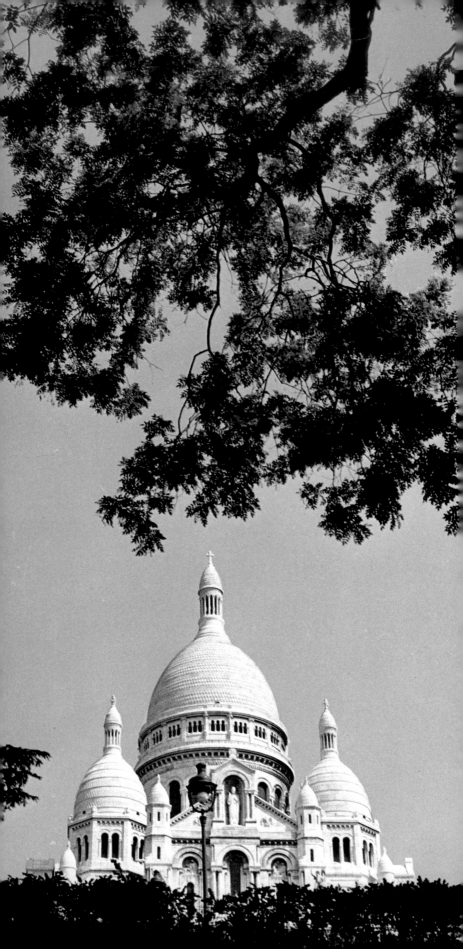

but Delacroix was entrusted with the Chapelle des Saints-Anges in Saint-Sulpice (*Jacob and the Angel* and *The Punishment of Heliodorus*, completed 1861); Puvis de Chavannes was invited to work with the 'official' artists at the Panthéon and at the Sorbonne; and Albert Besnard, in his decorations at the Ecole de Pharmacie, is not always so very far from the style of Vuillard and his school (the Nabis), who were often commissioned to do decorative panels for private houses. The smug inanity of Bouguereau and Gérôme, and their disdain for Manet and Cézanne, might be paralleled in any age; and, although Seurat was still unrecognized by the authorities in 1920, in the next generation Léger, Dufy, Picasso and Miró were afforded the opportunity to tackle large-scale compositions, and other artists, who lacked the aptitude for monumental works, found their way into private and public collections.

Since the end of the nineteenth century the little commemorative museums, linked to the presence of a writer or an artist, have proliferated in Paris. Like the plaques which commemorate Oscar Wilde, Wagner or Proust in certain streets, they are part of the Parisian consciousness of the past. One thinks of the Musée Balzac, in the rue Berton, the delightful Musée Gustave Moreau, in the rue Fontaine (1896), the Musée Henner, Avenue de Villiers (1934), and the municipally-owned Musée Bourdelle, rue Antoine-Bourdelle (1944).

As in many European towns, the conversion of certain buildings into museums in the nineteenth century was the only way of preserving them from destruction. Thus, in 1844 the Roman baths off the Boulevard Saint-Germain were formed, together with the neighbouring Paris residence of the abbots of Cluny, into the Musée de Cluny. This was later enriched by a number of major acquisitions including the famous tapestry of *La Dame à la Licorne* (in 1882). The Hôtel Carnavalet, acquired by the municipality in 1866, was turned from 1880 onwards into a great museum of the history of Paris which eventually overflowed into the former quarters of the Bibliothèque Historique de la Ville de Paris, in the former Hôtel Le Pelletier de Saint-Fargeau and the adjacent orangery, when that library moved to its present site in the Hôtel d'Angoulême in 1968. The old monastery of Saint-Martin des Champs, which has housed the Conservatoire des Arts et Métiers since the Revolution, contains a museum of machinery in the former church and a library in the refectory. In the Hôtel de Miramion, on the Quai de la Tournelle, which has come under the department of hospitals since 1810, there is now a Musée des Hôpitaux. In a part of the Hôtel Choiseul, rue Saint-Romain (1732), there is a small postal museum. The house in the Place des Vosges where Victor Hugo lived from 1832 to 1838 has been the poet's own museum since 1902. It possesses, in particular, besides his surprising 'sculptures', more than three hundred drawings which are essential to the understanding of his genius. The Hôtel Biron (1729) became State property in 1904 and was turned over to a colony of artists; in 1910 it was given to Rodin, and it is now the Musée Rodin, containing his works, including maquettes and drawings and his personal collections. Outside Paris

◁
Sacré-Cœur, Montmartre, by Abadie,
1876 onwards. Tower 94 m. (305 ft) high, by Magne, 1905-10.

there are small commemorative museums at the former artists' colonies of Barbizon, Milly-la-Forêt and Auvers-sur-Oise.

In 1882, in the early years of the Third Republic, two major initiatives led to two unusual museums. The first was the Musée des Monuments Français, at the Trocadéro, which is a collection of casts accompanied by a whole educational aparatus. It has since been supplemented by a Musée de la Fresque, consisting of tracings of mural paintings which all too often, alas, are the only record of lost originals. The other museum is the Musée des Arts Décoratifs, in the Pavillon de Marsan (part of the Palais du Louvre), which, under the direction of a private association, the Union Centrale, has become a rich collection of paintings, decorative pieces and tapestries of all ages. The same association is responsible for the Musée Nissim de Camondo (1936), which specializes in the eighteenth century. The City of Paris owns the Musée Cognacq-Jay (1928), also containing many eighteenth-century works. The Institut de France, the body which incorporates both the Académie Française and the Académie des Beaux-Arts, owns two remarkable establishments that are not seen by enough people. The Musée Jacquemart-André (1912), in a town house built to the taste of the *haute*

Lamp standard on the Pont
Alexandre-III.

Pont Alexandre-III, by Resal
and Alby, 1896-1900. A single
metal span, 107.5 m. (347 ft) long,
and 40 m. (130 ft) wide,
richly ornamented with swags, lamp
standards, statues and figures
of marine deities.

bourgeoisie of a hundred years ago, contains a number of important works of the Italian Renaissance and the eighteenth century, all acquired through dealers; and the Musée Marmottan (1932), containing Paul Marmottan's extensive collection of Napoleonic relics and works in the Empire style, has an added room full of extraordinary Impressionist paintings. There is also, at Boulogne-sur-Seine, a Bibliothèque Marmottan rich in First Empire documents.

The magnificently rich and varied resources of the collections made it possible to set up in the Louvre, once the palace had been finally made over as a permanent place of exhibition, a vast museum of art which

Pont de Bir-Hakeim, built 1906. Known until 1949 as the Pont de Passy; built to carry the elevated section of the Métro as well as a road.

was given its final form under the Second Empire. The additions to the collections of early paintings since then have not been extensive enough to upset the relative distribution of the various schools. The collection has, however, received a number of major additions, notably the Lacaze bequest of thirteenth-century works, and the Moreau-Nelaton bequest (1923 and 1927) of nineteenth-century works.

Long considered as the temple of art, the place where the final seal was set on an artist's reputation, the Louvre was the subject of a number of what now seem particularly archaic disputes on certain occasions when donors tried to present works by modern painters. The affair of

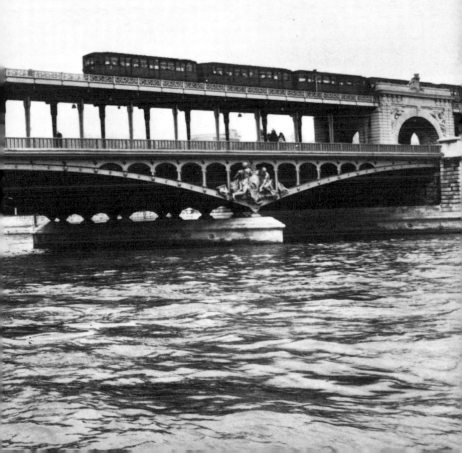

(above) 29 avenue Rapp, by Lavirotte, 1900. One of the masterpieces of Art Nouveau architecture.

Castel Béranger, by Guimard, 1894-98.
The front doorway has vegetable ornaments which may be compared with the Métro entrances designed by the same artist.

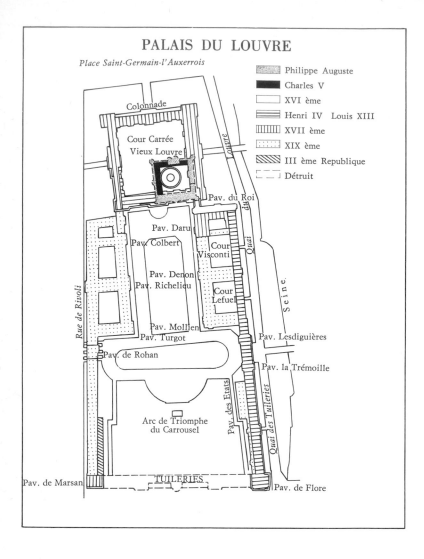

PALAIS DU LOUVRE

Place Saint-Germain-l'Auxerrois

Philippe Auguste
Charles V
XVI ème
Henri IV Louis XIII
XVII ème
XIX ème
III ème Republique
Détruit

Colonnade

Cour Carrée
Vieux Louvre

Pav. du Roi

Pav. Daru
Pav. Colbert
Cour Visconti

Pav. Denon
Pav. Richelieu
Cour Lefuel

Pav. Mollien
Pav. Turgot
Pav. de Rohan

Pav. Lesdiguières

Pav. la Trémoille

Arc de Triomphe
du Carrousel

Pav. des Etats

Rue de Rivoli

Louvre

Quai

Seine

Quai des Tuileries

Pav. de Marsan

TUILERIES

Pav. de Flore

Manet's *Olympia*, which was accepted only after a full-scale campaign to mobilize public opinion, and at the personal insistence of Clemenceau (1908), has remained the classic instance of academic obstructionism. The Caillebotte collection was accepted in 1886 only after twenty-nine paintings had been excluded; but it did bring to the Louvre sixty or so essential works, including Manet's *The Balcony* and Renoir's *Moulin de la Galette*. Twenty-three years later, Isaac de Camondo, who also left to the State an exceptional collection of eighteenth-century furniture (the Musée Nissim de Camondo), rounded off the Louvre's Impressionist collection by contributing some Cézannes,

P. 215

Céramic Hôtel, by Lavirotte, 1904. Employs an uninterrupted string of Art Nouveau vegetable ornament.

▷

Archer of the royal guard, relief from the Palace of Darius at Susa. Enamelled brick. Persian, 5th century B.C. *Musée du Louvre.*

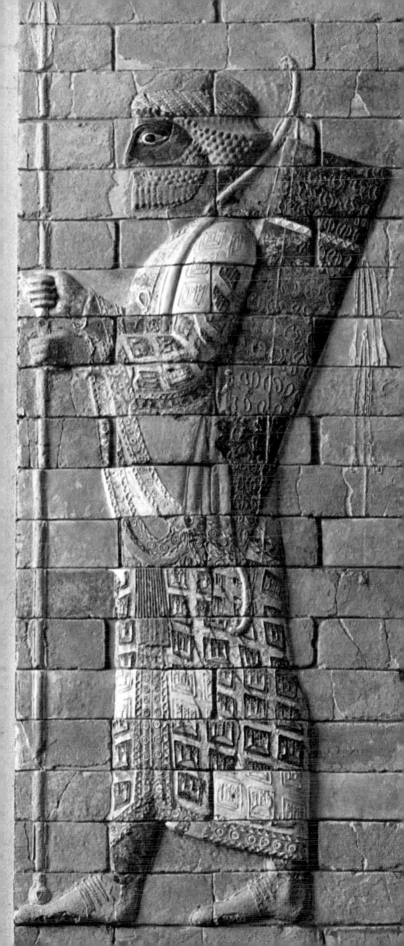

Leonardo: Mona Lisa, c. *1505. This portrait
of Mona Lisa di Giocondo was brought to
France by the artist himself in 1517,
and remained one of the most famous pictures
in the royal collections. Musée du Louvre.*

including *The House of the Hanged Man* and *The Card-players*, and a number of works by Degas including *Absinthe*. The Impressionist collection deserved a special display, and the further bequests of Paul Gachet contributed to the decision to give them a building of their own, the Jeu de Paume, on the terrace of the Tuileries. This was opened in 1947 as the Musée de l'Impressionnisme and has existed in its present form since 1958. On the other side of the same garden there is the building known as the Orangerie, where two rooms are set

Renoir: Moulin de la Galette, 1876. *All the plebeian charm of Montmartre, seen by the most sanguine of the Impressionists. Musée de l'Impressionisme.*

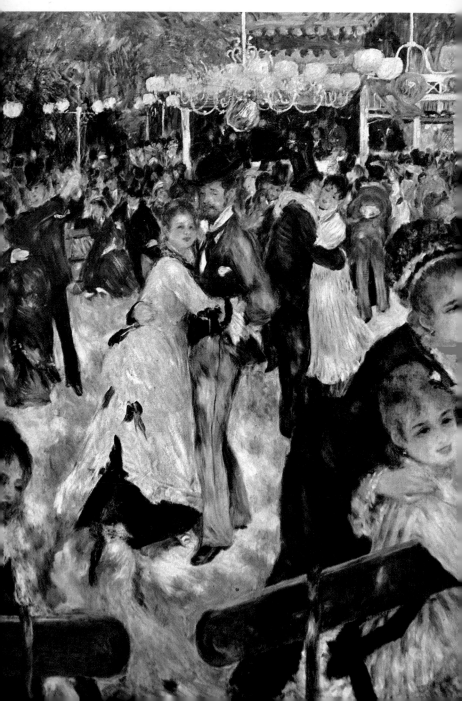

aside for the *Water-lilies* of Claude Monet, a series of huge canvases painted in 1915 at Giverny.

The other departments of the museum underwent spectacular developments in the course of the nineteenth century. The interest of French scholars in ancient Egypt, which dates from Bonaparte's expedition, led to the growth of the Egyptian section; and the expeditions of Renan, Dieulafoy and others resulted in the accumulation of a remarkable Assyrian collection which includes a huge fragment of the Frieze

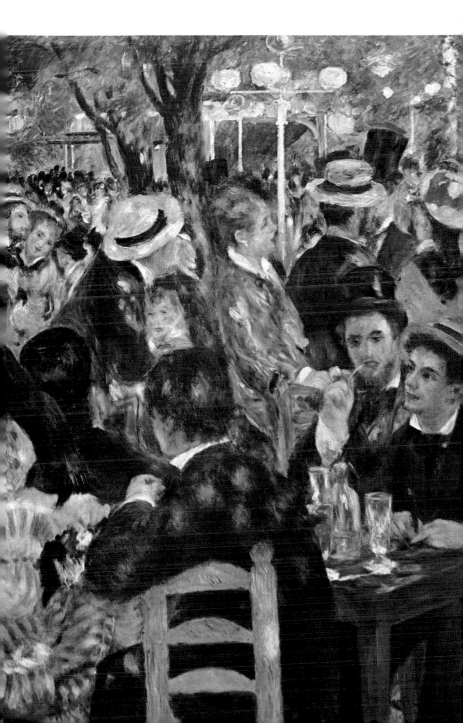

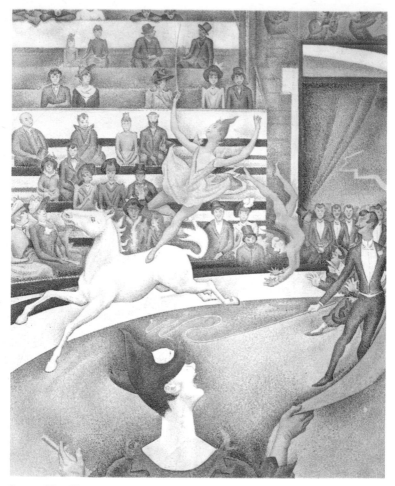

Seurat: The Circus, 1890-91. *One of the last major works of the master of Neo-Impressionism. Musée de l'Impressionnisme.*

(below) Delaunay: The City of Paris, 1910. *The Tower, symbol of the desire for modernity. Musée National d'Art Moderne.*

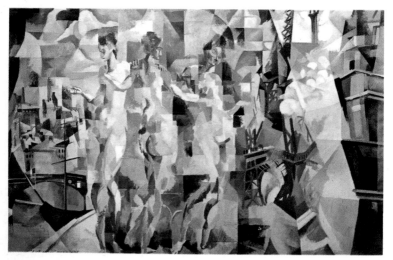

of the Archers from Persepolis. Meanwhile the department of classical antiquities had sensational acquisitions such as the Venus from the island of Melos and the winged Victory which adorned the trophy of Samothrace. Other departments include that of bronzes and medals, which serves to complement the magnificent collections of the Cabinet des Médailles, at the Bibliothèque Nationale; this comprises some forty thousand pieces, as well as a number of historic objects such as the throne of Dagobert and the Roman jewel known as the *Grand Camée de France*. The Cabinet des Dessins, the collection of drawings at the Louvre, with its works by Mariette and Crozat, is beyond comparison; but for prints the place to go is the Cabinet des Estampes at the Bibliothèque Nationale. There is, however, a separate and considerable collection of drawings and prints at the Louvre, built up around the collection of Edmond de Rothschild. Since 1920, the Louvre has also administered, through its department of *objets d'art*, the Musée de Cluny. The department of Oriental art was transferred in 1945 from the Louvre itself to the Musée Guimet, where its collections were amalgamated with those of the old Trocadéro and the Guimet collection itself. The importance of this institution rests on its discoveries from Bagram, Hadda, Gandhara and Cambodia; it has a municipal counterpart, the Musée Cernuschi, housing the bequest of a Parisian collector (1895).

Works by living French artists acquired by the State after 1818 were always housed in the orangery of the Palais du Luxembourg; foreign works were at the Jeu de Paume. When the latter was given over to Impressionism, after the Second World War, it was decided to assemble all the State-owned works later than the 1890s – the generation of the Nabis – in a new collection to be known as the Musée National d'Art Moderne. This was opened in 1947, in an undistinguished building left over from the exhibition of 1937. It had been left rather late; and the collection had yawning gaps which would never have been filled if it had not been for the spectacular bequests, during the 1960s, of a number of artists including Brancusi, Segonzac, Dufy, Delaunay and Rouault.

One peculiarity of Paris is the way in which the nationally-owned galleries of art are paralleled by municipal institutions. The Petit Palais, with its ceiling paintings by Besnard and Denis, was built by Girault in 1900 to house the collections of the city of Paris, including many eighteenth-century paintings, as well as enamels, Oriental pieces from the Dutuit collection, and masterpieces by Courbet, donated by his sister Juliette, and Vuillard. The Musée d'Art Moderne de la Ville de Paris, even less well arranged than its national counterpart, which it adjoins, contains the notable collection of Dr Girardin (Rouault, the Fauves, etc.).

Other public buildings of interest from the point of view of modern art are the imposing Théâtre des Champs-Elysées by the brothers Perret, whose spacious and elegant interior is decorated with sculptures

◁
Brancusi: The Kiss, *1910. The earliest Parisian example of this artist's strong and sober style. Montmartre cemetery.*

P. 223

Toulouse-Lautrec: Jane Avril Dancing, *1892. The art of poster design was to transform Paris streets. Cabinet des Dessins, Musée du Louvre.*

Victory of Samothrace. Hellenistic, c. 200 B.C. Discovered on Samothrace in 1863 by the French consul Champoiseau, it was brought to France in the same year. Beside the statue is displayed the right hand, found in 1950. Musée du Louvre.

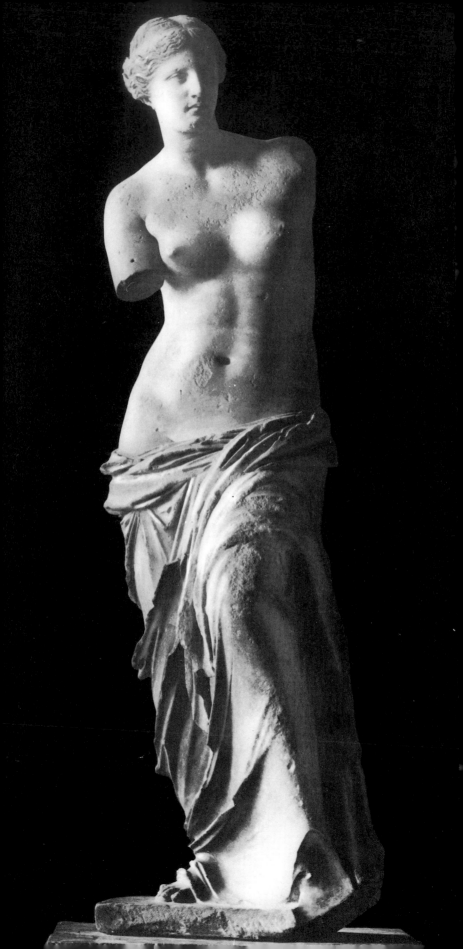

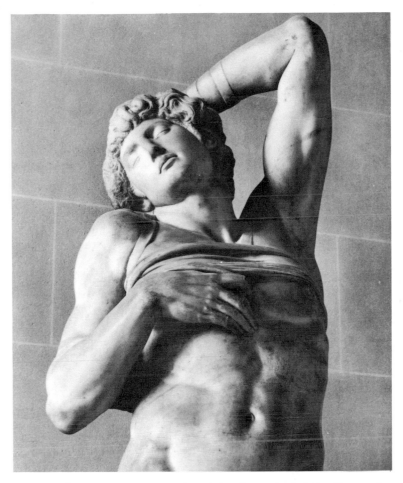

Michelangelo: Slave, c. *1513 14. Carved for the tomb of Julius II, a project which was never carried to completion. The artist presented it to R. Strozzi, who gave it to Connétable Anne de Montmorency. It later found its way into the Musée des Monuments Français. Musée du Louvre.*

by Bourdelle and paintings by Vuillard. More recently, the desire to bring modern art into the decoration of national institutions led to the commissioning of Chagall's brilliantly coloured, swirling ceiling paintings in the auditorium of the Opéra, and André Masson's powerful composition in that of the Odéon (both 1966).

In the 1950s there began a new wave of urban expansion which threatened to be as uncoordinated, and hence as dangerous, as those that had preceded it. The official response to this took the form of the setting up of the District de Paris, an authority whose function was to work out the plans necessary for the megalopolis that Paris will be in 1980. One happy decision was the siting of a new urban development round the Rond-Point de la Défense, north of Neuilly (an

◁

Vénus de Milo. Hellenistic, end of 2nd century B.C. *The most celebrated ancient work of art in Paris, discovered on Melos in 1820. Musée du Louvre.*

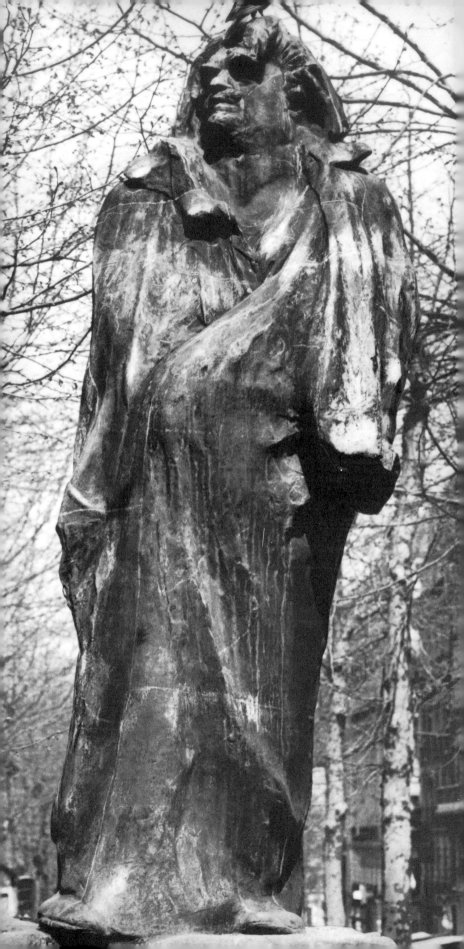

Picasso: Head of Woman, *1959. Monument to the poet Guillaume Apollinaire, in the Square de Saint-Germain des Prés.*

intersection named after the resistance to the besieging Prussian army in 1871). The Avenue du Général de Gaulle, which runs up to it, forms part of the continuation of the axis of the Champs-Elysées which was projected as early as the seventeenth century; around the immense three-cornered exhibition hall of the CNIT, the Centre National des Industries et Techniques (by Camelot, de Mailly and Zehrfuss, 1957-64), rise the mighty skyscraper blocks of the great industrial

◁
Rodin: Balzac, c. 1880. Bronze. *After remaining highly controversial for many years, this statue was set up in 1939 in its present position at the intersection of the Boulevard Montparnasse and the Boulevard Raspail.*

231

and commercial concerns. To the south of Paris another line of expansion is marked by Orly airport, with its elegant layout (soon to be extended), by a number of new towns, and by the new central markets at Rungis, with their road transport depot (markets opened in 1969), built to replace the old Halles in the centre of Paris.

West of the Eiffel Tower, the townscape was altered by the fine circular building of the ORTF, the Office National de la Radiodiffusion-Télévision Française (Henri Bernard, 1964) and the new high-rise riverside development at Grenelle (Lopez and Pottier, 1964 onwards). The Y-shaped Unesco building (Breuer, Nervi and Zehrfuss, 1954-58) was designed with a view to preserving the nature of the site of the Ecole Militaire, which had already been somewhat disfigured; artists from all over the world – Calder and Miró outside, Picasso, Afrò, Appel and others inside – were invited to decorate it.

Other high-rise structures, built or projected, will profoundly alter the Paris skyline: particularly the Maine-Montparnasse complex, a giant commercial centre (Lopez, Beaudoin and de Marion, 1964 onwards); this is to be topped by a 650-foot tower block which is as debatable an idea as is the siting of the whole complex, too close to the existing centre and ill-provided with approach roads.

All these transformations have aroused a stronger consciousness of responsibility for the conservation of the city. Examples are the study group devoted to the defence, restoration and revival of the superb seventeenth-century district of the Marais (headquarters 24 rue François-Miron) and the successful 1968 campaign to save from wanton destruction Baltard's superb iron cages on the vacant site of the Halles. The interest in old houses, and, above all, old neighbourhoods, cannot arrest the feverish pace of modern development; but it can at least recall to mind things that all the architecture of the future will need to take into account.

All these resources of the city give it an incomparable cultural status; but they do not necessarily make it easier to know Paris as it is. The abundance of chronicles, treatises, histories and novels, which enshrouds in a literary mist all the phenomena that make up Paris life, still leaves a wide field for explorations and surprises. It would be unthinkable not to take advantage of it. But contact with the inhabitants, observation of their habits, their ways, their words, is not so easy as it looks at first. There is in this cosmopolitan city a curious tendency, which eludes superficial scrutiny, towards a sort of neighbourhood provincialism.

Perhaps the trait which most Parisians have in common is a lively awareness of the value, and the fleeting nature, of the present moment. All the dimensions of culture are present in Paris, and Parisians perhaps have a tendency to deceive themselves about the extent of the privileges which are theirs, and which they seem to regard as a birthright. But

P. 233, 234/235, 236, 237
Tour Eiffel, 1887-89.

P. 238/239
Map showing principal monuments and museums of Paris.

P. 240
The Avenue des Champs-Elysées at night.

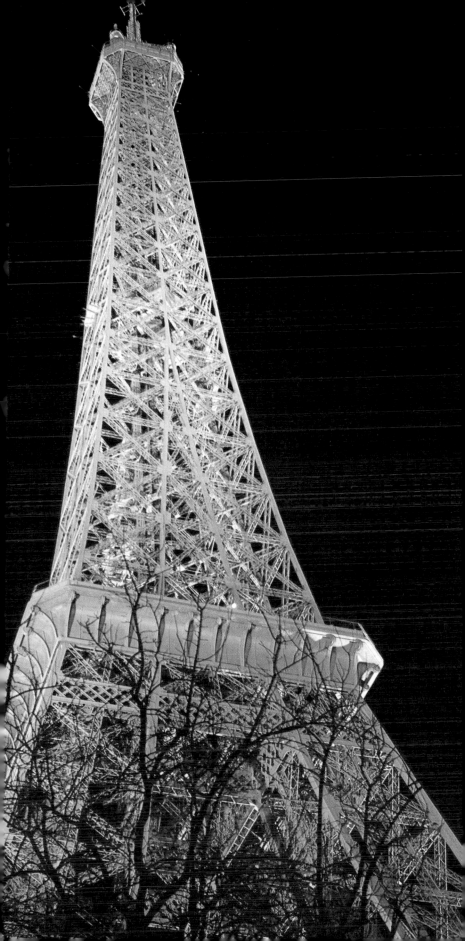

the most precious constituent of the Parisian atmosphere, instinctively nurtured by those who live their lives there, is the invitation to grasp all that is precious in the present moment, to extract happiness from the intuitive awareness of an instant in time. This subtle property, which is what endears the city to so many for whom it is an indispensable constituent of their lives, goes hand in hand with its power

to arouse and maintain an unending curiosity. This power, which Balzac was aware of, has nothing mysterious about it: it is the product of the slow work of time, the shapes of objects, their endless connection in space and in time. Balzac knew this, and this is why he wrote, in *Ferragus,* 'The streets of Paris have human qualities, against which we have no defence.'

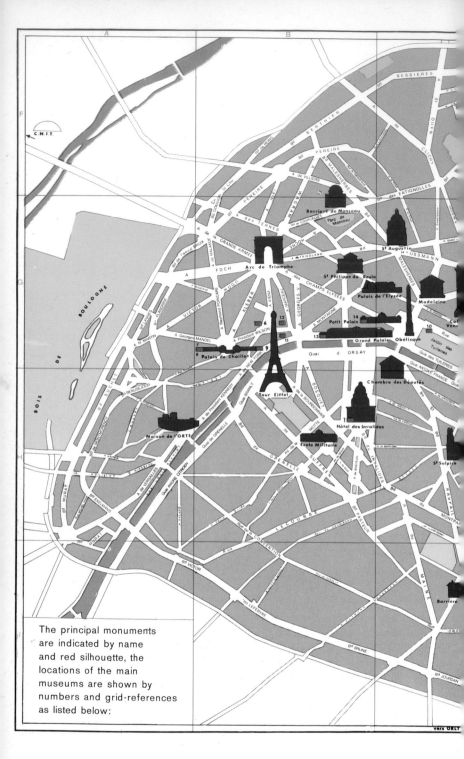

The principal monuments
are indicated by name
and red silhouette, the
locations of the main
museums are shown by
numbers and grid-references
as listed below:

Musée de l'Armée, *Esplanade des Invalides, VIIe* [B H 1]
Musée des Arts Décoratifs, *107 rue de Rivoli, Ier* [C G 3]
Musée Carnavalet, *23 rue de Sévigné, IIIe* [D H 4]
Musée de Cluny, *6 place Paul Painlevé, Ve* [C H 5]
Musée Galliera, *10 avenue Pierre Ier de Serbie, XVIe* [B G 12]
Musée Guimet, *6 place Iéna, XVIe* [B G 6]
Musée de l'Homme, *place du Trocadéro, XVIe* [B G 7]
Musée du Jeu de Paume, *Jardin des Tuileries, Ier* [C G 10]

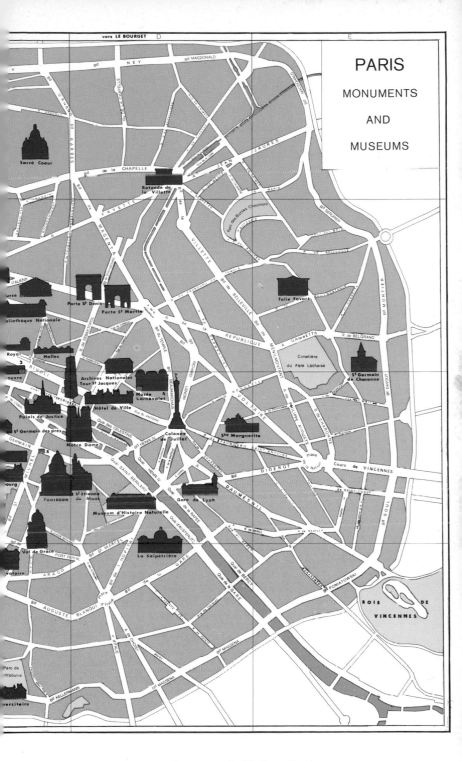

PARIS

MONUMENTS

AND

MUSEUMS

Musée du Louvre, *Cour du Carrousel, Iᵉʳ* [C G 2]
Musée de la Marine, *place du Trocadéro, XVIᵉ* [B G 8]
Musée des Monuments Français, *place du Trocadéro, XVIᵉ* [B G 9]
Musée Municipal d'Art Moderne, *11 avenue du Président Wilson, XVIᵉ* [B G 11]
Musée National d'Art Moderne, *11 avenue du Président Wilson, XVIᵉ* [B G 11]
Musée du Petit Palais, *avenue Alexandre III, VIIIᵉ* [B G 14]
Palais de la Découverte, *avenue Franklin Roosevelt, VIIIᵉ* [B G 13]

Museums and Galleries

Numbers in italic refer to the captions

Bibliothèque Nationale:
Cabinet des Médailles
58 rue de Richelieu, II. Open daily (except Sundays and holidays), 9.30–12, 1.30–4.45.
Created under Charles V, systematically reorganized by Colbert to contain the royal collections. Includes some 400,000 coins, cameos, intaglios; works of art from ancient Greece, the Middle Ages, the Renaissance and modern times (bronzes, vases and jewels). *18, 225.*

Musée de l'Armée
Hôtel des Invalides, Esplanade des Invalides, VII. Open daily (except Tuesdays and Sunday mornings), 10–12.15, 2.30–5.30 (winter), 2.30–6 (summer). Charge for admission.
Founded in 1905. Combines the collections of the Musée de l'Artillerie, established in 1794, and the Musée Historique, founded in 1896. Important collections of arms and armour of the 16th and 17th centuries. Among the paintings the most important are works by Van der Meulen (showing towns captured in 1677) and a portrait of *Napoleon I* by Ingres.

Musée d'Art Moderne
de la Ville de Paris
Palais de New-York, 11 avenue du Président-Wilson, XVI. Open daily (except Tuesdays), 10–12, 2–6. Charge for admission (free on Sundays).
Created in 1961 to house painting and sculpture since 1914. Good collections of Rouault, Gromaire and Dufy, one of whose masterpieces, *La Fée électricité* (1937), decorates a rotunda in the building.
On the ground floor, a Museum of Costume established in 1956 houses a collection presented by the Société de l'Histoire du Costume and by private individuals: 12,000 items and 2,000 complete costumes dating from 1725 to the present day, shown chronologically. The museum is an annexe of the Musée Carnavalet. The opposite wing of the Palais de New-York houses the Musée National d'Art Moderne. *225.*

Musée des Arts Africains
et Océaniens
293 avenue Daumesnil, XII. Open daily (except Tuesdays), 2–5.30 in winter, 2–6 in summer.
Established in 1935, in a building on the edge of the Bois de Vincennes designed for the Exposition Coloniale of 1931. History and art of French overseas territories from the 16th century to the present: historic gallery, paintings (including works by Gauguin), sculptures, and examples of native art.

Musée des Arts Décoratifs
107 rue de Rivoli, I. Open daily (except Tuesdays), 10–12, 2–5. Admission charge (Sunday afternoons free).
Established since 1905 in the Pavillon de Marsan, a wing of the Louvre. Brings together 45,000 objects connected with the decorative arts. Very rich collections of furniture, *objets d'art,* textiles, porcelain and wallpaper, of various dates; reconstructed interiors from Gothic to modern; important collection of Art Nouveau objects; section devoted to Oriental art. Major exhibitions held in ground-floor rooms.

Musée des Arts et Métiers
292 rue Saint-Martin, III. Open daily (except Tuesdays), 1.30–5.30, Sundays 10–5. Closed 1 January, Ascension Thursday, 14 July, 15 August, 1 and 11 November. Charge for admission (Sundays free).
Located in the former priory of Saint-Martin des Champs (*see* Buildings Index). The Conservatoire des Arts et Métiers was created in 1799 to house examples of machinery. All the varieties of mechanical invention are represented in the museum, which contains a collection of clocks outstanding for its scientific and artistic interest.

Musée des Arts et Traditions
Populaires
Bois de Boulogne, XVI. Open daily (except Tuesdays), 10–5. Charge for admission.
Established in 1936 at the Palais de Chaillot. An ethnographic laboratory and museum of folk life and folklore, containing mementos of various types of habitat, costume and furniture from the regions of France. The new building in the Bois de Boulogne (by Jean Dubuisson, 1962-6)

contains a cultural gallery, a scientific gallery, and an exhibition hall.

Musée de l'Assistance Publique
47 quai de la Tournelle, V. Open daily (except Tuesdays and legal holidays), 10–12, 2–5. Charge for admission (Sundays free).
Used from 1810 as Pharmacie Centrale des Hôpitaux (*see* Buildings Index, Hôtel de Miramion). Turned into a museum in 1934. Houses works of art and documents relating to Paris hospitals, and archives of the Assistance Publique. Fine collection of drug jars.

Musée Balzac
47 rue Raynouard and 24 rue Berton, XVI. Open daily (except Tuesdays and holidays), 10–12, 2–5 (April to October, 2–6). Charge for admission.
Eighteenth-century house, lived in by Balzac from 1840 to 1847. Here he wrote *La Cousine Bette, Le Cousin Pons,* and other works. Mementos and furniture belonging to the novelist, and important documents concerning him.

Musée Bourdelle
16 avenue Antoine-Bourdelle, XV. Open daily (except Tuesdays), 10–12, 2–5 or 2–6. Charge for admission (Sundays free).
Museum established in 1949, thanks to the gift by Mme Bourdelle of her husband's studio, sculptures, sketches, original plaster models, and personal mementos. Among the great many works on show are his most outstanding: *The Dying Centaur,* bronzes of the *Vierge à l'offrande* and *Sappho,* monuments to Alvarez and Mickiewicz, monuments to the dead of Montceau-les-Mines and Montauban (casts), *The Epic of Poland,* a unique cast of the *David,* the monumental bust of *Rodin,* Bourdelle's life-mask (executed by himself). Among the paintings in the studio is a portrait of *Cécile Sorel* at the age of 13. Exhibitions of modern sculpture are held every year. 209.

Musée Carnavalet
23 rue de Sévigné, III. Open daily (except Tuesdays), 10–12, 2–5 (15 November–14 February), 2–5.30 (15 February–14 April and 1 October–14 November), 2–6 (15 April–30 September). Charge for admission (Sundays free).
History: *see* Buildings Index, Hôtel Carnavalet. Museum of Paris history, created in 1880. Material on the history and social life of Paris from the 16th century to the present day. Particularly interesting are the galleries devoted to the Revolution, the Empire and the 19th century. Fine interiors have been re-erected in the museum: main bedroom of the former Hôtel de Rivière (Place Royale), with a ceiling by Le Brun; Louis XV panelling from the Premonstratensian convent of rue Hautefeuille; Louis XVI circular *salon* from the Hôtel Fersen. Paintings by major artists, including Mignard, Largillière, Prud'hon and Ingres, illustrate important personages in the city's history. Views of Paris by Van der Meulen, Coypel and Hubert Robert, and by such minor masters as Demachy. Large collection of trade signs. Library and print room; coin room containing tokens of municipal magistrates and commemorative medals. Stonework fragments and carvings from demolished buildings are housed in a 'Musée Lapidaire' in the orangery of the neighbouring Hôtel Le Pelletier de Saint-Fargeau (q.v.). 30, *88,* 94.

Musée Cernuschi
7 avenue Vélasquez, VIII. Open daily (except Tuesdays), 10–12, 2–5 (1 October–31 March) or 2–6 (1 April–30 September). Charge for admission (Sundays free).
House and Oriental art collection left to the City of Paris in 1845 by M. Cernuschi. The museum, arranged in 1937, contains a very fine collection of Chinese *objets d'art* and modern Chinese painting, and an equally important collection of Japanese art, including a large bronze Buddha. The museum is operated in close collaboration with the Musée Guimet. 225.

Musée de la Chasse
60 rue des Archives, III. Open daily (except Tuesdays), 10–5. Charge for admission.
Recently established, by private initiative, in the Hôtel Guénégaud. Includes a club and an interesting collection of art related to hunting: weapons of the prehistoric period and of the 14th, 15th, 16th, 17th and 19th centuries; animal trophies from Africa, America and Asia; tapestries, drawings and sculptures; paintings by Chardin, Oudry, Desportes, and others.

Musée de Cluny
6 Place Paul Painlevé, V. Open daily (except Tuesdays), 10–12.45, 2–5. Charge for admission (half-price on Sundays).
The museum buildings include the Roman baths and the Hôtel de Cluny. *Musée des Thermes:* ruins of the Roman baths (*see* Buildings Index, Thermes de Cluny), sculptures and reliefs, and the famous *Autel des Nautes.*
Hôtel de Cluny (see Buildings Index): contains the collection of medieval art formed by A. du Som-

merard. Objects concerning trade guilds: tailors, breeches-makers, weavers, embroiderers, carpenters, cabinet-makers, foundry workers, etc. Outstanding collection of 15th- and 16th-century tapestries, including *La Dame à la Licorne*, *La Vie seigneuriale* and the *Story of St Stephen*. One room devoted to metalwork and enamels contains superb Limoges enamels; in the chapel next door, there are fine coffers and retables, among them the treasure and the golden altarpiece of Basle. In the sculpture rooms, Flemish and German altarpieces, Romanesque and Gothic sculptures, and a romantic collection in Du Sommerard's study. *11, 13, 25, 28, 50, 160, 209, 225.*

Musée Cognacq-Jay
25 boulevard des Capucines, II. Open daily (except Tuesdays and legal holidays), 10–12, 2–5. Charge for admission (Sundays free).
Founded in 1931 to house the collections left by E. Cognacq and Marie-Louise Jay, owners of the Samaritaine department store. *Objets d'art* of the 18th century are housed in panelled salons. In the collection are porcelain, statuettes, jewels, paintings including a Tiepolo and a Rembrandt, drawings by Watteau, Fragonard and Hubert Robert. 210.

Musée Dupuytren
21 rue de l'École de Médecine, VI. Collection of pathological anatomy formed by Orfila in 1835. Soon to be rehoused in the new Faculté de Médecine, rue des Saints-Pères. 45.

Musée d'Ennery
59 avenue Foch, XVI. Open Sundays only, 1–5 or 1–6.
Collection of Oriental *objets d'art* formed by the playwright d'Ennery (1811–95), and collection of the Armenian museum founded in 1946.

Musée Eugène Delacroix
6 Place Furstemberg, VI. Open for temporary exhibitions.
In the house where Delacroix lived from 1857 until his death on 13 August 1863, personal mementos, autographs and documents are assembled. Exhibitions are held once a year.

Musée Galliéra
10 avenue Pierre-Ier-de-Serbie, XVI. Open for temporary exhibitions.
Built in 1889 to house the collections of the Duchesse de Galliéra, who, however, left only the building to the City of Paris. No permanent collections.

Musée Georges Clemenceau
8 rue Franklin, XVI. Open on Tuesdays, Thursdays, Saturdays, Sundays and holidays, 2–5. Closed in August.
Apartment where Clemenceau lived from 1895 until his death on 24 November 1929. Preserved as it was then; contains personal momentos, his collection of *objets d'art,* and his large library.

Musée des Gobelins
42 avenue des Gobelins, XIII. Open Thursdays and Fridays, 2–4.
Housed in the chapel of the Manufacture des Gobelins, the museum contains tapestries, drawings, models for ornament and examples of gold and silver work. Temporary exhibitions are held in other rooms.

Musée Grévin
10 boulevard Montmartre, IX. Open daily, 2–7.
Waxworks founded in 1882 by the caricaturist Grévin, contains figures of famous people and historic scenes. 190.

Musée Guimet
6 place d'Iéna, XVI. Open daily (except Tuesdays) 10–5. Charge for admission (half-price on Sundays).
Established in 1949 by uniting the collections of eastern and far eastern art formed by the explorer Guimet (given to the nation in 1879) with those of the former Asiatic Department of the Louvre and the Indochinese Museum of the Trocadéro. Particularly rich collection of Indian and Indonesian art. Large collection of art objects from China, Central Asia, Afghanistan, north-eastern India and Japan. Important library of books on eastern art and religion. Plaster casts of Khmer sculptures. 225.

Musée Gustave Moreau
14 rue de la Rochefoucauld, IX. Open daily (except Tuesdays and Sundays), 2–5. Closed in August.
At his death in 1896 Moreau left his house and collection to the State. The museum contains 1,000 paintings, most of them famous works by Moreau, and 7,000 drawings. 209.

Musée Henner
43 avenue de Villiers, XII. Open daily (except Mondays), 2–5.
The house where the Alsatian painter Jean-Jacques Henner died in 1905, bequeathed to the state in 1924. Contains works of all periods of the artist's career, notably some fine portraits. 209.

Musée de l'Histoire de France
60 rue des Francs-Bourgeois, III. Open daily (except Tuesdays), 12–5.
Housed in the apartments of the Prince and Princesse de Soubise (*see* Buildings Index: Hôtel de Soubise). Used for temporary exhibitions of documents and manuscripts from the Archives Nationales.

Muséum d'Histoire Naturelle
Jardin des Plantes, V. Open daily (except Tuesdays), 9–5 (November-February) or 9–6.
Includes a vivarium and galleries of zoology, mineralogy, geology, comparative anatomy and palaeontology. Rich collection of fossils, including those collected by Cuvier. Hunt collections of the Duc d'Orléans, presented in 1929. 74, 112.

Musée de l'Homme
Palais de Chaillot, Place du Trocadéro, XVI. Open daily (except Tuesdays), 10–5.
Ethnographical and anthropological museum, installed in the Palais de Chaillot in 1938. Collections relating to primitive cultures of all countries and periods. In the prehistoric section, note the ivory Venus of Lespugne. Fine collection of Pre-Columbian art, including a famous Aztec rock-crystal skull. From Africa and Oceania, bronzes, wooden masks and basketwork. Other primitive art from Asia, Europe, USSR, and the Arctic. Salle des Arts et Techniques opened in 1960.

Musée de l'Impressionisme (Jeu de Paume)
Place de la Concorde. Open daily (except Tuesdays), 10–5, Saturdays 10–8. Charge for admission (Sundays free).
Housed since 1947 in the Jeu de Paume (built in 1862–77 on the terrace of the Tuileries). Includes works by forerunners of Impressionism and the great innovators of the late 19th century up to Van Gogh, Seurat and Douanier Rousseau. Formed by uniting the Moreau, Nelaton, Caillebotte, Camondo, Personnaz and Paul Gachet collections, the museum contains works by Fantin-Latour (*Homage to Delacroix*), Corot, Boudin, Pissarro, Manet (*The Balcony, Moulin de la Galette, Olympia*), Monet (*Gare Saint-Lazare*, series of cathedrals), Degas (*The Dancing-Lesson*), Sisley, Cézanne (*The Card-Players*), Toulouse-Lautrec, Gauguin, and Van Gogh. Sculptures include Degas' *Petites danseuses* and low-reliefs on wood by Gauguin. 220, 220, 222, 225.

Musée des Instruments de Musique
14 rue de Madrid, VIII. Open Thursdays and Saturdays, 2–4.30. Closed 1 July–1 October.
Museum of the Conservatoire de Musique, contains musical instruments from the Renaissance to the 19th century.

Musée Jacquemart-André
158 boulevard Haussmann, VII.
Open daily (except Tuesdays), 1–5 (winter) or 1–6 (summer). Charge for admission.
Founded in 1912 after the death of the portrait-painter Nelie Jacquemart, widow of the rich collector Edouard André who had bequeathed his house and collections to the Institut de France. The museum contains examples of Egyptian, Greek and Roman art, but is especially known for Italian Renaissance sculpture, ceramics, small bronzes and paintings. Among French 18th-century painters Watteau, Chardin and Pigalle are well represented; good collection of Dutch and Flemish paintings. The apartments and reception rooms contain tapestries, furniture and antiques. On the staircase, fresco by Tiepolo. 210.

Musée de la Légion d'Honneur
64 rue de Lille (in a wing of the Hôtel de Salm). Open Thursdays and Saturdays, 2–5. Charge for admission.
Founded in 1925 by General Dubail. Collections of medals, decorations, documents, engravings and paintings (*Louis XIV* by Rigaud, *Bonaparte as First Consul* by Gros); material on the history of Orders of Chivalry and the Légion d'Honneur (decorations of the Templars and Knights of Malta); mementos of World War II, De Gaulle and the Resistance.

Musée du Louvre
Open daily (except Tuesdays), 10–7. Closed on Ascension Thursday, 1 January, 1 May, the second Wednesday after Easter, Pentecost, 14 July, 15 August (unless it falls on a Sunday), 1 and 11 November, 25 December.
See Buildings Index: Palais du Louvre. Museum initiated by the Marquis de Marigny in 1768 and by the Comte d'Angiviller, opened in 1793. Under Napoleon, housed works of art plundered throughout Europe, most of which were returned after 1815. Laid out under Louis-Philippe and especially under Napoleon III, periodically rearranged, recently completed by the acquisition of the Pavillon de Flore and the wing which leads to it (1969). The greatest French museum, equivalent to the Metropolitan Museum in New York or the Hermitage in Leningrad. Collections are divided into six departments.

I. Greek and Roman Antiquities
Shown on the ground floor of the new Louvre, around the Cour du Sphinx and in the SW corner of the Cour Carrée, and on the first floor. Far end of the Galerie Denon, at the

end of the Galerie Denon, at the top of the staircase: *Winged Victory of Samothrace* (late 3rd century BC), discovered on the island of Samothrace in 1883 by Champoiseau; a hand, found in 1953, is exhibited next to the statue. Hellenistic works (3rd-1st centuries BC) are shown in the Salle des Cariatides: the *Warrior* or *Borghese Gladiator*, signed by Agasias of Ephesus, and the *Diana of Versailles* (antique copy of a late 4th-century statue), bought at the time of Francis I. Archaic Greek sculpture is well represented by *kouroi* (youths) and *kourai* (maidens), the *Hera of Samos* (Ionian, 6th century BC) and the so-called *Lady of Auxerre* (Dorian, late 7th century BC). The Salle du Parthénon contains 1st-century sculptures and a fragment from the Pan-Athenaic frieze on the Parthenon. In the Salle de Phidias and Salle de Polyclète: antique copies of outstanding works by these two great sculptors of the 5th century BC, notably the *Venus de Milo* (2nd century BC), discovered in 1820 near the village of Castro on the island of Melos, bought in 1821 by the Marquis de Rivière, French Ambassador to Turkey.

Roman antiquities include wall-paintings from Rome and Pompeii (1st century BC), and mosaics from Carthage, Constantinople and Antioch (1st–6th centuries AD). A room is devoted to Early Christian art of the classical period. *Great Mosaic of the Seasons* from Antioch (4th century), with hunting scenes. Major collection of Roman busts and reliefs.

On the first floor, the former royal apartments house fine collections of antique jewels and ceramics.

II. Oriental Antiquities

Shown on the ground floor, on the N. side of the Cour Carrée. Founded in 1847, the department has been enriched over the years by the excavations of Botta, Victor-Place, P. Delaporte, Flandin and Thomas, and the recent excavations of Professors André Parrot, Claude Schaeffer and Roman Ghirshman. The collections are arranged by culture and excavation sites, and occupy 24 rooms and two crypts. Outstanding among the objects on exhibit: statue of Gudea, king of Lagash, reliefs from Khorsabad, winged bulls from the gateway at Khorsabad, stelae of Hammurabi, vultures of Naram-Sin, and the famous ceramic frieze of warriors from the palace at Susa; also ceramics, objects and statuettes from recent excavations at Mari.

III. Egyptian Antiquities

Department founded in 1825 by Champollion, enriched by the Salt and Drovetti collections (sphinx from sarcophagus of Ramses II, monolithic chapel from Philae) and the excavations of Mariette at Saqqara (monuments from the Serapeum, Old Kingdom statues, the *Seated Scribe*). Housed on the ground floor and first floor at the SE corner of the Cour Carrée, and in the basement where monumental statues and works of art are shown (large sphinx, statue of Osiris, large sarcophagi). On the ground floor the base of the obelisk from Luxor can be seeen, together with statues of Seti I and the goddess Hathor, a *mastaba* and the famous stela of the Serpent King. On the first floor: jewellery, canopic jars, bronze statuettes, etc.

IV. Medieval, Renaissance and Modern Sculpture

Department set up by Alexandre Lenoir in 1793, during the Revolution, to preserve tombs from demolished churches and works of art from confiscated châteaux. Lenoir's collection was dispersed by Louis XVIII, and since 1824 the department of sculpture has been enlarged by purchases and bequests (Arconati, Camondo, Rothschild, Thiers, Campana and Sauvageot). Collections shown on the ground floor of the Galerie du Bord de l'Eau, Pavillon des Etats and Pavillon de Flore.

Among the works of medieval sculpture: cloister arcade from Saint-Genis des Fontaines, retable from the church of Carrière-sur-Seine, Solomon and the Queen of Sheba cariatids from the west front of Notre-Dame, Corbeil (12th century), statues of Jeanne de Bourbon and Charles V (1375), tomb of Philippe Pot (15th century). Of the Renaissance: works of the Loire Valley school, and of the major French sculptors of the period: *St George and the Dragon* by Michel Colombe, from the Château de Gaillon; *Diana with a Deer*, from the château of Anet; *Three Graces* (monument for the heart of Henry II) and *Virgin of Sorrows* (terracotta) by Germain Pilon. Italian sculpture of the 14th-16th centuries is exhibited in the former stables of Napoleon III. It includes works by the most famous Florentine sculptors: Nino Pisano, the della Robbia, Donatello (*Virgin and Child*), Desiderio da Settignano, Michelangelo (*Slaves* for the tomb of Julius II). Among the 16th-century Italian works is the *Nymph of Fontainebleau* by Benvenuto Cellini.

The 17th-century French collection is dominated by works removed from churches and country houses for protection, notably tombs, decorative figures and busts. The ma-

jor sculptors are well represented: Coysevox (portraits of *Colbert*, *The Duchesse de Bourgogne as Diana*), Puget (*Milo of Crotona*, etc.). The 18th- and 19th-century collections, shown in the Pavillon de Flore, include works by Houdon (*Louise Brongniart*, *Diana*), Chaudet, Bouchardon (*Cupid fashioning a Bow*), Canova (bust of *Napoleon*), David d'Angers (medallions of famous men of the Romantic era), Rude (*Neapolitan Fisherman*, *Napoleon waking to Immortality*, studies for *La Marseillaise*), Carpeaux (magnificently represented by *La Danse*, executed for the Opéra, *Flora* in terracotta, and several busts).

V. Paintings

Shown in the first floor of the S. wing, from the Galerie d'Apollon to the Pavillon de Flore.

The department of paintings originated in the royal collections. Francis I commissioned Primaticcio and Andrea del Sarto to seek out the most precious works of art in Italy; at his death the collection contained several Raphaels, three works by Leonardo da Vinci, and the portrait of Francis I by Titian. Under Louis XIV, Colbert acquired for the king the collection of the German banker Jabach, including 5,542 drawings and 101 paintings. Under Louis XV, purchase of the collection of the Prince de Carignan, and royal commissions from French artists. Louis XVI enriched the collection by adding Dutch and Flemish paintings. Since its establishment the museum has acquired the following collections: Campana, La Caze, Duchatel, Thiers, Daville, Boucicaut, Rothschild, Picot, Caillebotte, Moreau-Nélaton, David-Weil, Beitstegui, Paul Jamot, Paul Gachet, etc.

Italian painting. An important collection. Sienese, Florentine and Venetian primitives: Simone Martini (*Christ carrying the Cross*), Giotto (his masterpiece, *The Stigmatization of St Francis*). Quattrocento: Fra Angelico (*Coronation of the Virgin*), Ghirlandaio (*Visitation*), Antonello da Messina (*Portrait of a Condottiere*), Mantegna (*St Sebastian*), Uccello (*Battle of San Romano*), Botticelli, Perugino, Signorelli, Carpaccio. The best represented is Leonardo da Vinci (*Mona Lisa*, *St John the Baptist*, *Virgin of the Rocks* and *St Anne*). Works by Raphael (*La Belle Jardinière*, *Portrait of Castiglione*). Masterpieces of Venetian painting: Titian (*Man with Glove*), Tintoretto, Veronese (*The Swoon of Esther*), Giorgione (*Concert champêtre*). Of the early 17th century, Caravaggio's astonishing *Death of the Virgin*.

Spanish painting. Masters including Zurbarán, Ribera, El Greco (*Crucifixion*), Velázquez, Murillo.

French painting. Primitives (*Villeneuve Pietà, Touzon Retable*); paintings by Jean Fouquet (*Portrait of Charles VII*), 16th-century portraits by the Clouet family and by Corneille de Lyon (reconstruction of a cabinet from a 16th-century château). Classical painting is represented by Philippe de Champaigne, Louis Le Nain, Georges de La Tour, Nicolas Poussin, Claude Lorrain, Rigaud (*Portrait of Louis XIV*), Mignard, Lebrun (*Battle of Arbelles*). From the 18th century, Watteau (*Embarkation from Cythera*), Boucher, Nattier, Chardin, Fragonard, Greuze. Works of the 19th century begin with Louis David's *Coronation of Napoleon in Notre-Dame* and continue with Ingres, Chassériau, Delacroix, Géricault, Courbet (the famous *Funeral at Ornans*), Corot and Boilly.

Flemish School. Van Eyck (*Madonna of Chancellor Rollin*), Rogier van der Weyden (*Braque Triptych*), Memling (diptych with the *Mystic Marriage of St Catherine*), Metsys (*The Money-Lender and his Wife*), Justus van Ghent (14 portraits of famous men, from the *studiolo* at Urbino).

Northern Schools of the 16th and 17th centuries and German School. Works by Dürer, Holbein (*Portrait of Erasmus*), Peter Bruegel the Elder (*Beggars*), Jan Gossaert called Mabuse (*Carondelet Diptych*), Lucas Cranach the Elder (*Venus in a Landscape*). Rembrandt (*The Flayed Ox*, *The Pilgrims at Emmaus*), Vermeer of Delft (*The Lace-Maker*), Frans Hals (*The Gypsy*).

Many works by Van Dyck (including a *Portrait of Charles I*) and Rubens (including the *Story of Marie de Médicis* from a gallery in the Luxembourg palace).

In the Cabinet Rothschild, numerous prints and 3,000 drawings may be seen by specialists on application.

VI. Objets d'Art and Furniture

Housed in the Cour Carrée (E., N. and half of the W. wings) and in the Galerie d'Apollon.

In the Galerie d'Apollon: Crown jewels, a collection begun by Charles V and enriched by Francis I and successive kings, in part looted during the Revolution. Among the most precious gems are the Regent diamond (137 carats) and the Hortense diamond.

Along the colonnade, *objets d'art* are shown by period and by technique: gold- and silversmiths' work, bronzes, medieval and Renaissance ivories, ceramics, enamels, etc. Attractive displays of 17th- and 18th-

century furniture. 30, *48*, *54*, *56*, 96, 114, 116, 133, *146*, *216*, *219*, *225*, *225*, 227, *229*.

Musée de la Marine
Palais de Chaillot, Place du Trocadéro. Open daily (except Tuesdays). Guided tours.
In the Palais de Chaillot since 1938. Collections include everything connected with the sea. Documents and ship models of all periods; large-scale models of former royal ships, the galley of Louis XIV with ornate figurehead; interesting collection of paintings, including a series of pictures of French ports by Vernet, commissioned in 1572 by the Marquis de Marigny.

Musée Marmottan
2 rue Louis Boilly, XVI. Open Saturdays and Sundays (closed in July and August).
Left to the Institut in 1932 by Paul Marmottan, writer on art and history. Attractive Empire furniture and works by German and Spanish primitives. Collection enriched by an important bequest of Impressionist paintings, including the famous Monet, *Impression, soleil levant.* 212.

Musée Mickiewicz
6 quai d'Orléans, IV. Open Thursdays (other than public holidays), 3–6.
Associated with the Polish library founded in 1903 by Ladislas Mickiewicz (eldest son of Adam Mickiewicz). Autographs of George Sand, Vigny, Hugo; documents of the Romantic era; bust of Adam Mickiewicz by David d'Angers; mementos of Chopin.

Musée de la Monnaie
11 quai de Conti, VI. Open daily (except Saturdays, Sundays and holidays), 1–6. Closed in August. Charge for admission.
Attached to the Mint. Established by Charles X in 1827, the museum contains collection of medals, portraits of engravers, and presses, and Napoleon's cabinet of medals.

Musée des Monuments Français
Palais de Chaillot, Place du Trocadéro, XVI. Open daily (except Tuesdays), 10–5. Charge for admission.
Founded by Viollet-le-Duc in 1879, housed in the Palais du Trocadéro in 1882 under the name of Musée de Sculpture Comparée. Reinstalled in Palais de Chaillot after the demolition of the Trocadéro. Casts of the principal monuments in France from the Romanesque to the 19th century (e.g. tympana of Moissac and Vézelay); copies of Romanesque, Gothic and Renaissance wall-paintings, many in a reconstructed setting

(Tavant, Saint-Savin-sur-Gartempe). 210, 229.

Musée Municipal d'Art Moderne
See **Musée d'Art Moderne de la Ville de Paris**

Musée Municipal d'Histoire et d'Art de Saint-Denis
4 place de la Légion d'Honneur. Open daily, 2–6.30.
Established in 1907 in the chapel of the former Hôtel-Dieu, removed after the latter's demolition to the present site. Collections include finds from excavations on the site of the basilica; documents on the history of the town and the basilica, including mementos of Abbot Suger; material relating to the funeral ceremonies of the kings of France, the Légion d'Honneur and the Commune (1871). Paintings and drawings of the 19th and 20th centuries, some concerned with the life of the workers, by Manet, Daumier, Victor Hugo, Signac, Pissarro, Cézanne, Forain, Steinlen, Marquet, Matisse, Walch, Léger; drawings and gouaches by Picasso. The Salle Paul Eluard has furniture, manuscripts and books.

Musée National d'Art Moderne
Palais de New-York, 11 avenue du Président Wilson, XVI. Open daily (except Tuesdays), 10–5. Charge for admission (free on Sundays).
Established in 1943, covers all 20th-century art. The following are represented; Neo-Impressionists (Seurat, Signac); School of Pont Aven (Emile Bernard, Maurice Denis); Nabis (Vuillard, Bonnard); Fauves (Matisse, Derain, Marquet, Vlaminck); Cubists (Picasso, Braque, Juan Gris); painters tending towards abstract (Kupka, Kandinsky, Bissière, Manessier). A room is devoted to naïve painters. Foreign artists who worked in Paris are well shown: Valloton, Van Dongen, Soutine, Picasso, Miró and Chagall, and the sculptor Zadkine. Important collection of sculpture: works by Despiau, Brancusi (whose studio is reconstructed in the museum), Zadkine, Germaine Richier and Calder. Modern tapestries by Lurçat and Carzou. The museum has been enriched in recent years by bequests from artists, including Brancusi, Dufy, Delaunay and Rouault. 222, 225.

Musée Nissim de Camondo
63 rue de Monceau, VIII. Open daily (except Tuesdays), 2–7. Closed in July.
Collections and house (built by Sergent, 1911–14, in 18th-century style) of Comte Moïse de Camondo, given to the state in memory of his son Nissim. Outstanding collection of 18th-century furniture signed by fa-

mous cabinetmakers; fine collection of Chinese ceramics. 210, 212.

Musée de l'Œuvre Notre-Dame
10 rue du Cloître-Notre-Dame, IV. Open Mondays, Thursdays, Saturdays and Sundays, 2–6.
Founded in 1951 by the Société des Amis de Notre-Dame. Collection of 5,000 engravings relating to the history of the cathedral. Houses temporary exhibitions.

Musée de l'Opéra
Place Charles-Garnier, IX. Open weekdays, 10–5. Charge for admission.
On first floor of the Pavillon d'Honneur of the Opera, the wing built as Napoleon III's state entrance to the Imperial box. Mementos of musicians, musical instruments, documents relating to performances at the Opera since the 17th century, busts of musicians by Carpeaux, portraits by Delacroix and a famous portrait of Wagner by Renoir. A Museum of Dance is to open soon.

Musée de l'Orangerie
9 Place de la Concorde, VIII. Open daily (except Tuesdays), 10–5 (Saturdays until 8). Charge for admission.
Built in 1853 in the Tuileries gardens. One room converted in 1921 to house Monet's *Waterlilies*; other rooms used for temporary exhibitions.

Palais de la Découverte
Avenue Franklin-Roosevelt, VIII. Open daily (except Fridays), 10–12, 2–6. Charge for admission which includes access to the cinema and lecture-theatre (free to students).
Museum for the popularization of science, created for the Exposition Internationale of 1937. Contains 54 rooms and laboratories, with sections devoted to mathematics, astronomy, physics, chemistry, biology, medicine, surgery, and history of science. Experiments performed in front of visitors. Planetarium (additional entrance fee): introductory sessions at 3 and 4.30, and at 9 on Wednesdays and Saturdays.

Musée du Petit Palais
Avenue Winston-Churchill, VIII. Open daily (except Tuesdays), 10–12, 2–6. Charge for admission.
History: *see* Buildings Index, Petit Palais. Founded in 1900. Contains religious works of art, works from the Middle Ages and the Renaissance as well as furniture and tapestries from the 17th century, paintings from the 18th century of the French, Italian and Flemish schools and works of art from the 19th and 20th centuries up to 1914. The painters

best represented are Courbet (*Les Demoiselles des bords de la Seine*), Odilon Redon, Bonnard and Vuillard. Works by official artists of the Third Republic. Among sculptors, an outstanding collection of sculptures and paintings by Carpeaux. Part of the building is set aside for temporary exhibitions.

Musée des Plans-Reliefs
Stairway K, Hôtel des Invalides, VII. Open daily (except Tuesdays and holidays), 10–12, 2–5.30. Charge for admission.
Set up by Louvois in 1668 to provide Louis XIV with information on French and foreign fortifications. The collection, added to by Napoleon, includes numerous models, maps, and topographic documents.

Musée Postal
4 rue Saint-Romain, VI. Open daily (except Tuesdays), 2–6. Charge for admission.
Housed in the Hôtel de Choiseul-Praslin (*see* Buildings Index). Important philatelic collection, pictorial documentation on postal services throughout the ages.

Musée Rodin
77 rue de Varenne, VII. Open daily (except Tuesdays), 1–5.
Housed in the Hôtel Biron (*see* Buildings Index), where Rodin lived from 1910 until his death in 1917. The museum contains the complete works of Rodin: bronzes, marble statues, drawings and personal mementos. In the garden: *The Thinker, Gates of Hell, Burghers of Calais* (copy). In the ground-floor rooms: *The Kiss, The Age of Bronze*. On the first floor, busts. The artist's personal collection includes Egyptian, Greek and Roman antiquities, and paintings by Van Gogh (*Le Père Tanguy*), Renoir, Manet and Carrière. 135, 209.

Musée Victor-Hugo
6 bis place des Vosges, IV. Open daily (except Tuesdays and holidays), 10–12, 2–6. Charge for admission (free on Sundays).
Located since 1902 in the house where Hugo lived from 1832 until 1848. Major collection of mementos, and works by Hugo (drawings and prints).

Musée du Vieux Montmartre
17 rue Saint-Vincent, XVIII. Open daily (except Tuesdays), 2–5. Charge for admission.
Founded in 1960. Contains documents on the history of Montmartre and mementos of the artists who lived there, as well as porcelain from the Manufacture de Clignancourt.

Académie de la Grande Chaumière
14 rue de la Grande-Chaumière, VI.
Academy of painting where many
early 20th-century artists worked.
Gauguin lived in the same street
at No. 10. 201.

Arc de Triomphe du Carrousel *Place
du Carrousel, I.* Built by Percier
and Fontaine, 1806–08. Served as
entrance to the *cour d'honneur* of
the Palais des Tuileries. Based on
the Arch of Septimius Severus in
Rome; attic stage with a quadriga
(until 1815 the horses were those
of St Mark's in Venice): reliefs of
the campaign of 1805. 146, 160, 173.

Arc de Triomphe de l'Etoile *Place
de l'Etoile, XVI.* Begun by Chal-
grin in 1807, unfinished at his death
in 1814, completed in 1836. Reliefs
by Rude including *The Departure
of the Volunteers,* known as *La Mar-
seillaise.* 147-50, *175.*

Archives Nationales *See* **Hôtel de
Soubise, Hôtel de Rohan.**

Arènes de Lutèce *6 rue des Arènes,
V, near rue Monge.* Roman amphi-
theatre of the 2nd century AD, cap-
able of seating 16,000 spectators.
Discovered in 1869, restored in
1917–18. 28.

Arsenal, Grand *1 rue de Sully, IV.*
Built 1594 as residence for Sully,
Grand Master of Artillery. Apart-
ments of the Maréchale de la Meille-
raye, decorated by Simon Vouet in
1637. Restored by Boffrand from
1723 onwards. In the 19th century,
taken over by the Bibliothèque de
l'Arsenal (open on Thursdays, 2–6).
76, 112.

Arsenal, Petit *47 boulevard de l'Hô-
pital, XIII.* Known as the Salpê-
trière after the saltpetre used in mak-
ing gunpowder. Hôpital de la Salpê-
trière (q.v.) built on same site in
1657. A few fragments of the ori-
ginal building remain. 112.

Auvers-sur-Oise *Val d'Oise.* 75 km.
from Paris. Country residence of
the painters Daubigny and Cézanne
(who painted here *The Hanged Man's
House* now in the Louvre). Van
Gogh lived at the Auberge Ravaux,
where one can see the room where
he died. Monument to Van Gogh
by Zadkine in the public park. 200,
209.

Bagatelle *Bois de Boulogne, XVI.*
Villa (*pavillon*). Built 1720 for Victor
Marie d'Estrées, marquis de Cœuvres.
Rebuilt by Belanger in 1777 for
the Comte d'Artois (later Charles

X); called the Folie d'Artois. Sold
in 1835 to Lord Yarmouth, from
whom it passed in 1870 to the Eng-
lish philanthropist and art collector
Richard Wallace (1818–90). Bought
by the City in 1904. Stands in a
fine 'English garden', near the famous
Bagatelle rose-gardens. 128, 136.

Banque de France *See* **Hôtel de la
Vrillère.**

Bastille *XI.* On the site of the pre-
sent Place de la Bastille stood the
former fortress of Saint-Antoine,
built by Charles V in 1370 at the
eastern entrance to Paris, and later
used as a prison. Its demolition was
proposed in 1784; captured by the
mob on 14 July 1789, it was demol-
ished in 1790. The square was laid
out in 1803. Colonne de Juillet
erected by Duc in 1840–41 to com-
memorate the Revolution of 1830;
47 m. high. 14, 65, 78, 145, 172,
174.

Bibliothèque Nationale *58 rue de
Richelieu, I.* On the site of the
Palais Mazarin (q.v.). Printed books
reading-room built by Labrouste in
1868; periodicals room built in 1900;
catalogue room (1934–8), map room
(1942–54) and print room built by
Roux-Spitz. Music room situated in
Square Louvois (built 1963). 45, *55,*
56, 105, 186.

Billettes, Cloître des *24 rue des Ar-
chives, IV.* Friary of La Charité No-
tre-Dame, founded in the late 13th
century by the burgher Régnier
Flaming, in atonement for a sacrilege
perpetrated on the consecrated host
by a Jew, Jonathas. The 15th-cen-
tury cloister survives. The chapel,
rebuilt in 1755, is now a Lutheran
church. 68.

Bois de Boulogne *XVI.* Formerly
a forest, to the west of Paris. En-
closed in the 16th century, laid out
as a park in 1852 by Alphand, who
created two lakes. 36, 80, *128, 146,*
177.

Bois de Vincennes *XII.* Formerly
a forest, to the east of Paris. En-
closed at the end of the 12th cen-
tury, replanted in 1731. Laid out
as a park by Alphand in 1858–60.
36, 56, 177.

Bon Marché, Le *Square Boucicaut,
VII.* Department store built by Boi-
leau and Eiffel, 1869–89, for the
draper Boucicaut. 163.

Buttes-Chaumont *XIX.* Large pub-
lic park on rough terrain, laid out
by Alphand in 1866-7 on the site

of gypsum quarries and a former gibbet. 36, 177.

Castel Béranger *14 rue La Fontaine, XVI.* Art Nouveau masterpiece by Guimard, built in 1894–8, showing great inventiveness in design and use of materials (stone, iron and brick). 175, 216.

Catacombs *Entry at 1 Place Denfert-Rochereau, XIV.* Limestone quarries, turned into an ossuary in the late 18th century when the Charnier des Innocents was closed. 16.

Cercle de la Librairie *117 boulevard St-Germain, VI.* One of the few private buildings by Garnier, with an interesting staircase. 175.

Chambre des Députés *See* **Palais Bourbon.**

Champ de Mars *VII.* Open space which owes its name to its use for military training; also used for ceremonies and festivities under the Ancien Régime and the Revolution. Later used for international exhibitions. 129, 146, 185.

Champs-Elysées, Avenue des *VIII.* Formerly called Grand Cours, 1667–7). Redesigned in 1828. Continues the axis of the Tuileries up to the Arc de Triomphe de l'Etoile. 112, 129, 150, 177, 185, 231, *232.*

Chantilly *Oise.* Small town 50 km. north of Paris, famous for its château and forest. Present château built by the Duc d'Aumale in 1876–82 on the site of the castle of the Connétable de Montmorency (1528–31), which had been altered under the Grand Condé in 1686 and destroyed during the Revolution. (Only survival of the earlier work is the small château lower down, built by Jean Bullant under Henri II.) Now houses the collection bequeathed to the Institut de France by the Duc d'Aumale in 1866 (q.v.). Vast stables to the west, added by Jean Aubert in 1719–40. 154, *163, 168, 181.*

Chapelle Expiatoire *Square Louis-XVI, VIII.* Memorial commemorating the execution of Louis XVI (in January 1793), built by Fontaine in 1815–26. The cemetery contains graves of many victims of the Terror.

Chapelle des Anges *See* **St-Sulpice.**

Charnier des Innocents *See* **Innocents.**

Chartres *Eure-et-Loir.* 96 km. from Paris. Historic Gallo-Roman city in the heart of the Beauce agricultural region, developed in the Middle Ages and famous for its cathedral.
Cathedral of Notre-Dame. Outstanding Gothic building. Built mainly in the 12th and 13th centuries; north

tower completed by a spire in the 16th century. Remarkable collection of stained glass in 156 windows, half of it dating from the 13th century; 12th-century glass in the western rose window. Choir enclosure of the 16th century. Portail Royal (west door), a key monument of early Gothic sculpture, survives from the previous cathedral. Numerous statues on the north and south transept fronts. Under the choir is a vast crypt with the 18th-century chapel of Notre-Dame sous Terre.
Saint-Pierre. Church of the vanished abbey of Saints-Pères (13th century). Stained glass windows with large figures (14th and 15th centuries). The former Bishop's Palace (16th-18th centuries) houses the Musée des Beaux-Arts: enamels, tapestries and paintings. Open daily (except Tuesdays and Wednesdays), 10–12.15, 2–6. 48, 51.

Châteaux *See* under place names.

Châtelet, Place du *I.* Takes its name from a bridge-head fortress, residence of the Captain of the Watch, which was destroyed in 1792. Square laid out in 1802, enlarged in 1858. 69.

Cité Universitaire *Boulevard Jourdan, XIV.* Residential complex for students established in 1921, including buildings for the following countries: Holland (by Dudok), Switzerland (by Le Corbusier and P. Jeanneret), and Brazil (by Le Corbusier and Lucio Costa). 188.

Cluny, Thermes de *Place Paul-Painlevé, V.* Ruins of Roman baths of the late 2nd-3rd centuries AD, built of stone with brick courses and covering an area 10 x 65 m. The *frigidarium,* a vast hall with central pool, survives intact: note, at the spring of the vaults, corbels in the shape of ships' prows, symbol of the corporation of *nautae* (boatmen). Lapidary museum in this hall. Annex to the Cluny Museum. *See* Museums Index. 65, 209.

CNIT (Centre National des Industries et des Techniques) *Rond-Point de la Défense, Puteaux, Hauts-de-Seine.* Vast triangular exhibition hall with a triple vault which is a triumph of modern technology. Architects: Camelot, de Mailly and Zehrfuss (1957–9). 231.

Collège des Bernardins *24 rue de Poissy, V.* Cistercian abbey founded in 1230; chapel (1244), college (1338). Entirely rebuilt in 1346. Destroyed in the 19th century, except for the magnificent refectory, used since 1845 as a fire station, which is to become a museum of stonework relics. 45.

Collège des Cordeliers *Rue de l'Ecole de Médecine, VI.* Franciscan friary incorporating a school, founded in 1232. Among famous Franciscans associated with the college were St Bonaventure and Roger Bacon. Meeting-place for a revolutionary club in 1792. Church demolished in 1804. A Gothic wing, comprising the dormitory and refectory, survives; this housed the Musée Dupuytren (closed since World War II). 45.

Collège de France *Rue des Ecoles, V.* Founded in 1530 by Guillaume Budé, under Francis I, as the Collège des Lecteurs Royaux. In the 17th century renamed Collège Royal de France; new design proposed under Henry IV in 1610. Building completed by Chalgrin in 1778, altered in the 19th century. 74.

Collège des Quatre Nations *See* **Institut de France.**

Comédie Française *See* **Théâtre Français.**

Conciergerie *See* **Palais de Justice.**

Cours la Reine *VIII.* Magnificent promenade laid out by Marie de Médicis in 1616. Part of it renamed Cours Albert-Ier in 1919. 78, 112.

Ecole des Beaux-Arts *14 rue Bonaparte, VI.* Stands on the site of the abbey of the Grands-Augustins. Founded in 1807 as part of the Institut de France, removed to its present site in 1830: this includes the former cloister (arranged by Duban), chapel, the Palais des Etudes (1832–7), and the Hôtel de Caraman-Chimay. The courtyard contains stone fragments from French monuments: remains from Anet and Gaillon, reliefs from the Hôtel Legendre, etc. 186.

Ecole Militaire *Place de Fontenoy, Champ de Mars, VII.* Founded by Louis XV in 1751, built by Jacques-Ange Gabriel in 1768–73 facing the parade ground of the Champ de Mars. A statue of Louis XV by Lemoyne stood in the courtyard until 1792. Additions built under the Second Empire. 129, 232.

Eiffel Tower *See* **Tour Eiffel.**

Enceinte des Fermiers Généraux *See* **Fermiers Généraux.**

Etoile *See* **Place de l'Etoile.**

Faculté de Médecine *12 rue de l'Ecole-de-Médecine, VI.* Formerly (15th century–1775) at 13 rue de la Bûcherie, V, where part of the 18th-century building survives. New building in rue de l'Ecole de Médecine begun in 1769 by Gondouin as the Ecole de Chirurgie; enlarged in 1900. Museum of the history of medicine on the 1st floor; includes busts by Houdon and Pigalle, and paintings by Nattier, Restout and Gérard. 45, 136.

Fermiers Généraux, Enceinte des. Wall around Paris built for customs purposes by Ledoux in 1784–89. Originally 23 km. long, demolished in 1860. Access to the town, on payment of a toll, was through one of the *barrières*, or toll-gates, of which the following survive: Villette, Enfer (Place Denfert-Rochereau), Chartres (Parc Monceau), Trône (Place de la Nation). 11, 36, 132.

Folie d'Artois *See* **Bagatelle.**

Folie de Chartres *See* **Parc Monceau.**

Folie St-James *34 avenue de Madrid, Neuilly.* Built by Belanger, 1771–85.

Fondation Suisse *7 boulevard Jourdan, XIV.* Pavilion in the Cité Universitaire, built by Le Corbusier and P. Jeanneret in 1931–2. 188.

Fontaine de la Croix du Trahoir *Rue St-Honoré at rue de l'Arbre-Sec, I.* Built in 1636, restored in 1776 by Soufflot. 109-10.

Fontaine des Innocents *60 square des Innocents, I.* Erected by Jean Goujon in 1548–9, formerly stood at the corner of rue St-Denis and rue aux Fers. Moved to its present location and given a fourth side by Pajou in 1786. 109, 116.

Fontaine de Mars *129 rue Saint Dominique, VII.* Built by Beauvallet in 1806–9. Decorated with pilasters and a Doric entablature; reliefs show Hygeia, the goddess of health, giving a drink to Mars. 134.

Fontaine Médicis *See* **Luxembourg.**

Fontaine de l'Observatoire *Place André-Honnorat, VI.* Built 1875, by Davioud. Also known as the Fontaine des Quatre Parties du Monde, after Carpeaux's famous sculptural group *The Four Continents.* Additional sculptures by Frémiet. *203, 205.*

Fontaine des Quatre Saisons *57-59 rue de Grenelle, VII.* Built by Bouchardon in 1736–9. Central block with two curved wings and three statues representing the City of Paris between the Seine and the Marne. In the wings, niches with the four seasons and allegorical reliefs. On the pediment, a laurel wreath replaces the royal arms. 134.

Fontaine St-Michel *Place St-Michel, V and VI.* Built on the axis of the bridge in 1806 by the architect Davioud and the sculptor Duret.

Fontainebleau *Seine-et-Marne.* 60 km. from Paris. Small residential

town built around the château and its park, on the edge of one of the largest forests in the Ile de France. The château was originally a keep built by St Louis. Francis I rebuilt it entirely after 1527, creating the magnificent Galerie François-Ier and using it to house his art collections. The château was completed to the west by Henry II and Charles IX, and to the east by Henry IV, for whom it was a favourite residence. Throughout the Ancien Régime the court regularly stayed at Fontainebleau: alterations under Louis XV and Louis XVI included the Cour du Cheval Blanc and the private apartments of Marie-Antoinette, by Jacques Ange Gabriel. Further altered by Napoleon I. Fashionable once again under Napoleon III, who added a small theatre, etc. A general restoration was undertaken in 1960. Near the château: Hermitage of Mme de Pompadour, an 18th-century villa in the style of Gabriel. 45, *61, 65, 67*, 80-1, 112, 114, 116, 128, 200.

Galerie d'Apollon *Palais du Louvre, I.* Gallery in the Louvre (q.v.) connecting the Cour Carrée with the Grande Galerie. Painted by Le Brun, with an addition by Delacroix. 114.

Galerie des Machines *Formerly Champ de Mars, VII.* Famous iron-framed exhibition hall, built by Dutert and Contamin for the Exposition Universelle of 1889. Demolished in 1910. 185.

Gare de Lyon *20 boulevard Diderot, XII.* Built by Toudoire in 1899 on the site of the former Lyons landing-stage (1847–52). Refurbished in 1927. Attractive Art Nouveau restaurant decorated by Gervex. 163.

Gobelins, Manufacture des *42 rue Barbier-du-Metz, avenue des Gobelins, XIII.* Built in 1667, burnt in 1871, enlarged under the Third Republic. Founded in 1662 by Colbert, who centralized the various Parisian tapestry workshops and put Le Brun in charge of the new factory. Famous for its *haute-lisse* tapestries. Joined in 1826 by the Savonnerie carpet workshops, and in 1940 by the Beauvais workshops producing *basse-lisse* tapestries. Workshops open on Thursday and Friday, 2-4. Museum (*see* Museums Index). 118.

Grand Palais *Avenue Winston-Churchill, VIII.* Exhibition hall built by Deglane and Louvet for the Exposition Centennielle of 1900. Vast interior with iron frame and glass roof; façade 20 m. high and 240 m. long, lavishly decorated. 185, 187.

Grand Pont *See* **Pont au Change.**

Grands-Augustins, monastery *Site of present Ecole des Beaux-Arts, 14 rue Bonaparte, VI. See* **Ecole des Beaux-Arts.** 160.

Halles Centrales *I.* Central market established by Philip Augustus at the end of the 12th century on the site of the former Marché de Champeaux; enlarged in the 13th century; partly rebuilt under Henry II in 1553; enlarged in 1788. New building in iron and glass, by Baltard, 1852 onwards. Further enlarged in 1936. Food market closed in 1969, and moved to Rungis, near Orly. 14, 45, 65, *80*, 105, 110, 130, 131, 176, 187, *197*, 232.

Hôpital Beaujon *208 rue du Faubourg Saint-Honoré, VIII.* Built in 1784. Now Ecole Pratique des Gardiens de la Paix. 136.

Hôpital de l'Hôtel-Dieu *Place du Parvis Notre-Dame, IV.* Originally on the south side of the forecourt of Notre-Dame; begun *c.* 1200. Totally demolished in 1878, when the present hospital (begun 1868) was completed on the north side. 69.

Hôpital Général de la Salpêtrière *See* **Salpêtrière.**

Hôpital St-Antoine *184 rue du Faubourg St-Antoine, XII.* Founded in the buildings of the former royal abbey of St-Antoine des Champs (12th century), rebuilt after 1770. New Centre Hospitalier Universitaire (CHU), student health centre in concrete, steel and glass, by A. Wogenski (1964–5).

Hôtel des Abbés de Cluny *See* **Hôtel de Cluny.**

Hôtel des Abbés de St-Germain des Prés *1-5 rue de l'Abbaye, VI.* The post of abbot of St-Germain was an opulent sinecure. Residence built in 1586 for Cardinal de Furstemberg; enlarged in 1691 for the Duc de Bourbon. Brick and stone, with typical *lucarnes* or dormers.

Hôtel des Ambassadeurs de Hollande (Hôtel Amelot de Bisseuil) *47 rue Vieille du Temple, IV.* Built by Cottard in 1655–60, entrance with sculptures by Regnaudin. Remarkable for the richness of its interior decoration, including a gallery painted with the story of Cupid and Psyche. Beaumarchais wrote *The Marriage of Figaro* here in 1770. Restored after 1924. 92.

Hôtel Amelot de Gournay *1 rue Saint-Dominique, VII.* Built by Boffrand in 1712.

Hôtel d'Angoulême (Hôtel Lamoignon) *24 rue Pavée, IV.* Old Marais house, built in 1584-6 to a very lively design; enlarged in the 18th

century; restored in 1949-66. Since 1968 houses the Bibliothèque Historique de la Ville de Paris. *81, 209.*

Hôtel Aubert de Fontenay (Hôtel Salé, Hôtel de Juigne) *5 rue de Thorigny, III.* Built 1656 by J. Boullier for Aubert de Fontenay, tax-farmer of the Gabelle or salt-tax (hence the name 'Salé'). *92.*

Hôtel d'Aumont (Hôtel Scarron) *7 rue de Jouy, IV.* Built by Le Vau in 1646-9, altered by François Mansart in 1656-62; decorated by Le Brun. Bought in 1935 by the City of Paris, who restored it and laid out a garden. Head office of the Administrative Tribunal of the Seine department. *105.*

Hôtel d'Avaux (Hôtel de St-Aignan) *71 rue du Temple, IV.* Built *c.* 1650 by P. Le Muet for Claude de Mesme, ambassador of Louis XIV. A grand composition, much altered in the 19th century. Bought in 1965 by the City of Paris, which is restoring it as a depot for archives.

Hôtel de Beauharnais *78 rue de Lille, VII.* Built in 1714 by Boffrand for himself, sold to the Marquis de Torcy; redecorated for Eugène de Beauharnais in Empire style, including the introduction of an Egyptian door in the *cour d'honneur*. Prussian legation in 1817; now West German embassy. Restored and refurbished after 1960. *136.*

Hôtel de Beauvais *68 rue François-Miron, IV.* Built in 1655 by Antoine Le Pautre for Mademoiselle de Beauvais; reliefs by Martin Desjardins in the staircase. Mozart as a child gave a concert here with his father in 1763. Bought in 1942 by the City of Paris. The restored central block is due to house the Musée des Instruments de Musique. *92-3.*

Hôtel de Bellegarde (Hôtel des Fermes) *45-51 rue Jean-Jacques-Rousseau, I.* Built 1612-17 by Louis Noblet (on plans by Androuet du Cerceau), for Roger de St-Larri, Duc de Bellegarde. Renamed Hôtel des Fermes when it became a tax office in the 18th century. Only fragments survive. *89, 96.*

Hôtel Biron *77 rue de Varenne, VIII.* Built in 1728-31 by Aubert and Gabriel for Peyrenc de Moras; acquired by Marshal de Biron in 1753. In the early 19th century, Russian embassy. Home of Rodin from 1908 onwards; became at his death the Musée Rodin (*see* Museums Index). *135, 209.*

Hôtel de Bretonvilliers *Rue de Bretonvilliers, IV.* Built 1637-43 by

Jean Androuet du Cerceau; demolished 1840-66. Only an arcaded pavilion survives. *89, 96.*

Hôtel de Bullion. *19 rue de Louvre, II.* Built *c.* 1640 for Noël de Bullion; rebuilt after 1727 by Boffrand. Now a savings bank. *89, 114.*

Hôtel Carnavalet *23 rue de Sévigné, II.* Built by Pierre Lescot for Président de Ligneris, 1544-50. Acquired 1578 by Mme de Kernevenoy whose name was corrupted to Carnavalet. Altered 1602-32 by Jacques Androuet du Cerceau; again altered 1655-61 by François Mansart. Mme de Sévigné lived there. Houses the Musée Carnavalet (*see* Museums Index). *90, 92, 94, 105, 116, 209.*

Hôtel de Choiseul-Praslin *4 rue St-Romain, VI.* Built in 1732 for the Comtesse de Choiseul, bequeathed in 1746 to her nephew the Comte de Praslin. Rented by Henri Rouvroy de Saint-Simon in the late 18th century. Bought by the state in 1886; since 1946 has housed the Musée Postal. *209.*

Hôtel de Clisson *58 rue des Archives, IV.* Built in the 1370s for Connétable Olivier de Clisson. Only the gatehouse and watchtower survive, incorporated in the Hôtel de Soubise (now Archives Nationales). *53, 55.*

Hôtel Crillon *See* **Place de la Concorde.**

Hôtel de Cluny *6 Place Paul-Painlevé, V.* One of the finest Flamboyant Gothic buildings to survive in Paris. Built in 1485-98 for Jacques d'Amboise, abbot of Cluny, on the site of a 14th-century house, as Paris residence of the abbots of Cluny. Consists of two large *corps de logis*, a chapel and six staircases, one of which is in a tower projecting from the façade and decorated with the emblems of St James of Compostela. Houses a museum of medieval art (*see* Museums Index). *68.*

Hôtel-Dieu *See* **Hôpital de l'Hôtel-Dieu.**

Hôtel des Ducs de Bourgogne *Site of the present 20 rue Etienne-Marcel, I.* Built in 1210 by Robert II of Artois; acquired by the Dukes of Burgundy in 1318 as their Paris residence. Only the so-called Tour de Jean sans Peur survives. *55.*

Hôtel d'Evreux (Palais de l'Elysée) *55-57 rue du Faubourg St-Honoré, VIII.* Built in 1718 by A.C. Mollet for the Comte d'Evreux. Given to Mme de Pompadour in 1748; residence of her brother in 1753; passed to the king in 1764; acquired in

1773 by Beaujon. Confiscated at the Revolution. Residence of Caroline Murat in 1805, restored by Percier and Fontaine to become a residence of Napoleon and Josephine. Since 1873, official residence of the head of state. 168.

Hôtel des Fermes *See* **Hôtel de Bellegarde.**

Hôtel Guénégaud *60 rue des Archives, III.* Handsome small mansion built by François Mansart in 1648–51. Houses the Musée de la Chasse (*see* Museums Index).

Hôtel d'Hallwyll *28 rue Michel-le-Comte, III.* Built in 1787 by Ledoux in a grand neoclassical style. Disfigured by 19th-century additions in the courtyard. 135.

Hôtel Lambert de Thorigny *2 rue St-Louis en l'Ile, IV.* Situated on the point of the Ile St-Louis. Begun by Le Vau at the end of the reign of Louis XIII, in 1640–44. Remarkable interior by E. Le Sueur and Le Brun includes a Galerie d'Hercule. Voltaire was among the many famous dwellers there. 89, 114, 115.

Hôtel Lamoignon *See* **Hôtel d'Angoulême.**

Hôtel de Lauzun (Hôtel Gruyn des Bordes) *17 quai d'Anjou, IV.* Built in 1656–7 by Le Vau for Charles de Gruyn des Bordes, supplier to the army. Luxurious interior decorated with hangings, panelled woodwork and painted landscapes; alcove in one room painted by Le Brun. Belonged to the Marquis de Lauzun from 1682 to 1685. Frequented in the 19th century by Baudelaire and Théophile Gautier. Now belongs to the City of Paris. 89-90.

Hôtel Le Pelletier de St-Fargeau *29 rue de Sévigné, IV.* Built in 1637 by Pierre Bullet for Michel Le Pelletier de Souzy, counsellor of state and superintendent of finance. Bought in 1897 by the City of Paris, and formerly Bibliothèque Historique de la Ville de Paris. Its orangery houses the archaeological collection of the Musée Carnavalet, of which this whole building is to become an annexe. 209, *94.*

Hôtel de Ligneris *See* **Hôtel Carnavalet.**

Hôtel de Masseran *11 rue de Masseran, VII.* Neoclassical masterpiece by Brongniart, built in 1787.

Hôtel Matignon *57 rue de Varenne, VII.* Built in 1721 by Jean Courtonne for the Marshal de Montmorency; one of the finest houses in the Faubourg St-Germain. Official residence of the Prime Minister since 1935. 135.

Hôtel de Mayenne (Hôtel d'Ormesson) *21 rue St-Antoine, IV.* Built in the 16th century, altered in 1609 for Charles, Duc de Mayenne and again in 1613 by Jacques Androuet du Cerceau. 96.

Hôtel de la Monnaie *See* **Monnaie.**

Hôtel de Miramion *47 quai de la Tournelle, V.* Built in 1670, acquired by Madame de Miramion, foundress of the Œuvre de la Sainte-Famille. Used at the Revolution as an arms factory, then in 1810 became the Pharmacie des Hôpitaux. Has housed the Musée de l'Assistance Publique (*see* Museums Index) since 1934. 209.

Hôtel de Rohan (Hôtel de Strasbourg) *87 rue Vieille du Temple, IV.* Built in 1705–10 by Delamair for Cardinal Armand de Rohan, Bishop of Strasbourg, who was succeeded here by four other Cardinals de Rohan, all also Bishops of Strasbourg. Handsome staircase; Salon des Singes, decorated by Huet in 1749–52, which despite its décor of monkeys served as an oratory; cabinet with paintings of the fables of Aesop from the Hôtel de Soubise. Fine stable-yard with a relief of the horses of the sun, a masterpiece of Robert Le Lorrain. Confiscated at the Revolution and used as a powder magazine. From 1808 to 1925 housed the Imprimerie Nationale. Restored in 1928, now part of the Archives Nationales.

Hôtel de St-Aignan *See* **Hôtel d'Avaux.**

Hôtel de St-Florentin *See* **Place de la Concorde.**

Hôtel St-Paul (Hôtel St-Pol) *Formerly between rue St-Antoine, rue St-Paul and rue du Petit-Musc.* Built in 1361; used as royal residence. In 1543 the buildings were demolished and the ground sold in lots. 34, 65, 105.

Hôtel Salé *See* **Hôtel Aubert de Fontenay.**

Hôtel de Salm *64 rue de Lille, VII.* Built in 1782 by P. Rousseau. Burnt in 1871 and restored. Headquarters of the Légion d'Honneur. Houses a museum (*see* Museums Index). 136, 171.

Hôtel de Sens *1 rue du Figuier, IV.* Corner of rue de l'Hôtel-de-Ville. Former Paris residence of the archbishops of Sens, built in 1474–1519 by Archbishop Tristan de Salazar. Bought at the end of the 17th century, it served as a terminus for riverboats from Burgundy (the *coches d'eau* or water coaches). Acquired in 1911 by the City of Paris.

Now houses the Bibliothèque For-ney. 25, 65.

Hôtel de Soissons (Hôtel de la Reine) *Site of present Bourse du Commerce, rue de Viarme, I.* Built in 1572 by Philibert Delorme for Catherine de Médicis, on the site of the convent of Filles Pénitentes. Altered after 1606, demolished in 1748. On its site were built the Halle au Blé and, at its demolition, the Bourse du Commerce. One giant column of the old mansion survives *in situ*.

Hôtel de Soubise *60 rue des Francs-Bourgeois, III.* Built in 1705–09 by Delamair, enlarged by Boffrand in 1735–45. Further enlarged when it became the headquarters of the Imprimerie Nationale in the 19th century. 132-3, *163.*

Hôtel Sully (Hôtel Mesme-Gallet) *62 rue St-Antoine IV.* Built in 1624 by Jacques Androuet du Cerceau, bought by Sully in 1634, enlarged in 1660. Altered in the 19th century. Restored as headquarters of the Caisse Nationale des Monuments Historiques. 90, 96, *79.*

Hôtel Tubeuf *50 rue de Richelieu, I.* Formerly Hôtel de Chevry, built in 1633 by Le Muet, bought by Mazarin in 1644. Now part of the Bibliothèque Nationale. 105.

Hôtel de Ville *Place de l'Hôtel de Ville, IV.* Built in 1533–50 by Domenico da Cortona, completed under Henry IV; enlarged in 1803–37 and 1841. Burnt in 1871. Rebuilt by Ballu to a new design in 1872–82. 30, 59, 71, 80, 105, *172,* 185.

Hôtel de Villette (Hôtel de Brage-lonne) *27 quai Voltaire, VII.* Built in 1712. Residence of Voltaire, who died here on 20 May 1778.

Hôtel de la Vrillère *1-3 rue de la Vrillère, I.* Built in 1635 6 by François Mansart for Louis Phélypeaux de la Vrillère, secretary of state. Restored in 1713–19 by Robert de Cotte for the Comte de Toulouse; extensively rebuilt in the 19th century. Headquarters of the Banque de France. 114.

Ile de la Cité *I and IV.* The heart of early Paris, centre of public life since the 3rd century AD. By the Middle Ages it contained the royal palace (Palais de la Cité, now Palais de Justice), cathedral and Parlement. Nearly ruined by Haussmann's new city plan in the 19th century, it still retains Notre-Dame and the Sainte-Chapelle — the outstanding Gothic buildings of Paris — and a few old houses in rue Chanoinesse. 16, *23,* 25, 27, *27,* 28, *58,* 68, 69, 79, 146, *172.*

Ile Louviers *Between quai Henri-IV and Boulevard Morland, IV.* Formerly served as exercise-ground for crossbowmen. The channel separating this island from the mainland was filled in in 1843. 112.

Ile St-Louis *IV.* Upstream of the Ile de la Cité, to which it is linked by the Pont St-Louis. Formed by linking two small islands, Ile Notre-Dame and Ile aux Vaches, pastures until 1610 (the course of the channel separating them is marked by the present rue Poulletier). Conversion into an elegant residential district was undertaken in the early 17th century by the contractor Marie and his associates, Le Regrattier and Poulletier. The luxurious houses were lived in by magistrates and financiers. Buildings by Le Vau: Hôtel Lambert, Hôtel de Lauzun and the church of St Louis en l'Ile. Voltaire lived in Hôtel Lambert, Baudelaire in Hôtel de Lauzun. The neighbourhood's charm is evoked in *Catherine-Paris,* by Princess Bibesco. 25, 70, 76, *80,* 88, 112.

Innocents, cemetery and charnel-house (Charnier des Saints-Innocents) *Site of the present Square des Innocents, I.* Cemetery which existed in Merovingian times; enclosed in 1186; charnel-houses built in the early 14th century. Closed in 1780–86. 16, 45, 70, 130, 176.

Institut de France *Quai de Conti, V.* Situated on the left bank of the river, facing the southern entrance of the Cour Carrée of the Louvre, to which it is linked by a footbridge, the Pont des Arts. Founded by Cardinal Mazarin as Collège des Quatre Nations (for young nobles from four newly annexed provinces) or Collège Mazarin. Built in 1665–88 to designs by Le Vau. Incurved façade; corner pavilions with giant order. The central domed building — formerly the chapel — has since 1805 housed the Institut de France, five academies of which the most famous is the Académie Française, founded by Richelieu. In the choir of the former chapel, tomb of Mazarin by Coysevox (1689). To the left, Bibliothèque Mazarine. 76, *88,* 98-9, *103, 107,* 111, 201.

Invalides, Les *Between Place des Invalides and Place Vauban, VII.* A huge palace, the Hôtel des Invalides, built in 1671–76 by Libéral Bruant as a home for military veterans. The façade facing the river is 210 m (682 ft) long. The Eglise du Dôme was added to the landward end of the military chapel of Saint-Louis des Invalides by Hardouin-Mansart from 1677 onwards. Built as a chapel

royal, it has housed the tomb of Napoleon since 1840. Marshals of France are buried here. The Hôtel des Invalides itself now houses a number of military agencies and the Musée de l'Armée. 88, 105, 115, *115*, *145*, 160, 185.

Jardin des Plantes See Museums Index: **Muséum d'Histoire Naturelle.**

Jeu de Paume *Jardin des Tuileries, I.* Pavilion built by Napoleon III on site of old real-tennis court (hence the name). Now houses the Impressionist collections of the Musée du Louvre (*see* Museums Index). 112, 220.

La Roche and Jeanneret, house of *Square du Dr-Blanche, Auteuil, XVI.* Built in 1923 by Le Corbusier.

Légion d'Honneur See **Hôtel de Salm.**

Louvre See **Palais du Louvre.**

Luxembourg, Jardin du See **Palais du Luxembourg.**

Lycée Charlemagne See **Maison Professe des Jésuites.**

Lycée Henri-IV See **Ste-Geneviève, Abbey.**

Madeleine, Church *Place de la Madeleine, VIII.* The initial design, by Contant d'Ivry (1764), was for a domed structure. After two false starts the present building, with its peristyle inspired by that of the Maison Carrée at Nîmes, was begun in 1806 to a design by Pierre Vignon. Intended by Napoleon I to serve as his 'Temple de la Gloire', it was finally completed (as a church) in 1842. 129, 146, 160.

Maine-Montparnasse development *Between rue de Rennes and boulevard Pasteur, XV.* Large-scale urban renewal scheme on the site of the Gare Montparnasse (demolished in 1969) and the area to the south of it, where the new station stands, surrounded by vast rectangular buildings erected at the beginning of the development in 1965–7. A 200 m. high tower block, oval in plan, will mark the centre of the new neighbourhood; it is already apparent that the centre should have been further south. Architects: Cassan, Beaudouin and Dubuisson. 232.

Maison de Verre *31 rue St-Guillaume, VII.* House built for Dr d'Alsace in 1931 by Pierre Chareau. Iron framed glass façade in 'International Modern' style. 99, 188.

Malmaison *Rueil-Malmaison, Hauts-de-Seine.* Village 8½ km. from Paris, on hills above the river. Château built in the 17th century, transformed after 1800 by Napoleon and

Josephine, who settled there in 1809. National museum since 1904.

Marais *III and IV.* District bordered by the rue du Temple, the Grands Boulevards and the river. Aristocratic dwellings grew up in the Middle Ages around Hotel St-Paul and Palais des Tournelles, and in the 17th century around the Place Royale (Place des Vosges). Abandoned by financiers and nobility at the end of the 17th century in favour of the Faubourg St-Germain. The neighbourhood deteriorated, and workshops were fitted into the courtyards of the great houses.
See entries for: **Rue des Archives, Rue des Francs-Bourgeois, Rue Pavée, Rue St Antoine, Rue de Sevigné, Rue du Temple, Rue de Thorigny, Rue Vieille du Temple.** 50, 55, 78, 80, 84-90, 92, 93, 105, 116, 129, 232.

Ministère de la Marine *Place de la Concorde, VIII.* Right wing of the former Garde-Meuble du Roi (furniture repository) built in 1760-75 by Jacques Ange Gabriel. 29.

Mobilier National *Rue Barbier-du-Metz, XIV.* State furniture repository, built in 1932–5 by A. Perret. 188.

Monceau, Parc de *Boulevard de Courcelles, VIII.* Remains of the Folie de Chartres, a suburban retreat built for the Duc de Chartres, Philippe d'Orléans (grandson of the Regent) by Carmontelle in 1778: an 'English', i.e. non-formal, garden, with pool and grotto. The garden was converted into a public park by Alphand in 1861. 36, 132, 177.

Monnaie, La *11 quai de Conti, VI.* National mint, built in 1768–75 by Antoine in a vigorous neoclassical style. On site of Hôtel de Nesle. 54, 130, 136.

Montmartre cemetery (Cimetière du Nord) *Rue Ganneron, off boulevard de Clichy, XVIII.* Opened in 1795. Contains the tombs, sometimes with eccentric monuments, of many artists and writers including Stendhal, Théophile Gautier, Renan, Fragonard and Degas. *225.*

Montmartre *XVIII. Former village* on a chalk hill (the Butte-Montmartre). Originated in the Abbaye des Dames de Montmartre, founded in 1133; in the late 18th century, covered with windmills. Absorbed into Paris in 1860, but remained rural until the First World War. Popular with artists (*see* Musée du Vieux Montmartre). 11, 16, 30, 185, 187, 200, 201, *220.*

Montparnasse cemetery (Cimetière du Sud) *3 boulevard Edgar-Quinet, XIV.* Opened in 1824, contains cu-

rious monuments and many famous tombs including those of Baudelaire, Sainte-Beuve, Maupassant, Houdon, Rude and Brancusi. On the tomb of T. Garsevskaïa: *The Kiss*, Cubist sculpture by Brancusi (1910).

Montsouris, Parc *Avenue Reille, XIV.* Area just within the line of the 19th-century fortifications, laid out as a public garden by Alphand in 1875–8. 177.

Musée des Travaux Publics *Place d'Iéna, XVI.* Built by Auguste Perret. Now Conseil Economique et Social. 188.

Notre-Dame de Paris *Place du Parvis-Notre-Dame, IV.* The cathedral of Paris, at the heart of the Ile de la Cité. Stands on the site of a church to St Stephen and an earlier church dedicated to the Virgin. Begun in 1163 by Bishop Maurice de Sully, continued throughout - the 13th and 14th centuries. Restored by Viollet-le-Duc in 1859–64. Outstanding example of Gothic architecture. Also worthy of note are the stained glass; former choir enclosure (14th century); choir-stalls and high altar (18th century); woodwork and sculptures by Coustou and Coysevox; 14th-century statue of the Virgin, on the south-east crossing pier; chapels radiating from the choir; mausoleum of Lieutenant d'Harcourt; 17th-century paintings. In the Trésor (treasury, entered from the sacristy): manuscripts, ornaments and liturgical objects. 9, 10, *17*, 23, *25*, *26*, 28, *32*, *33*, *34*, 34, *45*, 47 8, 50, 51-2, *70*, 152.

Notre-Dame du Travail, Church *95 rue Vercingétorix, XIV.* Built in 1899–1901 by Astruc; the nave and aisles are iron. 187.

Observatoire *Avenue de l'Observatoire, XIV.* Built for Louis XIV by Claude Perrault in 1668–72. Restored in the late 19th century. 74, *195.*

Odéon (Théâtre de France) *Place de l'Odéon, VI.* Built in 1779–82 by Peyre and Wailly; originally called Théâtre Français. Burnt in 1799, rebuilt in 1807 by Chalgrin on the same plan. 128, 229.

Opéra *Place de l'Opéra, II.* Built in 1862–75 by Charles Garnier, richly decorated. Ceiling of the auditorium painted by Chagall. 176, *197*, *201*, 229.

Opéra-Comique *1 Place Boïeldieu, II.* On site of old Théâtre des Italiens. Rebuilt after a fire in 1887, opened in 1898. 128.

Opéra du Palais Royal *See* **Palais Royal.**

Orangerie des Tuileries *Quai des Tuileries, I.* Built in 1853 at the west end of the Tuileries gardens. Now a museum (*see* Museums Index). 112.

Oratoire, Temple de l' *145 rue St-Honoré, I.* Formerly belonged to the Oratorian Congregation, founded by Louis XIII. Church begun in 1621 by Clément Métezeau, completed in 1630 by Jacques Lemercier; façade finished under Louis XV. Regarded as the chapel of the Louvre. Abandoned at the Revolution; has since 1811 been a Protestant church. 86.

Orly airport *Val-de-Marne.* 11 km. south of Paris. Former tourist airfield, built up since 1956. Central building designed by Henri Vicariot and Edouard Becker in 1961. Further extension in progress. 232.

ORTF, Maison de l' *116 avenue du Président-Kennedy, XVI.* Headquarters of French state radio and television, built in 1952–63 by Henri Bernard. Powerful design on a circular plan, decorated with sculpture by Stähly, mosaics by Bazaine and Singier, and tapestries by Manessier and Soulages. 232.

Palais Bourbon (Chambre des Députés) *Place du Palais-Bourbon, VII.* Built as a private mansion by Giardini, continued by Lassurance, Aubert and Gabriel. Confiscated at the Revolution; auditorium built for the Conseil des Cinq-Cents. North façade, facing the bridge, added by Poyet (1804–7). Council hall refurbished in 1828–32 for the Chambre des Députés. 129, 168.

Palais de Chaillot *Place du Trocadéro, XVI.* Built in 1934–7, on the site of the Palais du Trocadéro, by Carlu, Boileau and Azema. Houses four museums and a theatre.

Palais de l'Elysée *See* **Hôtel d'Evreux.**

Palais de Justice (Palais de la Cité) *Ile de la Cité, IV.* Royal palace begun under the Capetian kings in the 11th century; enlarged by St Louis in the 13th century; Chambre des Comptes added in 1350. After a fire in 1618, Grande Salle rebuilt by Salomon de Brosse (1622). Entirely rebuilt by Antoine in 1783–6. Restored in 1840. Cour de Cassation added by Duc in 1857–68. Remains of the early building: 14th-century kitchens, and especially the Conciergerie with its great guardroom (14th century) and prisoners' gallery, full of souvenirs of the Revolutionary period when the building was used as a prison (e.g. Marie-Antoinette's cell). Open daily (except

Tuesdays), 10–12, 1.30–5 in winter, 1.30–6 in summer. Entrance in quai de l'Horloge. *44, 55, 105.*

Palais du Louvre *I.* Original tower was part of the fortifications built by Philip Augustus to protect Paris before his departure on Crusade (1180). Rebuilt by Raymond du Temple under Charles V. Keep demolished in 1527. Rebuilding of the west range begun in 1547 by Pierre Lescot and Jean Goujon. Enlargement continued in 1594–1627 with the south-east and north ranges by Jacques Androuet du Cerceau, Métezeau and Lemercier. East front, towards the town, built by Perrault in 1661–80 (after the rejection of designs by Bernini). Galleries linking the complex with Palais des Tuileries completed in 1806–16 (by Percier and Fontaine) and in 1853–7 (by Visconti and Lefuel). A moat, designed in 1661 but not then executed, was dug in 1965–67 on the decision of the Minister for Culture, André Malraux. Royal apartments: Salon Henri-II; ballroom with caratids; Galerie d'Apollon (q.v.); Grande Galerie. (For the Museum, *see* Museums Index.) 9, 14, 25, 36, 52, 55, 56, 59, 76, *79*, 80, 81, *88*, 89, 96, *96*, 99, 105, 110, 115, 116, *129*, 145, 146, 158, 172, 185, *186*, *187*, *189*, *190*, 210, 212, 213.

Palais du Luxembourg *Rue de Vaugirard, VI.* Begun in 1615 by Salomon de Brosse for Marie de Médicis. Rubens commissioned in 1622 to paint the life story of Marie de Médicis for the gallery (in the Louvre since the 19th century). Palace of the Senate since Napoleon. Library painted by Delacroix in 1847. Park and garden with statues and a 17th-century nymphaeum (the Fontaine de Médicis). 34, 76, *81*, 96, 114, 168, *194*, 225.

Palais Mazarin (Bibliothèque Nationale) *58 rue de Richelieu, I.* Group of buildings acquired or erected by Mazarin: Hôtel Tubeuf (1635), and Galerie Mansart or Galerie Mazarine (by François Mansart, 1645). Taken over by the Bibliothèque Nationale in 1826. 105.

Palais Royal *Place du Palais-Royal, I.* Built for Richelieu (as Palais Cardinal) in 1624–45 by Lemercier; destroyed in the 18th century except for the Galerie des Proues. Rebuilt in 1722–8 by Cartaud for the Regent. Altered in 1764–70 by Contant d'Ivry and Moreau; Victor Louis laid out the gardens and galleries for the Regent's grandson Philippe (Egalité) d'Orléans as a luxurious residential and commercial speculation in 1781. At north-west corner,

Théâtre des Petits-Comédiens (Louis, 1784), much altered, and now Théâtre du Palais-Royal. At south-west corner, Théâtre Français (q.v.). Surrounding area laid out by Fontaine in 1820. 96, 120, 123, 129, 151, 163.

Palais du Trocadéro *Site of the present Palais de Chaillot, Place du Trocadéro, XVI.* Built for the Exposition Universelle of 1878 by Davioud, in Moorish style. Demolished in 1937. 185, 186.

Palais des Tuileries *Formerly Avenue du Général-Lemonnier, I.* Palace built for Catherine de Médicis, between the present Pavillon de Marsan and Pavillon de Flore; begun in 1567 by Philibert Delorme, continued by Jean Bullant. Linked to the Louvre in 1659 by the Grande Galerie (Le Vau and d'Orbay). Burnt in 1871, demolished in 1882–4. Gardens to the west laid out in 1560–70, redesigned by Le Nôtre in 1665. In the *parterres* to the east (Jardin du Carrousel), 17th- and 18th-century statues. Open-air museum of 19 works by Maillol, opened in 1969. 34, 70, 76, 89, 96, 108, 110, 112, *115*, 129, 138, 145, 146, 147, 158, 185.

Panthéon *Place du Panthéon, V.* Built as church of Ste-Geneviève in 1757–90 by Soufflot and Rondelet, on the top of the Colline Ste-Geneviève. By decree of the Revolutionary Convention, transformed into a burial-place for famous men (Voltaire, Rousseau, etc.). It was used as a church 1806–30, and 1851–85. Decorated in the 19th century with wall-paintings of historic scenes. 89, 133-4, 145, *158*, *160*, *163*, 209.

Passages Shopping arcades; the earliest and most famous is the Passage des Panoramas, off 11 boulevard Montmartre, II (1800). 165.

Pavillon de Flore *Palais du Louvre, I.* Built in 1608 by Jacques Androuet du Cerceau, south of the old Palais des Tuileries. Rebuilt by Lefuel in 1860–70. Burnt in 1871 (at the end of the Commune) and again restored by Lefuel in 1871–6. Named for the sculpture of *Flora* by Carpeaux in the pediment. Acquired by the Musée du Louvre in 1969. 96.

Père Lachaise cemetery (Cimetière de l'Est) *Boulevard Ménilmontant, XX.* On the hill of Ménilmontant; formerly land belonging to a Jesuit retreat patronized by Louis XIV's confessor, Père La Chaise, bought by the city and made into a cemetery in 1803-4. Fine views of Paris from the top. Famous tombs: Chopin, Musset, Balzac, Beaumarchais, Dela-

croix, Oscar Wilde. Large *Monument to the Dead* by Bartholomé (1895). On the eastern edge, Mur des Fédérés, where the last Communards were executed in May 1871. 85.

Petit Palais *Avenue Winston-Churchill, VIII.* Exhibition hall built by Girault for the Exposition Centennielle of 1900. Decorative paintings by Albert Besnard and Maurice Denis. Houses the Musée de la Ville de Paris. 185, *205,* 225.

Petit Pont *Between quai du Marché-Neuf, IV, and quai St-Michel, V.* A bridge at this point has existed since Roman times. Demolished in 1718, rebuilt in 1853. 69.

Place de la Bastille *See* **Bastille.**

Place Charles-de-Gaulle *See* **Place de l'Etoile.**

Place du Châtelet *I and IV.* Laid out in 1802 on the site of the Châtelet prison; enlarged in 1855–8. 36, 54, 172.

Place de la Concorde *VIII.* Formerly Place Louis-XV. Laid out in 1757–79 by Jacques Ange Gabriel around the equestrian statue of Louis XV by Bouchardon and Pigalle (destroyed at the Revolution). Originally bounded by ditches, whose line is marked by the present balustrades. On its north side, two grand colonnaded buildings, both by Gabriel, flank the rue Royale: on the right, the former Garde-Meuble du Roi (royal furniture repository), now Ministère de la Marine; on the left, former residence for ambassadors and important state guests, now Hôtel Crillon and Automobile Club. Renamed Place de la Révolution in 1792: Louis XVI guillotined in January 1793 by the entrance to rue Royale. Called Place de la Concorde in 1795; name changed back to Place Louis-XV under the Restoration, and back again in 1830. Layout improved in 1836–40; obelisk from Luxor, a gift from Mehemet Ali, erected in 1836. To the right of the Garde-Meuble is the Hôtel St-Florentin, built by Chalgrin in 1767 for the Duc de la Vrillère, Comte de St-Florentin; residence of Talleyrand and, later, of James de Rothschild, and now an annexe to the US embassy. To the left of the Hôtel Crillon, at the corner of rue Boissy-d'Anglas, is the US embassy itself, built in 1933 as a copy of Hôtel St-Florentin; it stands on the site of the neoclassical Hôtel Grimod de la Reynière (altered in the 19th century, demolished 1928). 105, 112, *122,* 129, 145.

Place Dauphine *I.* Triangular *place royale* built on the point of the Ile

de la Cité in 1607 after completion of the Pont Neuf. Named after the eldest son of Henri IV and Marie de Médicis, the future Louis XIII. Brick and stone houses (for the bourgeoisie); important in the history of urban planning. 36, 79, 94, 105.

Place Denfert-Rochereau *XIV.* Site of Barrière d'Enfer, one of the surviving toll-houses by Ledoux (1784) from the Enceinte des Fermiers Généraux. 16.

Place de l'Etoile (Place Charles-de-Gaulle) *VIII, XVI and XVII.* Named after the Butte de l'Etoile, a hillock levelled in the 1720s to improve the vista from the Tuileries along the Champs-Elysées. The superb hilltop site thus created remained empty (despite numerous projects) until 1807, when Chalgrin began his colossal Arc de Triomphe de l'Etoile, in honour of Napoleon's armies. Later, Haussmann laid out the twelve converging avenues (with twelve *hôtels* by Hittorf). Renamed after General de Gaulle on his death in 1970. 11, 150, *177.*

Place de la Nation *XI and XII.* Formerly Place du Trône; to the east of the city, between rue du Faubourg St-Antoine and the cours de Vincennes. On the Vincennes side is the Barrière du Trône: two pavilions with Doric columns, one of the toll-gates by Ledoux (1788) in the Enceinte des Fermiers Généraux (q.v.). 11, 172.

Place Royale *See* **Place des Vosges.**

Place Vendôme *I.* Formerly Place Louis-le-Grand. Originated in a scheme by Louvois to build a number of public buildings—mint, academy, etc.—on the land of the former Hôtel de Vendôme. Begun in 1686 by Hardouin-Mansart; completed in 1699 as an octagon framing an equestrian statue of Louis XIV by Girardon (destroyed at the Revolution). Column copied from Trajan's Column erected in 1806–10, pulled down by the Restoration, and later by the Commune; last rebuilt in 1874. Among the notable buildings in the square, Nos 11–13 have since 1815 housed the Ministry of Justice. 108, *110,* 160, *174.*

Place des Victoires *I, II.* Circular *place royale* laid out in 1685 to plans by Hardouin-Mansart, around a statue of Louis XIV commissioned from Desjardins by the Duc de la Feuillade (destroyed at the Revolution). A majestic formal composition; around the open space, with uniform monumental façades by Prévôt, the houses of important people: Duc de la Feuillade, Marshal of France (Nos 2

and 4), the financier Etienne Crozat (No. 3). Bronze statue of Louis XIV by Bosio (1822). One of the earliest monumental residential schemes in Europe. Disrupted in 1883 by the opening of the rue Etienne-Marcel. 108, *108*, 123.

Place des Vosges *III, IV.* Formerly Place Royale. In the heart of the Marais district, on the site of the Hôtel des Tournelles, where Henry II was killed in a joust. One of the most remarkable complexes in the city, built under Henry IV in 1607–12 as a square 108 m. wide. The first formal enclosed square in Europe, with an arcade at ground level. The houses are of brick and stone with slate roofs. At the end of rue de Birague, No. 1, was the Pavillon du Roy, for Henry IV; facing it, the Pavillon de la Reine. No. 6, Musée Victor Hugo, is the house where Hugo lived from 1832 to 1848; No. 7, Hôtel du Petit-Sully, is linked to Hôtel de Sully, rue St-Antoine. The equestrian statue of Louis XIII by P. Bard (1639) was destroyed at the Revolution and later replaced by a statue in marble (1825). Only one major alteration: the cutting of a NE opening to the rue du Pas-de-la-Mule in 1822. Otherwise the square gives a rare impression of 16th- and 17th-century Paris. Floodlit from 1 May to 15 October, 9.30-11 pm. 36, 65, 79, *84*, 94, 105, 209.

Pont Alexandre-III *Between cours la Reine, VIII, and quai d'Orsay, VII.* The widest bridge in Paris (40 m.), with a single arch 107 m. long. Built in 1896–1900 by Résal; first stone laid by Czar Nicholas II in commemoration of the Franco-Russian alliance. Allegorical figures: at the north end Medieval and Modern France; at the south end Renaissance and Louis XIV France; below the entrance piers, the rivers Seine and Neva. 70, 185, *211*.

Pont des Arts *Between quai du Louvre, I, and quais de Conti and Malaquais, VI.* Iron footbridge built in 1802–4, altered in 1871–6 by Visconti and Lefuel. Named after the Palais des Arts, as the Louvre was called at the time of the bridge's buliding. Pedestrians only. 70.

Pont au Change (Grand Pont) *Between Place du Châtelet and boulevard du Palais, I and IV.* Goes back to the 12th century, when it was lined with money-changers' booths. Rebuilt in 1637–47 by du Cerceau, and again in 1858. 10, *27*, 68, 130.

Pont de la Concorde *Between Place de la Concorde, VIII, and Palais Bourbon, VII.* Formerly Pont Louis-XVI, built in 1787–90 by Perronet;

doubled in width in 1930–32. 70, 129.

Pont au Double *Between Place du Parvis Notre-Dame, IV, and quai de Montebello, V.* Length 45 m., width 20m. Built in 1636, had buildings on it until 1835. Rebuilt in 1846 and again in 1882. 70, *27*.

Pont de Grenelle *Between quai de Grenelle, XV, and avenue du President-Kennedy, XVI.* Built in 1875, improved and widened in 1967. Halfway across the bridge, on the Ile aux Cygnes, stands a small version of Bartholdi's *Statue of Liberty.*

Pont d'Iéna *Between Champ de Mars, VII, and Chaillot, XVI.* Built in 1809–13, enlarged in 1914 and 1936. 146.

Pont Marie *Between quai d'Anjou and quai des Célestins, IV.* Length 97 m., width 22 m. Built in 1614–30 by the contractor Christophe Marie, originally covered with houses which were demolished between 1741 and 1788. Restored in 1851. 70, 130.

Pont Mirabeau *Between quai André-Citroën, XV, and quai Louis-Blériot, XVI.* Built of iron in 1895 by Résal. Title of a famous poem in Guillaume Apollinaire's *Alcools* (1913).

Pont Neuf *Between quai de la Mégisserie, I, and quai des Grands-Augustins, VI.* Crosses the river at the tip of Ile de la Cité. Built in 1578–1606 under Henry III and Henry IV; intended from the first to be free of houses. On the point of the island, equestrian statue of Henry IV (the *Vert Galant*) by Lemot (1818) replacing an earlier one by Giovanni Bologna and Pierre de Francheville. *27*, 70, *75*, 76, 88, *91*, 105, 110, 111, 116, 130.

Pont Notre-Dame *Between quai de Gesvres and quai de Corse, IV.* On the site of a Roman bridge, replaced in 1499 by a bridge lined with houses and shops (designed by the Veronese engineer and theorist Fra Giocondo). Buildings demolished in the late 18th century, bridge rebuilt in 1913. 69-70, 130.

Pont Royal *Between quai des Tuileries, I and quai Voltaire, VII.* Northern end adjoins the Pavillon de Flore. Length 133 m., width 15.80 m. Built in 1685–89 to designs by Jules Hardouin-Mansart. Restored 1839–44. 70.

Pont St-Michel *Between quai du Marché-Neuf, IV, and quai St-Michel, V.* Links Ile de la Cité and Latin Quarter. Named after a chapel of St Michel south of the Sainte-Chapelle (demolished in 1781); first built in 1378 by Hugues Aubriot,

Prévôt of the city. Rebuilt in the 19th century. *27, 69, 172.*

Pont de la Tournelle *Between quai de Béthune, IV, and quai de la Tournelle V.* South side of Ile St-Louis. Originally part of the walls of Philip Augustus, which crossed the river at this point. First built of wood (1369), several times rebuilt in stone. At the south end stands a statue of St Geneviève by Landowski. *112.*

Port-Royal, Abbey *119 boulevard de Port-Royal, XIV.* Parisian house of the abbey of Port-Royal des Champs. Begun in 1625; church by Le Pautre (1646–8). Suppressed in 1790. Now a maternity hospital.

Porte St-Denis *Intersection of rue du Faubourg St-Denis and boulevard St-Denis, X.* Triumphal arch erected in 1672 to celebrate the victories of Louis XIV on the Rhine; designed by Blondel, with sculpture by the Anguier brothers. *110, 112.*

Porte St-Martin *Intersection of rue du Faubourg St-Martin and boulevard St-Martin, X.* Triumphal arch erected in 1674, on the orders of the *Prévôt des Marchands* and *échevins* of Paris, to commemorate the capture of Besançon; designed by Pierre Bullet, with sculpture by various hands including Desjardins. *110.*

Procope, Le *13 rue de l'Ancienne-Comédie, VI.* Café established in 1670 by a Sicilian, Francesco Procopio. Instantly fashionable; popular in the 18th century with the Encyclopedists—Voltaire, Diderot, d'Alembert, etc.—and later the Revolutionaries; and in the 19th century with writers and artists. *120.*

Quai d'Anjou *IV.* Embankment on the north side of Ile St-Louis, from Pont Sully to Pont Marie. Built in 1614–47. Along it are a number of fine *hôtels*: 1, Hôtel Lambert (q.v.), with a handsome façade, rotunda and terraced garden; 3, *hôtel* by Le Vau, of 1690; 5, *hôtel* of 1633, lived in by the Marquis de Marigny in 1775 (fine balcony and ironwork on the door); 9, 11, 13, 15, built for Nicolas Lambert; 17, Hôtel de Lauzun (q.v.), built in 1657 by Le Vau for Charles de Gruyn des Bordes; 21, 27, 29, 31, 33, 37 and 39, built in the first half of the 17th century. *89.*

Quai de Béthune *IV.* Embankment on the south side of Ile St-Louis, from Pont Sully to Pont de la Tournelle; given its present name in 1806. Lined with old *hôtels*: 16, *maison de rapport* (1640); 18, built by Le Vau in 1643–7 for the Sieur d'Astry; 20, built in 1644–59 for Antoine Lefebvre, with a ceiling attributed to Mignard; 22, of the same period as 20; 24, modern building erected in 1935, replacing an *hôtel* by Le Vau of which only the door survives; 26, 28, 34, and 36 in 1642–4.

Quai de Bourbon *IV.* On the north side of Ile St-Louis, between Pont Marie and Passerelle St-Louis. Begun in 1617, named after the French royal house. Fine *hôtels* and other old buildings: 1, 17th century cabaret called 'Franc-Pinot'; 11, built in 1637–42 for Philippe de Champaigne, painter to the king; 19, built in 1660; 25, built in 1640, named Hôtel de Nevers in 1705; 31, built in 1642; 45–51, built by Le Vau, who died at No. 49 in 1676.

Quai de Conti *VI.* On the left bank, between Pont Neuf and Pont des Arts. Built in 1662 as quai de Nesle; renamed in 1670 after former Hôtel de Conti (replaced in 1781 by the Monnaie). Rebuilt in 1851–3.

Quai des Grands-Augustins *VI.* On the left bank, between Pont St-Michel and Pont Neuf. The earliest embankment in Paris, built in 1313 under Philip the Fair. Given its present name in 1670. A few old houses survive: No. 35 is 17th-century. *88, 111.*

Quai Malaquais *VI.* On the left bank, between Pont des Arts and Pont du Carrousel. Built in 1662, named after a former wharf, the Port Malaquais. Many old *hôtels*, including: 1, built in 1733 on the site of the Hôtel du Séjour de Nesles; 5, Hôtel de Château-neuf (1626); 15, built by Mansart *c.* 1640 for La Bazinière (now part of the Ecole des Beaux-Arts). *112.*

Quai de la Mégisserie *I.* On the right bank, from Pont au Change and Place du Châtelet to Pont Neuf. Named in the 18th century after the *mégissiers,* tanners of sheep and chamois skins, established there. Now a centre for shops selling pets, pet food and gardening supplies. *65, 173.*

Quai d'Orléans *IV.* On the south side of Ile St-Louis, from Pont de la Tournelle to Pont St-Louis. Built in 1614–46, named after Gaston, Duc d'Orléans (brother of Louis XIII). Truncated in 1867 by the cutting of rue Jean-du-Bellay. Old *hôtels* (some spoiled by alterations): No. 6, dating from 1655, has since 1838 housed the Polish Library and Musée Mickiewicz (*see* Museums Index).

Quai de la Tournelle *VII.* On the

left bank, between Pont de Sully and rue Maître-Albert, near Pont de la Tournelle. Built in 1750 as far as rue de Pontoise; extended to rue de Bièvre after 1835. Old houses: 37, 17th century; 47, Hôtel de Miramion (q.v.), 1629–96; 55, Hôtel de Nemours, 1630–40. 16, 209.

Quai Voltaire *VII*. On the left bank, between Pont du Carrousel and Pont Royal. So called since 1791, when it was officially separated from the quai Malaquais built in 1640. Fine 17th and 18th century houses: 7, the Hôtel de Montalle (1665); 13, house where Delacroix had his studio; 19, the former Hôtel Voltaire, where Wagner and Baudelaire stayed in furnished rooms; Musset lived at No. 25; Voltaire died at No. 27. 112.

Rond-Point de la Défense *Puteaux, Hauts-de-Seine*. Road intersection and urban centre 3 km. north-west of Paris, on the axis of Champs-Elysées, avenue de Neuilly and avenue de la Grande-Armée. Centre of a new scheme for the extension of Paris, due to include the CNIT building (q.v.), *Préfecture* of Hauts-de-Seine, technical centres and a 'Museum of the 20th Century'. 229.

Ruche, La *2 passage de Dantzig, XV*. Pavilion from the Exposition Centennielle of 1900, re-erected as artists' studios near the Vaugirard abattoirs. Given its name ('the beehive') by the artists who lived there after 1905: Léger, Chagall, Soutine, Zadkine, etc. 201.

Rue des Archives *III, V*. Between the Hôtel de Ville (rue de Rivoli) and the Square du Temple. In existence since the 15th century, given its present name in 1870–74. Interesting houses and monuments: 53, Fontaine des Haudriettes (1705); 58, door of the former Hôtel de Clisson (q.v.) (*c.* 1375); 60, Hôtel Guénégaud (now Musée de la Chasse: *see* Museum Index); 76 *hôtel* built in 1642; 78, Hôtel Amelot by Pierre Bullet (late 17th century). 50, 68.

Rue Clovis *V*. Behind the Panthéon (Place Ste-Geneviève). Laid out in 1807 on the site of the old abbey church of Ste-Geneviève. At No. 5, a section of the city wall of Philip Augustus. 9.

Rue de la Cossonnerie *I*. Between boulevard Sébastopol and the Halles. Named after the *cossons,* or egg retailers, active in the market. Existed in the 12th century. 65.

Rue Croulebarbe *XIV*. Between Manufacture des Gobelins and rue Corvisart. No. 33 is a 21-storey skyscraper built by Edouard Albert in 1959. Opposite this Square René Le Gall (or Square des Gobelins), a garden laid out by J.C. Moreux.

Rue des Ecoles *V*. Cut in 1852 between boulevard St-Michel and rue Jean-de-Beauvais, extended to rue du Cardinal-Lemoine in 1855. On the site of No. 2 stood the Porte St-Victor, in Philip Augustus' city wall (demolished in 1684). 173.

Rue du Faubourg St-Honoré *VIII*. Continuation of the rue St-Honoré beyond the former Porte St-Honoré; given its present name in 1847. The *faubourg* contains numerous 18th-century *hôtels*: 55–57, Palais de l'Elysée; 96, built in 1769 by Le Camus de Mézières; 208, former Hospice Beaujon (1784).

Rue du Faubourg St-Antoine *XI and XII*. Continuation of rue St-Antoine beyond the line of the medieval city wall. Named after the former abbey of St-Antoine, founded in 1198. The suburb (*faubourg*) grew in the 17th century, and became the centre of the furniture industry. Old houses of the 17th and 18th centuries.

Rue François-Miron *IV*. Between Place St-Gervais and 1 rue de Rivoli. Old street running along the side of St-Gervais, given its present name in 1865. No. 68 is the Hôtel de Beauvais (q.v.); No. 44, head office of the preservationist Association pour la Sauvegarde du Paris historique, is a 17th-century house standing on two storeys of 13th-century cellars. 92.

Rue des Francs-Bourgeois *III, IV*. Between Place des Vosges and 56 rue des Archives. Formerly several streets (rue de l'Echarpe, rue de Paradis, etc.), considered as one in 1868 and given its present name, from a 14th-century charitable institution. Numerous old *hôtels*: 26, Hôtel de Sandreville; 31, Hôtel d'Albret; 60 Hôtel de Soubise. 9.

Rue Galande *V*. Between 2 rue des Anglais and 1 rue St-Jacques. Recorded as rue Garlande as early as 1297. Old houses of the 14th and 15th centuries, including two with gables (27 and 31). 30.

Rue de Grenelle *VI-VII*. Between carrefour de la Croix-Rouge and Square des Invalides. Former Chemin de Garnelle, created in the 14th century as Chemin des Vaches; in the 17th century, Chemin de la Forêt; called rue de Grenelle when the Faubourg St-Germain was laid out. Numerous *hôtels*: 15, built by Brongniart in 1766; (57–9, fountain by Girardon); 73, Hôtel de Gallifet; 101, built by Lassurance in 1700–1704; 116, built by Boffrand; 127,

Hôtel du Châtelet (now Ministère du Travail), built by Cherpitel in 1770. 134.

Rue Guénégaud *VI.* Between quai de Conti and 15 rue Mazarine. Cut in 1641 through the site of the Hôtel de Nevers. No. 2, Hôtel de la Monnaie (Mint); in the courtyard of No. 29, tower surviving from the wall of Philip Augustus. 9.

Rue La Fontaine *XVI.* Between rue de l'Assomption and rue d'Auteuil. Contains notable buildings by the Art Nouveau architect Hector Guimard: 14, Castel Béranger (1894–8); 60, former Hôtel Mezzara, now a schoolchildren's hostel (1911). 75.

Rue de Lille *VII.* Between 4 rue des Saints-Pères and 9 rue de Bourgogne. Laid out c. 1640 through the Pré-aux-Clercs; called rue de Bourbon until 1792. Interesting *hôtels*: 1, Hôtel Pidoux (18th century); 64, Hôtel de Salm-Kirkburg; 78, Hôtel de Beauharnais. 136.

Rue des Lombards *I–IV.* Between 57 rue St-Martin and 2 rue Ste-Opportune. In existence since the 13th century, regarded as a whole and named in 1877. Contains a number of old houses, with Gothic cellars. 16, 65.

Rue Mazarine *VI.* Between 7 rue de Seine and 52 rue Dauphine. Formerly a path along the city walls of Philip Augustus. Laid out in the 16th century as rue des Buttes; called rue des Fossés in 1617. Given its present name in 1687, after the Collège Mazarin (Collège des Quatre Nations) founded by Mazarin. Old houses; at No. 12 stood the Illustre Théâtre founded by Molière.

Rue Michel-Lecomte *III.* Between 87 rue du Temple and 52 rue de Beaubourg. In existence since the late 13th century. Old houses and *hôtels,* including No. 16, partly 16th century; No. 28, Hôtel d'Hallwyll, rebuilt by Ledoux in 1797 and lived in by Necker. 135.

Rue Montmartre *I, II.* Between 126 rue Rambuteau and 1 boulevard Montmartre. Existed in 1200 as a track leading to Montmartre abbey. Built up as far as the Porte de Montmartre in the city wall (the line of the present boulevard Montmartre) in 1632. Numerous old apartment houses: Frédéric Mistral stayed at No. 172; No. 146 is the brasserie where Jean Jaurès was assassinated.

Rue Pavée *IV.* Between rue St-Antoine and rue des Francs-Bourgeois Laid out in the 14th century through market gardens, hence its former name of rue de la Couture (i.e. culture). No. 10, synagogue built by

Guimard in 1913, with four large superimposed bays; No. 24, Hôtel d'Angoulême.

Rue Réaumur *II-III.* Between 165 rue du Temple and 34 rue Notre-Dame des Victoires. Named after René Antoine Ferchault de Réaumur, physicist and naturalist. Cut in 1851 between rue Volta and rue St-Martin; extended to rue St-Denis in 1854; extended from rue Volta to rue du Temple in 1856. Several old houses, including No. 63 with a handsome façade, and No. 73, of the 17th century. 187.

Rue de Richelieu *I-II.* Between 2 Place du Théâtre-Français and the junction of boulevard des Italiens with boulevard Montmartre. Cut in 1634, when Cardinal Richelieu enlarged the Palais Cardinal. No. 2, Théâtre Français; 22, Hôtel du Président Hénault; old *hôtels* where actors lived; 35, Fontaine Molière by Visconti (1844); 58, Bibliothèque Nationale. 120.

Rue de Rivoli *I-IV.* Between 1 rue de Sévigné and Place de la Concorde. Laid out in 1804 by Percier and Fontaine between rue St-Florentin and rue de Rohan; formal street with arcades at ground level. Extended in 1848 between rue de Rohan and rue de Sévigné. The formal arrangement ends at rue du Louvre. 146, 172, 185.

Rue Royale *VIII.* Between 2 Place de la Concorde and 2 Place de la Madeleine. Laid out to give access to the new Place Louis-XV (now Place de la Concorde); given its present name in 1768. Formal arrangement of uniform buildings, some of them by Gabriel. The most outstanding are Nos. 2–14 and 5–13. Madame de Staël lived at No. 6. 129.

Rue St-André-des-Arts *VI.* Between 15 Place St-André-des-Arts and 1 rue de l'Ancienne-Comédie. On the line of an ancient road to the abbey of St-Germain des Prés. Laid out since the 16th century; truncated in the 19th century by the creation of Place St-Michel. At No. 52, Hôtel du Tillet de la Bissière (1750). 16.

Rue St-Antoine *IV.* Between 3 Place de la Bastille and 2 rue de Sévigné. Laid out in the 15th century on the line of the ancient Roman road from Paris to Melun. Many of its old houses destroyed to make rue de Rivoli; a few remain, including: 21, Hôtel du Petit-Musc, rebuilt by Jean Androuet du Cerceau in 1613; 62, Hôtel de Sully; 101, Lycée Charlemagne, in buildings formerly part of the Jesuit Maison Confesse (on the site of Porte St-Antoine in the walls

of Philip Augustus); 99, St-Paul-St-Louis. 16, 65, 86, 88, 90, 105, *172*.

Rue St-Denis *I-II*. Between 12 avenue Victoria and the junction of boulevard Bonne-Nouvelle and boulevard St-Denis. Since the 14th century, road leading to St-Denis; formerly called rue des Innocents. Old buildings include No. 281, with a gable, and No. 142, Fontaine de la Reine (1732). 22, 45, 69, 109, 110, 150-1.

Rue St-Dominique *VII*. Between 219 boulevard St-Germain and Place du Général-Gouraud. Named after the Dominican friary founded in 1631. Old buildings: 1, *hôtel* built in 1712 by Boffrand for Amelot; 3, *hôtel* of 1680; 14 and 16, Hôtel de Brienne (1714–30); 47, Hôtel de Seignelay; 57, Hôtel de Monaco or Sagan (1774–7) by Brongniart; 129, Fontaine de Mars, by Beauvallet. 94, 134.

Rue St-Germain-l'Auxerrois *I*. Between 1 rue des Lavandières-Ste-Opportune and rue des Bourdonnais. Near the church of St-Germain l'Auxerrois. In existence under its present name since 1450; in the 18th century, ran between rue St-Denis and crossroads at the Pont Neuf; truncated in 1860 by the building of Place du Châtelet to the east and the Belle Jardinière store to the west. Old buildings (which included, before 1783, Fort l'Evêque). *172*.

Rue St-Honoré *I and VIII*. Between 21 rue des Halles and 14 rue Royale. Named after a 13th-century church (destroyed in 1792). Was for a long time the main road leading out of Paris to the west. Until the 17th century, ended at Porte St-Honoré (at the level of the present No. 161); extended under Louis XII to the ramparts (the present rue Royale), whence it is continued by the rue du Faubourg St-Honoré towards Le Roule and Neuilly. Elegant shops, and numerous old buildings including: 95, house where Molière was born; 111, Fontaine de la Croix du Trahoir; 115, early 18th-century building with apothecary's shop; 368, *hôtel* built by Bulliet in 1705. 16, 45, 65, 86, 96, 108, 112, 176.

Rue St-Louis-en-l'Ile *IV*. Between 5 boulevard Henri-IV and 6 rue Jean-du-Bellay. Crosses the Ile St-Louis (q.v.). At Nos. 1 and 3, remains of the Hôtel de Bretonvilliers; 2, Hôtel Lambert; 51, Hôtel Chenizot (built in 1719 for the Receveur des Finances). 89.

Rue St-Martin *III-IV*. Between 10 quai de Gesvres and 1 boulevard St-Denis. Created in 1851 by the amalgamation of rue Planche-Milvray, rue des Arcis and rue St-Martin, whose name—derived from the former priory of St-Martin des Champs—it retained. No. 78, the Church of St-Merri. 32, 151.

Rue St-Séverin *V-VI*. Between 12 rue St-Jacques and 4 Place St-André-des-Arts. Laid out in the 16th century from rue St-Jacques to rue de la Harpe; extended in 1855 to rue St-André-des-Arts. Old buildings include No. 34, a 17th-century *hôtel*. 16.

Rue de Seine *VI*. Between 3 quai Malaquais and 16 rue St-Sulpice. The oldest part, between rue de Buci and the Seine, was originally the path from the townlet of St-Germain des Prés to the river. Layout of the street completed in 1789. Old houses: 26, Petit Maure, cabaret famous in the 17th century; 31, house where George Sand lived in 1831; 41.

Rue de Sévigné *III-IV*. Between rue du Parc-Royal and 100 rue St-Antoine. On the line of a path around the walls of Philip Augustus; made into a street in 1544 under the name Grande rue Ste-Catherine. Called rue de Sévigné after Madame de Sévigné (1629–96) lived in the Hôtel Carnavalet. No. 23, Hôtel (now Musée) Carnavalet; No. 29, Hôtel le Pelletier de St-Fargeau.

Rue du Temple *III-IV*. Between 64 rue de Rivoli and 13 Place de la République. Named after the former headquarters of the Templars. Since 1851 the street has incorporated the former rue des Coquilles, rue Barre-du-Bec and rue Ste-Avoye. Old houses including: 37, Hôtel de Titon (1663); 71–73, Hôtel St-Aignan, by Le Muet (1650); 122, residence of Balzac from 1814 to 1819.

Rue de Thorigny *III*. Between 2 rue de la Perle and 3 rue Debelleyme. Formerly ruelle de Thorigny (named after the Hôtel de Thorigny), a street since 1868. One of the Marais streets where old *hôtels* survive, notably that at No. 5: Hôtel Aubert de Fontenay (q.v.). 92.

Rue de l'Université *VII*. Between 20 rue des Saints-Pères and Allée Paul-Deschanel. Laid out in 1640 on land belonging to the university, between rue des Saints-Pères and the Esplanade des Invalides; extended in 1838 from the Invalides to avenue de la Bourdonnais; further lengthened in 1880–1908 to Allée Paul-Deschanel. Several fine *hôtels,* including: 15, Hôtel de Beauharnais or d'Aligre, of 1681; 21, Hôtel de Cambacérès; 24, Hôtel de Senneterre; 51, Hôtel Pozzo di Borgo, built by Lassurance in 1707.

Rue de Varenne *VII.* Between 14 rue de la Chaise and 17 boulevard des Invalides. Street in the Faubourg St-Germain. Laid out in 1605 between rue du Bac and the Invalides; given its present name (a corruption of the word *garenne*, or warren) in 1850. Numerous 18th-century *hôtels,* including: 47, Hôtel de Boisgelin (1787); 67, Hôtel Matignon (1721); 77, Hôtel Biron (Musée Rodin: *see* Museums Index.). 94, 135.

Rue de la Verrerie *IV.* Between 13 rue du Bourg-Tibourg and 78 rue St-Martin. In existence since the 13th century, named after a glassworks. Old buildings include No. 76, presbytery of the church of St-Merri; and No. 83, a 16th-century house. 16.

Rue Vertbois *III.* Between 75 rue Turbigo and 305 rue St-Martin. Begun in 1546 near St-Martin des Champs: part of the priory wall is visible at No. 51. 33.

Rue Vieille du Temple *III-IV.* Between 36 rue de Rivoli and 103 rue de Turenne. In existence in the 13th century as a path leading to the headquarters of the Knights Templar, known as 'vieille rue du Temple'. Given its present name in the 17th century. Numerous old *hôtels,* including: 47, Hôtel des Ambassadeurs de Hollande, by Pierre Cottard; 87, Hôtel de Rohan, by Delamair (1705–18). 92.

Sacré-Cœur, Church *37 rue du Cheval-de-la-Barre, XVIII.* Basilica on the top of the Butte Montmartre. Built in 1876 by national public subscription, to a design by Abadie. Inside, the decoration is of marble and mosaic; large statue of Christ the Sacred Heart in solid silver. 46, 185, *209.*

St-Aignan, Chapel *19 rue des Ursins, IV.* Built in 1118 by Etienne de la Garlande inside the cloister of Notre-Dame; much altered. Restored in 1966. 52.

St-Antoine, Faubourg *XII.* Suburb which grew up around the abbey of St-Antoine des Champs (now Hôpital St-Antoine, 184 rue du Faubourg St-Antoine). Annexed to Paris in 1702. 136, 153.

St-Augustin, Church *46 boulevard Malesherbes, VIII.* Built in 1860–71 by Baltard in an eclectic style. On the façade, statues of Christ and the apostles by Jouffroy; in the tympana, enamel medallions by Balze (1862). 176, 187.

Sainte-Chapelle *Palais de Justice, boulevard du Palais, IV.* Built in 1246–8 by St Louis, to house relics of Christ's Passion. Consists of two superimposed chapels, the undercroft for the common people and the upper chapel for the court; in it, a unique ensemble of 15 vast windows filled with stained glass (restored in 19th century). 10, *36, 44,* 50, 52, 55, 56.

St-Denis *Seine-St-Denis.* 4 km. north of Paris. Town famous for its Benedictine abbey church rebuilt in the 12th century by Abbot Suger: in the narthex (begun *c.* 1134) and the choir and ambulatory with chapels (1140-44) he used pointed arches and rib vaults—the earliest systematic exercise in the Gothic system of construction. In the choir, fine 12th-century stained glass. High Gothic nave, begun in the mid-13th century. Traditional burial-place of the kings of France. In 1633 the monastery received monks from the Congregation of St-Maur; in 1718–86, the monastic quarters were rebuilt to designs by Robert de Cotte. Monastery dissolved at the Revolution; now Institution de la Légion d'Honneur. Church derelict from Revolution to 1806. Restored by Viollet-le-Duc. *Tombs:* Philip III the Bold, by P. de Chelles (*c.* 1300); Louis XII and Anne of Brittany, by the Giusti, a family of Italian sculptors, (*c.* 1520); Francis I and Claude de France, by C. Bontemps and Fr. Marchant (*c.* 1550); Henry II and Catherine de Médicis, by Germain Pilon and Primaticcio (1560–73). The crypt thus forms a museum of the sculpture of the Renaissance in France. 10, 16, *18,* 22, 30, 45, 47, 48, 50, 51, 52, 105, 115, 160, 197.

St-Denys du St-Sacrement, Church *68 bis rue de Turenne, III.* Church of Restoration period (1826–35) on the site of a 17th-century Benedictine convent. In chapel on right: *Pietà* by Delacroix (1844).

St-Etienne du Mont, Church *Place Ste-Geneviève, V.* First built in 1225, rebuilt in 1492–1586; façade completed in 1606–12. Elaborate *jubé* (rood screen) built in 1525–35, at one time thought to be by Philibert Delorme. Pulpit erected in 1651 to a design by Laurent de la Hyre. Remarkable 16th-century stained glass. Paintings, including Largillière's *Vow of the City Fathers of Paris to St Geneviève* (1696); busts of Pascal and Boileau. Superb stained glass of 1612–22 in the gallery of the former charnel-house, around the choir (visible on application to the sacristan). 16, 50, *73,* 80, 85.

St-Eustache, Church *2 rue du Jour, I.* On the north side of the Halles.

Original church built on the site of a chapel to St Agnes, *c.* 1180–1223; enlarged in 1432. Totally rebuilt on an enormous scale in 1532–1640, with a Gothic structure but using Renaissance forms. Façade worked on in 1754–88. Restored by Baltard (later architect of the neighbouring Halles) after a fire in 1840. Was for a long time one of the richest churches in Paris. Contains the tomb of Colbert by Coysevox, paintings by Rubens and Simon Vouet, and a famous organ. 48, *58*, 80, 85, 176.

Ste-Geneviève, Church, *See* **Panthéon.**

Ste-Geneviève, Abbey *Formerly rue Clovis, V.* Site of an ancient sanctuary to SS. Peter and Paul, burnt in 857. Church rebuilt in 1180, refectory in the 13th century; cloister and tower 15th century; library early 17th century; cloister rebuilt in 1744. School, the Lycée Napoléon, set up in the buildings in 1796–1800. Church demolished in 1802. Lycée later renamed after Corneille; now Lycée Henri-IV. 32.

St-Germain l'Auxerrois, Church 2 *Place du Louvre, I.* Known as *la grande Paroisse,* as its parish includes the Louvre, of which it was formerly the Chapel Royal. On the site of a Merovingian sanctuary. Church built in the 12th (belfry) and 13th centuries, with a porch of 1435–9. Choir taken up again in the 18th century. Statues of the 14th-16th centuries, 16th-century stained glass and carved retable. Restored after 1840; flanked with a new belfry, by Ballu (1860), and the Mairie du Iᵉʳ Arrondissement, by Hittorf (1859). 68, 105, 110, *203.*

St-Germain en Laye *Yvelines.* Small town 21 km. west of Paris, on the edge of a large forest. Original feudal castle built by Louis VI the Fat, burnt except for the chapel of St Louis. Present château built for Francis I by Pierre Chambiges in 1514–39. Another château, called the Château Neuf, built for Henry II by Philibert Delorme in 1556, on the edge of the plateau, completed under Henry IV by Métezeau; destroyed in 1777. Spectacular terraces above the river laid out to the north of the two châteaux by Le Nôtre in the 17th century. The old château, turned into a prison in 1793, was restored for Napoleon III; it is now a Musée des Antiquités Nationales. 9, 68, *69,* 74, 80, 129, 200.

St-Germain des Prés, Church 3 *Place St-Germain des Prés, VI.* Originally the chapel of a 6th-century abbey, ravaged in 861 and rebuilt in 1000.

Of this 11th-century building the tower-porch survives. Rebuilt church dedicated in 1163; Lady Chapel added south of the chancel in 1239–55 by Pierre de Montreuil. Restoration in 1607; west and south portals and vaults by Gamard, 1646. Church restored in 1819–22, and again, by Baltard, in 1843. Murals by Flandrin, 1854–63. Several fine sculptures, including a 15th-century *Virgin and Child,* which may have come from Notre-Dame. Tomb of Jan Kasimierz (King of Poland, Abbot of St-Germain des Prés in 1669), by the Marsy brothers. In the square to the north of the church, re-erected fragments of the Lady Chapel. Monument to the memory of the poet Apollinaire by Picasso (a female head, presented by the artist). North of the choir, the abbot's palace (*see* Hôtel des Abbés de St-Germain des Prés). 14, *30,* 30, 33-4, 45, 48, 50, *50,* 94, 145, 201, *231.*

St-Germer de Fly, Church *Fly, Oise.* 21 km. east of Beauvais. Early Gothic church, built in the third quarter of the 12th century. High nave; *sainte-chapelle* added on the main axis in 1259. 48.

St-Gervais-St-Protais, Church 2 *rue François-Miron, IV.* Founded as a chapel in the 6th century, destroyed in 1213. New church begun in the same year, completed in 1420; destroyed in 1494, rebuilt by Pierre Chambiges. The façade of 1616–20, probably by Salomon de Brosse rather than Clément Métezeau, marks the first use in Paris of the classical orders in a religious building. Organ used by the Couperin family (17th century), the only one to survive intact in Paris. Stained glass by Pinaigrier (16th century); handsome choir-stalls (16th and 17th centuries); 17th-century paintings; sculptures, including the tomb of Michel Le Tellier, Grand Chancellor to Louis XIV (part of the monument is in the Louvre). 30, 50, *61,* 65, 85-6, *99,* 114.

St-Jacques du Haut Pas, Church 252 *rue St-Jacques, V.* Originally, chapel of the headquarters of the friars of St-Jacques du Haut Pas, hospitallers. Taken over by Oratorian Fathers in 1620. New church built by Gittard in 1630–84; contains tombs, including that of the Abbé de Saint-Cyran, the famous Jansenist (1643), and paintings (*St Louis* by Le Sueur).

St-Jean de Montmartre (St-Jean l'Evangéliste), Church *Place des Abbesses, XVIII.* Built by Baudot in 1897: one of the earliest systematic uses of reinforced concrete. 187.

St-Jean-St-François, Church *6 bis, rue Charlot, V.* Chapel built in the 17th century, enlarged and altered in the 19th century. At the entrance to the choir, statues of *St Francis of Assisi* by Germain Pilon and *St Denis* by J. Sarrazin.

St-Joseph des Carmes, Chapel *74 rue de Vaugirard, XV.* Chapel of the former convent of Discalced Carmelites. Built in 1613, severely damaged at the Revolution. The crypt contains bones of victims of the massacres of 1792. Dome painted in the 17th century; sculpture and paintings in the 17th-century chapel of Sacré-Coeur.

St-Julien le Pauvre, Church *Square René-Viviani, V.* Erected in 1170–1250 on the site of an oratory; nave shortened by two bays in the 17th century. Contains a 15th-century tombstone and medieval reliefs, including a 14th-century *Crucifixion*. Melchite church since 1889. 30.

St-Laurent, Church *68 bis, boulevard de Strasbourg, X.* Just south of the Gare de l'Est; original church dedicated to St Lawrence built in the 6th century; rebuilt in 1429. The old façade was demolished and a new one erected in 1862–6 when the boulevard Magenta was cut through. Notable keystones in the vaults. 32.

St-Leu d'Esserent, Church *Esserent, Oise.* 43 km. north of Paris. Benedictine priory, of which notably the church survives. Late 12th-century choir, nave c. 1225, the whole in an extremely pure Gothic style. Severely damaged in 1944; restored. There are stone quarries nearby. 48.

St-Leu-St-Gilles, Church *92 rue St-Denis, I.* Originally a chapel built in the 12th century. Church built in 1235, rebuilt in 1320, restored in 1727 and altered by Baltard in 1858. Fine sculpture, including a marble *St Anne* by Jean Bullant and 15th-century English alabaster reliefs; paintings of the 17th and 18th centuries. 48, 115.

St-Louis en l'Ile, Church *19 bis, rue St-Louis-en-l'Ile, IV.* Built as a chapel in 1623, when the island was first developed; demolished and rebuilt in 1664 by Le Vau, completed in 1725 by Duc and Doucet; belfry in 1765. Restored in the 19th century. Choir painted to designs by Philippe de Champaigne; in the transept chapels, statues of the Virgin and St Geneviève by Dalle; in the chapels off the aisles, paintings, English alabaster, Italian faience; in the baptistery, 15th-century Flemish paintings. 88.

Ste-Marguerite, Church *36 rue St-Bernard, XI.* In the Faubourg St-Antoine; Chapel, then church, built in 1624. Chapelle des Ames du Purgatoire added in 1764 by Victor Louis, with *grisaille* decoration by Brunetti. 136.

Ste-Marie, Temple (Ste-Marie de la Visitation) *17 rue St-Antoine, IV.* Formerly chapel of a Visitandine convent. Built by François Mansart in 1632–34 on a central plan, with dome. Protestant church (i.e. *temple*) since 1802. 88.

St-Martin des Champs, Abbey *292 rue St-Martin, III.* Church begun in 1130, with an important choir. Of the vast monastic complex only the 13th-century refectory survives. Altered in the 19th century by L. Vaudoyer. Since 1798 has housed the Conservatoire des Arts et Métiers (*see* Museums Index). *14, 33, 36, 46-7, 48, 145, 187, 209.*

St-Médard, Church *141 rue Mouffetard, V.* On the site of a 12th-century church. Present church begun in the mid-15th century, completed in 1655. Fragments of 16th-century stained glass, handsome 17th-century organ case, 17th- and 18th-century paintings. 71.

St-Merri, Church *78 rue St-Martin, IV.* Built in 1515–58 on the site of two previous churches, of the 9th and 12th centuries. Fine example of Flamboyant Gothic; restored in the 18th century by Boffrand, who added stucco decoration inside. Very fine organ; 18th-century pulpit by Slodtz; numerous paintings, including *St Charles Borromeo* by Van Loo and *St Merri* by Simon Vouet; sculpture, including a *Virgin of Pity* by Vassé.

St-Nicolas des Champs, Church *254 rue St-Martin, III.* Original 11th-century priory became parish church in 13th century. Rebuilt 1420 and enlarged 1541 and c. 1600. Ornamentation 17th century. South door designed by Philibert Delorme (1575). A fine organ. Many paintings, including a 14th-century altarpiece and an *Assumption* by Vouet above the high altar. Sculptures include *St Rita* by Bourdelle. 80.

St-Nicolas du Chardonneret, Church *23 rue des Bernardins, V.* Built 1656–1709 on the site of a 13th-century church. Tower built in 1625. Façade altered in 1935 by Halley. 17th-century organ. Tombs: Le Brun's mother, by Tuby and Collignon, designed by Le Brun (17th century); Le Brun, by Coysevox (18th century); Jérôme Bignon, Louis

St-Paul-St-Louis, Church *99 rue St-Antoine, IV.* Built by Père Derrand, 1627–41, as chapel for Maison Professe des Jésuites (q.v.); the outsize façade follows the example set by de Brosse at St-Gervais-St-Protais in using three superposed classical orders. 86, 115, *99.*

St-Philippe du Roule, Church *Place Chassaigne-Goyon, VIII.* On the site of Chapelle St-Jacques-St-Philippe, demolished in 1739. New church built by Chalgrin in 1774–84; enlarged in 1845 and 1860 by Baltard. Numerous paintings, including a *Descent from the Cross* by Chassériau. 134, *170, 171.*

St-Pierre de Montmartre, Church *2 rue du Mont-Cenis, XVIII.* Chapel of the former Benedictine abbey of Montmartre. Built in 1132–47 on the site of an earlier chapel, it is one of the oldest churches in Paris. Vaulted in the 15th century; façade erected in 1775. 33, 46, 69.

St-Roch, Church *286 rue St-Honoré, VIII.* Begun by Lemercier, choir and transept 1653–60; continued in various other building campaigns between 1701 and 1760. Nave decorated with Doric pilasters; dome on pendentives. Lady Chapel designed by Hardouin-Mansart on a highly original centralized plan, with eight vaulted bays. Chapelle du Calvaire by Boullée (1754). Façade built in 1735–40 to designs by Robert de Cotte. Dome of the Lady Chapel painted by J.B. Pierre (1749–56). Numerous 17th-century sculptures: *Nativity* by Michel Anguier (1666–7, from the Val-de-Grâce); *Christ on the Cross*, also by Michel Anguier (1685, from the Sorbonne church); tomb of Charles de Créqui, by Mazeline and Hurtrelle (1688); tomb of Henri de Lorraine, by Renard (1690).

St-Séverin, Church *1 rue des Prêtres-St-Séverin, V.* On the site of a 7th-century oratory. Church built in the 13th century, enlarged in the 14th century. Flamboyant Gothic choir erected in 1489–94. Modern stained glass windows by Bazaine. On the south side, charnel-house with 15th-, 16th- and 17th-century galleries. 30, 48, 50, 51, 68.

St-Sulpice, Church *Place St-Sulpice, VI.* Built by Gamard, Le Vau and Gittard from 1645 onward on the site of a 13th-century church; completed in 1719–36 by Oppenord and Servandoni. Lady Chapel decorated by Lemoyne (1730–32); Chapelle des Saints-Anges decorated by Delacroix (1853–63); tomb of incumbent Languet de Gergy by M.-A. Slodtz (1753–7); statues by Bouchardon. 133, 151, 209.

St-Sulpice de Favières, Church *Favières, Essonne.* 40 km. from Paris. A fine Gothic church begun in 1260 on the site of a 12th-century church of which the Chapelle des Miracles survives. Pilgrimage church, housing the relics of St Sulpicius, Bishop of Bourges; 17th-century choir stalls; 13th-century stained glass. 48, *155.*

St-Thomas d'Aquin, Church *Place St-Thomas-D'Aquin, VIII.* Former chapel of the Dominican Novitiate, built by Pierre Bullet in 1683. Façade erected in 1765–9 to designs by Père Claude. In the choir, *Transfiguration* by F. Lemoyne (1723–4). 151.

Ste-Ursule de la Sorbonne *See* **Sorbonne.**

Salpêtrière, Hôpital Général de la *Boulevard de l'Hôpital, V.* Begun by Le Vau in 1657 as a paupers' hospital on the site of the Petit Arsenal (q.v.) continued by Libéral Bruant: laid out as a vast quadrangle, with courts surrounding a centrally-planned chapel. 11, 88, 112.

Samaritaine, La *Quai du Louvre at rue de la Monnaie, I.* Department store; for the origin of the name *see* Fontaine de la Samaritaine. First building erected by Frantz Jourdain in 1905, on the site of the old Hôtel des Monnaies: Art Nouveau design in glass and iron. Additional buildings put up in 1927. The original building has been altered almost out of recognition. 164.

Savoye, Villa *Poissy, Yvelines.* On the heights of Beauregard, 27 km. to the west of Paris. Outstanding example of modern architecture, built in 1928–30 by Le Corbusier. 187.

Sèvres, Manufacture de *Hauts-de-Seine.* 3 km. from Paris, across the Pont de Sèvres, on the road southwest to Versailles. Porcelain factory removed from Vincennes to Sèvres in 1756 on the initiative of Madame de Pompadour; bought by the king in 1760. Still active. (*See* Museums Index.) 152, 153.

Sorbonne *Rue des Ecoles and rue de la Sorbonne, V.* Main building of the University of Paris. Originally the college of Robert de Sorbon, founded under St Louis in 1256; rebuilt by Lemercier in 1627–42. Major alterations after 1880 by Nenot, who added an enormous façade facing rue des Ecoles. Church (Ste-Ursule), built by Lemercier in 1635–42, has two façades, one to the west and another on to the courtyard; in it, the tomb of Cardinal Richelieu by Girardon (1694). 9, 88, 96, 209.

XIV's librarian, by Girardon (1656). 51.

Square Jasmin *Off No. 10 rue Jasmin, XVI.* At No. 3, town house by Guimard (1922).

Temple *III.* Former headquarters of the Knights Templar: occupied the site of the present square du Temple and Mairie du IIIᵉ Arrondissement. The Templars settled here in the 12th century, first building the church and *donjon* (keep), until the community formed a small town surrounded by a fortification wall. Absorbed into the city in 1383. The wall survived until the Revolution, when the royal family was imprisoned in the keep, the Tour du Temple (1792). Keep demolished in 1808; remaining buildings demolished in 1853. Site of the Marché du Temple (or Carreau du Temple), second-hand-clothes market. 36, 78, 145.

Temple de la Gloire *See* **Madeleine.**

Théâtre des Champs-Elysées *13-15 avenue Montaigne, VIII.* Built of reinforced concrete in 1911–13 by the Perret brothers. Contains three auditoriums with spacious entrances access corridors. Reliefs by Bourdelle on the façade; ceiling by Maurice Denis; foyer decorated by Vuillard. 225.

Théâtre du Châtelet *Place du Châtelet, I.* Built by Davioud in 1862, at the same time as the Théâtre Sarah-Bernhardt opposite (now Théâtre de la Ville).

Théâtre Français (Comédie Française) *Place du Palais-Royal, I.* Formerly Théâtre des Variétés-Amusantes. Built on the edge of the Palais Royal development in 1786–90 by Victor Louis, using an iron skeleton. Home of the Comédie Française since 1799; its statutes were laid down by Napoleon during his Russian campaign (in the so-called *Décret de Moscou*) in 1812. South front by Chabrol (1850). Restored after 1900. In the vestibule and foyer, busts and statues of famous writers, including the *Voltaire Seated* by Houdon. 120.

Théâtre Italien *Formerly Rue Ventadour, I.* Built in 1826–9 as the Opéra-Comique. Italian theatre from 1843 to 1870; home of the Opéra from 1873 to 1875. On its site, an annexe to the Banque de France. 123.

Théâtre de la Porte St-Martin *18 boulevard St-Martin, X.* Built after the Opéra du Palais-Royal was burnt in 1781.

Tour de Clovis *Rue Clovis, V.* 12th-century belfry of the former abbey of Ste-Geneviève (now Lycée Henri IV). 32.

Tour Eiffel *Champ de Mars, VII.* Built for the Exhibition of 1889 by the great engineer Eiffel, as a demonstration of iron structure. Height 320 m. (1040 ft.), weight 7,000 tons; rests on four masses of masonry. These are three platforms and a balcony, from which one can see for a distance of 90 km. Tearoom on the first stage. (Open daily, July-September 10–6.30, October-June 10.30–6.30; second stage open until midnight). 176, 185, *223.*

Tour de Nesle *Site of present Institut de France. Pont des Arts, VI.* Fortified tower opposite the Louvre, defending access to the river, often depicted in old prints. 111.

Tour St-Jacques *Square St-Jacques, IV.* Adjoins Place du Châtelet. Surviving south tower of the church of St-Jacques de la Boucherie (14th–16th centuries), which was destroyed in 1797. Flamboyant Gothic style, built under Francis I in 1509–23. Moved to its present site during Haussmann's replanning of Paris. 36, *56,* 172.

Trianon, Grand and Petit *See* **Versailles.**

Trinité, Church *Place Estienne-d'Orvres, IX.* Built by Ballu in 1860–65 in an eclectic style, with a domed western bell tower and raised choir. Statues on the façade include *Temperance* by Carpeaux. Interior: paintings, including *The Presentation in the Temple* and *Pentecost* by Morgan-Snell (1866); sculptures, including *Christ in Glory* by J. P. Pernot, in hammered copper. 185, 190.

Trône, Place and Barrière du *See* **Place du la Nation.**

Tzara, Tristan, house of *14 avenue Junod, XVIII.* Important modern building by Adolf Loos.

Tuileries, Jardin des *See* **Palais des Tuileries.**

Unesco, Maison de l' *Place de Fontenoy, VII.* Complex designed by Nervi, Breuer and Zehrfuss (1955–58), consisting of a large triangular building with concave sides and a conference building. In the conference hall, allegorical painting by Picasso; in the Salle des Commissions, wall-painting by Rufino Tamayo. On the various floors of the secretariat building, decorations by Afrò, Appel, Matta, Brassaï, sculptures by Arp, Chillida and Kelly. On the esplanade to the east, mobile by Calder, reclining figure by Moore, and two walls with ceramics designed by Miró (executed by Artigas). To the south, Japanese garden by Noguchi. 232.

Val-de-Grâce, Church and Abbey 277 *bis, rue St-Jacques, V.* Former abbey of the Benedictines of Le Val Profond, founded in 1621; used as military hospital since 1795. New church commissioned by Anne of Austria in 1638, to celebrate the long-awaited birth of the Dauphin, later Louis XIV; begun in 1645 by François Mansart, continued by Lemercier, Le Muet, and Le Duc who built the dome in Italian Baroque style. (1665). In the dome, paintings of the *Blessed in Glory* by Mignard; baldacchino over the high altar by Le Duc and the Anguier brothers (beneath it, a marble copy of the St-Roch *Nativity,* which originally stood here). 88, 115, *103.*

Vaux-le-Vicomte *Maincy, Seine-et-Marne,* Chateau 40 miles east of Paris. The first example of the great classical French château, designed by Louis Le Vau, and decorated by Charles Le Brun, with immense grounds planned by Le Nôtre, from 1657–61, for the minister Fouquet. There is a fine decorated great Salon in the interior. The park is one of the most complete, with French-style flower-beds, ornamental lakes and grottoes. Open to visitors from Palm Sunday to November 11 from 2 p.m. to 6 p.m. on Saturdays and Sundays. 115.

Versailles *Yvelines.* 16 miles south-west of Paris. A village where Louis XIII built a simple hunting lodge in 1624. Louis XIV afterwards commissioned Louis Le Vau to expand the building by surrounding it with a construction on a much larger scale to be made into a royal palace. After 1678, Jules Hardouin-Mansart developed the garden front and the wings to correspond to the park designed by Le Nôtre from 1661–68 to a gigantic plan stretching beyond the terrace.
The chapel was built between 1699 and 1710 by Jules Hardouin-Mansart and Robert de Cotte. An entire town grew up round the residence of the court. The apartments were altered in the eighteenth century and the Opera was designed by Gabriel. More alterations were made under Louis XVI and Marie-Antoinette. The château was abandoned after 1792, but was restored and partly converted into a history museum in 1837. Restored again (roofing) in 1920 and (interior) in 1952.
In addition to the sumptuous chapel, and the elegant opera by Gabriel, there are the state apartments and the Galerie des Glaces, by Mansart, with paintings by Le Brun, the apartments of Louis XV, with panel-ling and furniture, and of Marie-Antoinette, by Mique, the Galerie des Batailles and the history museum.
The park was created by Le Nôtre around a huge axis: Parterre de Latone, lawn (Tapis Vert), Grand Canal, and a series of groves (Salles de Verdure) with architecture and decoration: the most famous is the Bosquet de la Colonnade; in the Bosquet des Bains d'Apollon, the Grotte de Téthys with the famous group sculpted by Girardon.
Three outstanding structures in the park, each illustrating one of the great periods:
Grand Trianon, designed in 1687 by J. H. Mansart, with two wings round a court-yard closed by a portico (extremely well-restored, 1963–66).
Petit Trianon, built 1762–68 by Gabriel, a gem of sober elegance. In the gardens: the Temple de l'Amour, a rotunda with twelve Corinthian columns by Mique, 1778.
Hameau. Pastoral village designed for Marie-Antoinette by Mique from 1775–84, intended for 'idyllic' life. On the parade-ground in front of the château, three avenues open out in a crow's foot, separated by two sumptuous buildings, the Grandes Ecuries and Petites Ecuries, nowa-days used for university and administrative purposes. The regular-ly-planned town leading up to the château contains the fine classical cathedral of St-Louis, built 1734–54 by Mansart's grandson, and several old hôtels: Boulevard de la Reine, 54, Hôtel Lambinet (museum); Avenue de St-Cloud, Lycée Hoche (former convent, with a chapel by Mique). 51, 74, 81-4, 96, 99, 105, 114, 115, 116, 117, 118, *118,* 120, *123, 127, 128,* 128, *130, 132, 134,* 136, 138, *145, 146, 151,* 151, 165.

Vincennes *XII and Val-de-Marne.* Château on edge of forest (*See* Bois de Vincennes). The construction of the château was undertaken by Philip VI of Valois in the 14th century, on the site of a former hunting-box used by the Capetians. Work went on under John the Good and Charles V, who built the great perimeter wall enclosing the château and its keep. A Sainte-Chapelle was finished by Francis I. In the 17th century, Le Vau designed two classical wings, the King's wing in the west and the Queen's wing in the east, linked by screen-wall with a portal, now reconstructed. (*See* Museums Index: Musée historique and Musée de la guerre). Open to visitors every day except Tuesday 10-12, 1.30-5.30 (winter 2-5.30). 45, 81, 105, 153.

Painters, Sculptors and Architects

Abadie, Paul (Paris 1812–Chatou 1884. Architect. Worked on the restoration of Notre-Dame in Paris (1845). Major work is the basilica of the Sacré-Coeur, in neo-Byzantine style (1876). 185, *209.*

Abbate, Niccolo dell' (Modena 1512–1571). Painter of mythological subjects and peasant scenes; joined the School of Fontainebleau in 1552. In the Louvre: *The Continence of Scipio, The Toilet of Venus.* 110, 112.

Adam, Nicolas Sébastien (Nancy 1705–Paris 1778). Sculptor and decorator. Decorated the Salon Oval, Hôtel de Soubise. Portal of the Oratoire (145 rue Saint-Honoré, I). Various works in connection with the Château de Versailles, including the sculptures of the Fontaine de Neptune, on which he worked with his elder brother. 133.

Afrò (Afrò Basaldella; born Udine 1912). Painter. In 1952 founded the group of 'Eight Italian Painters'. Painting in UNESCO building (1958). 232.

Alavoine, Jean Antoine (1778–1834). Architect. Several works in Paris, including the Colonne de Juillet, Place de la Bastille (1840–41, with Duc). *174.*

Alby. Engineer. Designed the Pont Alexandre III (1900).

Alphand, Jean-Charles (1817–1891). Landscape gardener. Designed, for Baron Haussman, the Bois de Boulogne (after 1852), Buttes-Chaumont (1866–67), Bois de Vincennes (1858–60). Restored the Parc Monceau. 177.

Androuet du Cerceau. See **Du Cerceau.**

Antoine, Jacques Denis (Paris 1733–1801). Architect. Hôtel Jaucourt (62 rue de Varenne, VII), Chapel of the Communion at Saint-Nicolas des Champs. Most important work is the Hôtel de la Monnaie (11 quai de Conti, VI; 1768–75). 130, 136.

Appel, Karel (Born Amsterdam 1921). Painter. Established himself in Paris in 1949. Founder of the COBRA experimental group. Large painting in the UNESCO building: *Meeting in Spring* (1958). 232.

Arp, Jean (Strasbourg 1888–Basle 1966). Sculptor and painter. Work in UNESCO building (1958).

Astruc, Jules (Avignon 1862–1955). Architect specializing in metal construction. Notre-Dame du Travail (59 rue Vercingétorix, XIV; 1899–1901). 187.

Aubert, Jean (Died Paris 1741). Architect. Hôtel Biron (now Musée Rodin, 77 rue de Varenne). Worked with others on the Palais Bourbon (Chambre des Députés, Place du Palais-Bourbon, VII). Great stables at Chantilly. P.

Ballu, Théodore (Paris 1817–1885). Architect. Neo-Gothic belfry of Saint Germain l'Auxerrois (1860). Major work is the church of La Trinité (Place d'Estienne d'Orves, IX; 1861–75). Worked with others on the rebuilding of the Hôtel de Ville (after 1871). 185, *190, 203.*

Baltard, Victor (Paris 1805–1874). Architect. Builder of the Halles Centrales, with their iron pavilions (begun 1852). Restored Saint-Eustache. Built Saint-Augustin with an iron frame inside traditional stone masonry (1866). *170, 176, 187, 197, 232.*

Barre, Nicolas (active in Paris in the late 18th century). Architect. Hôtel Grimod de la Reynière (at the corner of the Champs-Elysées and Place de la Concorde; *c.* 1770, demolished 1928).

Bartholdi, Frédéric (1834–1904). Sculptor. *Lion de Belfort* (Place Denfert-Rochereau, XIV; 1880); *Liberty lighting the World,* or *Statue of Liberty* (New York harbour; 1886. Reduced scale model stands on the Ile aux Cygnes, Pont de Grenelle).

Bartholomé, Albert (1848–1928). Sculptor. *Monument aux Morts* (Père Lachaise cemetery; 1895–99).

Bartlett, Paul Wayland (New Haven 1865–Paris 1925). Sculptor. Worked in Paris; works include the equestrian *Lafayette* in the Cour du Carrousel of the Louvre. *187.*

Barye, Antoine (Paris 1796–1875). Sculptor and animal painter. In the Louvre: *Lions* (painting); in the Petit Palais: *Centaur and Lapith* (sculpture); in the Musée Condé, Chantilly: *L'Hallali au cerf* (sculpture).

Baudot, Anatole de (Sarrebourg 1834–Paris 1915). Architect and theoretician. Defined principles of use for reinforced materials. Saint-Jean de Montmartre (Place des Abbesses, XVIII; 1894–1902). 187.

Bazaine, Jean (Born Paris 1904). Painter. Creator of stained-glass windows and mosaics, including a mosaic for the UNESCO building

(1958). Stained glass for Saint-Séverin (rue des Prêtres Saint-Séverin, V). 51.

Beaudoin, Eugène (Born Paris 1898). Architect and town planner. Worked with Lods on several schemes in the suburbs of Paris: Cité des Oiseaux, Bagneux (1931–32), Cité de la Muette, Drancy (1932–35), open-air school at Suresnes (1933). One of the designers of the Maine-Montparnasse complex (in progress). 232.

Beauneveu de Valenciennes, André (Valenciennes c. 1335–Bourges 1413). Painter, illuminator and sculptor in the service of Charles V and the Duc de Berry. In the Bibliothèque Nationale: *Psalter of the Duc de Berry.* Sculptor of the tombs of Philip VI de Valois, Jean le Bon, Jeanne de Bourgogne (1353) and Charles V (1364). In the Louvre: statues of *Charles V as Saint Louis* and *Marguerite de Provence as Jeanne de Bourbon.* 53.

Beauvallet, Pierre-Nicolas (Le Havre 1750–Paris 1818). Sculptor. Works at Château de Compiegne. Busts, among which is *Marat. Fontaine de Mars* in rue St Dominique. 134.

Belanger, François Joseph (Paris 1744–1818). Architect, superintendent of buildings to Louis XVI's brother, Comte d'Artois (later Charles X). Designed the Bagatelle pavilion and the Folie St-James (both in the Bois de Boulogne), and a great many *hôtels* — since demolished — in the Chaussée d'Antin district. Restored the château of Saint-Germain en Laye. 128, 136.

Bernard, Henry (Born Albertville 1912). Architect. ORTF (1963), Shell building (27 rue de Berri, VIII). 232.

Bernini, Gian Lorenzo (Naples 1598–Rome 1680). Architect and sculptor. Called to Paris by Louis XIV, he made several Baroque designs for the east front of the Louvre, none of which was carried out. At Versailles: equestrian statue of Louis XIV (later transformed into a statue of Marcius Curtius) at the southern end of the Pièce d'Eau des Suisses; bust of Louis XIV in state apartments. 89, 117, *130.*

Besnard, Albert (Paris 1849–1934). Painter and decorative artist. Ecole de Pharmacie, Sorbonne, cupola of the Petit Palais, ceilings of the Hôtel de Ville. In the Théâtre Français: *Apollo, The Hours, and the Muses.* Works in the Louvre and in the Musée des Arts Décoratifs. 209, 225.

Bigot, Trophime (Active in the 17th century). Painter. Identified with the 'Master of the Candle'. 115.

Blanchard, Jacques (Paris 1600–1638). Painter and decorative artist. Decorated the Hôtel de Bullion (destroyed). In the Louvre: *Charity, Cimon and Iphigenia.* 114.

Blondel, François (Ribemont, Aisne, c. 1618–1686). Architect. Author of *Cours d'architecture* (1675) and, with Bullet, of a plan of Paris. Porte Saint-Denis (1672). 110, *112.*

Boffrand, Germain (Nantes 1667–1754). Architect. Author of a book on architecture (1745). The Orangerie at Versailles, Hôtel de Soubise (rue des Francs Bourgeois, III), Hôtel de Brissac (116 rue de Grenelle, VII), Hôtel Amelot de Gournay (1 rue Saint-Dominique, VII). 132, 136.

Boileau, Louis Charles (1837–1910). Architect. Built the Bon Marché department store (Square Boucicaut, VI) after designs by his father (1876). 163.

Boizot, Simon Louis (Paris 1743–1809). Sculptor. Fontaine du Palmier (Place du Châtelet, IV). In the Louvre: *Meleager.* In Saint-Sulpice: *The Four Evangelists.*

Boldini, Giovanni (Ferrara 1842–Paris 1931). Painter, society portraitist . Works in the Musée National d'Art Moderne include portraits of *Henri de Rochefort* and the *Comte de Montesquiou.* 200.

Bologna, Giovanni (Douai 1529–Florence 1608). Sculptor of Flemish origin, settled in Tuscany. With P. de Francheville, produced the equestrian statue of *Henry IV* on the Pont Neuf. In the Louvre: *Mercury* (copy), and maquette for the monument to Ferdinand I, Grand Duke of Ferrara. 75.

Bonington, Richard Parkes (Arnold, Nottingham, 1801–London 1828). Painter, pupil of Gros. In the Louvre: *Parterre d'Eau, Versailles* (1826). 190.

Bonnat, Joseph Florentin Léon (Bayonne 1833–1922). Painter. Works in the Louvre include *Portrait of Victor Hugo.* In the Petit Palais: *Madame Ehrler.* In the Panthéon: *Martyrdom of St Denis.* 195.

Bontemps, Pierre (1505–1568). Sculptor, active at Fontainebleau and Paris. Worked with Philibert Delorme on the tomb of Francis I at St-Denis. In the Louvre: funerary effigy of Charles de Maigny; tomb of Jean d'Humières (royal chamberlain); and his masterpiece, the tomb of Admiral Chabot. 116.

Bordoni, Francesco (1580–1654). Sculptor. In the Louvre: *Chained Slaves* (for the statue of *Henry IV* on the Pont Neuf), executed in collaboration with Francheville.

Bosch, Hieronymus ('s Hertogen-bosch *c.* 1460–1516). Painter. In the Louvre: *The Ship of Fools,* and drawings. In the Musée Municipal, Saint-Germain en Laye: *The Conjuror* (copy of a lost original).

Bosio, François Joseph (Monaco 1769–1845). Sculptor. Works in the Louvre. Statue of *Louis XIV* (Place des Victoires, 1).

Bouchardon, Edme (Chaumont 1698–Paris 1762). Sculptor and draughts-man. Fontaine des Quatre Saisons (rue de Grenelle). Made 800 drawings of *The Cries of Paris,* in the Louvre (engraved by Caylus). 129, 134, *146,* 153, 190.

Boucher, François (Paris 1703–1770). Painter of history and genre subjects, and decorative artist. Drawing-master to Madame de Pompadour; *premier peintre* to the king. Designed tapestry cartoons. Many works in the Louvre, including *Venus at the Forge of Vulcan, Rinaldo and Armida,* and *The Bath of Diana.* In the Musée Condé, Chantilly: *Portrait of Watteau.* 133, 152.

Bouguereau, William (La Rochelle 1825–1905). Official painter. In the Louvre: *Youth and Love, Virgin of Consolation.* Decorated chapels in Sainte-Clotilde, Saint-Augustin, and Saint-Vincent de Paul. 209.

Boullée, Etienne-Louis (Paris 1728–1799). Architect, professor, and theoretician. Built several *hôtels* in Paris, then made numerous designs for public buildings, including the Hôtel de la Monnaie. 136.

Boullier, Jean (*c.* 1630–1714). Architect. Hôtel Aubert de Fontenay, (Hôtel Salé) (5 rue de Thorigny, III). 92.

Bourdelle, Emile Antoine (Montauban 1861–1929). Sculptor. Monument to Adam Mickiewicz (Place de l'Alma; 1929); eight reliefs on the façade of the Théâtre des Champs-Elysées (1911–13); statue of *St Rita* in Saint-Nicolas des Champs (III). A museum devoted to his work has been established in his former studio (*see* Museums Index). Other works in the Musée National d'Art Moderne. 229.

Bourdon, Sébastien (Montpellier 1616–Paris 1671). Painter and decorative artist. Decorated the gallery in the Hôtel de Bretonvilliers (Ile Saint-Louis, destroyed) with the *Story of Phaeton* (1663). In the Louvre: *Self-portrait, Gypsies at Roadside, Solomon sacrificing to Idols.* Other works in the Musée Condé, Chantilly. 89.

Boyceau, Jacques (Active in the first half of the 17th century). Gardener.

Designed the great parterre in the garden of the Palais du Luxembourg.

Brancusi, Constantin (Romania 1876–Paris 1957). Sculptor. Settled in Montparnasse in 1907, lived in Impasse Ronsin (XV) from 1918 until his death. To the Musée National d'Art Moderne he bequeathed his studio and works, including *The White Negress* and maquettes for *L'Esprit de Bouddha* and *La Colonne sans fin.* Monument to T. Garsevskaïa, *The Kiss* (1910), in Montparnasse cemetery (corner nearest Raspail Métro station). 225, *225.*

Braque, Georges (Argenteuil 1882–Paris 1963). Painter and sculptor. With Picasso, founded Cubism. In the Musée National d'Art Moderne: *Le Quotidien, Composition with the Ace of Clubs, Young Girl with a Guitar, The Sofa, Canephorus, Duo, Billiards, Hymen.* In the Louvre: ceiling of the former Cabinet Henri II (SW corner of the Cour Carrée, first floor).

Bretez, Louis (18th century). Architectural draughtsman. Produced the so-called Turgot Plan of Paris in 1739. 136.

Breuer, Marcel (Born Pecs, Hungary, 1902). Architect. One of the designers of the UNESCO building. 232.

Brongniart, Alexandre Théodore (Paris 1739–1813). Architect. Responsible for many dwellings in the Faubourg Saint-Germain and in the districts of the Invalides and Chaussée d'Antin: Hôtel de Bourbon-Condé (12 rue Monsieur, VII); Hôtel de Masseran (11 rue de Masseran, VII); alterations to the Hôtel de Chanac-Pompadour (142 rue de Grenelle, VII). Began building of the Bourse (1808). 135, 153.

Bruant, Libéral (Paris *c.* 1635–1697). Architect. Responsible for plans of the Salpêtrière and Hôtel des Invalides. Worked on Notre-Dame des Victoires and several Parisian houses. 112, *116, 145.*

Brunetti, Paul Antoine (Died Paris 1783). Architect and decorative artist. Worked at the Hôtel de Luynes and Hôtel de Soubise; executed grisaille decorations in a chapel in Sainte-Marguerite (36 rue Saint-Bernard, XI). 135.

Bullant, Jean (*c.* 1510–1578). Architect. Worked on the Tuileries and on the Hôtel de Soissons (of this a column survives, near the Bourse du Commerce, rue de Viarmes, I). Designed the north portico of the Château d'Ecouen, and the Petit Château at Chantilly. *181.*

Bullet, Pierre (Paris 1639–1716). Architect of the City of Paris, elected to the Academy in 1685. Worked with François Blondel on a plan of Paris. Decorated two transept chapels in Saint-Germain des Prés. Built the Porte Saint-Martin (1674); Hôtel Crozat (19 Place Vendôme, I); Hôtel de Castries (23 Place Vendôme, I); Hôtel de Brancas (6 rue de Tournon, VI); 368 rue Saint-Honoré (1705); conventual buildings of Saint-Martin des Champs (292 rue Saint-Martin, III). 110, 94.

Buyster, Philippe de (Antwerp 1595–1688). Sculptor. Worked on decorations at the Val-de-Grâce, Louvre, and Versailles. 96.

Calder, Alexander (Born Philadelphia 1898). Sculptor and painter. Inventor of the 'mobile', designer of theatrical décors. Giant mobile for the UNESCO building (1958). Many works in the Musée National d'Art Moderne. 232.

Callot, Jacques (Nancy 1592–1635). Engraver. Series of engravings: *Les Miseres de la Guerre, Caprices, Beggars*, etc. 111, 114.

Camelot, Robert (Born Reims 1903). Architect. Responsible for the Centre National d'Enseignement Technique, Cachan; CNIT, Rond-Point de la Défense (1958); housing estate at Nanterre. 231.

Camus de Mézières, Nicolas Le (Paris 1721–1789). Architect. Built the Halle au Blé (burnt down 1803) and houses near the Opéra-Comique.

Candida, Giovanni di (Before 1450–after 1504). Italian medallist. In the Musée Jacquemart-André: medal of *François d'Angoulême*.

Canova, Antonio (Possagno 1757–Venice 1822). Sculptor. Worked for Napoleon I. In the Louvre: *Cupid and Psyche*. 153.

Cappiello, Leonetto (Leghorn 1875–Grasse 1942). Painter and draughtsman; specialized in posters and illustration. 190.

Caravaggio, Michelangelo Merisi da (Caravaggio 1568–Porto Ercole 1609). Painter. In the Louvre: *Death of the Virgin, The Fortune-Teller, The Concert, Portrait of Alof de Wignacourt* (1601). 195.

Carlin, Martin (*c.* 1730–1785). Cabinet-maker of German origin, active in Paris. Specialized in furniture covered with marquetry and trimmed with bronze. Produced marquetry clocks (Conservatoire des Arts et Métiers) and a music desk in rosewood and Sèvres porcelain for Marie-Antoinette. Works in the Louvre. 154.

Carlu, Jacques (Born 1890). Architect. With Boileau, designed the Palais de Chaillot. 186.

Carpeaux, Jean-Baptiste (Valenciennes 1827–Paris 1875). Sculptor. Architectural sculpture: *The Dance* for the Opéra (replaced by a copy): *Triumph* for the Pavillon de Flore (1836–66); *Four Corners of the World* for the Fontaine de l'Observatoire. In the Petit Palais and Louvre: busts of *Napoleon III, Empress Eugénie, Princess Mathilde, Charles Garnier* (architect of the Opéra); *Fisherman with a Shell; Ugolino and his Children*; original of *The Dance*. 197, 205.

Carpi, Seibec de (Active between 1535 and 1554). Italian cabinetmaker and decorator. Works in the Louvre, at Saint-Germain en Laye, and decorations for the Galerie François I^{er} at Fontainebleau. 65.

Carracci. Family of Bolognese painters.
— Annibale (Bologna 1560–Rome 1609). In the Louvre: *Sleep of the Child Jesus* (called *'le silence du Carrache'*), *The Virgin appearing to St Luke, The Infant Hercules, Diana and Callisto, Concert on the Water, Hunting, Fishing*.
— Antonio (Venice 1583–Rome 1618). In the Louvre: *The Deluge*. Works in the Musée Condé, Chantilly.
— Lodovico (Bologna 1555–1619). In the Louvre: *Annunciation, Virgin and Child, The Virgin and Child appearing to St Hyacinth*. Works in the Musée Condé, Chantilly. 158.

Cartaud, J.S. (1675–1758). Architect. Worked on the Palais Royal (formerly Palais Cardinal).

Cavelier, Pierre Jules (Paris 1814–96). Sculptor. Works include *Justice*, in Trinité church, and the cariatids and cresting of the Pavillon Turgot of the Louvre. 188.

Cézanne, Paul (Aix-en-Provence 1839–1906). Painter. The most influential painter of the 19th century; his works were decisive in the development of modern French painting. Well represented in the Musée de l'Impressionnisme (Jeu de Paume): *A Modern Olympia, The House of the Hanged Man, The Blue Vase, The Card-Player, The Sea at l'Estaque*. 209, 213.

Chagall, Marc (Born Vitebsk 1887). Painter of Russian origin, active in Paris from 1910. Works in the Musée National d'Art Moderne include *Me and the Village, Around Her*. Painted the ceiling of the Opéra (1964). 200, 229.

Chalgrin, Jean François (Paris 1739–1814). Architect. Responsible for

the church of Saint-Philippe du Roule (1769–84), Arc de Triomphe (begun 1806), and north tower of Saint-Sulpice (1777). Restored the Luxembourg when the building was taken over by the Directoire, and rebuilt the interior of the Odéon theatre. 133, 134, 147, *170, 171, 195.*

Chambiges, Pierre (Active in the late 15th and early 16th centuries). Architect. Worked on Saint-Gervais-Saint-Protais (1494), and on the châteaux of Chantilly and Saint-Germain en Laye for Francis I. *68, 69.*

Champaigne, Jean-Baptiste (Brussels 1631–Paris 1681). Painter. Nephew of Philippe de Champaigne. Decorated Saint-Louis en l'Ile.

Champaigne, Philippe de (Brussels 1602–Paris 1674). Painter. Works in the Louvre include *Mother Agnes Arnauld and Sister Catherine de Sainte Suzanne, Arnaud d'Andilly.* In the Musée Jacquemart-André: *Portrait of a Man.* In the Musée Condé, Chantilly: *Portrait of Mazarin.* 96.

Chareau, Pierre (Le Havre 1883–New York 1950). Architect. Maison de Verre (house of Dr d'Alsace, 31 rue Saint-Guillaume, VII). 188.

Chastillon, Claude (1547–1616). Architect and engineer. Hôpital Saint-Louis in Paris; project for the Place de France (unexecuted).

Chaudet, Antoine Denis (Paris 1763–1810). Sculptor and official painter. Statue of *Napoleon I as Caesar,* formerly on the Colonne Vendôme; allegorical relief on the Pavillon de Beauvais (Cour du Louvre). Works in the Louvre include: *The Infant Oedipus restored to life by Phorbas,* bronze bust of *Napoleon I.* 108, *174.*

Chédanne, Georges Paul (Naronne, Seine-Maritime, 1861–1940). Architect, specialized in iron and concrete structures. Palace Hôtel (Champs-Elysées), office block at 124 rue Réaumur (IX). 187.

Chéret, Jules (1836–1930). Poster artist; also worked as decorative painter in 18th-century style. 190.

Cherpitel, Mathurin (Paris 1736–1809). Architect. Several Paris *hôtels,* including the Hôtel de Rochechouart (110 rue de Grenelle, VII) and Hôtel du Châtelet (127 rue de Grenelle, VII).

Chevotet, Jean-Michel (1698–1772). Designed the Pavillon de Hanovre (now in the park of Sceaux) for the Maréchal de Richelieu.

Chillida, Eduardo (Born San Sebastián, Spain, 1924). Sculptor. Creator of monumental sculptures in iron,

bronze and wood. Work for UNESCO (1970).

Claude Lorrain. *See* **Lorrain.**

Colin, Paul (Born 1892). Painter and decorative artist specializing in posters and theatre sets. 190.

Collignon, Gaspard (Died 1702). Sculptor. Worked with Tuby on the tomb of Lebrun's mother (Saint-Nicolas du Chardonnet).

Contamin, Paul (1840–1893). Engineer. With Dutert, built the Galerie des Machines for the Paris Exposition of 1889 (demolished 1910). 185.

Contant d'Ivry (Pierre Contant; Ivry-sur-Seine 1698–Paris 1777). Architect. Palais Royal; abbey of Panthémont (106 rue de Grenelle, VII; 1747–56); staircase of the Hôtel Crozat (19 place Vendôme, I); project for the Madeleine. 129.

Cortona, Domenico da (Died *c.* 1550). Architect. Built the first Hôtel de Ville in Paris (1533–50).

Cortot, Jean Pierre (Paris 1787–1843). Sculptor. On the Arc de Triomphe, *Triumph of Napoleon;* in the Chapelle Expiatoire (square Louis-XVI), *Marie-Antoinette.*

Costa, Lucio (Born Toulouse 1902). Architect and theoretician of modern architecture. Active in Brazil and Paris. With Le Corbusier, designed the Maison du Brésil at the Cité Universitaire.

Cottard, Pierre (Mid-17th-century). Architect. Designed the Hôtel Amelot de Bisseuil (Hôtel des Ambassadeurs de Hollande, 47 rue Vieille du Temple). 92.

Cotte, Robert de (Paris 1656–1735). Architect to the king in 1689, Premier Architecte in 1708. In the studio of Jules Hardouin-Mansart, several of whose works he completed. Designed the Hôtel d'Estrée (79 rue de Grenelle, VII), and the high altar of Notre-Dame. Completed the church of Saint-Roch (286 rue Saint-Honoré). 158.

Courbet, Gustave (Ornans 1819–La Tour de Peilz, Switzerland, 1877). Painter. Died in exile, having been condemned after the Commune for his part in the destruction of the Colonne Vendôme in 1871. Important collection of works in the Louvre: *Funeral at Ornans, La Remise des Chevreuils, The Wave, Portrait of Jules Champfleury, Spring Rut, Deer Fighting, The Covered Stream, Man with a Leather Belt* (self-portrait), *The Spring, The Painter's Studio.* In the Petit Palais: *Les Demoiselles de la Seine, Sleep.* 195, 225.

Courtonne, Jean (Paris 1671–1739). Architect. Designed the former Hôtel de Noirmoutiers (138-140 rue de Grenelle, VII); Hôtel de l'Etat-Major de l'Armée; Hôtel Matignon (57 rue de Varenne), residence of the Premier; Hôtel du Lude (rue Saint-Dominique; only a small part of a natural history collection survives); Château de Villarceaux (Seine-et-Oise, commune of Chauny). *135.*

Cousin, Jean 'Le Père' (Sens c. 1490-Paris 1560). Painter and sculptor. Author of a treatise on perspective and the proportions of the human body. Painted on glass. In the Louvre: *Eva prima Pandora, Last Judgment. 109.*

Coustou, Guillaume (Lyons 1671–1746). One of a family of sculptors. Worked on the Trianon and at Marly. Sculpted the *Chevaux de Marly* (Place de la Concorde). *26.*

Coustou, Nicolas (Lyons 1658–1733). Brother of Guillaume C. Worked on the Trianon and at Marly. Works in the Louvre.

Coypel. Family of painters.
— Noël (Paris 1628–1707). In the Louvre: *Solon defending the Justice of his Laws against the Objections of the Athenians, Hercules killing the Centaur* (1699–1704), *Apollo crowned by Victory.*
— Antoine (Paris 1661–1722). In the Louvre: *Athalie driven from the Temple, Esther fainting, Rebecca and Eliz, Girl stroking a Dog, Democritus.*
— Noël-Nicolas (Paris 1690–1734). In the Louvre: *Venus, Bacchus and Cupid* (1727), *Innocence and Love* (1734).
— Charles-Antoine (Paris 1694–1752). In the Louvre: *Perseus and Andromeda. 115, 151, 158.*

Coysevox, Antoine (Lyons 1640–1720). Sculptor. Responsible for several tombs, including that of Le Brun at Saint-Nicolas du Chardonner and that of Mazarin in the Institut de France. Numerous sculpted portraits of members of the court of Louis XIV. Works in the Louvre. Decorated the Salon de la Guerre at Versailles. *26, 94, 115.*

Cressent, Charles (Amiens 1685–Paris 1768). Cabinetmaker to the Regent. Member of the Academy of St Luke (1714) and collector. His furniture, decorated with sculpture, has a refined elegance. It is well represented by clocks and candelabra in the Musée des Arts Décoratifs (Pavillon de Marsan). As a sculptor he produced statuettes, medallions and busts, among them a bronze portrait of *Louis d'Orléans*, son of the Regent. *154.*

Dalou, Jules (Paris 1838–1902). Sculptor. In the Louvre: *The Peasant.* Responsible for the *Triumph of the Republic* (Place de la Nation, 1899).

Dantan, Antoine Laurent (Saint-Cloud 1798–1878). Sculptor. Carved numerous busts. Works in the foyer of the Théâtre Français include a bust of *Rachel.*

Daumier, Honoré (Marseilles 1808–Valmondois 1879). Painter and caricaturist. Published numerous collections of lithographs on various social groups: magistrates, shopkeepers, etc. Works in the Louvre include *The Thieves and the Donkey, Portrait of the painter Théodore Rousseau, La République* (1848), *The Laundress.* In the Petit Palais: *Print-collector, Trio of Amateurs. 169.*

Dauzats, Adrien (Bordeaux 1804–Paris 1868). Painter specializing in picturesque reportage. In the Louvre: *Interior of the Church of St Gereon at Cologne; The Giralda, Seville.* In the Musée Condé, Chantilly: *Place du Gouvernement, Algiers. 190.*

David, Jacques Louis (Paris 1748–Brussels 1825). History and portrait painter, father of neoclassicism in painting. Official painter of the Convention and, later, of the Empire. Major works in the Louvre: *Leonidas at Thermopylae* (1819), *Rape of the Sabine Women* (sketch), *Oath of the Horatii, Paris and Helen,* and *Coronation of the Empress Josephine.* In the Château de la Malmaison: *Bonaparte crossing the Alps.* Other works in the Musée Jacquemart-André and Petit Palais. *151, 152, 158.*

David d'Angers, Pierre Jean (Angers 1788–1856). Sculptor and medallist. In the Louvre: medals and maquettes. Carved the pediment of the Panthéon. Other works in the Musée Adam Mickiewicz (6 quai d'Orléans, IV).

Davioud, Gabriel Jean Antoine (1823–1881). Architect, worked with Haussmann. Designed the former Palais du Trocadéro (demolished 1936), the twin theatres in the Place du Châtelet, and the Fontaine Saint-Michel. *203.*

De Brosse, Salomon (Verneuil-sur-Oise c. 1562–1626). Architect. Nephew of Jacques Androuet du Cerceau. Extremely important during the regency of Marie de Médicis. Designed the Palais du Luxembourg (1620) and probably the façade of Saint-Gervais (1616–61). *76, 81, 86, 96, 99.*

Degas, Edgar (Paris 1834–1917). Painter, sculptor and engraver. Instigated exhibitions of the Impressionist group. A great draughtsman, he produced scenes of dancers and daily life. Works in the Musée de l'Impressionnisme (Jeu de Paume) and other Paris museums. 196, 200, *220*.

Deglane, Henri (1855-1931). Architect. Grand Palais. 187.

Delacroix, Eugène (Charenton-Saint-Maurice 1798–Paris 1863). Painter of large Romantic compositions. Carried out wall-paintings in Saint-Sulpice, the Chambre des Députés and Senate, and the Galerie d'Apollon in the Louvre. Masterpieces in the Louvre include *Le 28 Juillet* (1830), *The Barque of Don Juan, Entry of the Crusaders into Constantinople, Women of Algiers*. The studio in Place Furstemberg, where he died, is now a museum. Decorated the Chapelle des Saints-Anges at Saint-Sulpice. *Pietà* at Saint-Denis du Saint-Sacrement. 114, 151, 160, 185, 195, 209.

Delagrive, Jean (18th century). Engraver). Produced a famous map of Paris in 1728. 136.

Delamair, Pierre Alexis (1676–1745). Architect. Hôtel de Soubise (60 rue des Francs-Bourgeois, IV), Hôtel de Rohan (87 rue Vieille du Temple, IV), and Hôtel de Chanac-Pompadour (142 rue de Grenelle, VII). The Hôtel de Soubise and Hôtel de Rohan, built between 1704 and 1710, are now part of the Archives Nationales. 132, *163*.

Delaunay, Robert (Paris 1885–Montpellier 1941). Painter. Decorated the Palais des Chemins de Fer and the Palais de l'Air at the Exposition Universelle of 1937. Works in the Musée National d'Art Moderne. *222*, 225.

Delorme, Philibert (Lyons *c.* 1515–Paris 1570). Official architect to Henry II and Diane de Poitiers. Designed the Château d'Anet (Eure-et-Loir), worked at Saint-Germain en Laye and Villers-Cotterets, built the Tuileries palace (begun 1563). The rood-screen of Saint-Etienne du Mont has been attributed to him. Published a treatise on architecture (1567). *73*, 80, 81, 84, 96, 158.

Denis, Maurice (Granville 1870–Saint-Germain en Laye 1943). Follower of Gauguin. Painter, engraver, theorist on religious art. Produced important theoretical writings. Decorated the Théâtre des Champs-Elysées (1912 13). In the Musée National d'Art Moderne: *La meilleure part, Maternité blanche, Annuncia-tion, Homage to Cézanne* (1900). 200, 225.

Denon, Dominique Vivant, Baron (Givry 1747–1825). Writer and administrator; director-general of museums under Napoleon I. 160.

Derrand, François (Paris 1588–Agde 1644). Architect. Jesuit. Designed façade of the Jesuit church in Paris, Saint-Paul-Saint-Louis (98 rue St-Antoine, IV; 1627–41). 86, *99*.

Desjardins, Martin (Martin van den Bogaert; Breda 1640–1694). Sculptor and Academician. Produced statues for the park at Versailles, the now-destroyed statue of *Louis XIV* for the Place des Victoires, and bas-reliefs in the staircase of the Hôtel de Beauvais. 105.

Domenico da Cortona (Domenico Bernabei; born Cortona, died Paris 1549). Architect and engineer. Worked in Paris, produced plans of the Hôtel de Ville.

Duban, Jacques Félix (Paris 1797–Bordeaux 1870). Architect. Designed additions to the Louvre for Napoleon III; installed a 'lapidary museum' in the courtyard of the Ecole des Beaux-Arts (1834). 187.

Dubois, Ambroise (Antwerp 1543–Fontainebleau 1616). Painter. Worked for Henry IV at Fontainebleau. Works there and in Louvre.

Dubreuil, Toussaint (Paris *c.* 1551–1602). Painter and decorator. Painted a now destroyed ceiling in the Louvre; made tapestry cartoons for the Manufacture de Paris. In the Louvre: *Antique Sacrifice*.

Dubuisson, Jean (Born Lille 1914). Designed the new Musée des Arts et Traditions Populaires (Bois de Boulogne); worked on Maine-Montparnasse complex.

Duc, Joseph-Louis (1802–1879). Architect. Worked on Palais de Justice; designed Colonne de Juillet, Place de la Bastille. *174*.

Du Cerceau. Family of architects.
— Jacques I Androuet (1515–1585). Remodelled Hôtel de Ligneris (Carnavalet). Published *Les plus excellens bastimens de France* (1576–1579). 96.
— Baptiste (1547–1590). Eldest son of Jacques I. *Architecte ordinaire* to the king. One of the designers of the Pont Neuf.
— Jacques II (*c.* 1550–1614). Worked on the Louvre, Tuileries, Hôtel de Bellegarde and Hôtel de Mayenne. 96.
— Jean I (*c.* 1590–1649). Nephew of Jacques I . Designed Hôtel de Sully (62 rue St-Antoine, XII), Hôtel des Fermes (Hôtel de Bellegarde, cité

des Fermes, I), Pont au Change (1639). Rebuilt Hôtel du Petit-Muse (21 rue St-Antoine, IV). *67, 79, 90, 96.*

Duchamp, brothers. Painters and sculptors, settled at Puteaux, around whom a group of artists gathered *c.* 1912.
— Gaston 'Jacques Villon'; Damville, Eure, 1875–Puteaux 1963. *See* **Villon.**
— Marcel (Blainville, Eure, 1887–New York 1965). Leading figure in the Dada movement. Works in the Musée National d'Art Moderne.
— Raymond (Raymond Duchamp-Villon; Damville 1876–Cannes 1918). Sculptor. In the Musée National d'Art Moderne: *Baudelaire* (1911), *Naggy* (1912), *Le Grand Cheval* (1914). *200.*

Dudok, Willem Marius (Born Amsterdam 1884). Architect and townplanner. Designed Netherlands Pavilion at the Cité Universitaire (1927–28). *188.*

Dufy, Raoul (Le Havre 1877–Forcalquier 1953). Painter. Major work: *Fée Electricité* (1937), in the Musée d'Art Moderne de la Ville de Paris. Other works in the Musée National d'Art Moderne. *209, 225.*

Dumont. Family of sculptors.
— Jacques-Edme (Paris 1761–1844). Active during the Revolution, worked on projects for Napoleon I.
— Augustin (Paris 1801–1884). Responsible for the *Génie de la Liberté* on the Colonne de Juillet, Place de la Bastille.

Dunoyer de Segonzac, André (Born Boussy-Saint-Antoine, Seine-et-Oise, 1884). Painter. Works in the Musée National d'Art Moderne.

Dupré, Jules (Nantes 1811–L'Isle-Adam 1889). Landscape painter associated with the Barbizon School. Works in the Louvre include *The Lagoon, The Little Cart. 200.*

Duret, Francisque-Joseph (Paris 1804–65). Sculptor. Bronze group on Fontaine Saint-Michel (V).

Dutert, C.L.F. (1845–1906). Architect. With Contamin, built Galerie des Machines for the Exhibition of 1889 (demolished). *185.*

Eiffel, Gustave (Dijon 1832–Paris 1923). Engineer, specializing in metal construction. Built viaducts and the Tour Eiffel (1887–89), erected for the Exhibition of 1889.

Etex, Antoine (Paris 1808–1888). Sculptor. Executed high-reliefs of *Resistance* and *Peace* on the Arc de Triomphe.

Falconet, Etienne (Paris 1716–1791). Sculptor. Friend of Diderot, worked

for Madame de Pompadour. Works in the Louvre (*Bather*) and Musée Nissim de Camondo. *152, 153.*

Flandrin, Hippolyte (Lyons 1809–Rome 1864). Painter and decorative artist, pupil of Ingres. Decorated Saint-Germain des Prés (1842–61) and Saint-Vincent de Paul (1849–53). *50, 195.*

Fontaine, Pierre François Léonard (Pontoise 1762–Paris 1853). Architect. With Percier, played a major role in the modernization of Paris: restoration and extension of the Louvre, clearing of the area around the Tuileries palace, construction of the rue de Rivoli and Arc de Triomphe du Carrousel, project for a palace for the Roi de Rome on the hill of Chaillot, works at the Palais Royal (Galerie d'Orléans). Designed the Chapelle Expiatoire (square Louis-XVI, VIII). *146, 151, 173.*

Fouquet, Jean (Tours, first quarter of 15th century–*c.* 1480). Painter and miniaturist. Painted miniatures in manuscripts (Bibliothèque Nationale, Musée Condé, Chantilly). In the Louvre: *Guillaume Juvenel des Ursins* and *Charles VII. 54.*

Fragonard, Jean Honoré (Grasse 1732–Paris 1806). Painter. Works in the Louvre include *Coroesus and Callirhoë, The Vow to Cupid, The Music Lesson, The Bathers, Sleeping Bacchante, The Shift.* Other works in the Musée Jacquemart-André and the Petit-Palais. *152, 158.*

Francheville or **Franqueville, Pierre** (Cambrai 1548–1615). Sculptor. Settled in Florence, was summoned to Paris to work on the statue of *Henry IV* on the Pont Neuf, for which he produced *Slaves.* Works in the Louvre include *Orpheus charming the Animals.*

Francine. Family of architects and designers of fountains, of Italian origin. Notable are François (died 1688), who worked at Versailles, and Pierre François (1654–1720), his successor as *Intendant Général des Eaux et Fontaines.*

Frémiet, Emmanuel (Paris 1824–1910). Sculptor. Executed gilt bronze statue of *Joan of Arc* in Place des Pyramides (1874). *203.*

Froment, Nicolas (Born at Uzès, died at Avignon where he is recorded between 1461 and 1482). Painter. In the Louvre: *Matheron Diptych.*

Gabriel, Jacques (1667–1742). Architect and town-planner. Often worked with his son Jacques-Ange. Built numerous *hôtels* in Paris, designed Hôtel Biron (Musée Rodin,

77 rue de Varenne, VII). Worked on apartments at Versailles. 112.

Gabriel, Jacques-Ange (Paris 1699–1782). Leading architect under Louis XIV. Work at the château of Fontainebleau includes south wing of the Cour du Cheval Blanc. Additions to Versailles. In Paris, designed twin buildings in Place Louis-XV (Place de la Concorde), neighbouring houses in rue Royale, Ecole Militaire (from 1751), and plans for Champ de Mars. *61, 65, 127, 128,* 129, 136, *181.*

Garnier, Charles (Paris 1825–1898). Architect. Major work is the Paris Opéra (1862–75). Also built Théâtre Marigny, Cercle de la Librairie (117 boulevard St-Germain). *175, 176, 197,* 201.

Gauguin, Paul (Paris 1848–Tahiti 1903). Painter, ceramist, engraver and woodcarver. Friend of Van Gogh, gathered together a group of artistic innovators at Pont-Aven in 1887–88. Produced theoretical writings. Works in the Musée de l'Impressionnisme (Jeu de Paume) include *Tahitian Women, L'or de leur corps.* 195, 200, 201.

Gavarni (Hippolyte Guillaume Sulpice Chevalier; Paris 1804–1866). Draughtsman specializing in wash drawings and in genre scenes, often reproduced in *Le Charivari.* Illustrated works of Balzac and Eugène Sue. 169.

Géricault, Jean Louis André Théodore (Rouen 1791–Paris 1824). Romantic painter. Works in the Louvre include *The Raft of the 'Medusa'* and racing scenes. 160.

Gérôme, Jean Léon (Vesoul 1824–Paris 1904). Painter of history and genre subjects, sculptor and engraver. In the Louvre: *Cock Fight.* In the Musée Condé, Chantilly: *Suite d'un Bal Masqué.* 209.

Gervex, Henri (Paris 1852–1929). Painter. Decorated restaurant of the Gare de Lyon.

Giacometti, Alberto (Stampa, Switzerland, 1901–Coire 1966). Sculptor. Executed *Walking Man* (*L'Homme qui marche*) for UNESCO.

Giocondo, Fra Giovanni (Verona c. 1433–Rome 1515). Architect. Called to France by Louis XII to rebuild the Pont Notre-Dame. Built new Chambre des Comptes and staircase in Palais de la Cité. Numerous works in France. 70.

Girardon, François (Troyes 1628–Paris 1715). Official sculptor to Louis XIV. Executed sculptures in the Galerie d'Apollon at the Louvre, and the tomb of Richelieu in the Sorbonne church. Numerous works

at Versailles, in the park and château. Tomb of Bignon at St-Nicolas du Chardonner; statue of Louis XIV for Place Vendôme (destroyed). 108, 116, 117, *130.*

Girault, Charles (Cosne (Nièvre) 1851–1932). Architect. Designed the Petit Palais (1900). *205, 225.*

Girodet-Trioson (Anne Louis Girodet de Roussy; Montargis 1767–Paris 1824). Pre-Romantic painter. Works in the Louvre include *The Sleep of Endymion, Atala, The Entombment, The Deluge.* Other works at Malmaison. 152.

Gittard, Daniel (Blandy 1625–Paris 1686). Architect and engineer. Designed Place Saint-Sulpice, portal of Saint-Jacques du Haut-Pas.

Gleizes, Albert (Paris 1881–Avignon 1953). Painter. Theorist of Cubism in 1911. Works in Musée d'Art Moderne de la Ville de Paris.

Gomboust, Jacques (France, 17th century). Royal engineer under Louis XIII. Drew a remarkable plan of Paris in nine sheets (each 180 x 45 cm.) between 1647 and 1652. 25.

Gondouin (Gondoin), Jacques (Saint-Ouen 1737–1818). Neoclassical architect. Designed Ecole de Chirurgie (1769–77). One of the designers of the Colonne Vendôme. 136, *174.*

Goujon, Jean (Early 16th century–1567). Architect and sculptor, active in Rouen and Paris. Responsible for the Fontaine des Innocents (c. 1549); reliefs at the Hôtel Carnavalet; and, in the Lescot wing of the Louvre, both reliefs on the exterior and caryatids in the Salle des Antiques. *70,* 89, 90, *94,* 109, 116.

Goya y Lucientes, Francisco José de (Fuente de Todos, Aragón, 1746–Bordeaux 1828). Painter. In the Louvre: *The Ambassador F. Guillemardet, Young Spanish Woman, Woman with a Fan, Señor de Castro.* In the Musée Jacquemart-André: *Portrait of a Subaltern of the Almanza Dragoons.* 190.

Greuze, Jean Baptiste (Tournus 1725–Paris 1805). Painter and engraver. Famous for portraits and moralistic genre scenes. Works in the Louvre include *L'Accordée de village, The Father's Curse, A Son Punished,* and *The Broken Jug.* In the Musée Jacquemart-André: *Portrait of Wille.* 152.

Gros, Antoine Jean, Baron (Paris 1771–1835). History painter in the service of Napoleon. In the Louvre: *Bonaparte visiting the Plague Hospital at Jaffa, Napoleon at Eylau, Bonaparte at Arcole, Francis I and Charles V at the Basilica of Saint-De-*

nis. Numerous portraits, especially in the Musée Carnavalet. 152, 160.

Guérin, Gilles (Paris 1609–1678). Sculptor. Decorated king's bedroom in the Louvre; executed full-length statue of Louis XIV for the Hôtel de Ville courtyard (1654); sculptures in the park at Versailles; medallion of Descartes in Saint-Étienne du Mont. *96*, 117.

Guillaume, Eugène (1822–1905). Sculptor. A Frenchman, active in Paris where he worked with Cavelier on the Louvre. *189.*

Guimard, Hector (Lyons 1867–New York 1942). Architect and interior decorator, major artist of the Art Nouveau movement. Many buildings in the XVI: 41 rue Chardon-Lagache (Hôtel Jessede or Hôtel de la Réunion, now a clinic); 14 (Castel Béranger) and 60 (Hôtel Mazzara, now annex to a school) rue La Fontaine; 122 avenue Mozart (house of the architect); 3 square Jasmin (private house, entered from rue Jasmin; 1922). Elsewhere in Paris: a synagogue at 10 rue Pavée (IV). Outside Paris: villa at 72 route de Montesson, Le Vésinet. 176, *216.*

Guys, Constantin (Flushing 1805–Paris 1892). Draughtsman. His lithographed reportage series were highly praised by Baudelaire. 152.

Haussmann, Georges, Baron (Paris 1809–91). *Préfet* of the Seine during the Second Empire. Responsible for new layout and major rebuilding of Paris. 76, 80, 172, 173.

Henner, Jean Jacques (Bernviller 1829–1905). Painter. In the Petit Palais: *Eclogue, St Mary of Egypt.* Musée Henner contains 400 paintings.

Heurtier, Jean François (Paris 1739–Versailles 1822). Architect. Designed Théâtre Montansier at Versailles, Opéra-Comique in Paris. 128.

Hittorf, Jacques Ignace (1792–1867). Architect. Designed Saint-Vincent de Paul (1824–44); Gare du Nord (1861–86); several town halls, notably that of the 1st *arrondissement* (balancing Saint-Germain l'Auxerrois) and that of the 5th, Place du Panthéon (1848–51); and the Cirque d'Hiver (Place Pasdeloup; 1852). 163, 172.

Houdon, Jean Antoine (Versailles 1741–Paris 1828). Sculptor and bronze-caster. Produced numerous busts. Works in the Louvre include *Diana* and busts of *Duquesnoy, Lavoisier, Voltaire, Franklin, Buffon, Washington, Louis XVI, Mirabeau, Louise Brongniart,* and *The Brongniart Children.* At the Théâtre-Français:

Voltaire. Other works in Musée Cognacq-Jay and Musée Nissim de Camondo. 152.

Huet, Christophe (Died 1759). Painter. Painted *chinoiseries* in Salon des Singes of the Hôtel de Rohan; decorated great and little *singeries* at Chantilly.

Ingres, Jean Auguste Dominique (Montauban 1780–Paris 1867). Painter. Leader of academic classicism. In the Louvre: religious works, including *Christ's Charge to St Peter, Virgin with the Eucharist;* learned allegories, *The Apotheosis of Homer, Oedipus and the Sphinx;* images of women, *La Source, La grande Odalisque;* and portraits, *Philibert Rivière, Madame Rivière, Monsieur Bochet, Monsieur Bertin, Cherubini.* In the Musée des Arts Décoratifs: *Casino of Raphael, Rome.* 52, 185, 195.

Jacquemart de Hesdin (Died *c.* 1409). Painter and illuminator. In the Bibliothèque Nationale: *Grandes Heures du Duc de Berry.*

Jacquet, Mathieu (Born Avon before 1610). Sculptor to Henry IV. Worked at Fontainebleau (a fine chimneypiece) and on pendentives of Saint-Gervais-Saint-Protais in Paris. In the Louvre: *Battle of Ivry* and *Surrender of Nantes* (marble reliefs). 116.

Jeanneret, Pierre (Born Geneva 1896). Architect. Cousin and partner of Le Corbusier. Co-designer of Fondation Suisse at the Cité Universitaire.

Jourdain, Frantz (Antwerp 1847–Paris 1935). Architect and polemicist, associated with Art Nouveau. Designed Samaritaine store (Place de l'Ecole and rue de la Monnaie; 1905, since altered). 164.

Justi. Family of sculptors in the service of Louis XII and Francis I.
— Antoine (San Martino, near Florence, 1479–Tours 1519). Assisted his brother Jean I on the tomb of Louis XII at Saint-Denis.
— Jean I (Florence 1485–Tours 1549). Executed tomb of Louis XII and Anne de Bretagne at Saint-Denis.
— Juste I (Tours 1505–1559). Son of Antoine. Carved *Apostles* and *Virtues* on tomb of Louis XII at Saint-Denis. 116.

Kandinsky, Wassily (Moscow 1866–Neuilly 1944). Painter. Associated with the Bauhaus, settled in Paris in 1934. Works in Musée National d'Art Moderne. 194.

Kelly, Ellsworth (Born 1923). American painter. Geometric abstraction. Work at UNESCO (1970).

Kisling, Moïse (Cracow 1891–Sanary-sur Mer 1953). Painter. Settled in Paris where he became a member of the School of Paris. Works in Musée National d'Art Moderne. 200.

Labrouste, Henri (Paris 1801–Fontainebleau 1875). Architect. Designed Bibliothèque Sainte-Geneviève (1843–50), Bibliothèque Nationale (Salle des Imprimés 1862–68). 164, 186.

La Fosse, Charles de (Paris 1636–1716). History painter, notable colourist. Major works in the Louvre: *Moses rescued from the Water, Marriage of the Virgin, Triumph of Bacchus, Clytra transformed into a Sunflower.* Painted the dome of the Invalides church. 115.

La Hyre, Laurent de (Paris 1606–1656). Painter and engraver of religious subjects. Works in the Louvre include *Christ appearing to the Three Marys, Virgin and Child, Landscape with Bathers.* In Notre-Dame: *Miracle of St Peter* (1635)'. 114.

Laloux, Victor (Paris 1850–Tours 1896). Architect. Designed Gare d'Orsay and its hotel (Quai Anatole-France, 1900). 163, 187.

Landowski, Paul (Paris 1875–Boulogne-sur-Seine 1961). Sculptor. Responsible for statue of *St Geneviève* at the entrance to Pont de la Tournelle (IV).

Largillière, Nicolas de (Paris 1656–1746). Painter of history subjects and portraits. Works in the Louvre include *Le Prévôt des marchands et les échevins de la ville de Paris, Charles Le Brun.* At Saint-Etienne du Mont: *Vow of the échevins of Paris.* 115.

Lassurance, Pierre (1655–1724). Architect. Worked on construction of Palais Bourbon (1719–22); plans of several Paris *hôtels,* notably Hôtel Pozzo di Borgo (51 rue de l'Université, VII).

Lassus, Jean Baptiste Antoine (1807–1857). Architect and archaeologist. Worked with Viollet-le-Duc on the restoration of Notre-Dame, Saint-Séverin and the Sainte-Chapelle.

La Touche, Gaston (St-Cloud 1854–Paris 1913). Painter. With Gervex, decorated Gare de Lyon.

La Tour, Georges de (Vic-sur-Seille 1593–1652). Painter. Works in the Louvre include *Adoration of the Child.* 114.

La Tour, Maurice Quentin de (Saint-Quentin 1704–1788). Pastel-worker, fashionable at the time of Louis XIV. Produced numerous portraits.

In the Louvre: *Louis XIV, The Queen, Madame de Pompadour, The Dauphine, Chardin, Self-portrait.* 152.

Lavirotte, Jules (Lyons 1864–Paris 1924). Architect and interior decorator. Follower of Art Nouveau, notable for his use of ornament based on vegetation. Major works: apartment building (29 avenue Rapp, VII), Céramic Hôtel (34 avenue de Wagram, VIII). *216.*

Le Bar, Jean (France, 14th century). Architect. Built kitchens of Palais de la Cité. 55.

Le Brun, Charles (Paris 1619–1690). History painter, leading figure of French School under Louis XIV. Began work at Vaux-le-Vicomte (grand salon); superintendent of works at the Louvre (Galerie d'Apollon); and at Versailles (Galerie des Glaces); decorated Galerie d'Hercule in Hôtel Lambert (2 rue Saint-Louis en l'Ile, IV). Painted religious subjects, designed cartoons for Gobelins tapestry cycles. Works in the Louvre include *Adoration of the Shepherds, Holy Family saying Grace, Christ's Entry into Jerusalem* and the *Story of Alexander.* 84, 89, 96, 114, 115, 117, 118.

Le Corbusier (Charles Edouard Jeanneret; La Chaux-de-Fonds 1887–Roquebrune-Cap Martin 1965). Architect and theorist of town-planning. Maison Raoul La Roche and P. Jeanneret (Auteuil); Maison Ozenfant (avenue Reille, XIV); Pavillon Suisse and Pavillon Brésilien at the Cité Universitaire; Cité-Refuge for the Salvation Army (rue du Chevaleret, XIII). At Poissy: Villa Savoye. At Garches: Maison Stein. 187, 188.

Ledoux, Charles Nicolas (Dormans 1736–Paris 1806). Architect and writer. Designed numerous *hôtels*: Hôtel d'Hallwyll (28 rue Michel Lecomte, III); house at 30 rue du Faubourg-Poissonnière; Hôtel d'Uzès (112 rue Montmartre). Built tollgates (*barrières*) of the new Enceinte des Fermiers Généraux: these survive at the Parc Monceau, La Villette, Place Denfert-Rochereau and at the entrance to the Cours de Vincennes. 11, 132, 135, 136.

Le Duc, Gabriel (Died 1704). Architect. Worked at the Val-de-Grâce and Notre-Dame des Victoires. *103.*

Lefuel, Hector (Versailles 1810–Paris 1881). Architect. With Visconti, designed link between the Louvre and Tuileries palace, and laid out the museum under Napoleon III. Also with Visconti, built the Pont des Arts. 185, *186, 188, 190.*

Léger, Fernand (Argentan 1881–Paris

1955). Painter, designer of stained glass and ceramics, maker of the film *Ballet mécanique*. Works in Musée National d'Art Moderne include *The Wedding, Women in Red and Green*. 209.

Le Hongre, Etienne (Paris 1628–1690). Sculptor. Executed the *River-God* for the lake at Versailles. Works in the Louvre include *Louis XIII, Louis XIV, Anne of Austria*.

Le Lorrain, Robert (Paris 1666–1743). Sculptor. Executed *Horses of the Sun*, a masterpiece of relief sculpture, for stables of the Hôtel de Rohan (1731–38).

Lemercier, Jacques (Pontoise 1585–1654). Architect to Richelieu. Worked on enlargement of the Louvre and the remodelling of the Sorbonne (1624–29), where he built the University chapel (dedicated to St Ursula). Worked at the Oratory and Val-de-Grâce; built choir and nave of Saint-Roch. 89, 96, *96, 103*.

Lemoyne, François (Paris 1688-1737) Painter of history and genre subjects. Painted cupola of the Lady Chapel, Saint-Sulpice; *Transfiguration* in Saint-Thomas d'Aquin (1723); ceiling of Salon d'Hercule at Versailles (1733–36). Works in the Louvre include *Juno, Iris and Flora, Hercules and Omphale, The Education of Cupid*. 151.

Lemot, François Frédéric (Lyons 1772–Paris 1827). Sculptor. Active in Paris; works include a bas-relief on the Chambre des Deputés (Palais Bourbon) and the statue of Henry IV on the Pont Neuf (replacing Giovanni Bologna's original, melted down for cannon in the Revolutionary wars). *75*.

Le Muet, Pierre (Dijon 1591–Paris 1669). Architect and theorist. Worked at the Val-de-Grâce, Salpêtrière, Notre-Dame des Victoires, Hôtel d'Avaux (71 rue du Temple, IV), Hôtel Tubeuf (56 rue de Richelieu, I). *103*.

Le Nain, brothers. Painters.
— Antoine (Laon 1588–Paris 1648). Works in the Louvre include *Family Reunion*. 114.
— Louis (Laon 1593–Paris 1648). In the Louvre: *Peasant Meal*.
— Mathieu (Laon 1607–Paris 1677). In the Louvre: *Backgammon Players*. In Saint-Etienne du Mont: *Birth of the Virgin* (*c*. 1640; attrib.).

Le Nôtre, André (Paris 1613–1700). Designer of gardens, inventor of the *jardin à la française*, the French style of formal garden. Worked at Vaux-le-Vicomte, Tuileries, Saint-Cloud, Saint-Germain en Laye; designed park at Versailles.

Leonardo da Vinci (Vinci 1452–Cloux 1519). Painter, sculptor, architect. Called by Francis I to Amboise. Masterpieces in the Louvre: *Mona Lisa, St John the Baptist, St Anne, Virgin of the Rocks, Bacchus*. 112, *219*.

Le Pautre, Antoine (Paris *c*. 1621–1691). Architect and engraver. Designed numerous *hôtels*, in Paris (Hôtel de Beauvais, 1655), Versailles and Saint-Germain en Laye. Built château of Saint-Ouen (demolished). 92.

Lepère, Jean Baptiste (1761–1844). Architect and bronze-founder. Worked with Gondouin on the Colonne Vendôme (Place Vendôme), 1806–10. *174*.

Lescot, Pierre (Paris 1515–1578). Architect. Designed the new Louvre for Francis I and Henry II, with the sculptor Jean Goujon. 89.

Lestin, Jacques de (Troyes 1597–1661). Painter of the school of Vouet. In Saint-Paul-Saint-Louis: *Death of St Louis*. 115.

Le Sueur, Eustache (Paris 1617–1655). Painter of mythological and religious subjects. Works in the Louvre (54 in all) include *Rape of Ganymede, Life of St Bruno* (from the Chartreuse), *Muses* (from Hôtel Lambert). In Saint-Jacques du Haut Pas: *St Louis*. 26, 114.

Le Vau, Louis (1612–1670). Architect. Responsible for 17th-century portions of château of Vincennes; called to work on the Louvre by Louis XIV; designed the Collège des Quatre-Nations (now Institut de France) and Saint-Louis en l'Ile; built Hôtel Lambert, Hôtel Tambonneau and Vaux-le-Vicomte. 81, 88, 89, 96, 98, 99, 103, *105, 107, 118, 122*.

Limbourg, brothers (Early 15th-century). Famous miniaturists. Masterpiece in the Musée Condé, Chantilly: *Très Riches Heures du Duc de Berry*.

Lods, Marcel (Born Paris 1891). Architect, pioneer in the use of steel. Works designed with E. Beaudoin: Cité des Oiseaux, Bagneux, making a systematic use of prefabrication (1931–32); Cité de la Muette, Drancy, with tower-blocks (1932–35); housing estate of the Grandes Terres, Marly (designed in association with Honnegger and Beufé, 1958–60).

Loos, Adolf (Brünn 1870–Vienna 1933). Pioneer of modern architecture, active in Paris and Vienna. Designed Tristan Tzara's house in Montmartre (14 avenue Junod). 187.

Lopez, Raymond (Montrouge 1904–Paris 1966). Architect. Involved in major urban redevelopment schemes

for Paris; plan for improvement of river banks. 232.

Lorrain, Claude (Claude Gellée; near Mirecourt 1600–Rome 1682). Landscape painter and draughtsman. Settled in Rome. Works in the Louvre include *Seaport at Sunrise, Campo Vaccino, Rome, Village Fair, Seaport at Sunset, The Landing of Cleopatra, David anointed by Samuel, Louis XIII au Pas de Suze* (1629). 115.

Louis, Victor (Paris 1735–1807). Architect, specializing in theatres. Built new Théâtre Français; theatre and gardens of the Palais-Royal; Chapelle des Ames du Purgatoire at Sainte-Marguerite (1764). 135.

Lurçat, André (Born Bruyères, Vosges, 1894). Architect. Built a school at Villejuif (1931) and studios in the Cité Seurat (101 rue de la Tombe-Issoire, XIV).

Magne, Marcel (early 20th century). Architect. Designed tower of Sacré-Cœur, 1905–10. *209.*

Maillol, Aristide (Banyuls 1861–Perpignan 1944). Painter and sculptor. Nineteen works in the Tuileries gardens. In the Musée National d'Art Moderne: *Mountain, Three Nymphs.*

Mailly, Jean de (Born 1911). Architect and town-planner. In Rond-Point de la Défense scheme, built CNIT (with Bernard Zehrfuss and R. Camelot) and the SIMCA building. Developments at Argenteuil, Champigny, Clamart, Rosny-sous-Bois, Rueil-Malmaison.

Mallet-Stevens, Robert (Paris 1886–1945). Architect characterized by his use of geometrical forms. Designed private houses in rue Mallet-Stevens, Auteuil (1926–27); Alfa-Romeo building (rue Marbeuf, VIII; 1925); Pavillon de la Lumière at the Paris Exhibition of 1937. 187.

Manet, Edouard (Paris 1832–1883). Painter, founder of Impressionism. Works in Musée de l'Impressionnisme (Jeu de Paume) include *Olympia* (1863), *Déjeuner sur l'herbe* (1863), *Woman with a Fan* (1872), *The Balcony, Lola de Valence* (1861–62), *The Fifer* (1866), *Portrait of Zola.* In the Petit Palais: *Portrait of Théodore Duret.* 195, 196, 200, 209, 213.

Mansart, François (Paris 1598–1666). Architect. Church of the Visitation (17 rue Saint-Antoine, IV; 1632–34); monastery and church of the Val-de-Grâce (lower part only, 1645); Palais Mazarin (now Bibliothèque Nationale, 58 rue de Richelieu, II; 1633–49); Hôtel d'Aumont (7 rue de Jouy, IV); Hôtel de la Bazinière (15 quai Malaquais, VI). Also built

château of Maisons-Laffitte (Yvelines). *87,* 88, 98, 99, *103,* 105.

Mansart, Jules Hardouin (Paris 1646–Marly 1708). Architect. Nephew of François Mansart, whose name he took; favourite of Louvois. Several major schemes under Louis XIV: Place des Victoires (I-II); Place Vendôme (I; 1685); church of the Invalides (VII; 1693); Lady Chapel in Saint-Roch (286 rue Saint-Honoré, VIII; 1707). Works at Versailles: garden front, Galerie des Glaces (with Lebrun), buildings connected with the Trianons (1688), Château de Marly. Altered Château de Meudon for the Grand Dauphin. 84, 85, 105, 108, 110, 118, 122, 134, 145.

Mantegna, Andrea (Padua 1431–Mantua 1506). Painter. In the Louvre: *St Sebastian, Madonna of Victory, Calvary* (central predella panel from the altarpiece of San Zeno, Verona; side panels in the museum at Tours). In the Musée Jacquemart-André: *Christ Mocked.*

Marot, Jean (*c.* 1619–1679). Engraver of architectural subjects, famous for his engravings of Parisian buildings. 89.

Marsy, Gaspard (Cambrai 1624–Paris 1674). Sculptor. Responsible for statues in the park at Versailles: *Horses of Apollo and Tritons* (Bains d'Apollon), *Latona and her Children* (Bassin de Latone). Worked closely with his brother Balthazar (Cambrai 1628–Paris 1681). 117.

Martellange (Etienne Ange Martel; Lyons 1569–Paris 1641). Jesuit architect. Began Saint-Paul-Saint-Louis (99 rue Saint-Antoine, IV) in 1627.

Masson, André (Born Balagny, Oise, 1896). Painter and engraver associated with the Surrealist movement. Decorated ceiling of the Odéon theatre.

Master of the Candle (Active in the 17th century). Painter. Perhaps Trophime Bigot. Noted for night scenes resembling those of Georges de La Tour. In St-Leu-Saint-Gilles (92 rue Saint-Denis, I): *St Jerome.*

Master Honoré (Active in the 13th century). Parisian miniaturist. In the Bibliothèque Nationale: *Breviary of Philippe le Bel* (MS latin 1023), *La Somme le Roy* (MS français 938). 54.

Master of Moulins (Active 1480–1500). Painter. Identified with Jean Hay. In the Louvre: *Portrait of the Dauphin Charles* (1494), *St Mary Magdalen with a female donor.* 56.

Matta (Roberto Matta Echaurren; born Santiago, Chile, 1911). Painter. Work at UNESCO (1958).

Mazeline, Pierre (Rouen 1632–Paris 1708). Sculptor. Carved tomb of Le Tellier in Saint-Gervais-Saint-Protais (IV) and tomb of Charles de Créqui in Saint-Roch (286 rue Saint-Honoré, VIII).

Méryon, Charles (Paris 1821–Saint-Maurice, Seine, 1868). Draughtsman and engraver, noted for views of Paris. 169.

Métezeau. Family of architects.
— Thibaut (Dreux c. 1533–Paris 1593). Worked on Valois tombs at Saint-Denis and on the Pont-Neuf.
— Louis (Dreux 1562–Paris 1615). Worked at the Louvre and Saint-Germain en Laye, designed façades of houses in Place des Vosges (IV).
— Clément II (Dreux 1581–Paris 1652). Worked at the Luxembourg (VI) and Oratoire (145 rue Saint-Honoré, I).

Michalowski, Piotr (Cracow 1800–Kryztoporzyec 1855). Painter. Lived in Paris 1832–48, painted battle-scenes and portraits. 200.

Michelangelo Buonarroti (Caprese 1475–Rome 1564). Florentine painter, sculptor and architect. In the Louvre: two *Slaves* (intended for the tomb of Julius II). 112, *229*.

Mignard, Pierre (Troyes 1612–Paris 1695). Painter of history-subjects and portraits. Great output, including the following pictures. In the Louvre: *Virgin and Child with a bunch of grapes, Christ and the Woman of Samaria, The Grand Dauphin and his Family, Françoise d'Aubigné, Marquise de Maintenon* (1694), *Self-portrait*. In the Musée Carnavalet: *Madame de Grignan*. In the Comédie Française: *Molière as Caesar*. In the Musée Condé, Chantilly: *Molière, Mazarin*. Painted dome of Val-de-Grâce church. 115.

Millet, Jean François (Gréville, Manche, 1814–Barbizon 1875). Painter of landscapes and peasants, member of the Barbizon Group. Works in the Louvre include *Church at Gréville* (1871), *The Gleaners, Le repos des Faneurs* (1848), *The Angelus* (1858–9), *Reclining Nude*. Also painted portraits. 200.

Mique, Richard (Nancy 1728–Paris 1794). *Premier architecte* to Louis XVI after 1775. Works for Marie-Antoinette at Versailles: in the park, *hameau,* Petit Trianon and Temple of Love (with 12 Corinthian columns, 1778); in the château, apartments of Marie-Antoinette. *146, 151.*

Miró, Joan (Born near Barcelona 1893). Painter, ceramist and sculptor. Work at UNESCO (1958). Well represented in the Musée National d'Art Moderne. 209, 232.

Modigliani, Amedeo (Leghorn 1884–Paris 1920). Painter and sculptor. Works in Musée National d'Art Moderne include *Lolotte.* 200.

Mollet, A.C. (1660–1742). Architect. Designed Hôtel d'Evreux (now Palais de l'Elysée). 168.

Monet, Claude (Paris 1840–1926). Painter. Leader of the Impressionist movement, named after a painting by him (Musée Marmottan). Painted numerous scenes of Paris, and series of cathedrals, haystacks (Musée de l'Impressionnisme) and waterlilies (Orangerie). 10, 196, 221.

Montreuil, Pierre de (13th-century). Master mason. He was long thought to be the architect of both the Sainte-Chapelle and the south rose-window of Notre-Dame, as well as the nave of Saint-Denis, which was executed about 1240, a century after Suger's choir. Modern scholarship questions all this; but at least we must allow him the credit for the sumptuous Lady Chapel in the church of Saint-Germain des Prés, where he was buried (1267). It was pulled down in 1803, when the rue de l'Abbaye was opened through the secularized conventual buildings. 48, *50.*

Moore, Henry (Born Castleford 1898). Sculptor. Executed a *Reclining Figure* for UNESCO (1958). In the Musée National d'Art Moderne: *Reclining Figure.*

Moreau, Gustave (Paris 1829–1898). History-painter and watercolourist. Painted elaborate works, of which many are housed in his former studio, now a museum (14 rue La Rochefoucauld, VII). In the Louvre: *Orpheus, Rape of Europa.* Other works in the Petit Palais.

Mottez, Victor Louis (Lille 1809–Bièvres, Seine-et-Oise, 1897). Painter of history subjects and portraits. In the Louvre: *Portrait of Madame Mottez* (1840). Painted chapels of St Francis de Sales and St Anne and St Mary at Saint-Séverin (V). Painted chapel of St Martin at Saint-Sulpice (VI). 195.

Mucha, Alphonse (Ivancice, Czechoslovakia, 1860–Prague 1939). Painter, illustrator and poster-artist. 200.

Natoire, Charles Joseph (Nîmes 1700–Castelgandolfo 1777). Painter and decorative artist. Painted Salon Oval in the Hôtel de Soubise (60 rue des Francs-Bourgeois, III) with 8 compositions of *Cupid and Psyche; Bacchus and Ariadne* at Versailles. In the Louvre: *Triumph of Bacchus, Three Graces.* In the Petit Palais: *Château de Compiègne.* 133, 152.

Nattier, Jean Marc (Paris 1685–1766). Painter, famous for portraits

of the nobility. Works in the Louvre include *Madame Adelaïde de France* (1758), *Mademoiselle de Lambesc below the figure of Minerva arming her brother the Comte de Brionne* (1732), *Madame Henriette de France, Duc Michel-Ferdinand as Hercules.* 152.

Nénot, Henri Paul (Paris 1853–1934). Architect. Built new Sorbonne (1884–89); enlarged Ecole des Sciences Politiques; built numerous institutes and *hôtels.* Design for Palais de la Société des Nations awarded first prize in 1927 (in preference to a design by Le Corbusier).

Nervi, Pier Luigi (Born Sondrio 1891). Leading modern architect. Co-designer of UNESCO building (Place de Fontenoy, VII; 1953–7). 232.

Noguchi, Isamu (Born Los Angeles 1924). Sculptor and designer. Laid out Japanese rock garden at UNESCO building (1958).

Oppenord, Gilles Marie (Paris 1672–1742). Architect. Designed high altar of Saint-Germain des Prés (1704); choir and south portal of Saint-Sulpice; house at 13 rue Tiquetonne (II). 133.

Ottin, Auguste Louis Marie (Paris 1811–90). Sculptor. Carved the marble group *Acis and Galatea surprised by Polyphemus* on the Fontaine Médicis in the Luxembourg gardens. *81.*

Pajou, Augustin (Paris 1730–1809). Sculptor. Works in various Paris museums. In Muséum d'Histoire Naturelle: *Buffon, Marmottan.* Other works at the Institut, Musée Jacquemart-André, Comédie Française, Versailles, Musée de Châalis (*Jacques Poitevin*). Remodelled Fontaine des Innocents (60 square des Innocents, I). *70, 109.*

Pascin, Jules (Julius Pincas; Widin, Bulgaria, 1885–Paris 1930). Painter. 200.

Percier, Charles (Paris 1764–1838). Architect. Worked with Fontaine (q.v.) on the Arc de Triomphe du Carrousel (1806), rue de Rivoli and rue de Castiglione (begun 1806), and Place des Pyramides. 146, *173.*

Perrault, Claude (Paris 1613–1688). Architect and doctor, brother of Charles (author of the fairy tales). Major work is the east front of the Louvre (1665). Designed the Observatoire (VI; 1667–8). Wrote a treatise, *De l'ordonnance des cinq espèces de colonnes selon la méthode des anciens.* 74, 89.

Perret, Auguste (Brussels 1874–Paris 1954). Architect specializing in the use of reinforced concrete ('First attempt at an aesthetic use of concrete': apartment building at 25*bis,* rue Franklin, XVI). Built Théâtre des Champs-Elysées (1913), church of Le Raincy (Seine-Saint-Denis; 1922–3); Ecole Normale de Musique (1929); apartment building at 51 rue Raynouard (XVI); Mobilier National (rue Berbier-du-Metz, XIV; 1932–5); Musée des Travaux Publiques (place d'Iéna, XVI; 1937); naval laboratories (boulevard Victor, XV; 1928). 186, 188, 225.

Perrier, François (Salins *c.* 1590–Paris/Saint-Jean de Cosne 1656). Painter, decorative artist and engraver. Decorations in Hôtel Lambert (2 rue Saint-Louis en l'Ile, IV); painted ceiling of the gallery in Hôtel de la Vrillère (now Banque de France; paintings to be replaced by 19th-century copies). 114.

Perronet, Jean Rodolphe (Suresnes 1708–Paris 1794). Architect and engineer. Designed Pont Louis-XVI (now Pont de la Concorde; 1787–92). 129.

Peyre, Marie Joseph (Paris 1730–Choisy-le-Roi 1788). Painter and architect. With de Wailly, built the Odéon theatre (VI; 1779–82). Author of a book on architecture. 128, 136.

Picasso, Pablo Ruiz (Born Malaga 1881). Painter, sculptor, ceramist and engraver. With Braque, founded Cubism. Settled in Provence in 1947. Mural for UNESCO building (1958). Works in Musée National d'Art Moderne: *Portrait of a Woman, Figure, The Muse, Woman in Blue, Still-life with cherries, Portrait of Madame Paul Eluard.* Public monument to Guillaume Apollinaire (bronze) in Square de Saint-Germain des Prés. 200, 209, *231, 232.*

Pierre de Chelles (Active easily 13th century). French master mason. Worked at Notre-Dame; tomb of Philip III the Bold at Saint-Denis.

Pigalle, Jean Baptiste (Paris 1714–1785). Sculptor in the employ of Mme de Pompadour; produced allegorical statues and portraits. Works in the Louvre, Musée de Cluny, Musée Jacquemart-André, Musée des Arts Décoratifs and Musée de l'Ecole de Médecine. Executed portal of the church of the Enfants-trouvés (72 avenue Denfert-Rochereau, XIV); and mausoleum of the duc d'Harcourt in Notre-Dame. 129, 152.

Pilon, Germain (Paris *c.* 1535–1590). Outstanding French sculptor of the 16th century. Executed tombs and realistic portraits, e.g. sculptures on the tomb of Henry II at Saint-Denis

(1565–83). *Virgin of Sorrows,* at Saint-Paul-Saint-Louis (marble). Works in the Louvre include the monument for the heart of Henry II, called *The Three Graces* (marble, 1559), funeral effigy of Cardinal René de Birague, and the *Virgin of Sorrows.* In Saint-Jean-Saint-François (6 rue Charlot, III): statue of *St Francis* from the Valois Chapel at Saint-Denis. 110, 116.

Pils, Isidore (Paris 1815–Douarnenez 1875). Painter. Works at Ste-Clotilde, near the Invalides; ceiling of grand staircase, Opéra. *197.*

Pinaigrier. Family of stained-glass artists (active Paris 16th century). Made the large *Life of the Virgin* window in St-Gervais-St-Protais (*c.* 1520). *61.*

Pissarro, Camille (St Thomas, Virgin Islands, 1830–Paris 1903). Draughtsman, painter and engraver, active supporter of the Impressionist movement. Works in the Musée de l'Impressionnisme (Jeu de Paume) include *Frost at Auvers-sur-Oise, The Pont Royal and Pavillon de Flore, The Stage-Coach, Pontoise, Red Roofs* (1877), *The Loing Canal* (1902). In the Musée National d'Art Moderne: *Red Roofs.* Also in Musée Marmottan. 196, 200.

Poussin, Nicolas (Grand Andelys 1594–Rome 1665). Painter. Many works in the Louvre, including *The Four Seasons* (1660–64), *Arcadian Shepherds* (1650–55), *Philistines struck by the Plague* (1635), *Rape of the Sabines* (1637–9), *Judgment of Solomon* (1665) . In the Musée Condé, Chantilly: *Childhood of Bacchus.* 114, 115.

Poyet, Bernard (Dijon 1742–Paris 1824). Architect. Designed Saint-Laurent (1780); river front of the Palais Bourbon (1808). 129.

Primaticcio, Francesco (Bologna 1504–Paris 1570). Decorative artist called to Fontainebleau by Francis I. In the château, painted and designed stucco in Galerie d'Ulysse (1561–70 , and ballroom (1551–6). In the Louvre: drawings of antique subjects. 80, 112.

Pucelle, Jean (Active Paris 1319–27). Miniaturist. In the Bibliotheque Nationale; *Belleville Breviary.* 10, 54. (1881). 32, 209.

Puvis de Chavannes, Pierre (Lyons 1824–Paris 1898). Painter. Frescoes in the Panthéon (*Life of St Geneviève,* 1876–98), Sorbonne (*Sacred Wood,* 1877), and Hôtel de Ville (*Summer* and *Winter,* 1891–2). In the Louvre: *Bathers, Poor Fisherman* (1881).

Ramey, Claude (Dijon 1754–Paris 1838). Sculptor. Reliefs on Arc de Triomphe du Carrousel. In the Louvre: *Sappho, Napoleon.* At Versailles: *Eugène de Beauharnais, Viceroy of Italy.*

Raphael Sanzio (Urbino 1483–Rome 1520). Painter. Well represented in the Louvre and at Chantilly: *La Belle Jardinière, Virgin of the Veil, Holy Family of Francis I.* 112, 158, 195.

Regnaudin, Thomas (Moulins 1622–Paris 1706) Sculptor. Worked at Versailles with Girardon: *Apollo attended by Nymphs, Ceres* (in Grotte de Téthys), *Loire* and *Loiret.* Designed portal of Hôtel des Ambassadeurs de Hollande. 117.

Renoir, Auguste (Limoges 1841–Cagnes 1919). Painter of landscapes and portraits, engraver, lithographer and sculptor. Belonged to Impressionist group. Works in Musée de l'Impressionnisme (Jeu de Paume) include *Girl with a Straw Hat, Moulin de la Galette* (1876), *Girls at the Piano.* 196, 213, 220.

Ribot, Théodule Augustin (St-Nicolas d'Allez, Eure, 1823–Colombes 1891). Painter of history and genre subjects and portraits. Works in the Louvre include *La Ravaudeuse, The Samaritan, St Sebastian, Jesus and the Doctor, Self-portrait.* In the Petit Palais : *Little Girl in Grey.* 195.

Riesner, Jean Henri (1734–1806). Cabinetmaker of German origin, outstanding under Louis XV and Louis XVI. 154.

Robert, Hubert (Paris 1733–1808). Landscape painter, engraver and draughtsman. Works in the Louvre include *The Maison Carrée at Nîmes, Arena at Nîmes, Tour Magne, Nîmes,* and *Pont du Gard.* Executed views of Paris of which some are in Musée Carnavalet: *Opéra Fire* (1781), *Demolition of the Bastille* (1789). 117, 136, 152, 158.

Rodin, René François Auguste (Paris 1840–Meudon 1917). Sculptor. Bronze statue of *Balzac* (corner of boulevard Montparnasse and boulevard Raspail). Most works in Musée Rodin (rue de Varenne, VII): *The Kiss, The Age of Bronze, Gates of Hell, Alphonse Le Gros,* etc. 197, 209, *231.*

Rondelet, J. B. (1743–1829). Architect. Worked at the Panthéon, with and after Soufflot (1757–1790). Strengthened supports of dome and filled in windows. *158.*

Rosso, Giovanni Battista (Florence 1494–Paris 1540). Painter and decorative artist. With Primaticcio de-

corated the Galerie François I at Fontainebleau. In the Louvre: *Pietà*. 65, 112.

Rouault, Georges (Paris 1871–1958). Painter and stained-glass designer. Works in Musée National d'Art Moderne include *The Poor Woman, Girl with a Mirror* (1906), *Faubourg des longues peines* (1911), *Sorcerer's Apprentice* (self-portrait, 1925), *The Holy Face* (1933), *Christian Nocturne* (1952), 58 engravings (*Miserere*). 225.

Rousseau, Pierre (Nantes *c.* 1750–1810). Architect. Designed Hôtel de Salm (now Légion d'Honneur, 64 rue de Lille, VII). 136, *170*.

Rousseau, Théodore Pierre Etienne (Paris 1812–Barbizon 1867). Landscape painter. Works in the Louvre include *Edge of the Forest of Fontainebleau at Sunset* (1848–50), *Edge of a Forest at Sunset* (1849), *Storm Effect,* and *Marsh in the Landes* (1852). *200.*

Rubens, Peter Paul (Siegen 1577–Antwerp 1640). Painter. Works in the Louvre include *The Flight of Lot, Virgin and Child with Angels,* and gallery of 21 paintings of the *Life of Marie de Médicis* from the Palais du Luxembourg (1622–5). In the Petit Palais: *Rape of Proserpine.* 96, 114, 158, 195.

Rude, François (Dijon 1784–Paris 1855). Sculptor. Works in the Louvre include *Bust of Louis David* (1826), *Young Neapolitan Fisherman* (1832), *Mercury fastening his Sandal.* On the Arc de Triomphe: *Departure of the Volunteers in 1792,* or *La Marseillaise* (1835–6). Statue of *Marshal Ney* at the Carrefour de l'Observatoire (1852–3); tomb of Cavaignac in Montmartre cemetery (1847). 150, *175.*

Saint-Aubin, Gabriel de (Paris 1724–1780). Draughtsman and engraver. Charming etchings of Paris scenes, including *Le spectacle des Tuileries* (1760). Executed 50 engravings 1750–1773, including *Le salon du Louvre* (1754), *The Charlatan, Sunday at Saint-Cloud* (1762). 152.

Sarto, Andrea del (1486–1531). Florentine painter. Called to France in 1518 where he worked for Francis I. In the Louvre: *Charity, Holy Family, Portrait of Andrea Fausti.* 112.

Saunier. Family of cabinetmakers in the 18th century. Works in Musée des Arts Décoratifs. 154.

Sédille, Paul (1836–1900). Architect. Built Grands Magasins du Printemps (1881–9). Published *L'Architecture moderne* (1890). 164.

Servandoni, Jean Nicolas (Florence 1695–Paris 1766). Architect and decorative artist. Saint-Sulpice. 133.

Seurat, Georges (Paris 1859–1891). Painter. Founder of Neo-Impressionism, also known as Pointillism and Divisionism. In the Musée de l'Impressionnisme (Jeu de Paume): *The Circus* (1890–91, unfinished). 200, 209, *222.*

Severini, Gino (Cortona 1883–Paris 1966). Painter associated with the Futurist movement. In Musée National d'Art Moderne: *La Danse du Pan-Pan* (1909–11).

Silvestre, Israël (Nancy 1621–Paris 1691). Engraver. Produced engravings of court entertainments: *Courses de testes et de bagues* (1662); *Les plaisirs de l'île enchantée* (1664). 114.

Soto, Jésus Raphaël (Born Venezuela 1923). Kinetic artist. Works at UNESCO (1970).

Soufflot, Jacques Germain (Irancy, Yonne, 1709–Paris 1780). Architect. Designed the Panthéon (formerly Sainte-Geneviève; 1758); Ecole de Droit (Place du Panthéon, V); Fontaine de la Croix du Trahoir (rue de l'Arbre Sec, I); treasury and great sacristy at Notre-Dame (1756). 89, 111, 133, 134, *158.*

Soutine, Chaim (Smilovitchi 1894–Paris 1943). Painter. In the Louvre (J. Walter, Paul Guillaume collections): *Grooms, Skaters* (1922–3). 200.

Stähly, François (Born Constance 1911). Sculptor. Executed work for ORTF.

Stefano della Bella (Florence 1610–1664). Engraver. Produced views of Paris.

Subleyras, Pierre (St-Gilles du Gard 1699–Rome 1749). History painter. Works in the Louvre include *Charon ferrying souls across the Styx* (before 1743), *Mass of St Basil* (1747, sketch). Other works in Musée Condé, Chantilly. 152.

Tamayo, Rufino (Born Oaxaca, Mexico, 1899). Painter. Executed mural for UNESCO (1958).

Taraval, Hugues (Paris 1728–1785). Painter and engraver. Works in the Louvre include *Triumph of Amphitrite* and, on the ceiling of the Galerie d'Apollon, *Autumn.* 152.

Temple, Raymond du. Architect to Charles V and Charles VI in the 14th century. Worked at the old Louvre (newel stair). 56.

Tissot, James (Nantes 1836–Bouillon 1902). Painter of genre, history, landscapes and portraits; draughtsman and watercolourist. Works in the Louvre include *Portrait in a Park, Faust and Marguerite* (shown at the

Salon of 1861), *The Prodigal Son*. 1951.

Titian (Tiziano Vecelli; Pieve di Cadore 1477–Venice 1576). Painter. Numerous works in the Louvre, including *Virgin and Child with Saints, Virgin and Child with a Rabbit, Disciples at Emmaus, Francis I*. 158, 195.

Tocqué, Louis (Paris 1696–1772). Portrait painter. In the Louvre: *Galloche, J. Le Moyne, The Dauphin in his Study, Marie Leczinska*. 152.

Toudoire, D. M. (1852–?). Architect of the Gare de Lyon. 163.

Toulouse-Lautrec, Henri de (Albi 1864–Malromé 1901). Painter. In the Musée de l'Impressionnisme (Jeu de Paume): *Jane Avril, The Bed*. 190, *225*.

Tuby, Jean-Baptiste (Rome 1635–1700). Also known as Le Romain. Sculptor. Worked with Coysevox at Versailles, on groups for fountains, etc., designed by Le Brun. *132, 138*.

Valentin de Boulogne (Coulommiers 1591–Rome 1634). Painter, imitator of Caravaggio. In the Louvre: *Susanna's Innocence Recognized, The Judgment of Solomon*. 114.

Van Gogh, Vincent (Zudert 1853–Auvers-sur-Oise 1890). Painter. Major works in Musée de l'Impressionnisme (Jeu de Paume). 200.

Vaudoyer, Léon (1803–1872). Architect. Worked at church and abbey of Saint-Martin des Champs: designed Conservatoire des Arts et Métiers (292 rue Saint-Martin, III).

Verniquet, Edme (1727–1824). Author of a plan of Paris published in 1796. 138, 145.

Vien, Joseph Marie (Montpellier 1716–Paris 1809). Painter. Works in the Louvre include *St Germanus, Bishop of Auxerre with St Vincent the Hermit, Deacon of Saragossa*. 152.

Vignon, Claude (Tours 1593–Paris 1670). Painter and engraver. Works in the Louvre include *Solomon and the Queen of Sheba*. 114.

Vignon, Pierre-Alexandre (1763–1828). Architect to Napoleon. Designed the Madeleine (formerly Temple de la Gloire).

Villard de Honnecourt (Active *c.* 1241–1250). Architect. Known for an album of drawings of architectural details and proportion studies (Bibliothèque Nationale). 45.

Viollet-le-Duc, Eugène Emmanuel (Paris 1814–Lausanne 1879). Architect and theorist. Restorer of medieval buildings: Saint-Denis, Notre-Dame, etc. Author of *Dictionnaire raisonné de l'architecture française du*

XIe au XIVe siècle (1854–68). *23, 52, 177*.

Visconti, Ludovico (Rome 1791–Paris 1853). Architect. Designed Fontaine de Gaillon (1824); tomb of Napoleon in the Invalides church; buildings linking the Louvre and Tuileries palaces. 185, *186, 188, 190*.

Vouet, Simon (Paris 1590–1649). Decorative painter. Decorated a ceiling in the former Hôtel Tubeuf. Altarpieces at Saint-Merri, Saint-Eustache and Saint-Nicolas des Champs. Works in the Louvre include *The Presentation in the Temple, Christ on the Cross, Louis XIII between two female figures symbolizing France and Navarre*. 89, 114.

Vuillard, Edouard (Cuiseaux, Saône-et-Loire, 1868–La Baule 1940). Painter of the Nabi group. Well represented in the Musée National d'Art Moderne: *In Bed* (1891); panels from the Natanson dining room (1894). In the Petit Palais: *Interiors* (1896). Painted the foyer of the Théâtre des Champs-Elysées (1912-13); panel in hall of the Palais de Chaillot. 209, 225, 229.

Wailly, Charles de (1829–1898). Architect and decorative artist. With Payre, designed Odéon theatre. 128.

Watteau, Antoine (Valenciennes 1684–Nogent-sur-Marne 1721). Painter. In the Musée Condé, Chantilly: *L'Amante inquiète, Donneur de sérénade, Love disarmed*. In the Louvre: *L'Indifférent, Jupiter and Antiope, Embarkation from Cythera, Judgment of Paris, Gathering in a Park*. 151.

Whistler, James Abbott McNeill (Lowell, Mass., 1834–London 1903). Painter and engraver. In the Louvre: *Portrait of the Artist's Mother* (*Harmony in Grey and Black*; 1871–72). 195.

Wogenski, A. (Born Remiremont, Vosges, 1916). Architect and town-planner, working with Le Corbusier. Designed Centre Hospitalier Universitaire, Hôpital Saint-Antoine (184 rue du Faubourg Saint-Antoine, IV).

Zadkine, Ossip (Smolensk 1890–Paris 1967). Sculptor. In the Musée National d'Art Moderne: *Mother and Child*. 200.

Zandomeneghi, Federico (Venice 1841-Paris 1917). Painter of the Macchiaioli group. Executed extremely delicate pastels. 200.

Zehrfuss, Bernard (Born Angers 1911). Architect. Co-designer of UNESCO building; worked with Camelot and de Mailly on Rond-Point de la Défense scheme. 231, 232.

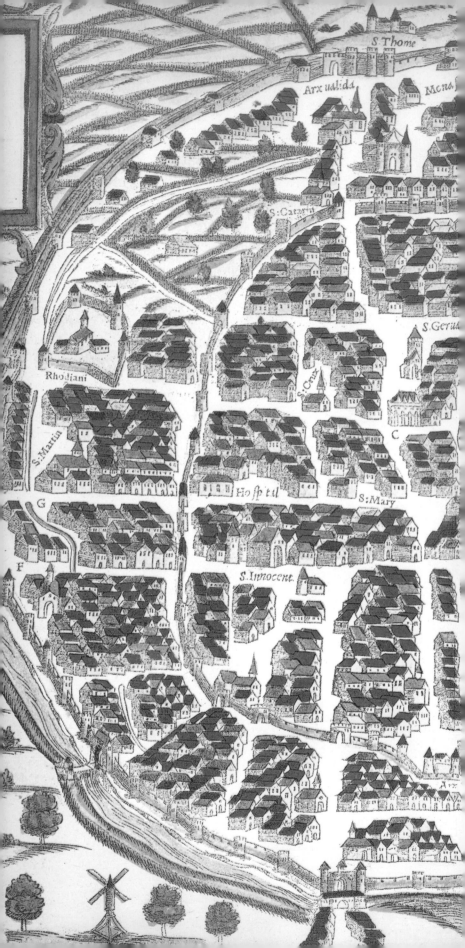

S. Thome

Arx ualida

Mena,

S. Cataria

S. Gerus

Rhodiani

S. Crus

C

S. Martin

Ho ſp tıl

S. Mary

G

F

S. Innocent

Arx

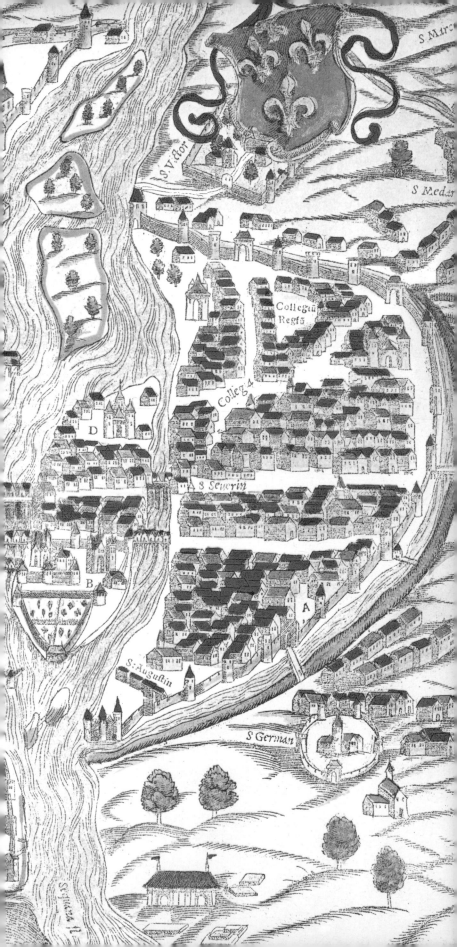

S Marc

S V ctor

S Med.r

Collegiū
Regis

Colleg 4

D

S Seuerin

B

A

S:Augustin

S German